WALTHER BERNT

The Netherlandish Painters of the Seventeenth Century

III

The Netherlandish Painters

WALTHER BERNT

of the Seventeenth Century

Three volumes · 800 artists · 1460 reproductions

Volume Three

PHAIDON

All rights reserved by Phaidon Press Ltd.
5 Cromwell Place, London S.W. 7
First published 1970

Phaidon Publishers Inc., New York
Distributors in the United States:
Praeger Publishers, Inc.,
111 Fourth Avenue, New York, N.Y. 10003
Library of Congress Catalog Card Number: 76–105 963

TRANSLATED
FROM THE THIRD GERMAN EDITION
BY P.S.FALLA

© 1948/1960/1970 by Verlag F.Bruckmann KG, Munich
English translation © 1970 by Phaidon Press Ltd.
SBN 7148 1429 6
Printed in Germany

Romeyn, Willem

EXROMEYN

b. Haarlem about 1624,
d. there about 1694
979, 980

Haarlem animal painter and landscapist, a pupil of N. Berchem and K. Dujardin; his Italianate landscapes with figures of herdsmen and shepherds resemble the latter's work. His later pictures, which are mostly small, show negligent drawing and hard, darkening colours. He may be confused with K. Dujardin and also with the weaker artist A. Klomp.

Rootius, Jakob

b. Hoorn 1644,
d. there
about 1681
981

Dutch painter of flowers and fruit; son of Jan Albertsz. Rootius and a pupil and imitator of J. D. de Heem. He differs from the latter by the particularly hard and contrasting illumination of his bouquets and fruit against a dark background. The breakfast still lifes composed in the manner of W. C. Heda and formerly ascribed to him are probably by his father, who, however, was mainly a portraitist. As was common at the time, Jakob Rootius frequently composed flowers and fruit together. His work shows some resemblance to the still lifes of A. Mignon and to that of the numerous other pupils and followers of J. D. de Heem. His treatment of light shows affinity with Maria van Oosterwyck, who, however, is less influenced by De Heem.

Literature: H. F. Wijnman, *Oud Holland*, XLVII, 1930, pp. 60–7.

Rootius, Jan Albertsz.

b. Medemblik
1624,
d. Hoorn 1666
982, 983

Dutch portraitist and still-life painter; pupil of P. Lastman and father of Jakob Rootius. He painted individual and group portraits of Frisian families. His work sometimes resembles that of the weaker Frisian portraitist W. de Geest. His pictures of children – boys and girls under a tree – are reminiscent of J. G. Cuyp in their conception and accessories: a shepherd's crook, a goat and some fruit. His rare breakfast still lifes, on a table with a white cloth against a light background, belong to the "monochrome banquet" group around P. Claesz and W. C. Heda.

Literature: H. F. Wijnman, *Oud Holland*, XLVII, 1930, pp. 60–7.

Royen, Willem Fr. van

b. Haarlem 1645,
d. Berlin 1723
984, 985

Dutch-German still-life painter, active at Haarlem, The Hague and Berlin; a pupil of M. d'Hondecoeter. From 1669 to 1679, together with the still-life artist O. Elliger, he was court painter to the Great Elector at Potsdam. His still lifes, composed on a grand scale and with strong illumination against a dark background, recall S. Verelst and W. van Aelst. For the court at Berlin he painted numerous small flower and fruit pieces with parrots and other birds, often with rare plants from the Elector's garden. Though painted at Berlin in his later years, these still lifes still show the influence of Dutch models. His hunting still lifes with dead hares recall J. Weenix by their subject and A. Gryeff by the variegated colour characteristic of the later period.

Ruelles, Pieter des

b. Amsterdam about 1630,
d. The Hague 1658
986

Dutch landscape painter and poet. His landscapes are rare and somewhat amateurish in style; buildings such as monasteries, old towers and ruins play a prominent part, while figures are of less importance. Most of his pictures are signed with his full name.

Ruisdael, Jakob von

b. Haarlem about 1628,
d. Amsterdam 1682
987, 988, 989, 990, 991, 992, 993

Important Haarlem landscape painter, perhaps a pupil of his uncle Salomon van Ruysdael. He was initially influenced by Cornelis Vroom and painted the well-wooded dune landscapes of the country round Haarlem. These pictures are simple in composition and seem to have been painted from nature, with sparing use of detail. In his later work trees, the foreground and soil are painted in a more exact and plastic fashion. The composition becomes more spectacular, and the subject is enriched with streams, meadows, cornfields, hilly dunes and more strongly emphasized clumps of trees. He pays special attention to the sky, clouds and the effects of light and shade on the ground beneath. The coloration is cool but with strong accents of local colour, e. g. red brickwork. After 1650 he painted masterly panoramas of the grave, imposing countryside around Haarlem, with distant churches or ruins on the horizon, their height emphasized for effect. He seldom paints direct sunlight or a cloudless sky, nor do his pictures often represent a particular

time of day (sunrise or sunset). Figures play a minor part, but are more prominent in his rarer beach scenes and seascapes with overcast skies. After 1655 he painted melancholy landscapes of Gelderland and Overijssel with half-timbered buildings, water-mills and forest marshes. Churchyards, lofty ruins and old, withered trees symbolize the transience of life. In his later period, like Allart van Everdingen, he painted Scandinavian mountain landscapes: broad waterfalls between high ridges, or lonely forests of Northern fir-trees. The cascades of water foaming over the rocks, the wet moss on stones and uprooted tree-trunks are rendered in a masterly fashion, though at times the effect of these late works is diminished by excessive rhetoric. To this late period also belong his rare views of Amsterdam and excellent winter scenes, in which the grey sky has often become darker with time. Figures – sometimes bright red in hue – play a more prominent part in these works, whereas in most of his landscapes the figures which he painted himself are few and unimportant. Among painters who contributed figures to his works are Adriaen van de Velde, Philips Wouwerman, J. Lingelbach, N. Berchem, Adriaen van Ostade and Eglon van der Neer. Ruisdael himself provided landscape backgrounds for works by B. van der Helst and the animal painters Jacobus Victors and Jan Vonck.

The whole art of landscape painting was influenced by Ruisdael till the end of the nineteenth century. Artists who painted in his style included Roelof van Vries, G. van Hees, G. Dubois, C. Decker, Jan van Kessel, J. Lagoor, Salomon Rombouts and J. Vermeer van Haarlem the Elder. Neither his many contemporary imitators nor later copyists and forgers were successful in capturing the deep seriousness of his majestic landscapes.

Literature: C. Hofstede de Groot, *Catalogue raisonné*, vol. IV, Esslingen, 1911; J. Rosenberg, *J. van Ruisdael*, Berlin, 1928; N. MacLaren, *National Gallery Catalogues, Dutch School*, London, 1960, p. 353; W. Stechow, *Dutch Landscape Painting of the Seventeenth Century*, London, 1968.

Ruysch, Rachel

b. Amsterdam 1664,
d. there 1750
994, 995

Important Amsterdam flower-painter; pupil of W. van Aelst. Her work is small in quantity: about 100 pictures, composed with excellent taste and always painterly in spite of their delicate, almost over-precise execution. They mostly depict in a natural style bouquets of flowers on a table-top; less often fruit enlivened by caterpillars, butterflies etc. Although her active career lasted till the middle of the eighteenth century, she continued to use dark backgrounds. In comparison to the enamel-like work of contemporary flower-painters her pictures have an old-fashioned look, but are strong and noble. Many of them show a preference for evening light; unfortunately some have been darkened by time. In a very few cases the flowers are seen against a back-ground of landscape or architecture. Her rarer pictures of plants in a forest setting – shrubs, thistles, moss with reptiles, butterflies at night – are reminiscent of O. Marseus. Her subjects also recall those of E. van den Broeck and J. van Huysum. Works by A. de Lust, A. Mignon and Maria van Oosterwyck are often ascribed to her.

Literature: C. Hofstede de Groot, *Catalogue raisonné*, vol. x, Esslingen, 1928; M. H. Grant, *R. Ruysch*, Leigh-on-Sea, 1956.

Ruysdael, Jakob Salomonsz. van

b. Haarlem about 1630, d. there 1681
996, 997

Haarlem landscape painter, son of Salomon van Ruysdael and cousin of Jakob van Ruisdael. His forest landscapes are often large and depict undulating, well-wooded country; they are related to his father's later work, but may be recognized by the somewhat prominent figures of fallow-brown cows and sheep. The wooded area, with its strong green and brown colouring, stands out against a deep-blue sky, often diversified by cumulus cloud. Large single oak-trees with massive trunks are especially prominent in the foreground. Withered branches are reproduced in a manneristic style. Owing to the use of dark priming, the foliage in his later work is often opaque. His best pictures approach his father's work by the skilful, somewhat one-sided talent for composition and predilection for effect. Owing to his use of the monogram JR, many of his works have been attributed to his celebrated father.

Literature: W. Stechow, *Salomon van Ruysdael*, Berlin, 1938, pp. 45 ff.; N. MacLaren, *National Gallery Catalogues, Dutch School*, London, 1960, p. 375.

Ruysdael, Salomon van

b. Naarden about 1601,
d. Haarlem 1670
998, 999, 1000, 1001, 1002

Important Haarlem landscape and sea painter; father of Jakob Salomonsz. van Ruysdael, uncle of Jakob van Ruisdael. His early work was influenced by Esaias van de Velde and P. de Molijn and resembles the contemporary painting of J. van Goyen: flat landscapes of dunes and trees, ranging in colour from yellow-brown to grey-green, often with a dark shadowy stretch in the foreground. The effect of space is enhanced by trees at the side of the picture, blown out of shape by the wind. His best work was done after 1645. In this period the figures become larger and more colourful instead of being mere outlines; the spectator's vision is attracted into the distance by large houses, high church-towers and citadels. A strong black is used for outlines and shadows. White clouds, very well observed, drift across a deep-blue sky. Water becomes of increasing

importance: a ferryboat crowded with passengers is seen traversing a calm, broad stream with tall trees standing close together on its banks. The expanse of inland sea, with its steely-grey waters and mannered little waves, is animated by a skilful disposition of sailing-boats. His later works are often large in size and have a monumental, decorative character. His son, Jakob Salomonsz. van Ruysdael, developed this tendency further. His rare ice scenes with numerous small, nervously drawn figures have a more colourful effect than those of J. van Goyen and Isaac van Ostade, which they otherwise resemble. His still lifes with dead birds contrast with his other work and are thought to belong to his late period; the plumage is rendered in masterly fashion against a light grey background. His works are very numerous and are usually signed and often dated. His son Jakob resembles him in style and was probably his pupil. The father's early work shows the influence of the canal scenes of P. Nolpe and P. de Neyn, and sometimes resembles the beach and winter landscapes of W. Kool.

Literature: J. Goudstikker, *Tentoonstelling S. van Ruysdael*, Amsterdam, 1936; W. Stechow, *Salomon van Ruysdael*, Berlin, 1938; N. Mac-Laren, *National Gallery Catalogues, Dutch School*, London, 1960, p. 377; W. Stechow, *Dutch Landscape Painting of the Seventeenth Century*, London, 1968.

Ruytenbach, E.

active in the
second half of
the seventeenth
century
1003

Dutch landscape painter; nothing is known of his life. His river and village scenes are distinctively composed: on one side are peasant cottages under tall trees, and in front of them a patch of ground or river brightly lit by the sun. He is also fond of using numerous lively figures. His treatment of the theme *Halt at an Inn* shows close affinity with B. Gael in subject and execution, including the typical white horse. His river scenes have a thematic resemblance to Th. Heeremans. His pictures are usually signed and dated and were mostly painted in the 1680s.

Ryck, Cornelia de

b. Delft 1656
1004

Dutch painter of poultry and farmyard scenes, less rich in composition and less animated than those of Melchior d'Hondecoeter; the animals, however, are particularly natural, their peculiar charm recalling the work of the Amsterdam painter Jacobus Victors. Her work is extremely rare.

Ryck, Pieter Cornelisz. van

b. Delft 1568,
d. Haarlem after 1628
1005

Dutch still-life painter and imitator of P. Aertsen and J. Beuckelaer, to whom he is inferior. Italian influence appears in his kitchens full of implements and utensils, with pictorial figures of serving-men and maids. His themes include sumptuous banquets illustrating the parables of Dives and Lazarus or the Prodigal Son. The profusion of implements makes his pictures of interest from the viewpoint of social history. Similar plentifully equipped kitchens were painted by Cornelis Jacobsz. Delff and F. van Schooten.

Ryckaert the Younger, David

b. Antwerp 1612,
d. there 1661
1006, 1007, 1008, 1009

Flemish genre painter, nephew of the landscape painter Marten Ryckaert. Beginning with the warm chiaroscuro of A. Brouwer, he later painted in the lighter, cooler hues of D. Teniers. His subjects were peasant interiors with family feasts and merry-making (Twelfth Night festivities) and musical parties. Less often he painted village surgeons, craftsmen (shoemakers at work), religious and ghostly themes (Temptation of St. Anthony, witches and alchemists). He has a good eye for physiognomy. His range of types is very large, but some figures, e. g. a bald old man, recur frequently. Inanimate objects are also painted with care and sometimes form an entire composition – vessels, farming equipment, stores of meat and vegetables – depicted in a barn with a single unobtrusive human figure. These works may be confused with similar ones by H. Potuyl and F. Ryckhals. Later he became increasingly concerned with bourgeois scenes: the figures are now more numerous and the painting more detailed, while many are set out of doors (kermesses). His many pictures are generally signed in full and dated; their didactic and illustrative conception is unmistakable. The similarity of subject relates them to the work of D. Teniers and G. van Tilborgh.

Literature: F. C. Legrand, *Les Peintres flamands de genre*, Brussels, 1963.

Ryckaert, Marten

b. Antwerp 1587, d. there 1631
1010, 1011

Flemish painter of river-valleys with wooded cliffs and small figures, in the style of P. Bril's middle period. Pupil of T. Verhaecht, from whom he acquired a taste for fantastic rock formations with plunging waterfalls and for a cool, pallid green. He may easily be confused with P. Bril, especially as his figures are often of Biblical origin. The craggy forest landscapes of

Gillis d'Hondecoeter show similarity of theme. His pictures, which are rare, generally bear the monogram MR.

Literature: G. Martin, *National Gallery Catalogues, Flemish School*, London, 1970, p. 233.

Ryckhals, François

b. Middelburg after 1600,
d. 1647
1012, 1013

Flemish-Dutch still-life painter. His early work, yellow in tonality, consists of matter-of-fact compositions of vessels, glasses, earthenware jugs and pewter plates on a table-top. Later he chiefly painted barn interiors with peasants' gear in the style of the Rotterdam artists H. M. Sorgh and E. van der Poel or of H. Potuyl, with any of whom he may easily be confused. His later work is a great deal richer, with somewhat crowded compositions of costly silver dishes and goblets, Venetian glassware and books. Mistaken reading of the signature F R Hals formerly led to his work being ascribed to Frans Hals.

Literature: A. Bredius, *Oud Holland*, XXXV, 1917, pp. 1–11; I. Bergström, "François Ryckhals," *Oud Holland*, LXIV, 1949, pp. 18 ff.

Rysbraeck, Pieter

b. Antwerp 1655, d. Brussels 1729
1014

Flemish landscape painter and etcher. A pupil of Ph. A. Immenraet in 1672, master in the Antwerp Guild in 1673; from 1720 he lived in Brussels. His early scenes of wooded hills with open, brightly lit patches of sand are reminiscent of the older Flemish artists J. d'Arthois and L. de Vadder. His later landscapes, like his master's, belong to the Italianate classical school; his treatment of detail becomes more delicate and his figures more important, while his backgrounds begin to feature antique fountains, pillared halls and Roman cities. These pictures resemble the work of the French artist Jean-François Millet, whom he met in France in 1675. He occasionally worked with the still-life painter J. P. Gillemans: hunting still lifes, especially with feathered game. He may be confused with his son, also called Pieter, who was his pupil and painted hunting still lifes, and also with G. de Witte.

Rysen, Warnand van

b. Zaltbommel about 1625,
d. in Spain after 1665
1015

Dutch landscape painter, pupil of C. van Poelenburgh of Utrecht. In 1665 he went to Spain to trade in precious stones, and according to Houbraken he continued his studies in Italy. He is one of the less-known artists of Poelenburgh's circle,

together with J. van Haensbergen, D. Vertangen and D. van der Lisse. Like them, he painted rocky caves in a southern landscape with resting shepherds or anchorites. A typical landscape of his with the Holy Family was in a sale at Christie's, London, on 10 July 1953; there is a landscape with nymphs in the Staedel Institute at Frankfurt and a view from a grotto, with sheep and goats, in the former Hoschek Collection at Prague. Unlike C. van Poelenburgh, he has a characteristic preference for grey-violet tones. His pictures are frequently mentioned in old inventories, but only a few of those extant are authenticated by his monogram WvR; probably this was removed in most cases so as to attribute his work to C. van Poelenburgh, who was greatly admired from an early date. Fr. Verwilt's Arcadian landscapes with nymphs resemble those of Van Rysen; G. Hoet was the latter's pupil before 1672.

Literature: Th. von Frimmel, *Studien und Skizzen zur Gemäldekunde*, vol. I (1913–15), pp. 142–6; vol. II (1915–16), pp. 101.

Saenredam, Pieter

b. Assendelft 1597, d. Haarlem 1665
1016, 1017, 1018, 1019

Important Dutch painter of architecture; a pupil of P. de Grebber, in whose style he began by painting portraits and landscapes. His depiction of churches is unsurpassed in the careful choice of viewpoint and fidelity to the object, as well as in a particular technique of rendering light. A draughtsman rather than a painter, he is said to have made very careful preliminary drawings for all his pictures. The perspective of his church interiors and (less frequent) exteriors appears absolutely accurate. His pictures of buildings are also topographically precise, being generally marked with the place and date, and thus rank as archaeological documents. An overwhelming sense of space is imparted by his famous shimmering, golden light, reproduced in his best period by a technique of silvery white and grey tones. In this respect he stands as a model for the entire Dutch school of church painting. He was not a skilful painter of figures: those he added to his pictures are small and uncertainly drawn. Some were contributed by Adriaen van Ostade and, less often, Jan Both. I. van Nickele was probably a pupil of his.

Literature: P. T. A. Swillens, *P. J. Saenredam*, Amsterdam, 1935; D. Hannema, *Tentoonstelling P. Saenredam*, Boymans Museum, Rotterdam, 1938; *Catalogue raisonné of P. J. Saenredam*, Central Museum, Utrecht, 1961; N. MacLaren, *National Gallery Catalogues, Dutch School*, London, 1960, p. 378.

Saftleven, Cornelis

b. Gorkum 1607,
d. Rotterdam 1681
1020, 1021, 1022, 1023

Versatile Rotterdam painter of peasant scenes in the manner of H. M. Sorgh and P. de Bloot. In his early period he painted barn

interiors with still lifes of earthenware vessels, barrels, brass jugs and miscellaneous stores, in a skilful composition with warm, diffuse light falling from above: these may be mistaken for early works by his brother Herman Saftleven or for the more brightly coloured scenes of E. van der Poel. He also painted extensive landscapes with isolated tall trees or bridges, cattle and herdsmen, reminiscent of Govert Dirksz. Camphuysen and Aelbert Cuyp. He often painted indoor and outdoor peasant scenes of a genre type: meals, festivals, village surgeons. His religious scenes are mostly set in the open air and derive a special charm from their peasant-type figures: the Annunciation and Nativity, the Temptation of St. Anthony. Animal figures are used with excellent symbolic effect in critical or satirical representations.

Saftleven, Herman

b. Rotterdam 1609,
d. Utrecht 1685
1024, 1025, 1026, 1027

Dutch landscape painter, pupil of his brother Cornelis Saftleven, in whose style he initially painted barn interiors: D. Teniers is said to have provided some of the figures for these. His winter scenes with skaters on the city moat are seldom met with. About the middle of the century he painted large hilly forest landscapes in dark olive-green or brown tones, often with fantastic rocks in the background. The greater part of his work depicts river valleys from above, with steep hills rising to either side (scenery of the Moselle or upper Rhine), with numerous small figures executed with the precision of a miniature: peasants and travellers, vintner's boats at landing-stages. Pictures of this type, usually small in size, were painted by many of his successors up to the end of the eighteenth century, including J. Griffier and finally the German painter of Rhine scenes, Chr. G. Schütz. The monogram consisting of the interlinked letters HSL (to which he often added the date) has frequently been misread. Some of his early landscapes were provided by C. van Poelenburgh with mythological nudes of the well-known type.

Literature: N. MacLaren, *National Gallery Catalogues, Dutch School*, London, 1960, p. 382; W. Stechow, *Dutch Landscape Painting of the Seventeenth Century*, London, 1968.

Sallaert, Antoine

b. Brussels about 1590,
d. there about 1658
1028

Flemish painter of historical and religious scenes with large figures, in the style of Rubens; principally for Brussels churches, for which he also designed tapestries. Less often he painted religious and festive processions, which are of interest to the student of cultural history: the crowds are so multitudinous that they can only be taken in from an elevated viewpoint. His small portraits are delicate but not especially characteristic. He painted some figures for landscapes by J. d'Arthois, and according to old sources collaborated with Rubens and Van Dyck.

Literature: M. L. Hairs, *Revue belge d'archéologie et d'histoire de l'art*, XXIX, 1960, p. 42.

Sanders, Hercules

b. Amsterdam 1606,
d. there after 1673
1029

Dutch portrait painter, active at Amsterdam from 1635. His carefully executed portraits are reminiscent of the early work of B. van der Helst. He was evidently much esteemed in his own time, as he generally painted important personalities. As a rule they are seen standing and from the front, in full or three-quarter length, wearing large lace-collars and silver or gold braid. There are many large companion-pictures of gentlemen and their wives, also family groups. A portrait of a scholar in a high vaulted room was in a London sale in 1939. Less often he painted Old and New Testament scenes, which belong indirectly to the school of Rembrandt.

Sant-Acker, F.

active in the seventeenth century
1030, 1031

Dutch still-life and genre painter; nothing is known of his career. His fine still lifes bear a certain resemblance to those of W. Kalf: rare costly vessels, Delft bowls and glasses on a marble table-top. A still life of this type, with vessels and implements, was seen at Amsterdam in 1933 in Goudstikker's exhibition Het Stilleven. His work may be confused with that of J. van Streeck. His rare conversation pieces in elegantly furnished interiors bear a distant resemblance to those of M. van Musscher.

Santvoort, Dirck

b. Amsterdam 1610,
d. there 1680
1032, 1033

Amsterdam portrait painter who also treated historical themes: his style is severe and somewhat old-fashioned, after the manner of N. Elias and C. van der Voort. He shows good psychological observation but pays less attention to the rendering of material

objects; his colouring is on the sober side. His early Regent pieces are grave and distinguished, in contrast to his gay, artless portraits of children, which recall P. Moreelse and Jacob Gerritsz. Cuyp.

Literature: N. MacLaren, *National Gallery Catalogues, Dutch School*, London, 1960, p. 384.

Santvort, Pieter Dircksz.

P.v.Santvoort. fe

b. Amsterdam 1604,
d. there 1635
1034, 1035

Dutch landscape painter and draughtsman: great-grandson of Pieter Aertsen and son of Dirck Pietersz; like his father, he painted under the name of Bontepaert. His landscapes are somewhat like those of P. de Molyn: a winding sandy path leads into the distance through the undulating Haarlem dunes. In their uniform brown and green tonality they sometimes resemble the landscapes of J. van de Velde, who also belonged to the early Dutch school of landscape painting. Santvort's paintings are rarer than his drawings. Some winter landscapes by him are known.

Sauts, Dirck

T. SAVTS:

active at The Hague
in the mid-seventeenth century
1036

Dutch still-life painter: crabs, oysters, grapes, nuts and rummers on a table. He often paints a large crab lying on its back in the foreground. Nothing is known of his life. He usually signed "T. Sauts" and is very probably identical with Theodorus Smits of Dordrecht, who signed "T Smits" or "L Smits" and painted very similar still lifes. Several still lifes with the monogram D. S. (Dircks) also appear to be by the same artist. Saut's pictures are mostly small, somewhat unvarying in composition and executed with broad, steady brushstrokes. His garlands of fruit, which are rare, show Flemish and Dutch influence and are in the style of De Heem's follower, J. van Son.

Literature: *Oud Holland*, LXXII, 1957, pp. 53–6.

Savery, Roelant

ROELANT.
SAVERY.

b. Courtrai 1576,
d. Utrecht 1639
1037, 1038, 1039, 1040

Important Dutch painter of landscapes, animals and flower still lifes; court painter to the emperor Rudolph II. Under the influence of the Fleming Jan Brueghel and G. van Coninxloo he painted forest landscapes with jungle-like vegetation, fantastic rocks and ruins, the scene being further enlivened by tame and wild animals, which he was the first Dutch artist to paint, in a somewhat mannered style. The occasion for these was afforded by frequent representations of Paradise, Noah's Ark and the Flood, or Orpheus charming the beasts. Sometimes he also introduced small Biblical or genre-type figures. His hunting scenes and mountain landscapes suggest that he knew the Alps. His very tasteful bouquets are generally depicted in a stone niche and animated with lifelike frogs, lizards, grasshoppers, beetles and butterflies. They are more tonal and realistic than contemporary flower pictures of Jan Brueghel or Ambrosius Bosschaert the Elder, which together with them mark the beginning of the great age of Dutch flower painting. His pictures, usually signed and dated, seldom exceed middle size. Willem van Nieulandt and Allaert van Everdingen are said to have been his pupils. His early landscapes, in which figures are not prominent, can hardly be confused with those of Marten Ryckaert or Gillis d'Hondecoeter, who is thought to have been his pupil.

Literature: K. Erasmus, *R. Savery* (dissertation), Halle, 1908; A. Laes, *Le Peintre R. Savery*, Brussels, 1931; Y. Thiéry, *Le Paysage flamand*, Brussels, 1953; P. Eeckhout, *R. Savery exhibition*, Ghent, 1954; J. Bialostocki, "Les Bêtes et les humains de R. Savery," *Bulletin des Musées Royaux*, VII, Brussels, 1958, pp. 69ff.; N. MacLaren, *National Gallery Catalogues, Dutch School*, London, 1960, p. 385; W. Stechow, *Dutch Landscape Painting of the Seventeenth Century*, London, 1968.

Schalcke, Cornelis S. van der

CS vSchalck 1644

b. Haarlem 1611,
d. there 1671
1041, 1042

Haarlem landscape painter. His pictures of dunes with distant views of cities in greyish-yellow tones resemble Jan van Goyen, but he was not an imitator of the latter: nor were P. de Molijn, F. de Hulst and J. Vermeer van Haarlem the Elder, who painted in a similar style. His later works in the manner of Salomon van Ruysdael – river landscapes with ferries, bastions or ruins with genre-type figures in a somewhat hard moonlight – are not numerous. His pictures were often signed and dated, but many of them pass as works by the better-known artists named above.

Literature: J. Q. van Regteren Altena, *Oud Holland*, XLIII, 1926, pp. 49–61; N. MacLaren, *National Gallery Catalogues, Dutch School*, London, 1960, p. 386.

Schalcken, Godfried

G. Schalcken

b. Made 1643,
d. The Hague 1706
1043, 1044, 1045

Dordrecht genre and portrait painter of the late period; a pupil of S. van Hoogstraten and G. Dou. His delicate, often humor-

ous genre pictures are in the style of G. Dou and Frans van Mieris. He was especially known for his pictures, mostly small in size, with light-effects: half-length figures of girls, youths, old men and women, illuminated by lamps or candles. The style of painting, initially soft, became very smooth in later years. Like G. Dou, he depicted maids engaged in household tasks and seen through a window opening. Less often he painted allegories and genre-like Biblical or mythological scenes. His daylight portraits are good, and in their fashionable mannerism recall Caspar Netscher and Adriaen van der Werff; they usually have a landscape background. K. de Moor and A. Boonen are said to have been his pupils; the latter's candle-light pictures have harder colours and sharper outlines.

Literature: C. Hofstede de Groot, *Catalogue raisonné*, vol. v, Esslingen, 1912; N. MacLaren, *National Gallery Catalogues, Dutch School*, London, 1960, p. 388.

Schellinks, Willem

b. Amsterdam about 1627,
d. there 1678
1046

Dutch landscape painter, influenced by J. Asselyn. His pictures, which are rare, resemble the work of Frederik de Moucheron, who, like N. Berchem, completed works by W. Schellinks after the latter's death and added figures to them. His themes comprise Dutch and Italian vedute, river and harbour scenes, inns or ancient ruins with resting horsemen and hunting parties, also winter scenes. Many landscapes by him are without doubt still attributed to J. Asselyn or Jan Both. He may be confused with Jacob and Willem de Heusch or with J. Lapp. Most of his pictures are in the State Museum, Copenhagen.

Literature: Ch. Steland-Stief, "J. Asselyn und W. Schellinks," *Oud Holland*, LXXIX, 1964, pp. 99 ff.

Schoeff, Johannes

b. The Hague 1608,
d. Bergen op Zoom after 1666
1047, 1048

Rare Dutch landscapist belonging to the circle of J. van Goyen and Salomon van Ruysdael. In his early period he painted river banks with distant views under a lofty sky. The foreground generally consists of high hills, beyond which the land stretches away to a remote horizon. Later he painted woods and fields in strong tones ranging from light brown to olive. He is distinguished by close attention to detail and a mannered way of depicting foliage by stippling, like Salomon van Ruysdael around 1640.

Literature: W. Stechow, *Salomon van Ruysdael*, Berlin, 1938, pp. 55 ff.

Schoevaerdts, Mathys

b. Brussels about 1665,
d. after 1694
1049, 1050

Flemish landscape painter, a pupil of A. F. Boudewyns. His views of cities and his village, harbour, forest and park landscapes with castles are distinguished by a profusion of small, brightly coloured figures, disposed in large groups of a genre character: processions, kermesses, popular amusements, vegetable and fish markets. His pictures are mostly small. He also contributed carefully drawn figures to paintings by J. d'Arthois and his own master, A. F. Boudewyns. His themes resemble those of Theobald Michau, who, like him, was influenced by Jan Brueghel.

Schoock, Hendrick

b. Utrecht 1630,
d. there 1707
1051

Utrecht flower-painter: a pupil of Abraham Bloemaert, Jan Lievens and Jan Davidsz. de Heem, to whose school he belonged in particular. His elaborate bouquets in glass vases, framed in stone niches, are very reminiscent of De Heem's better-known pupil A. Mignon, whom he also resembles in his choice of flowers (sunflowers with ears of corn). His small pictures of luxuriant vegetation – flowers and shrubs growing at the foot of a tree – are animated by birds and reptiles; there is usually a thistle in shadow in the foreground. This theme too may give rise to confusion with A. Mignon.

Schooten, Floris van

b. about 1590,
d. Haarlem after 1655
1052, 1053, 1054

Dutch still-life and historical painter, of the school of P. Aertsen and J. Beuckelaer. His large, somewhat matter-of-fact kitchen still lifes depict poultry, fish, fruit and various provisions, also lovingly painted tableware and in some cases portrait-like figures of maids or children, similar to those of P. C. van Ryck. His smaller still lifes or figures with fruit and Delft bowls are frequently met with and are more independent in style: they foreshadow the work of P. Claesz and Willem Claesz. Heda and are easy to confuse with Floris van Dyck. The composition is simple, with attention to pictorial light effects. He painted a few Biblical scenes and histories with large figures. Most of his works bear the monogram FvS: it sometimes appears in small letters in unusual positions, such as the middle of the picture.

Schotanus, Petrus

Leeuwarden, second half
of the seventeenth century

1055

Rare Dutch painter of still lifes, landscapes and portraits. His "Vanity" still lifes comprise dead birds (snipe), a globe, an hourglass, books, plaster figures and a guttering candle; they are distinguished by a picturesque brown-toned chiaroscuro. Some church interiors by him are also known.

Literature: Kunsthistorische Mededelingen, III, 1948, p. 4.

Schoubroeck, Pieter

b. Hessheim 1570,
d. Frankenthal 1607

1056, 1057

PE SCHVBRVCK
1606

Flemish-Frankenthal painter of landscapes with figures; influenced by G. van Coninxloo. His bright-coloured, tiny figures, running into hundreds, are seen partly in light and partly engulfed in shadow; they depict themes from the Bible and classical history. The landscapes are hilly and are usually shut in at the sides by sloping oak-forests. Much of his work is signed and dated. Owing to the colourful figures it is sometimes attributed to Jan Brueghel. He may also be confused with A. Mirou and M. Molanus.

Literature: E. Plietzsch, *Die Frankenthaler Maler*, Leipzig, 1910; Y. Thiéry, *Le Paysage flamand*, Brussels, 1953; L. W. Böhm and H. Wellensiek, *Die Frankenthaler Maler*, Reiss-Museum, Mannheim, 1962.

Schut, Cornelis

b. Antwerp 1597, d. there 1655

1058

Flemish painter of scenes with large figures for churches, also some allegories and histories. He was initially influenced by Rubens, but no examples of this are extant. His later work shows a more personal style, with cool colours, animated composition and contrasts of light. Some of his works are in churches in Flanders and Cologne. He often painted Madonnas, groups of children and allegories to fill the centre of flower garlands by Daniel Seghers. He is said to have collaborated occasionally with J. Wildens.

Schut, C. W.

active at Amsterdam
in the mid-seventeenth century

1059

Dutch sea-painter, active at Amsterdam and Dordrecht, where he belonged to a large family of artists. He was not related to Cornelis Schut, the Flemish figure-painter. Nothing is known of his career. His seascapes mostly depict calm waters with clear reflections; they recall those of A. Cuyp and H. de Meyer, with which they are sometimes confused, although have a style of their own; the clouds look schematic.

Seghers, Daniel

b. Antwerp 1590,
d. there 1661

1060, 1061

Flemish flower-painter, a pupil of Jan Brueghel the Elder. His flowers are generally arranged in bouquets or festoons in front of sculpted baroque cartouches; they are brightly coloured, at times somewhat hard, and are always most distinctively painted. Restricted as his subject-matter is – it hardly ever includes fruit – he exhausted every resource of artistry. To present-day taste his most attractive work consists of bouquets loosely arranged in a Venetian glass vase with a neutral dark background, against which lifelike butterflies, wasps and other insects are seen. These pictures probably date from after his stay in Rome in 1625–1627. His flower cartouches often surround pictures of the Madonna and saints, sportive putti, portraits and portrait busts, executed by other artists such as C. Schut, J. van Boeckhorst, J. van den Hoecke, E. Quellinus, T. van Thulden and G. Coques. Seghers had many imitators and pupils, including J. van Thielen, J. van den Hecke, C. Luycks, N. van Veerendael, J. P. Gillemans and F. Ykens. Some pictures by Jan van Kessel resemble his work.

Literature: M. L. Hairs, *Les Peintres flamands de fleurs*, Brussels, 1955; M. L. Hairs, *Revue belge d'archéologie et d'histoire de l'art*, XXIX, 1960, pp. 224 ff.

Seghers, Gerard

b. Antwerp 1591,
d. 1651

1062, 1063

Flemish painter of the Caravaggist school, later more influenced by Rubens and Van Dyck, in whose style he painted altar-pictures and historical and moralistic works with large figures in dramatic attitudes. The bodies are sketchily drawn, and he avoids landscape backgrounds. His genre-like nocturnal scenes of elaborately dressed gamblers and music-makers, on whom candle-light falls from one side, recall the work of the Utrecht mannerists J. van Bylert, J. G. van Bronchorst and Gerard van Honthorst. P. Franchoys was a pupil of his.

Literature: A. von Schneider, *Caravaggio*, Marburg, 1933, p. 104; D. Roggen and H. Pauwels, *Gentse Bijdragen*, XVI, 1955.

Seghers, Hercules

b. Haarlem about 1590,
d. after 1633
1064, 1065

Important Dutch painter of extensive flat landscapes and fantastic mountain scenes; he had a decisive influence on later Dutch landscape painting. His pictures, which are few in number, were initially influenced by his master G. van Coninxloo but soon became more spacious and closer to nature, the human figures being merely accessory. The sureness of perspective and the convincing treatment of atmosphere are especially noticeable in his flat landscapes with riven cliffs rising to one side, the high viewpoint ensuring a distant prospect. Shadows and strong colours are subordinated to impressionistic light effects. Rembrandt and Philips Koninck certainly drew inspiration from his work. Like them, he conveys a sense of the infinity, solemnity and loneliness of a wide-enveloping landscape spanned by a lofty, radiant sky. He probably also influenced the later artists R. Roghman and Allart van Everdingen, while the Alpine landscapes of his contemporary Joost de Momper, with figures and distant vistas, are more in the colourful Flemish style. He shows a degree of relationship to the yellow-toned mannered landscapes of J. van Geel; these are sometimes ascribed to him, as are portions of works by Joost de Momper.

Literature: G. Knuttel, *H. Seghers*, Palet-serie, Amsterdam; J. G. van Gelder, "H. Seghers," *Oud Holland*, LXV, 1950, pp. 216–26; J. G. van Gelder, "H. Seghers," *Oud Holland*, LXVIII, 1953, pp. 149 to 157; L. C. Collins, *H. Seghers*, Chicago, 1953; N. MacLaren, *National Gallery Catalogues, Dutch School*, London, 1960, p. 391; E. Haverkamp Begeman, *H. Seghers*, Amsterdam, 1968; W. Stechow, *Dutch Landscape Painting of the Seventeenth Century*, London, 1968.

Siberechts, Jan

b. Antwerp 1627,
d. London about 1703
1066, 1067, 1068

Flemish landscape and animal painter. His early work is in the Italianate style of the Dutch artists N. Berchem, Jan Both and K. Dujardin. Later he painted aspects of the Flemish landscape in a lifelike manner: large figures of peasant women, with cattle and laden carts, on the way to market along flooded roads or crossing a ford. Their movements and the splashing of the water are depicted in a lively and realistic fashion. Silvery light plays on the waving foliage or is reflected in shallow water. The grey-green tone of the landscape is relieved by the blue and red of garments, flashing brass utensils, piebald horses and cows. In his later, English period more attention is paid to buildings: the landscapes are often large, with dairy farms and country mansions, and have suffered from the darkening of their brownish tonality. About a hundred of his works are known, most of them signed and dated.

Literature: T.-H. Fokker, *J. Siberechts*, Brussels, 1931; Y. Thiéry, *Le Paysage flamand*, Brussels, 1953; G. Martin, *National Gallery Catalogues, Flemish School*, London, 1970, p. 236.

Simons, Michiel

d. Utrecht 1673
1069, 1070

Utrecht painter of hunting still lifes, with dead birds on a table-corner covered with a green or red cloth. Less often he painted fruit, tableware with crabs or strawberries, and breakfast pieces properly so called. The painterly treatment of silver vessels is especially fine. His rare hunting scenes with figures are reminiscent of Jan Weenix.

Sion, Peeter

d. Antwerp 1695
1071

Flemish still-life painter. Master in St Luke's Guild at Antwerp, 1649; Dean of the Guild in 1682. Up to the present he is known only by a single *Vanitas*, signed in full. To judge by the quality of execution and originality of composition, he was a highly individual artist and it is to be supposed that more of his works may come to light.

Literature: Mautner, *Oud Holland*, LVIII, 1941, p. 43.

Slabbaert, Karel

b. Zierikzee about 1618,
d. Middelburg 1654
1072, 1073

Dutch genre painter and portraitist. His large half-length figures show strong contrasts of lighting and are notable for exaggerated perspective. His subjects include boys and girls with a bird, soldiers carousing or in camp, kitchen scenes (a plucked fowl) and good portraits, also some still lifes. Only the similarity of theme could lead to confusion with M. Sweerts.

Slingeland, Pieter van

b. Leiden 1640,
d. there 1691
1074, 1075, 1076

Leiden "fine painter", a pupil of G. Dou. His work is varied, but limited in quantity. He was at his best in genre-type interiors: mothers with children, domestic scenes, lace-making and music

lessons, all painted in Dou's manner, but harder and in brighter colours. His scenes of workshops and kitchens resemble those of H. M. Sorgh. Despite errors of perspective, the interiors are depicted with care. He painted a few portraits with a sketchy landscape background, also *Vanitas* still lifes. Most of his portraits, which are somewhat smooth, belong to his later period. In his better works he resembles Frans van Mieris or G. Schalcken. His pupil J. Tilius was a still smoother painter of the same type. A. van Gaesbeeck often imitated him. His still lifes and kitchen scenes sometimes recall those of the older P. van den Bosch.

Literature: J. Smith, *Catalogue Raisonné*, vol. I, London, 1829.

Sluys, Jacob van der

b. Leiden about 1660,
d. 1732
1077, 1078

Dutch genre painter, pupil of A. de Vois and P. van Slingeland; member of St Luke's Guild at Leiden, 1685. His pictures (bathing nymph and satyr, allegory of surgery in the Lakenhal at Leiden) show him to be a successor of the Leiden "fine painters."

Literature: *Leids Jaarboekje*, 1948, pp. 133–6.

Smit, Aernout

b. 1641,
d. Amsterdam 1710
1079

Dutch sea-painter, pupil of J. T. Blanckerhoff. Seascapes known to be by him bear dates between 1667 and 1678. His early pictures have a delicate grey atmosphere and excellent perspective. Later he was more influenced by L. Backhuysen; his seascapes become more colourful, the sky showing contrasting blues and yellows. At this period he mostly painted the southern sea under a dramatic sky, but also Greenland with ice-floes and Polar bears (Nantes museum): these pictures are so lifelike that they might have been painted on the spot. His seascapes may be confused with those of J. T. Blanckerhoff and A. van Everdingen.

Literature: F. C. Willis, *Die Niederländische Marinemalerei*, Leipzig, 1911.

Snayers, Pieter

b. Antwerp 1592,
d. Brussels after 1666
1080, 1081

Flemish painter of battles and hunting scenes, pupil of S. Vrancx. In his early period he painted, in the latter's style, landscapes with cavalry fights and scenes of looting in villages amid tall trees; the pictures are in a crudely narrative style, the figures robust and highly coloured. His later work shows greater variety of tone and more elaborate composition: hunting parties with separate groups in the foreground, and numerous panoramas of beleaguered fortresses. His strategic reconstructions, from a bird's-eye viewpoint, of large-scale infantry and cavalry battles owe more to imagination than to experience and are of little historical value. P. Meulener painted cavalry engagements in a similar fashion. A. F. van der Meulen, a more elegant painter than Snayers and a superior colourist, was his pupil. The work of these two may be confused, but the later style of Van der Meulen is distinctive, as is his nervous and cursory execution.

Literature: F. C. Legrand, *Les Peintres flamands de genre*, Brussels, 1963.

Snellinck, Andries

b. Antwerp 1587,
d. 1653
1082

Flemish landscape painter. Little is known of his life. From 1620 he carried on, like many of his fellow-painters, a business as an art dealer. His tree-covered landscapes with low hills, watercourses and travellers or mythological beings are typical of Antwerp painting in the first half of the seventeenth century. There is also sometimes a resemblance to the cavalry battle-pieces of Jan Snellinck. Andries' landscapes are often mentioned in old sales catalogues, as are his animal pictures and fruit and flower still lifes, but most of them have disappeared. Only the presence of full and authentic signatures makes it possible to assign pictures correctly to the numerous Flemish landscapists who bore this surname. Andries is said to have collaborated with Joost de Momper and Cornelis de Vos.

Literature: M. L. Hairs, *Les Peintres flamands de fleurs*, Brussels, 1955.

Snellinck, Cornelis

d. Rotterdam 1669
1083

Rare Dutch landscape painter. Skilful perspective and obliquely falling light give a fine effect of depth to his landscapes with clusters of tall trees, peasants' cottages, castles and quiet streams. The figures are small in size and fit well into the scene.

Literature: A. Bredius, *Oud Holland*, VIII, 1890, p. 5.

Snyders, Frans

b. Antwerp 1579,
d. there 1657
1084, 1085, 1086, 1087, 1088

Important Flemish animal and still-life painter, pupil of Pieter Brueghel the Younger and Hendrick van Balen. His majestic

and glowingly colourful style attained especial brilliance under the influence of Rubens and Jacob Jordaens and in collaboration with them. He was first and foremost an animal painter. His hunting scenes (wild boar, stags) and pictures of animals fighting are vivid and lifelike. His versatile range includes game of all kinds, monkeys, dogs, cats, wild birds, poultry, fish, fruit, vegetables, kitchens and pantries with their contents. His still lifes are characterized by elaborate, animated and sometimes dramatic composition. The taste of our own day prefers his smaller pieces with economically composed fruit, vegetables and birds to the commoner type of picture, in which eatables of every kind are piled high, in dishes and baskets, on sumptuously draped tables. The pantry scenes are enlivened by cats on the prowl, dogs nosing about, a maid or a huntsman. He painted Biblical subjects only if they offered an opportunity of depicting animals (Noah's Ark, Paradise). In his still lifes he was mostly content with a neutral background, the suggestion of a wall or a view on to a landscape. He often contributed animals to figure paintings and landscapes by Rubens, Van Dyck, Abraham Janssens, Cornelis de Vos and J. Wildens, and is known to have collaborated from time to time with the landscapist Jan Brueghel the Younger and the figure painter Hendrick van Balen. J. Fyt was a pupil of his. Paul de Vos, who probably worked in his studio for a time, approaches him closely. Snyders' work was much esteemed during his lifetime as well as later, so that copies and imitations are plentiful.

Literature: Ch. Sterling, *La Nature morte*, Paris, 1952; E. Greindl, *Les Peintres flamands de nature morte*, Brussels, 1956; G. Martin, *National Gallery Catalogues, Flemish School*, London, 1970, p. 238.

Snyers, Pieter

b. Antwerp 1681, d. there 1752
1089, 1090

Flemish still-life and genre painter. His still lifes mostly depict store-room tables with vegetables, fruit, a lobster and poultry, less often flowers. He also occasionally painted thistle-bushes with a bird's nest on a patch of forest ground, with flowers and fruit in a hard evening light. His large genre-type figures in front of a landscape are very personal in conception. His pictures are tastefully composed, and are usually signed with his full name.

Literature: G. Martin, *National Gallery Catalogues, Flemish School*, London, 1970, p. 240.

Son, Joris van

b. Antwerp 1623, d. there 1667
1091, 1092

Flemish still-life painter in the style of Jan Davidsz. de Heem: tasteful compositions of fruit, flowers, shellfish, plates, glass goblets and metalware. Less often he painted garlands of flowers and fruit for large baroque cartouches, in the manner of Daniel Seghers. He is notable for especial attention to foliage and skill in drawing it, while his painting of the folds of a crumpled tablecloth appears stereotyped. In truth to nature he comes close to his model Jan Davidsz. de Heem, and he has links with J. P. Gillemans the Elder. Many of his still lifes are signed J. van Son and dated; as his son Jan van Son painted in a similar style, the date is the only means of distinguishing their work. Among the father's pupils were J. P. Gillemans the Younger and Fr. van Everbroeck.

Literature: E. Greindl, *Les Peintres flamands de nature morte*, Brussels, 1956; A. P. de Mirimonde, *La Revue des Arts*, 1960.

Sonje, Jan

b. Delft about 1625,
d. Rotterdam 1707
1093

Dutch landscape painter of the Italianate school; pupil of A. Pynacker. His sunlit, hilly landscapes with cattle, herdsmen, and ruins are reminiscent of Pynacker and still more of N. Berchem, and used often to be attributed to these artists, but this is disproved by the weaker drawing, especially of cattle. Purely Dutch motifs (views of towns) are rarer in his work. K. Dujardin is said to have occasionally contributed figures to his pictures.

Soolmaker, Jan Frans

b. Antwerp 1635,
d. after 1665
1094, 1095

Flemish-Dutch landscape painter and imitator of N. Berchem. He painted Italian landscapes with herds in a style similar to the latter's, but harder and with less feeling for Mediterranean sunlight. The cattle and accompanying figures of herdsmen, riders and peasants are often numerous but are sketchily drawn; the landscape is that of the Campagna with the usual ruins, houses and fountains. He generally signed his pictures in full, but the signature was often removed so as to attribute his work to N. Berchem. He might be confused with J. van der Bent, who uses yellower tones, and W. Romeyn.

Sorgh, Hendrick Martensz.

b. Rotterdam 1611,
d. there 1670
1096, 1097, 1098, 1099, 1100, 1101

Versatile Rotterdam painter of peasants, still lifes and portraits in the manner of Cornelis Saftleven and P. de Bloot. His rare, tasteful seascapes belong to the "grey" school of Jan Porcellis

and S. de Vlieger. His market and peasant scenes are carefully drawn and generally have a uniform brownish tonality. His barn still lifes are filled with ably depicted kitchenware, implements and vegetables. His paintings of this type may easily be confused with those of Cornelis Saftleven, E. van der Poel and Hubert van Ravesteyn. His work varies in quality; the peasant pictures used to be ascribed to A. Brouwer owing to their harmonious colouring and well-balanced chiaroscuro. With this group of genre paintings may be ranked his homely New Testament scenes, which show peasant types in simple Dutch interiors. The barn-pictures of F. Ryckhals are very close to his. His town and market scenes are similar in conception to those of E. de Witte. His pupil A. Diepram, who also painted peasants, is uninventive and coarser in style.

Literature: N. MacLaren, *National Gallery Catalogues, Dutch School*, London, 1960, p. 394.

Spreeuwen, Jacob van

b. Leiden 1611, d. after 1650
1102, 1103

Rare Leiden genre and "fine" painter, influenced by Rembrandt as were G. Dou and Q. van Brekelenkam. He painted hermits, old people reading or praying, philosophers in their studies, painters in studios and children blowing soap-bubbles. Owing to the similarity of subject-matter he may be confused with J. van Staveren.

Literature: B. Rapp, "J. van Spreeuwen," *Oud Holland*, LXII, 1947, pp. 72–6; K. Bauch, *Der frühe Rembrandt*, Berlin, 1960, p. 226.

Stalbemt, Adriaen van

b. Antwerp 1580,
d. there 1662
1104, 1105

Flemish landscape painter of the Brueghels' wider circle; he is known to have worked from time to time with Pieter Brueghel the Younger. His early forest landscapes with a few tiny figures and old, uprooted oaks seem to have been painted under the influence of G. van Coninxloo. His pictures are mostly small; the figures of peasants, Biblical or mythological characters show a personal sensibility. The houses in his village scenes (kermesses) are unusually tall; we see boats on a canal being unloaded, or the bustle and variety of a market. Most of his pictures are signed in full. Departing from the style of the Brueghel circle, he also painted landscapes of a Dutch type with numerous large figures (Judgement of Midas, the Gods feasting). Owing to the delicate treatment of foliage and the blue-green tonality, his pictures were sometimes attributed to Jan Brueghel the Elder.

Literature: Y. Thiéry, *Le Paysage flamand*, Brussels, 1953.

Stalpaert, Pieter

b. Brussels 1572,
d. Amsterdam
before 1639
1106

Dutch landscape and sea painter, active at Amsterdam. His rare landscapes, in which brown and green tones predominate, belong to the early period of Dutch landscape painting and are somewhat reminiscent of A. van Stalbemt. Like the latter, he often has a stretch of dark shadow in the foreground. He paints foliage carefully; houses and figures are not very prominent. We may suppose, from the skilful composition and execution of his pictures, that he painted many more than have come down to us. Some may still be ascribed to P. de Molyn or Jan van de Velde. He is said to have also painted seascapes.

Staveren, Jan van

b. Leiden about 1625,
d. after 1668
1107, 1108

A Leiden genre and "fine" painter in the style of Q. van Brekelenkam and G. Dou, the latter of whom he imitated. His subjects include hermits and aged men reading or praying in caves or beside dead trees, scholars, schoolmasters, smokers, children with a birdcage, and kitchen interiors. Most of his pictures are signed in full or with an interlaced ST. Owing to the similarity of subjects he may be confused with J. van Spreeuwen.

Literature: S. J. Gudlaugsson, "J. van Staveren," *Oud Holland*, LXXII, 1957, p. 125.

Staverenus, Petrus

active at The Hague,
1634–54
1109, 1110

Dutch genre painter, portraitist and copper engraver. In 1635 he was a member of the Haarlem Guild; a notebook of his dating from 1646 is in the Bredius Museum at The Hague. His pictures show one or two genre-type figures with fish or at a table covered in still-life style, or a man and woman singing (Zwolle, private collection, and a replica in the art trade at The Hague, 1919). The representation is lively, somewhat reminiscent of Frans Hals; the colours are bright and varied, the paint thinly applied. The execution is not over-delicate, and the smiling faces are sometimes rather stiff. A genre-type series of the Five Senses, represented by five single figures, was in the Berlin art trade in 1942.

Steen, Jan

b. Leiden 1626,
d. there 1679

1111, 1112, 1113, 1114, 1115, 1116, 1117

Important and versatile Dutch painter of genre, Biblical, mythological and historical pictures, landscapes and portraits. His early landscapes, including winter scenes, are enlivened by numerous small, earthy figures in the manner of the two Ostades. Later his figures become larger, less numerous and better characterized: inns with men playing at skittles or cards, drunkards scuffling. He also depicts simple folk with accuracy and often with humour: quacks and alchemists, loving couples and old people, women performing household tasks such as pig-slaughtering. He has an especially humorous touch with unruly children at school, at family festivities and kermesses. Genre-type narrative Biblical themes give him an opportunity to depict the actors and spectators in a human fashion, as if the scenes were drawn from the life of the Dutch people. He often introduces allusions to the transience of earthly things. His upper-class scenes and portraits are rarer: doctors with hypochondriac patients, men and women eating oysters, young ladies at their dressing-table or music-lesson. The technique is effortless; his mature work shows the influence of Frans van Mieris, Jan Vermeer of Delft and P. de Hooch, but it is transmuted throughout by his own artistry. Strong brick-red and fresh blue colours stand out amid a delicate chiaroscuro. Metal implements, furniture and draperies are depicted with perfect fidelity in still-life fashion. His total *œuvre* consists of some 700 pictures, including much that is crude and cursory as well as exquisite masterpieces; his powers remained unimpaired until his death. He had no pupils. His only successor and imitator was R. Brakenburgh, whose lack of inventiveness is seen in the frequent repetition of types. G. Lundens and Egbert van Heemskerck painted rustic interiors which are sometimes similar in theme, but less able and different in style.

Literature: C. Hofstede de Groot, *Catalogue raisonné*, vol. I, Esslingen, 1907; A. Bredius, *J. Steen*, Amsterdam, 1927; Thieme-Becker, *Künstler-Lexikon*, vol. XXXI, 1937; C. H. de Jonge, *J. Steen*, Palet series, Amsterdam, 1939; H. Gerson, "Landschappen van J. Steen," *Oud Holland*, LXIII, 1948, p. 51; W. Martin, *J. Steen*, Amsterdam, 1954; N. MacLaren, *National Gallery Catalogues, Dutch School*, London, 1960, p. 396.

Steenwyck, Harmen van

b. Delft 1612,
d. after 1655

1118, 1119

Delft painter of still lifes in light, grey-brown tones. His pictures of fruit and other objects are distinguished by a tasteful diagonal composition, with light falling from the left on to a bright wall in the background. The plastic effect is extremely subtle, as is the rendering of the consistency of such objects as shells, peaches or a plucked duck. His numerous "Vanities" with open folio volumes and a skull crowned with a wreath are realistically treated in delicate grey tones. He occasionally painted interiors, for instance a man reading by the fireside, with kitchen gear arranged as for a still life. His early work, like that of Jan Davidsz. de Heem, shows the influence of Rembrandt.

Literature: Ashmolean Museum, *Dutch and Flemish Still Life Pictures*, Oxford, 1950; N. MacLaren, *National Gallery Catalogues, Dutch School*, London, 1960, p. 406.

Steenwyck the Elder, Hendrick van

b. Steenwijk about 1550,
d. Frankfurt 1603

1120, 1121

Early Flemish-German painter of architecture. Departing from the practice of his predecessors, he was the first to depict his themes realistically and not merely from imagination. They include churches, open spaces in towns and, later, palace courtyards. Initially the point of vision is high, giving an extensive view, but it becomes progressively lower. Many side-views of naves are shown, such as could hardly in fact be enjoyed from a single view-point. The pictures are characterized by a pleasing, warm golden-brown tone and by the diminishing importance of drawing. Other artists sometimes added the figures. Together with his son and pupil, Hendrick van Steenwyck the Younger, he influenced most Dutch painters of church interiors. The son's pictures are livelier in colour, but are hard to distinguish from his father's.

Literature: H. Jantzen, *Das Niederländische Architekturbild*, Leipzig, 1910.

Steenwyck the Younger, Hendrick van

b. Antwerp about 1580,
d. 1649

1122, 1123

Flemish painter of architecture, pupil of his father Hendrick van Steenwyck the Elder: he chiefly painted church interiors in the latter's style. Like his apartments in castles and palace courtyards, they are fuller of detail than his father's, with less sense of space and tranquillity and with a lower horizon; the drawing is in excellent perspective. The colours are brighter and more varied, though the prevailing tone of the whole is grey-yellow. Harmonious contrasts of blue and yellow are distinctive. Besides church interiors he painted vaulted dungeons with the Liberation of St Peter, the Beheading of St John the Baptist, and St Jerome in his study. He sometimes also used an architectural vista as the background to a portrait. F. Francken the Younger provided

figures for some of his church interiors. His work is often mistaken for his father's or that of his contemporary, the less important P. Neeffs the Elder.

Literature: H. Jantzen, *Das Niederländische Architekturbild*, Leipzig, 1910; G. Martin, *National Gallery Catalogues, Flemish School*, London, 1970, p. 240.

Steenwyck, Pieter van

b. Delft
1124

Dutch painter of still lifes, genre and interiors. In about 1633 to 1635 he and his brother Harmen van Steenwyck were pupils of their uncle D. Bailly at Leiden. He was a member of the Guild at Delft in 1642 and was active at The Hague in 1652–1654. His still lifes belong to the school of the "Vanity" painters H. Andriessen, J. de Claeuw, N. L. Peschier, J. Vermeulen, L. van der Vinne and P. van der Willigen. A typical "Vanity" by him is in the Prado at Madrid, and a signed self-portrait *(The Artist at his Easel painting a Still Life)* in the Ypres Museum. A signed barn interior by him was sold at Amsterdam in 1888.

Literature: R. van Luttervelt, *Schilders van het Stilleven*, Naarden, 1947, p. 43.

Stevens, Pieter

PE·STEPH·

b. about 1567,
d. Prague (?) after 1624

1125

Netherlandish painter, draughtsman and engraver; member of an old family of artists at Malines. From 1594 to 1612 he was court painter to the emperor Rudolph II at Prague, an appointment also held by R. Savery. In 1598 he was in St Luke's Guild at Antwerp; about 1600 in Venice, then in Rome. In old catalogues he is also called Stephani. His landscapes of hilly country with river valleys are similar in theme to those of G. van Coninxloo, A. van Stalbemt and Fr. van Valckenborch, and are characterized by delicately stippled foliage. A distinction was formerly made between an elder and a younger P. Stevens, but they are probably identical. Few signed pictures of his are extant, but many others are ascribed to him.

Stock, Ignatius van der

Ignatius V. d. Stock

active at Brussels in the second half of the seventeenth century

1126, 1127

Flemish landscape painter and etcher, pupil of L. de Vadder. He was a master at Brussels in 1660, and in 1665 taught A. F. Boudewijns. His numerous engravings of landscapes by J. Fou-

quier suggest that he was a pupil of the latter's also. His landscapes with trees are mostly large, sweepingly painted and fresh in colour, reminiscent of J. d'Arthois and L. de Vadder. The foliage is somewhat coarse; the distant view of flat ranges of hills is especially fine. A deep-blue sky is animated by large white clouds. These landscapes have often been ascribed to J. d'Arthois; confusion is also possible with L. Achtschellinck and C. Huysmans. A characteristic landscape of 1660 is in the Prado, Madrid.

Stockman, Jan Gerritsz.

active at Haarlem from 1636,
d. 1670

1128

Rare Haarlem painter of hilly, wooded landscapes, composed in a classic style reminiscent of Claude Lorrain. Italian influence is discernible in the antique citadels, ruins and added figures. The conception of landscape shows some affinity with J. van der Haagen.

Stoffe, Jan van der

b. Leiden 1611,
d. 1682

1129

Dutch painter of cavalry engagements and hunting scenes in the style of Palamedes Palamedesz. The horses, which are somewhat heavy and at times sketchily drawn, are inferior to those of J. Martsen de Jonge. He repeated, without attention to landscape, scenes of cavalry fights and Swedish or Imperial troops in camp. He can hardly be confused with P. C. Verbeeck or Dirck Stoop, who painted cavalry skirmishes in a more Italianate style.

Stoop, Dirck

D. Stoop f. 1649

b. Utrecht about 1618,
d. there 1686

1130, 1131

Utrecht painter of horses and landscapes; brother of Maerten Stoop. His lively hunting scenes, pictures of horsemen and cavalry skirmishes are set in sunny landscapes; a white or grey horse often lightens a dark patch of the background. Elegant travellers or huntsmen rest with their horses in front of Italian palaces or ruins; these pictures, in a somewhat dry style and a uniform golden tone, belong to his late period. Up to 1660 his signature was usually D. Stoop; later he used the initial R (for Roderigo) or Theod. (Theodorus). He may be confused with his brother Maerten through misreading of the signature, also with

P. C. Verbeeck or Philips Wouwerman. He occasionally worked with Jan Baptist Weenix, as is shown by jointly signed pictures.

Literature: P. T. A. Swillens, "D. en M. Stoop," *Oud Holland*, LI, 1934, pp. 116–35, 175–81.

Stoop, Maerten

b. Rotterdam about 1620,
d. Utrecht 1647
1132, 1133

Dutch genre painter, brother of Dirck Stoop. His subjects (guard-rooms, pillaging, soldiers and girls playing cards, rustic inns, the Prodigal Son, St Martin) present contemporary popular types, with a tendency towards moralizing and allegory. The figures are often seen from behind, with the light concentrated on a single one in the middle of the picture; silver-grey and light-brown shadowy tones prevail. The influence of L. Bramer and the German N. Knüpfer is recognizable. His works sometimes recall J. A. Duck and Jan Baptist Weenix; they are often confused with those of his brother Dirck Stoop.

Literature: P. T. A. Swillens, "D. en M. Stoop," *Oud Holland*, LI, 1934, pp. 116–35.

Stooter, Cornelis

STO

active in the first half of the
seventeenth century;
d. Leiden 1655
1134

Dutch painter of seascapes and portraits; on record at Leiden from 1620, and dean of the Guild there in 1648. His pictures of sailing-boats and fishing vessels tossed about on a grey-toned, stormy sea are reminiscent of J. Porcellis, whose pupil he probably was. Like J. A. Bellevois and the two Flemish sea-painters named Peeters, he was also fond of depicting ships about to be wrecked on high, fantastic cliffs. His portraits of princes of the House of Orange have been destroyed by fire. His signature – usually STO – was often misread. A typical scene of ships on a rough sea is in the Lakenhal Museum at Leiden.

Storck, Abraham

A: StorcK

b. Amsterdam about 1635,
d. after 1704
1135, 1136

Dutch sea-painter, a follower of L. Backhuysen. He was a good draughtsman and his views of sailing-boats and frigates, seen from the shore, are skilfully composed. As usual in the late period of Dutch painting, his colours, against a grey overall tone, are somewhat hard and bright. He often painted Dutch ports

with true-to-life city skylines (Amsterdam) or bastions. His sunny Italian coast and harbour scenes, on the other hand, with their prominent architectural features, are drawn from imagination. His later work gives an impression of greater crowding. His small winter landscapes with sketchily drawn skaters are rare.

Literature: F. C. Willis, *Die Niederländische Marinemalerei*, Leipzig, 1911; N. MacLaren, *National Gallery Catalogues, Dutch School*, London, 1960, p. 408.

Storck, Jacobus

J. STORCK.

b. Amsterdam 1641, d. 1687
1137, 1138

Dutch marine and landscape painter, also draughtsman. There is little documentary record of his career. He was probably the brother of the better-known sea-painter Abraham Storck. From certain pictures and drawings it can be reasonably assumed that he visited Italy. In his views of towns by quiet canals, the buildings on the banks are rendered with great skill and topographical exactitude. There is often a pleasure-boat in the centre, full of passengers, with a very tall sail. He depicts in light, cheerful colours the fresh greenery of the trees and the grey-blue waters under an azure summer sky with white clouds. He painted several studies of the water-surrounded castle of Nijnrode on the Vecht. About twenty of his pictures are known, some with the signature "Sturck." He was often confused with his brother Abraham.

Literature: J. Vuyck, *Oud Holland*, LII, 1935, pp. 121–6, with list of works; J. H. van Eeghen, *Oud Holland*, LXVIII, 1953, pp. 216–33.

Straaten, Lambert van der

L. V. Straaten.

b. Haarlem 1631, d. 1712
1139

Dutch landscape painter; was a pupil of Gillis Rombouts in 1656, but does not resemble him. His Haarlem landscapes are pleasantly composed, but are marred by awkward and unconvincingly placed figures and by the cursory treatment of foliage.

Streeck, Hendrik van

H. v. Streeck:

b. Amsterdam 1659,
d. after 1719
1140, 1141

Amsterdam painter of still lifes and church interiors. He began as a pupil of his father Juriaen van Streeck; his still lifes are in the latter's style, but he fails to reproduce the lifelike sheen of metal and glass vessels or fruit. After his father's death in 1687

he transferred his attention to painting architecture and was the only pupil of E. de Witte. His church interiors are wholly in the style of his master's late period, so much so that he took over De Witte's compositions. Here too, however, he can be recognized by his less successful treatment of light and atmosphere. Those of his church interiors which are not based on De Witte give a strikingly accurate picture of a defined space. He may sometimes also be distinguished from his master by the later fashion of the costume of the staffage figures.

Literature: I. Manke, *E. de Witte*, Amsterdam, 1963, with list of works.

Streeck, Juriaen van

b. 1632, d. Amsterdam 1687
1142, 1143

Dutch still-life painter and portraitist. His softly painted still lifes, with rich deep colours against a dark background, resemble, especially in his later period, the work of W. Kalf and Barent Vermeer. Oranges, lemons, tall Delft vases, pitchers with narrow necks, vessels of precious metal and Venetian glasses are composed in a well-thought-out, economical style. Soft reflections gleam in the darkness; a velvet cloth with gold fringes is often draped over the table-corner. The background is neutral, sometimes an unobtrusive niche. Breakfast pieces properly so called are rare. Attribution to W. Kalf is frequent, as is confusion with the similar painters Barent Vermeer and C. Striep.

Literature: I. Bergström, *Dutch Still Life Painting*, London, 1956.

Striep, Christian

b. 's-Hertogenbosch 1634,
d. Amsterdam 1673
1144

Rare Amsterdam still-life painter, follower of W. Kalf. His economical compositions of vessels of precious metal, glasses, lemons and Delft ware, on a large scale and in dark tones, resemble the works of G. W. Horst and Pieter Janssens Elinga, which however are richer and painted in a broader style, and also the later work of J. van Streeck. His pictures with forest plants, butterflies and snakes, in the manner of O. Marseus and M. Withoos, are very often ascribed to these artists.

Susenier, Abraham

b. Leiden about 1620,
d. Dordrecht after 1667
1145

Rare Dordrecht still-life and landscape painter. His breakfast pieces display fruit, crabs, bread, glasses and metalware on a wooden board with a crumpled velvet cloth, often with vine-branches trailing over them. His "Vanities" with a Bible, globe, candlestick, flowers and an hour-glass are less frequently met with. The colours recall A. van Beyeren, to whom his pictures are often ascribed, especially as the first two letters of Susenier's monogram AB. S were confused with the other's. The pictures are light in tone and very accurately drawn.

Susio, Ludovico de

active in the first half
of the seventeenth century
1146

Flemish still-life painter. He was active at Amsterdam or Leiden in 1616 and in Turin, at the Palace, in 1620; later he went to Rome. His rare still lifes recall the work of his contemporary, Fe de Galicia. In view of the excellence of his painting it is reasonable to suppose that more works by him will come to light.

Suycker, Reyer Claesz.

b. Haarlem about 1590,
d. after 1653
1147

Rare painter of extensive landscapes with city skylines (Haarlem, Leiden) in the background, also canal landscapes which recall Esaias van de Velde by their construction and especially the mannered rendering of trees. The predominant tonality is green and brown. His usual monogram R. C. was mistakenly interpreted as Rafael Camphuysen. He has links with his contemporary Pieter de Neyn, also a pupil of Esaias van de Velde: e.g. his landscape in the Brussels Museum, No. 1054.

Literature: H. Gerson, *Kunsthistorische Mededelingen*, 1, 1946, p. 53.

Swanenburgh, Jacob Is.

b. Leiden 1571,
d. 1638
1148, 1149, 1150

Early Dutch painter of landscapes, figures and portraits. In 1605 he travelled by way of Venice to Naples, where he opened a shop; a picture entitled *Witches' Sabbath* was seized there by the Inquisition in 1608. Later he went to Rome, where he stayed till 1617. His many pictures of the Piazza San Pietro are chiefly of topographical interest today: his artistic strength lay more in the realm of fantasy. According to old tradition he was a "good painter of infernal visions" – the mouth of Hell, souls crossing the Styx, Pluto's chariot – which in their imaginative profusion recall Hieronymus Bosch. He repeated these themes many times, as he did his vedute of cities. (The "mouth of Hell," with its

wealth of figures, can be seen at Brussels, and there is a mono-grammed version in the museum at Gdansk). The Flemish painter O. van Veen was his pupil.

Literature: T. von Frimmel, *Blätter für Gemäldekunde*, II, 1906, pp. 61 and 95; G. Marlier, *Weltkunst*, 15 December 1959.

Swanevelt, Herman van

b. Woerden about 1600,
d. Paris 1655
1151

Dutch-French landscape painter of the Italianate school. His decorative southern landscapes with hills and water-courses are completed with Biblical, mythological or Arcadian figures. His style was continued by Frederik de Moucheron and the later J. Glauber. He has often been confused with Jan Both owing to the similarity of their landscape themes and the minute painting of foliage, but he may be distinguished by his luminous green tones.

Literature: G. J. Hoogewerff, *De Bentvueghels*, The Hague, 1952; M. Waddingham, "H. van Swanevelt," *Paragone*, XI, 121, 1960, pp. 37 ff.; W. Stechow, *Dutch Landscape Painting of the Seventeenth Century*, London, 1968.

Sweerts, Michiel

b. Brussels 1624,
d. Goa 1664
1152, 1153, 1154

Netherlandish-Roman portraitist and genre painter. His groups of large male figures (allegories, artists' studios) and pictures of individuals engaged in quiet occupations are distinguished by a chiaroscuro which is personal in style though it shows the influence of Caravaggio. The heavy, sometimes opaque shadows recall P. van Laer. Light-red flesh-tints are characteristic. Heads of children and smaller portraits show good, pleasantly subdued colouring: delicately graded tones of silver-grey against a dark background. He also painted evening landscapes, but in these too the main stress is on large genre-type figures in the foreground with still-life accessories. The statuesque and somewhat impassive figures have a curious, melancholy air. The Mediterranean character of his work is accounted for by a period spent in Rome and the influence of P. van Laer. His works were formerly ascribed for the most part to various other eminent painters of interiors, and it is only in recent times that art historians have appraised them at their true value. Works by Wallerant Vaillant (paintings of artists' studios) have frequently been attributed to him.

Literature: W. Stechow, *Art Quarterly*, XIV, 1951; R. Kultzen, *M. Sweerts*, dissertation, Hamburg, 1954; *M. Sweerts en Tijdgenoten*, Boymans Museum, Rotterdam, 1958; J. Q. van Regteren Altena, "Over M. Sweerts als Portrettist," *Oud Holland*, LXXIV, 1959, p. 222; V. Bloch, *M. Sweerts*, The Hague, 1968.

Tempel, Abraham van den

b. Leeuwarden 1622,
d. Amsterdam 1672
1155, 1156

Amsterdam painter of individual and group portraits, histories and allegories. He was a pupil of J. A. Backer, but imitated him only in early realistic half-length portraits. His family groups (gentlemen with their wives, musical parties) recall B. van der Helst in the decorative attitudes of the figures and the effective, painterly treatment of materials. Pillars with curtains, balustrades and views of a park landscape at evening form the background to these somewhat superficial portraits of good Amsterdam society. His portraits are similar in conception to those of P. Hennekijn and J. van Noordt; he may also be confused with N. de Helt-Stocade, whose lighting is rather more contrasted. Frans van Mieris the Elder, K. de Moor and M. van Musscher were his pupils but did not continue his style.

Tengnagel, Jan

b. Amsterdam 1584,
d. 1635
1157, 1158, 1159

Dutch painter of figures, in landscapes and portraits; brother-in-law of the artists Jacob and Jan Pynas. In 1608 he was in Rome, where he came under the influence of A. Elsheimer. Before 1619 he became head of the Guild at Amsterdam. In his early period he painted single and group portraits: a militia company's banquet of 1613, with seventeen persons, is in the Rijksmuseum. Most of his works are Biblical, mythological and historical scenes with large figures. In conception and composition they recall P. Lastman and, less directly, Jacob and Jan Pynas: he thus belongs to the pre-Rembrandtist group. His more recondite themes from these three domains show a many-sided education such as was still common in his time. The fanciful landscape is no more than a background to the realistic narrative of his figures with their strict composition. About thirty of his pictures are known; many used to be attributed to P. Lastman.

Literature: H. Schneider, *Oud Holland*, XXXIX, 1921, pp. 11–27, with list of works; K. Bauch, *Der frühe Rembrandt*, Berlin, 1960.

Teniers, David

b. Antwerp 1610,
d. Brussels 1690
1160, 1161, 1162, 1163, 1164, 1165, 1166, 1167

Important Flemish landscape, genre and portrait painter. His early conversation pieces recall F. Francken; his early pictures

of peasants are in the manner of A. Brouwer, but do not equal the latter's subtle coloration and witty character-drawing. Teniers' later, personal style is distinguished by lighter, stronger local colours and well-drawn figures: these, while recognizably types, are full of variety and are of increasing importance in the landscape. His work reaches its climax in the many variations on harvest and kermesse scenes and dances outside village inns. His later work is less inventive, the colours fainter and duller. Barrels, kitchen-gear, furniture and other accessories are rendered with care and constitute admirable still lifes in themselves. Less often he painted religious subjects (the Temptation of St Anthony), mythology and fantastic scenes of ghosts and witches; also contemporary events and genre-type pictures of dressed-up cats and monkeys. His portraits of individuals, which are mostly small, are executed with care, as are his small copies, made for reproduction as prints, of pictures from the Arch-Ducal gallery in Brussels. His views of picture-gallery interiors are equally interesting from the historical standpoint. His paintings were in great demand and he worked at speed: the number of extant pictures by him must be about 2,000. In addition, he has been credited with many works painted by pupils, copyists, imitators and forgers. He contributed many figures to landscapes by J. D'Arthois. Th. van Apshoven and M. van Helmont emulated his style but are inferior in technique and versatility. G. van Tilborgh chose similar themes, but stands apart from him as an artistic personality.

Literature: J. Smith, *Catalogue Raisonné*, vol. III, London, 1831; A. Rosenberg, *D. Teniers*, Bielefeld, 1895; Y. Thiéry, *Le Paysage flamand*, Brussels, 1953; S. Speth-Holterhoff, *Les Cabinets d'amateurs*, Brussels, 1957; F. C. Legrand, *Les peintres flamands de genre*, Brussels, 1963; G. Martin, *National Gallery Catalogues, Flemish School*, London, 1970, p. 253.

Terbrugghen, Hendrick

b. Deventer 1588,
d. Utrecht 1629
1168, 1169, 1170, 1171

Important Dutch painter of the Caravaggist school of Utrecht mannerists; pupil of Abraham Bloemaert. His Biblical (mostly Old Testament) scenes with many figures are notable for the treatment of atmosphere and the violet-grey tonality; despite their contrasts of lighting, they are thus more painterly than most of the work of the Utrecht academics. The figures have a realistic, portrait-like character, and a genre effect is produced by such accessories as sheets of music and instruments, or bread, a knife and a wineglass. The soft brushwork and play of flickering light foreshadow Vermeer of Delft. Less often he painted half-length figures of an allegorical nature – e.g. Heraclitus and Democritus – or portraits, which are excellent. His works are generally dated and monogrammed or signed in full. The numerous repetitions are a complicating factor, and it is often hard to distinguish between a replica and a copy. He is superior to the other Utrecht mannerists Gerard van Honthorst, J. van Bylert and D. van Baburen.

Literature: A. von Schneider, *Caravaggio und die Niederländer*, Marburg, 1933; B. Nicolson, *H. Terbrugghen*, London, 1958.

Terwesten, Augustin

b. The Hague 1649,
d. Berlin 1711
1172

Dutch-German painter of the late period. His subjects were mythological and historical scenes, also allegories with skilfully combined groups of figures, often in antique garb. He furnished large decorative paintings for walls and ceilings (Berlin palaces).

Thielen, Jan van

b. Malines 1618,
d. Boisschot 1667
1173

Flemish painter of flower still lifes; pupil of Theodor Rombouts and Daniel Seghers. He was especially close to the latter, but the drawing in his pictures (which are mostly large) is less detailed and the colouring less bright than in his master's. His rich bouquets and garlands adorn baroque cartouches, which were often completed by other artists such as E. Quellinus; less often he painted flowers in vases. His work is close to that of the other painters of Daniel Seghers' circle: J. P. Gillemans the Elder, Chr. Luycks, J. van Son and N. van Veerendael.

Literature: M. L. Hairs, *Les peintres flamands de fleurs*, Brussels, 1955.

Thomas, Gerard

b. Antwerp 1663,
d. there 1720
1174

Flemish genre painter; pupil of Godfried Maes in 1680, master in St Luke's Guild at Antwerp in 1688. He continued D. Ryckaert's genre style of interior painting, especially well-furnished bourgeois rooms with small figures; also doctors' and alchemists' studies, painters and sculptors in their studios, which closely resemble the work of his contemporaries B. van den Bossche and H. Govaerts. His pictures are brown in tone, and the backgrounds especially have darkened a great deal. As was common in the early eighteenth century, he often painted pictures in pairs and also repetitions of the same theme. B. van den Bossche was his pupil and continued his style.

Thulden, Theodor van

b. 's-Hertogenbosch 1606,
d. there 1669
1175, 1176

Flemish painter, a pupil of Rubens, with whom he collaborated. His altar-panels with large figures, and his less numerous mythological and allegorical scenes and portraits show him to have been an artist of varied talents, who became more and more independent of Rubens' influence. Compared with the latter, his colours are softer in gradation, less bright and at times somewhat heavy; the tonality is brownish-grey. His compositions are skilful and not copied from Rubens. He contributed some large figures to still lifes by A. van Utrecht and J. Fyt. Many inferior works by other pupils of Rubens and copyists are ascribed to him.

Literature: H. Schneider, "Th. van Thulden," *Oud Holland,* XLV, 1928, pp. 1, 200.

Thys, Pieter

b. Antwerp 1624,
d. there 1677
1177, 1178

Flemish painter of historical subjects, churches and portraits, also draughtsman. Member of a large Flemish family of artists, several of whom bore the same name. Master in St Luke's Guild at Antwerp, 1644. He may be regarded as a follower of Rubens and also of Van Dyck, whom he sometimes directly imitated (portrait of the burgomaster of Antwerp). We possess a number of portraits of noted personalities, commissioned from him by the city of Antwerp: the Archduke Leopold William, son of Ferdinand II, and the painter David Teniers. At the beginning of the 1660s he visited Holland to carry out portrait commissions. He also painted religious pictures with large figures, many of which are still to be found in Belgian churches, and cartoons for church tapestries.

Tieling, Lodewyck

active in the second half
of the seventeenth century
1179

Rare Amsterdam landscape painter, influenced by N. Berchem and Adriaen van de Velde: hilly landscapes of an Italian type with large clusters of trees, sometimes also architecture and herds, the latter becoming increasingly prominent; generally in evening light. The animals are less well drawn than those of his models; the style is clearly that of a later period.

Tilborgh, Gillis van

b. Brussels 1625, d. there 1678
1180, 1181

Flemish painter of peasants, genre and portraits, influenced by J. van Craesbeeck. He painted with especial care and in a personal style group portraits of the bourgeoisie – small figures in the open air – which sometimes bear the name of the abler G. Coques. His indoor and outdoor scenes of peasants, with numerous but less carefully drawn figures, are reminiscent of David Ryckaert: like the latter, he painted allegories of the Five Senses, groups eating and carousing, brawls and weddings at rustic inns. His single figures drinking or reading at an inn sometimes recall D. Teniers, whose pupil he is said to have been. Most of his pictures bear a monogram composed of the letters TB and are dated between 1650 and 1670. He has links with M. van Helmont, who painted similar themes.

Literature: S. Speth-Holterhoff, *Les Cabinets d'amateurs,* Brussels, 1957; F. C. Legrand, *Les Peintres flamands de genre,* Brussels, 1963.

Tilens, Jan

b. Antwerp 1589, d. 1630
1182

Flemish painter of hilly landscapes, partly wooded and traversed by rivers, with a typical strong green tonality. The composition with its broad river-valleys is somewhat reminiscent of Joost de Momper. The background is formed by antique-style ruins, citadels and castles on rocky crags. Various artists, including Hendrik van Balen, supplied the figures of nymphs, horsemen and travellers resting, which are generally unobtrusive.

Tilius, Jan

b. Hilvarenbeek;
active in the second half of
the seventeenth century
1183

Rare "fine painter" of the Hague school, a pupil of P. van Slingeland. His genre-type figures (music-making, conversation pieces, women at quiet occupations) are delicately executed and recall the two Van Mierises, to whom his pictures were often ascribed. The costumes are characterized by hard folds.

Tol, Dominicus van

b. Bodegraven about 1635,
d. Leiden 1676
1184, 1185

Leiden "fine painter," a pupil, imitator and copier of his uncle G. Dou. His genre subjects are similar to Dou's: women engaged

in domestic tasks, drinkers, smokers, old people reading. Less often he painted small portraits. His characters are often seen through an arched window. His signature was frequently removed in order to ascribe his pictures to G. Dou; on the other hand, he himself has been credited with numerous imitations of the work of his famous uncle.

of the composition are generally few: an earthenware jug, a Delft bowl, a glass, a pewter tankard and a white or coloured cloth pushed across the table. In this field of representation he is closest to his brother-in-law.

Literature: N. R. A. Vroom, *De Schilders van het Monochrome Banketje*, Amsterdam, 1945; N. MacLaren, *National Gallery Catalogues, Dutch School*, London, 1960, p. 409.

Toorenvliet, Jacob

b. Leiden about 1635,
d. there 1719
1186, 1187, 1188

Leiden painter of portraits and genre. The composition of the latter is crowded and the attitudes lively: musicians and music-lessons, inn scenes, card-players, smokers, drinkers, craftsmen, and sellers of butcher's meat, game, fish, baker's wares and eggs. Occasionally he depicts more elegant types in the style of Frans van Mieris (doctor visiting a patient). His pictures have a cool, grey overall tonality and excellent chiaroscuro; materials and folds are rendered with great skill. His well-composed interiors are sometimes attributed to G. Metsu.

Torrentius, Johannes

b. Amsterdam 1589,
d. there 1644
1189

Rare Amsterdam painter, whose carefully composed still lifes on a dark background recall Jan van de Velde and the circle of Willem Claesz. Heda. The treatment of materials is admirable. The complete accuracy of perspective suggests that he used a camera obscura. According to literary evidence, he painted mythological scenes with excellent nudes.

Literature: A. Bredius, *J. Torrentius*, The Hague, 1909; A. Rehorst, *J. Torrentius*, Rotterdam, 1939.

Treck, Jan Jansz.

b. Amsterdam about 1606,
d. before 1653
1190, 1191

Rare Dutch still-life painter, pupil of his brother-in-law J. J. den Uyl; also influenced by Willem Claesz. Heda and Pieter Claesz. His still lifes are tastefully and economically constructed, with an elegant chiaroscuro reminiscent of Jan van de Velde and J. van Streeck. They approach W. Kalf in their grey-brown tonality and the exact observation of reflections. The elements

Troyen, Rombout van

1192, 1193

Amsterdam painter of fanciful southern landscapes with ruins; the figures are shepherds or mythological and Biblical characters. He was a pupil of Jan Pynas. He was particularly fond of rocky caves and grottoes, diversified with numerous small figures, statues and antique tombs. He is related to A. van Cuylenborch in his choice of subjects only.

Tyssens, Jan Baptist

Antwerp, second half
of the seventeenth century
1194

Rare Flemish still-life painter of weapons, flags, drums and booty. He also painted antique and mythological scenes, with well-depicted weapons and metal implements in the foreground (Vulcan's forge).

Uden, Lucas van

b. Antwerp 1595,
d. there 1672
1195, 1196, 1197

Flemish landscape painter influenced by Rubens, for whom he executed many landscape backgrounds. His independently painted landscapes (they include scarcely any winter scenes) are naturalistic in conception, with a bluish-green tonality. Hills or wooded slopes rise to one side of the picture, while the other offers a distant view of the spacious Flemish landscape, traversed by a river. In the foreground are tall trees, their trunks sometimes contorted; the foliage is treated in a rather schematic and mannered style. Figures of travellers and other wayfarers, Biblical or mythological characters were often contributed by D. Teniers, Hendrik van Balen, P. van Avont and G. Coques. Many of the pictures are signed L V V or with his name in full. P. A. Immenraet was a pupil of his.

Literature: Y. Thiéry, *Le Paysage flamand*, Brussels, 1953; G. Martin, *National Gallery Catalogues, Flemish School*, London, 1970, p. 283.

Ulft, Jakob van der

b. Gorkum 1627,
d. Noordwijk 1689

1198

Gorkum painter of landscapes, architecture and figures in the Italianate style. His hilly landscapes with prominent antique buildings derive especial appeal from the skilfully composed groups of figures. He painted charming views of Dutch and Italian cities, also with a profusion of figures. His scenes of armies on the march, parades and triumphal processions are rare: they display great skill in the rendering of large numbers of people.

Urselincx, Johannes

d. Amsterdam 1664

1199

Rare Netherlandish painter. The only two known pictures by him, both signed, are a kitchen interior from the Stuers collection at The Hague and a landscape with a peasant woman feeding ducks. His handling of trees recalls the earlier artists Gillis d'Hondecoeter and W. Bundel.

Utrecht, Adriaen van

b. Antwerp 1599, d. there 1652

1200, 1201, 1202

Flemish still-life painter. His wide range of subjects comprises breakfast pieces with vessels, garlands of fruit and vegetables, fish, birds, poulterers' shops, kitchens and store-rooms. The pictures are mostly large and sometimes overcrowded; large figures were contributed by Jacob Jordaens, Theodor Rombouts and T. van Thulden. His scenes of poultry-yards were formerly very popular, but are inferior to Melchior d'Hondecoeter in colour and composition. The drawing is accurate and the general effect plastic, with a one-sided illumination that is often somewhat hard. Compared with F. Snyders his work is richer in contrast, the coloration cooler, the construction less bold and unified. Only the similar subject-matter could lead to confusion with Snyders or J. Fyt. Elias Vonck approaches him more closely in his hunting still lifes of dead birds.

Literature: E. Greindl, *Les Peintres flamands de nature morte*, Brussels, 1956.

Uyl, Jan Jansz. den

b. Amsterdam 1595, d. 1640

1203

Rare Amsterdam still-life painter in the manner of Willem Claesz. Heda and J. J. Treck, who was his brother-in-law and with whom he may be confused. A few objects (e.g. a pewter jug, a silver beaker, a ham) are disposed with taste and care in front of a niche or wall lit faintly from the side. He frequently paints with great skill a crumpled white or coloured table-cloth and a large dark pewter jug. His later pictures are more elaborate: costly silver vessels, glass goblets and artistic tableware are introduced, without spoiling the bold effect of the whole. He often added a small owl to his full signature. The work of M. Boelema and C. Kruys, who were also followers of Heda, is weaker.

Literature: P. de Boer, "J. J. den Uyl," *Oud Holland*, LVII, 1940, pp. 49–64; N. R. A. Vroom, *De Schilders van het Monochrome Banketje*, Amsterdam, 1945.

Uyttenbroeck, Moses van

b. The Hague about 1590,
d. there 1648

1204, 1205, 1206

Dutch landscape painter, influenced by his teacher A. Elsheimer. His rather pallid green, hilly landscapes with cattle, antique-style ruins and large manneristic groups of trees by river-banks are often animated by mythological or Arcadian figures (nymphs bathing). In this he is related to C. van Poelenburgh, but only as regards subject: the forms are thick-set and plump, fit awkwardly into the landscape and do not conform to the Greek ideals of beauty. Less often his figures are taken from the Old or New Testament. When larger and more important in the picture, they recall J. Pynas and N. Moyart. He is characterized by a minute treatment of foliage, reminiscent of Elsheimer. The corners of the foreground are filled with big leaves, herb plants and thistles. He probably taught D. Dalens, and painted small figures for the latter's landscapes.

Literature: U. Weisner, *M. van Uyttenbroeck* (dissertation), Kiel, 1963; U. Weisner, "M. van Uyttenbroeck," *Oud Holland*, LXXIX, 1964, p. 189.

Vadder, Lodewyk de

b. Brussels 1605,
d. there 1655

1207

Flemish landscapist. He painted in a broad, flowing style scenes of the Brabant countryside: well-wooded, hilly dune-lands and ravines with sunlit patches of sandy ground under a sky with white clouds in lively movement. The figures of horsemen and wayfarers, which are not numerous, were sometimes contributed by D. Teniers. He often signed with the monogram LDV. He may be confused with the other Brussels painters C. Huysmans and J. d'Arthois, but they are distinguished by more detailed

handling and darker colours. He is said to have painted landscape backgrounds for the large compositions of C. de Crayer. L. Achtschellinck and I. van der Stock were among his pupils.

Literature: Y. Thiéry, *Le Paysage flamand*, Brussels, 1953.

Vaillant, Wallerant

b. Lille 1623,
d. Amsterdam 1677
1208, 1209

Netherlandish genre painter and portraitist; influenced initially by B. van der Helst and later more by the French school, as a result of which his work became fashionable in polite circles. He frequently painted young men engaged in drawing, in well-composed interiors reminiscent of M. Sweerts. He shows special interest in accessories, which he treats ably in a still-life manner. His later portraits are skilfully posed and decorative, without trying to capture the sitter's personality.

Literature: A. Czobor, "W. Vaillant," *Oud Holland*, LXXV, 1960, p. 242; N. MacLaren, *National Gallery Catalogues, Dutch School*, London, 1960, p. 410.

Valckenborch, Frederick van

b. Antwerp about 1570,
d. Nuremberg 1623
1210, 1211, 1212

Flemish painter influenced by G. van Coninxloo; son of Martin van Valckenborch and brother of Gillis van Valckenborch. His pictures of forests, with figures of travellers, animals or mythological characters, have a somewhat crude and fanciful air. He also painted wild mountain scenes with crags vaguely reminiscent of A. Mirou and P. Schoubroeck, attacks by brigands, torchlit processions, kermesses, sea-battles and scenes of thundery weather. Strong contrasts of light are used to enhance the effect of depth. He often used a monogram composed of the letters FVV (generally with date), which was sometimes misread. His river landscapes were confused at times with those of his uncle Lucas van Valckenborch, but the latter are more old-fashioned and are easily distinguished by the figures' costumes.

Literature: Y. Thiéry, *Le Paysage flamand*, Brussels, 1953; A. Pigler, "F. van Valckenborch," *Oud Holland*, LXXVII, 1962, pp. 127–51.

Valckenborch, Gillis van

b. Antwerp about 1570,
d. Frankfurt 1622
1213

Flemish painter of figures and landscapes; son of Martin van Valckenborch and brother of Frederick van Valckenborch. A

Romanizing, manneristic painter of the transition: scenes from mythology and Greco-Roman history, with typical ruins. The figures, also manneristic, form large, animated groups; they are painted in large surfaces, with little local colour. Dramatic cloud-effects are usual. He may be confused with his brother Frederick.

Valckenborch, Lucas van

b. Malines about 1535,
d. Frankfurt 1597
1214, 1215, 1216, 1217, 1218

Important Flemish painter of the transition, brother of Martin van Valckenborch; influenced by Pieter Bruegel the Elder. His landscapes, which are often small, are distinguished by especially careful painting. His mountain and rural landscapes are given narrative quality and interest by the inclusion of ironworks, huntsmen and riders, peasant weddings and kermesses, depiction of the four seasons and allegories (the Tower of Babel). The pictures are rich in variety; the early landscapes of the Meuse are topographically exact and of special historical interest. The tiny figures are strongly and individually coloured, the foliage treated with the delicacy of a miniature; a large part of the picture is occupied by rocky cliffs. He generally used the monogram LVV, often with date. His works were often ascribed to Pieter Brueghel the Younger, and also confused with the river landscapes of his nephew Frederick van Valckenborch, which are less delicately executed.

Literature: *Les Sites mosans de Lucas I. et Martin I. van Valckenborch*, Liège, 1954; S. J. Gudlaugsson, "Errera Schetsboek en L. van Valckenborch," *Oud Holland*, LXXIV, 1959, p. 118; H. Minkowski, *Turm zu Babel*, Berlin, 1960, pp. 70ff.; A. Wied, *L. van Valckenborch* (dissertation), Innsbruck, 1968.

Valckenborch, Martin van

b. Louvain 1535,
d. Frankfurt 1612
1219, 1220, 1221

Flemish painter of the transition; father of Frederick and Gillis van Valckenborch, brother of Lucas van Valckenborch. His fanciful mountain landscapes, which are often large and seen from a high point of vision, were influenced by his brother Lucas; the figures are Biblical or of genre type (months of the year, the Tower of Babel). His somewhat crudely drawn figures are reminiscent of Pieter Brueghel the Younger, those of his brother Lucas being more carefully executed.

Literature: A. Laes, "M. van Valckenborch," *Annuaire des Musées Royaux Belges*, I, 1938, pp. 123–41; *Les Sites mosans de Lucas I. et Martin I. van Valckenborch*, Liège, 1954.

Valckert, Werner van den

b. Amsterdam about 1585,
d. after 1627

1222, 1223

Dutch painter of successful group and Regent pieces, less often individual portraits. As with his master H. Goltzius, the red flesh-tints of the faces in his pictures are somewhat overdone. The plastic effect is enhanced by contrasts of lighting; over-bright reflections sometimes look unnatural. Goltzius' influence is scarcely discernible in Valckert's religious and moral pictures with large figures: feeding the poor, healing the sick, Christ blessing children. Well-handled Renaissance architecture plays an important part in his work. The portraitist N. Elias was influenced by him.

Literature: F. W. Hudig, "W. van den Valckert," *Oud Holland*, LIV, 1937, pp. 54–66.

Valk, Hendrik de

Haarlem, second half
of the seventeenth century

1224

Rare Dutch genre painter and portraitist, follower of R. Brakenburgh. His inn scenes with their exaggerated merriment are reminiscent of the latter and thus also of J. Steen; the colouring is somewhat harsh and the drawing cursory. His mediocre portraits are in the style of the late seventeenth century.

Valkenburg, Dirk

b. Amsterdam 1675,
d. 1721

1225

Late Amsterdam painter of animal still lifes in the style of his teacher Jan Weenix. As in the latter's work, hunting gear plays an important accessory part; the composition, however, is less well balanced and the tints are cooler. Occasionally he supplies a landscape background, but the execution is inferior to his teacher's. He chiefly painted dead hares and deer, less often partridges and other feathered game. His work is often ascribed to Jan Weenix.

Veen, Balthasar van der

b. Amsterdam 1596,
d. Haarlem after 1657

1226, 1227

Dutch landscape painter in the style of the Haarlem artists C. Decker, S. Rombouts and R. van Vries. He lived at Gorkum in

1637, in Amsterdam in 1639, at Naarden in 1650, and finally at Haarlem again. His landscapes, which are personal in style, are brown in tone, somewhat coarsely painted and seen in a close-up perspective. They recall J. van Goyen, and were often also ascribed in later years to M. Hobbema. Only a few signed pictures by him are extant; the unsigned ones have mostly been attributed to better-known artists. A fine landscape with windmill was ascribed to him in the Enthoven collection, Amsterdam, 1932.

Literature: A. Bredius, "De schilder B. van der Veen," *Oud Holland*, XII, 1894–5.

Veen, Otto van

b. Leiden 1556,
d. Brussels 1629

1228, 1229

Flemish painter of churches and historical pictures in the style of Italian and Dutch mannerism; a pupil of the Dutch artist J. Cl. Swanenburgh. His numerous large altar-pieces, which later provided the transition to the baroque style of Rubens, do not rise to a higher level than that of formal composition. The background to his large figures is formed by buildings or half-indicated landscapes with oak-trees. His rare portraits of celebrities are conventional and of little interest from the point of view of character. Rubens worked for four years in his studio.

Veer, Johannes de

b. Utrecht about 1610,
d. 1662

1230

Dutch painter of Biblical and mythological subjects, also portraits. He was at Utrecht in 1640, and in 1642 went to Rome, where he was nicknamed "bird of paradise." After 1658 he was back in Utrecht. He is chiefly known for his portraits, which are, however, somewhat impersonal in conception. They are to some extent reminiscent of C. Janssens van Ceulen. The half-shades are in brownish tones. B. van der Helst was his model as regards conception, the attitude of the sitters and their lifelike expression. (Two portraits in the Gothenburg Museum; one, listed as by J. van Ceulen, in the Muller sale at Amsterdam, 1905.) His Biblical and mythological pictures are less often seen than his portraits (*Adoration of the Shepherds* in the Central Museum, Utrecht).

Literature: C. Hofstede de Groot, *Oud Holland*, XXXVII, 1919, pp. 118ff.; G. J. Hoogewerff, *Bentvueghels te Rome*, III, 1923, p. 237; H. Gerson, *Ausbreitung und Nachwirkung der holländischen Malerei des 17. Jahrhunderts*, 1942, p. 171.

Veerendael, Nicolas van

b. Antwerp 1640,
d. there 1691
1231, 1232

Flemish painter of flower garlands and festoons of fruit in front of sculpted baroque cartouches, in the manner of Daniel Seghers. As with the latter, the centres were filled in with pictures of the Madonna or mythological subjects by E. Quellinus, G. Coques and others. Veerendael also painted bouquets in glass vases, with stone niches behind. His pictures of flowers are characterized by pleasant half-tones and softer colours than those of Seghers' other follower, J. van Thielen. His pictures of poultry and game are rare, as are *Vanitas* pieces and genre pictures with monkeys in the manner of D. Teniers. J. Boeckhorst is said to have painted figures for his still lifes.

Literature: M. L. Hairs, *Les Peintres flamands de fleurs*, Brussels, 1955.

Velde, Adriaen van de

b. Amsterdam 1636,
d. there 1672
1233, 1234, 1235, 1236, 1237

Important, versatile Amsterdam painter of animals, landscapes, genre and portraits; brother of the sea-painter Willem van de Velde and pupil of J. Wynants. His early works, somewhat influenced by Paulus Potter, are pictures of cattle, in which the typical Dutch pasture landscape plays an important part. His drawing is less exact than Potter's; the soft contours are further blurred by gradations of colour. From this point of view the influence of K. Dujardin is discernible. The staffage figures mostly depict the respectable Dutch bourgeoisie. As with Potter, his best pictures are the smaller ones of cabinet size. The kinds of trees are well distinguished, and the foliage differentiated by varying shades of green. The changes of light at different hours of the day are effectively rendered. All material objects are depicted with tasteful gradations of colour. The landscape and figures are well balanced and of equal importance to the total effect. Next to the well-wooded landscapes with cattle he is celebrated for his scenes of the beach at Scheveningen, where the breadth and depth of the open space is convincingly indicated by the many groups of figures, their size diminishing in accurate perspective. The figures in his excellent winter landscapes are more prominent than those of Aert van der Neer and Jan van de Cappelle. The elegant figures right in the foreground, whose animation is never unrestful, are particularly impressive. In his later work the Italian accessories (houses, antique ruins) become more important, the illumination more restless, the construction more elaborate. The blue and red garments of shepherds and shepherdesses shine out from the dark-green landscape. Unfortunately in many of these works the bolus ground, which he

adopted from Italy, has shown through and added to the darkening effect of time. His portraits – usually of half-length figures making music, eating or drinking – are notable for their quiet poses. He also showed much skill and taste in providing figures and animals for landscapes by other painters: J. van der Haagen, J. Hackaert, J. van der Heyden, M. Hobbema, Philips Koninck, Frederik de Moucheron, Jakob van Ruisdael, Willem van de Velde, A. Verboom and J. Wynants. Among his pupils were J. van der Bent, who however followed N. Berchem, and D. van Bergen: the latter can scarcely be confused with him, as in particular his drawing of animals is inferior. Jakob and Simon van der Does are on a lower level; A. Klomp and P. van der Leeuw treated similar themes.

Literature: C. Hofstede de Groot, *Catalogue raisonné*, vol. IV, Esslingen, 1911; K. Zoege von Manteuffel, *Die Künstlerfamilie van de Velde*, Bielefeld, 1927; N. MacLaren, *National Gallery Catalogues, Dutch School*, London, 1960, p. 413; W. Stechow, *Dutch Landscape Painting of the Seventeenth Century*, London, 1968; R. Kidzum, *A. van de Velde* (dissertation), Bonn, 1968.

Velde II, Anthonie

b. Haarlem 1617,
d. Amsterdam 1672
1238

Dutch still-life painter, probably the son of E. van de Velde I. He lived mostly in Amsterdam, where he is known to have been from 1645 to 1662. The painterly charm of the bright and grey tones of his still life is an example of the specialized artistic craftsmanship of Dutch painters in the second half of the seventeenth century. Unfortunately only one signed and dated still life by him is at present known: from its skilful composition and delicate execution we may suppose that a larger body of his work exists.

Literature: K. Zoege von Manteuffel, *Die Künstlerfamilie van de Velde*, Bielefeld, 1927, p. 32.

Velde, Esaias van de

b. Amsterdam about 1590,
d. The Hague 1630
1239, 1240, 1241, 1242

Dutch painter, who shows great freshness and inventiveness in his lifelike, typically Dutch scenes of dunes in summer and winter, with stout oak trees blown about by the wind. At this stage of his development the clouds and atmosphere are as yet of no importance. His later works are more elaborately constructed and increasingly colourful and painterly: broad banks of quiet rivers with ferry-boats, village squares with numerous figures, skaters on the moat under the city bastions. His skilfully painted figures are particularly effective in his genre-like scenes

of elegant companies feasting in park landscapes: these are reminiscent of W. Buytewech. His coarse-bred horses, realistically depicted in cavalry engagements and scenes of attack and pillage, served as a model for many successors in this line. He also contributed figures to the church interiors of B. van Bassen. J. van Goyen, P. de Neyn and J. Asselyn were pupils of his.

Literature: K. Zoege von Manteuffel, *Die Künstlerfamilie van de Velde*, Bielefeld, 1927; W. Stechow, "E. van de Velde," *Nederlandsch Kunsthistorisch Jaarboek*, 1, 1947, pp. 83 ff.; N. MacLaren, *National Gallery Catalogues, Dutch School*, London, 1960, p. 418; W. Stechow, *Dutch Landscape Painting of the Seventeenth Century*, London, 1968.

Velde, Jan van de

b. Haarlem about 1620,
d. Enkhuizen after 1662
1243, 1244

Haarlem still-life painter, influenced by P. Claesz. His early works are brighter and harder, with detailed delineations of vessels, playing-cards, pipes and braziers. Those of his mature period are carefully and economically composed against a dark background: on the corner of a table, which is generally bare, are displayed a rummer, a graduated glass with a lemon, chestnuts, medlars, oysters or smoker's implements. The tonality, ranging from yellow to dark brown, and the emphatic local tints are reminiscent of W. Kalf. The pictures are for the most part fairly small, and upright in shape. Works by Juriaen van Streeck, J. J. Treck, J. J. den Uyl and Simon Luttichuys are sometimes mistakenly ascribed to him.

Literature: N. R. A. Vroom, *De Schilders van het Monochrome Banketje*, Amsterdam, 1945; N. MacLaren, *National Gallery Catalogues, Dutch School*, London, 1960, p. 419.

Velde, Pieter van de

b. Antwerp 1634,
d. there after 1687
1245, 1246

Flemish sea-painter; according to old tradition he was a close relative of the well-known Dutch sea-painter Willem van de Velde the Younger. In 1654 he was a master in St Luke's Guild at Antwerp. The turbulent sea and the accessory figures recall Jan Peeters by their composition and style of painting, but the drawing is weaker and the execution less polished. The treatment of the waves is schematic, the prevailing colours are brown and grey. He is fond of painting shipwrecks on exotic coasts with fantastic rocky cliffs; sometimes also ports with a city skyline (Antwerp or Rotterdam). Following the fashion, he later painted Italian coasts with watch-towers; the figures in these are coarse and unrealistic.

Literature: L. Preston, *Sea and River Painters of the Netherlands*, London, 1937.

Velde the Younger, Willem van de

b. Leiden 1633,
d. London 1707
1247, 1248, 1249, 1250, 1251

Important Amsterdam sea-painter; son of Willem van de Velde the Elder, whose work consists mainly of pen drawings of ships, and brother of Adriaen van de Velde; pupil of S. de Vlieger. He combined exceptional ability as a draughtsman with his master's expert handling of tones and light, though his own style tended more and more towards the use of colour. His skill in composition is of the first importance, involving the exact observation of the time of day, atmosphere, clouds, wind and waves, the set of a ship's sails and her position in the water. The sea serves in fact as a mere setting within which the ship is depicted with nautical precision down to the last details of her rigging, the artist's work displaying a knowledge of shipbuilding in all its aspects. Most of the sea-pieces of his early, better period are small, except those that represent historical events. His predilection is for calm or gently moving seas: scenes of low water with flat patches of ooze in the foreground, sailing-boats at anchor mirrored in the waves at evening, fishermen bringing their catch ashore. The later pictures of his English period are more elaborate and rhetorical. The sea is animated by large frigates drawn with a practised hand, the pictures are larger in size and the colours more restless; the drama is heightened by sharp illumination together with thunderous darkness. In these works he sometimes resembles L. Backhuysen. His figures are true to life and painted with delicate gradations of tone; small at the beginning, they later assume greater importance in the picture. In some cases they were supplied by his younger brother Adriaen. Willem van de Velde, the greatest Dutch sea-painter after J. van de Capelle, left no pupils in Holland, but continued to influence European marine painting until the nineteenth century.

Literature: C. Hofstede de Groot, *Catalogue raisonné*, vol. VII, Esslingen, 1918; F. C. Willis, *Die Niederländische Marinemalerei*, Leipzig, 1911; L. Preston, *Sea and River Painters of the Netherlands*, London, 1937; H. P. Baard, *Willem van de Velde*, Palet-Serie, Amsterdam, 1942; N. MacLaren, *National Gallery Catalogues, Dutch School*, London, 1960, p. 420; W. Stechow, *Dutch Landscape Painting of the Seventeenth Century*, London, 1968.

Velsen, Jacob van

active at Delft 1625,
d. Amsterdam 1656
1252

Rare Dutch painter of conversation pieces and guard-room scenes in the style of Anthonie Palamedesz., P. Codde and Simon Kick. Compared with these artists, his colours and contrasts of

light and shade are stronger; his backgrounds are of a striking light grey. Many of his pictures are probably still concealed among the works of other painters of soldiers: J. Duck, J. Olis, H. G. Pot and Pieter Potter.

Literature: N. MacLaren, *National Gallery Catalogues, Dutch School*, London, 1960, p. 433.

Venne, Adriaen Pietersz. van de

b. Delft 1589,
d. The Hague 1662
1253, 1254, 1255

Dutch painter of figures and genre subjects. His arrangement of the picture and his treatment of foliage are still reminiscent of the Flemish style of the Brueghel group. But the drawing and colours are increasingly Dutch and realistic in manner, as is the observation of the sky and atmosphere. He depicted the cheerful bustle of fairs and kermesses in strong local colours, the well executed summer and winter landscapes providing a narrative frame for the portrayal of original types of the common people. Less often he illustrated Biblical and historical themes, with the same humour and plentiful figures, the most important of which often make the impression of portraits. To his late period belong a large number of grotesques in grey or brownish tonality (grisailles): groups of beggars and vagabonds, peasants and women quarrelling, cavaliers and their ladies, illustrations of Dutch proverbs, figures symbolizing worldly poverty and misery. His rare portraits, some equestrian, have a distinctive freshness.

Literature: D. Franken, *A. van de Venne*, Amsterdam, 1878; L. J. Bol, "A. P. van de Venne," *Oud Holland*, LXXIII, 1958; L. J. Bol, *Oud Holland*, LXXV, 1960, p. 128.

Venne, Pseudo Van de

Netherlandish, first half
of the seventeenth century
1256

Probably an Antwerp painter of allegorical genre scenes: tramps, cripples, ghostly figures, dances and brawls. A hard, one-sided illumination is characteristic of him. The background often consists of rocky caves, as in D. Teniers' scenes of witches. This painter, whose real name is unknown, is a different artist from Adriaen Pietersz. van de Venne. His closest affinity is with P. Quast as a portrayer of figures with caricature-like faces; he can hardly be confused with D. Teniers or David Ryckaert.

Literature: A. Heppner, *Oud Holland*, XLVII, 1930.

Verbeeck, Cornelis

b. Haarlem about 1590,
d. about 1633
1257

Dutch marine painter, father of Pieter Cornelisz. Verbeeck, who painted genre scenes and horses. Member of the Haarlem Guild about 1610. As was usual in the early days of Dutch sea-painting, he laid much stress on the careful and exact delineation of ships in all their details, with large flags etc. In a manner reminiscent of A. van Eertvelt, the foreground is often in shadow and the sea represented with great breakers, among which dolphins, casks and planks are seen floating. Sometimes ships are drifting in the rough sea on to fantastic rocks: an example of this theme is in the Museum of Maritime History at Amsterdam. In his early period the relation between the ship and the water is tenuous, but later he strove continually to depict the sea in a realistic fashion; it was reserved for his followers to succeed in this. He may be confused with the other early sea-painters A. van Eertvelt, H. C. Vroom and C. C. van Wieringen.

Verbeeck, Pieter Cornelisz.

b. Haarlem about 1610,
d. about 1654
1258, 1259

Dutch painter of horses, who is believed to have taught Philips Wouwerman. His cavalry skirmishes and raids resemble the work of J. Martsen or J. van der Stoffe. His accurate depiction of horses and fondness for sketchy Italianate landscapes have at times led to confusion with Dirck Stoop, but the latter's general tonality is yellower.

Literature: N. MacLaren, *National Gallery Catalogues, Dutch School*, London, 1960, p. 434.

Verboom, Adriaen

b. Rotterdam about 1628,
d. Amsterdam about 1670
1260, 1261

Dutch landscape painter of Jakob van Ruisdael's circle. His forest landscapes are somewhat hard and painted in deep brown or blackish tones; they are similar to the work of C. G. Decker, Roelof van Vries, A. Waterloo and J. Vermeer van Haarlem the Elder. An evening light plays on the trunks of great oaks or on a sandy path, often with suitable figures added by J. Lingelbach or Adriaen van de Velde. The drawing of his later pictures is more cursory.

Verbruggen, Gaspar Peeter

gasp. Verbruggen 1668

b. Antwerp 1635,
d. 1681
1262, 1263

Flemish flower-painter, pupil of C. Mahu. His rich bouquets are painted in a bold style, often in elaborate stone vases and with the addition of Mediterranean fruit. Large garlands of flowers in front of cartouches are especially sumptuous and admirably executed. He was a prolific painter in the decorative style; at times his work is cursory and in an unpleasing rusty-red tonality. He is often credited with weaker pictures by his son (1664–1730), who painted in a similar style, and members of related Italianate schools. The priming of his pictures has darkened considerably, so that the shadows have often become opaque.

Literature: M. L. Hairs, *Les Peintres flamands de fleurs*, Brussels, 1955.

Verburgh, Dionijs

DVB

active at Rotterdam;
d. before 1722
1264

Rotterdam painter of river landscapes with figures. The point of vision is high and the painting is in a bold style. A river with towns on its banks winds into the distance between hills planted with tall trees. The silvery colours and sketchy treatment of the distance are typical of the turn-of-the-century style. His rare views of Surinam also date from this period. He signed in full or, frequently, with the monogram DVB.

Literature: H. C. Hazewinkel, "De Rotterdamsche Schildersfamilie Verburgh," *Oud Holland*, LV, 1938, 217–22.

Verdoel, Adriaen

A. verdoelf

b. Flushing about 1620,
d. 1695
1265, 1266

Dutch painter of the wider Rembrandt school. In 1649 he was a member of the Guild at Haarlem; later he was at Flushing, where he was crowned as a poet in 1675. He is said to have been a pupil of D. Hals and J. de Wet; his work closely resembles the latter's. He chiefly painted Biblical themes, in which Rembrandt's influence is increasingly noticeable, e. g. the *Queen of Sheba visiting Solomon*, in the Schwerin Museum; the *Triumph of Mordecai*, and *Joseph and his Brethren*, in the Pushkin Museum, Moscow. Within the pattern of the wider Rembrandt school he is a good colourist with typical brown and red hues, warm golden intermediate tones and light effects. The figures are slightly drawn and the landscape background only hinted at. Exceptionally he treated genre subjects (*The Operation*, *An Old Scholar*, *The Dance*, *Man Counting Money* in the style of S. Koninck) and *Vanities*, which were popular in the Rembrandt school. Although his name often occurs in old inventories, only about twenty of his pictures are known today. He is often confused with J. de Wet and J. Marienhof.

Literature: S. Rosenthal, *Art in America*, 17, 1928/9, pp. 249–58, with list of works.

Verelst, Pieter

P.VERELST 1648

b. Dordrecht about 1618,
d. Hulst about 1678
1267, 1268, 1269

Dordrecht painter of genre, portraits and still life, influenced by G. Dou, who was probably his teacher. His old men and women in quiet domestic occupations are reminiscent of Dou and of Salomon Koninck. His rustic interiors – peasants smoking in a tavern, gambling and quarrelling – are distinguished by a soft, elegant style and delicate gradations of tone: they sometimes resemble those of Philips Koninck. His still lifes and portraits are rare. His son, the still-life painter Simon Verelst, was a pupil of his.

Verelst, Simon

S. ver Elst

b. The Hague 1644,
d. London 1721
1270, 1271

Dutch still-life painter and portraitist, son of Pieter Verelst. His tasteful bouquets on a dark background are more economic in composition than those of A. Mignon or Rachel Ruysch. The small pictures of flowers in simple glass vases are artistically superior to his large overloaded compositions. His genre-like heads of old men and women are rare, as are bird still lifes with fruit and implements, which recall similar paintings by his father. His flower still lifes are often ascribed to Rachel Ruysch, who painted at a later date.

Verhaecht, Tobias

b. Antwerp 1561,
d. there 1631
1272, 1273

Flemish artist of the transition: he painted mountain landscapes in the style of Joost de Momper and river valleys spanned by bridges, with the typical strong greens and blues of his time and small figures of travellers or, less often, of Biblical characters. Like Brueghel and L. van Valckenborch, he painted several

versions of the Tower of Babel. Jan Brueghel occasionally supplied him with accessory figures. Rubens was a pupil of his, as was Marten Ryckaert, whose mountain landscapes with waterfalls resemble his work.

Literature: J. A. Count Raczynski, *Die flämische Landschaft vor Rubens*, Frankfurt, 1937; Y. Thiéry, *Le Paysage flamand*, Brussels, 1953.

Verhaert, Dirck

active 1631, d. after 1664

1274, 1275

Dutch landscape painter; member of St Luke's Guild at The Hague in 1631, and in 1637 of the Guild at Haarlem, where he spent most of his active life; was at Leiden in 1664. He belongs to the group of Italianate landscapists. Mountains crowned with ruins or citadels rise behind fortified towns situated on the banks of rivers. Harbour towns, with their watch-towers, in Mediterranean bays are depicted in careful detail, in a characteristic tonality ranging from yellow to reddish-brown. Dark accessory figures, sketchily drawn, are often seen in the foreground, with a bright extent of space behind. He generally used the monogram DVH, and as a result most of his pictures were ascribed to the Flemish artist D. van Heil; they have only been distinguished in recent times.

Verhout, Constantyn

active at Gouda, second half of the seventeenth century

1276, 1277

Dutch still-life and genre painter. Nothing is known of his life except that he came to live at Gouda in 1666. His genre pictures show one or two half-length figures engaged in some quiet activity, e.g. a writing lesson; there is usually a still-life arrangement of books. The books, materials etc. are rendered with more boldness and colour than in the similar works of Gerrit van Vucht.

Literature: A. Bredius, *Burlington Magazine*, 41, 1922, p. 175, with three reproductions.

Verkolje, Jan

b. Amsterdam 1650,
d. Delft 1693

1278

Dutch painter of genre, mythological scenes and portraits. He was a follower of G. Metsu, G. ter Borch and Caspar Netscher, and like them painted elegant society in rich interiors, but in a smoother style. His portraits, which are rarer, were prized for their "fine painter" qualities. In some instances he is close to

Eglon van der Neer. After the death of G. van Zyl he completed the latter's mythological and genre scenes. His son and pupil Nicolaes Verkolje, and the rare painter Th. van der Wilt, followed him in subject-matter and style.

Verkolje, Nicolaes

b. Delft 1673,
d. Amsterdam 1746

1279

Amsterdam "fine painter" of the decadence; pupil of his father Jan Verkolje, and influenced by G. Metsu and Adriaen van der Werff. A versatile artist with a charming sense of colour, he chiefly painted genre pictures: lovers, hunting and musical parties and drawing-room games. His mythological, Old and New Testament scenes and court portraits are rare. His pictures are sometimes ascribed to his father. He occasionally contributed figures to paintings by Isaac de Moucheron.

Vermeer, Barent

b. Haarlem 1659,
d. before 1702

1280

Haarlem still-life painter; son of the landscapist Jan Vermeer of Haarlem the Elder, and brother of Jan Vermeer of Haarlem the Younger. His fruit pieces with precious tableware and silver vessels, generally composed on a Persian carpet, recall those of W. Kalf, with which they have in common subdued chiaroscuro and elegant gradations of tone. The figures of servants or large birds are prominent but do not affect the still-life character of the whole. Some of his pictures are elaborate in composition, an effect enhanced by stone tables or marble slabs, which are nearly always sculpted. The centre is often occupied by baroque cabinet pieces such as ivory vessels, Venetian and nautilus goblets and large Delft vases. He may be confused with J. van Streeck, whose paintings are similar but with a more economical selection of objects. Christian Striep is also close to him.

Literature: I. Bergström, *Dutch Still Life Painting*, London, 1956.

Vermeer of Haarlem the Elder, Jan

b. Haarlem 1628,
d. there 1691

1281, 1282, 1283, 1284

Haarlem landscape painter; a pupil of J. de Wet, though his work shows nothing of the latter's Rembrandtesque style. He painted flat landscapes which are much admired, first in the style

of Jakob van Ruisdael and later in that of Philips Koninck. His extensive and distant views of the dunes at Overveen under a high, cloudy sky lack the atmosphere of similar works by Jakob van Ruisdael; his colouring is browner in tone. A dune is often seen in shadow to one side of the foreground. These works may easily be confused with the flat landscapes of J. van Kessel. His pictures of forest verges – paths, with figures on horseback and on foot, leading out of tall oak groves, sunny vistas beyond and impasted foliage – recall A. Verboom, J. van Kessel and Salomon Rombouts. He also painted marines, battle pieces and pastoral scenes; his son continued this last genre in a more Italian style. Adriaen van Ostade occasionally supplied him with figures. The spacious dune landscapes of Claes Hals sometimes resemble his.

Vermeer of Haarlem the Younger, Jan

b. Haarlem 1656, d. 1705
1285

Landscape and animal painter, pupil of his father and N. Berchem. The latter's influence is seen in his pictures of flocks and herds (mostly sheep) and pastoral scenes in a mountainous, Italian-type landscape with woods and rivers. From his father he adopted a somewhat heavy, uniform brown or greenish tonality. The foliage is sketchy and shows little individuality of style. Together with the similar painters Simon van der Does and D. van Bergen, he belongs to the late period of Dutch landscape painting in the Italian style.

Vermeulen, Jan

b. Haarlem; active from 1638 to 1674
1286

Vanitas painter belonging to the circle of Pieter Potter, Pieter van Steenwyck and the early Jan Davidsz. de Heem. Documents, a globe, musical instruments, a helmet and weapons are depicted in a crowded composition on a table corner, against a greyish-green background. His usual monogram VM often appears on the spine of a book or the open page of a folio which is prominent in the picture. He may be confused with E. Collier, but the latter is more economical in composition and less painterly.

Literature: I. Bergström, *Dutch Still Life Painting*, London, 1956.

Verschuier, Lieve

b. Rotterdam about 1630,
d. there 1686
1287, 1288

Rotterdam sea-painter; a follower of Aelbert Cuyp, with whom he shares a fondness for poetic sunrises in warm tones and the use of brick-red and yellow. He is said to have been a pupil of S. de Vlieger. He often depicted the Meuse at Rotterdam in a gentle breeze: typical of his style are short ripples running in the same direction and caught by the sun's rays at a low angle. His early work is distinguished by good painting of clouds and fine atmospheric tones, while many of his later pictures suffer from a hard variegation of colour. As in the later work of Willem van de Velde, there is a more formal and less restful touch about his sea-battles and naval reviews, which show exactitude of detail and furnished the opportunity to delineate particular ships. His monogram LVS was often misread, his work being ascribed to the more important artists Aelbert Cuyp, Willem van de Velde and J. van de Cappelle.

Literature: F. C. Willis, *Die Niederländische Marinemalerei*, Leipzig, 1911; W. Stechow, *Dutch Landscape Painting of the Seventeenth Century*, London, 1968.

Verschuring, Hendrik

b. Gorkum 1627,
d. Dordrecht 1690
1289, 1290

Dutch painter of horses and landscapes; a follower of Philips Wouwerman and pupil of Jan Both. His Italian landscapes with ruins are not very reminiscent of the latter's; they suffer from a hard, bright illumination. His best-known pictures are of elegant companies on horseback, parties setting out for the chase or resting with hounds, also riding-schools and cavalry engagements. He also painted typically Dutch scenes of the beach with fishermen laying out their catch for sale at the foot of the dunes. In these too he often introduced well-painted horses. His half-length, genre-like portraits are rarer. He provided figures for the forest landscapes of P. van Asch.

Literature: N. MacLaren, *National Gallery Catalogues*, *Dutch School*, London, 1960, p. 440.

Verspronck, Jan

b. Haarlem 1597, d. there 1662
1291, 1292

Haarlem painter of excellent portraits in the style of his master Frans Hals; his approach, however, is less spontaneous and more that of a quiet observer. The sitters have a more reserved and elegant air and there is always something captivating about their attitude, especially in the admirable portraits of women. His early work is harder and brighter; later he achieved a delicate chiaroscuro and a broad, fresh style of painting with subdued colouring. His portraits and groups of this period are reminiscent, in their light and shade effects, of the Rembrandt school and especially of J. A. Backer. The sitters are usually portrayed in half-length, with their hands showing, and without genre-type accessories.

Verstralen, Antonie

b. Gorkum about 1593,
d. Amsterdam 1641
1293, 1294

AVS.

Dutch landscape painter, follower of the two Avercamps, to whom his better work was often ascribed. He mostly painted winter scenes with people disporting themselves on frozen canals: the detail is carefully rendered, the houses prominent and the trees scanty. The perspective of the remoter figures is less successful. He signed in full or, frequently, with the monogram AVS.

Vertangen, Daniel

b. The Hague about 1598,
d. Amsterdam before 1684
1295, 1296

Daniel Vertangen

Dutch painter of Arcadian landscapes, with somewhat clumsy nudes representing Biblical or mythological characters. He was a pupil of C. van Poelenburgh and imitated his style, without catching the atmosphere of the southern landscape or the liveliness of his figures. He used chilly, bluish-green tones to a greater extent than his teacher. Occasionally he painted rocky caves with nymphs bathing, which might be mistaken for works by A. van Cuylenborch.

Verwer, Abraham de

b. Amsterdam before 1600,
d. 1650
1297

A. D. verwer · in · fecit 1621

Dutch landscapist, marine painter and draughtsman; like many artists of his time he was also an architect and engineer. The sea-painter Justus de Verwer was his son and pupil. He was at Amsterdam in 1617 and was active in France in 1639, painting three views of the Louvre and numerous vedute of French towns. To judge from his drawings he also worked at Le Havre and Nantes and in Belgium. After 1641 he returned to Amsterdam. The marines and sea-battles of his early period are brightly coloured, and with their ships depicted on a large scale resemble the work of A. van Antum and C. Verbeeck (sea-battle of 1573 on the Zuider Zee, signed and dated 1621.) Later he painted the sea in a more lifelike fashion, in a uniform grey-brown tonality; the ships at this period are of less importance. He may be confused with the sea-painters C. Verbeeck and H. Vroom, whose development was similar, and, in his later work, with his son Justus de Verwer.

Literature: G. Pascal, *Gazette des Beaux-Arts*, XIV, 1926, pp. 288–92; L. Preston, *Sea and River Painters of the Netherlands*, London, 1937.

Verwer, Justus de

b. about 1626, d. before 1688
1298

Dutch marine painter, son and pupil of Abraham de Verwer. After a long stay in the Indies he settled at Amsterdam in 1656; in 1685 he was living at Gouda. His work resembles his father's later style. The sea, grey in tone, is rendered with broad strokes of the brush; the treatment of the waves is mannered. In the distance there is usually a narrow strip of shore with sketchily indicated buildings, landing-places or dunes. These pictures belong to the period of "grey sea-painting." His pictures, few of which bear the monogram JDV, were not distinguished from his father's till fairly recent times.

Literature: L. Preston, *Sea and River Painters of the Netherlands*, London, 1937.

Verwilt, François

b. Rotterdam about 1620,
d. 1691
1299

Versatile Dutch painter. His Arcadian landscapes with pastoral or mythological figures (nymphs) are in the style of his teacher C. van Poelenburgh. Less often he painted portraits in the manner of B. van der Helst. His interiors with elegant companies making music or gambling are closely related to the circle of Anthonie Palamedesz.

Vianen II, Paulus von

b. Prague before 1613,
d. Utrecht 1652
1300

VIANEN · F
1643

Dutch painter, son of a goldsmith and draughtsman of the same name. In 1642 he was a member of St Luke's Guild at Utrecht, where he presented a landscape with ruins to St Job's Hospital. Old records ascribe to him many pictures and drawings of landscapes with Biblical figures.

Victors, Jacobus

b. Amsterdam 1640,
d. there 1705
1301, 1302

Italian-Dutch painter of poultry. Although he was not a follower of Melchior d'Hondecoeter, his work is similar in manner. Stepbrother of Jan Victors. Besides pigeons, which he painted especially well, he often depicted poultry-yards, turkeys and rabbits. The brown-green landscape background is only sketchily indicated. In some of his pictures the background is by

Jakob van Ruisdael. The works of his early Venetian period are in elegant tones of grey, brown and black; owing to the use of a strong bolus ground, many of them have darkened considerably. Ascription of his work to Melchior d'Hondecoeter can only be due to the similarity of subject.

Victors, Jan

b. Amsterdam 1620,
d. 1676 in the East Indies
1303, 1304, 1305, 1306

Amsterdam painter of genre and historical subjects and portraits; a pupil of Rembrandt, whom he initially imitated. Later he painted in the style of G. Flinck and F. Bol, who, however, are superior to him. His Old Testament compositions are mostly large; they are in the spirit of his teacher but more rhetorical, and the shadows are somewhat too heavy. His distinguished portraits, in grey-brown tones, also belong to the wider Amsterdam circle influenced by Rembrandt. He is most admired for his genre scenes of the everyday life of the streets, less often indoors: village pedlars, sellers of fruit and poultry, quacks, butchers and craftsmen. His earthy characters, standing stiffly on legs that are too short for them, are portrayed with a characteristic, simple humour. His work is sometimes ascribed to G. Flinck or F. Bol; his portraits are sometimes hard to distinguish from those of J. A. Backer.

Literature: N. MacLaren, *National Gallery Catalogues, Dutch School*, London, 1960, p. 441.

Victoryns, Anthonie

b. Antwerp before 1620,
d. before 1656
1307

Rare Flemish painter of rural scenes, who imitated and copied works of Adriaen van Ostade dating from the 1630s. He painted, in yellow-grey tones, peasants drinking or fighting in a thatched cottage, a village school with many children in a large barn, also representations of the Five Senses. His name is often attached to other imitations of A. van Ostade, A. Brouwer and David Ryckaert.

Literature: G. Glück, "A. Victoryns," *Oud Holland*, 1932, p. 70; G. Glück, *Rubens, van Dyck und ihr Kreis*, Vienna, 1933, p. 365.

Villeers, Jacob de

b. Leiden 1616, d. Rotterdam 1667
1308

Rare Dutch painter of mountain and river landscapes with ruins. In 1646 he painted landscapes for two ship's cabins for Prince Frederick Henry of Orange.

Vinckboons, David

b. Malines 1576,
d. Amsterdam after 1632
1309, 1310, 1311, 1312

Versatile Flemish-Dutch landscape painter of the transition; he belonged to the Brueghels' wider circle. His small forest landscapes, sometimes with a river-course, recall the Frankenthal painter G. van Coninxloo. Open spaces in villages and towns are peopled with numerous, lifelike figures of peasants dancing, feasting and merry-making. The large, colourful figures in his genre scenes of soldiers, beggars and children in procession are akin to those of Pieter Brueghel the Younger. Less often he painted Biblical and historical themes: St John the Baptist preaching, Christ bearing the Cross. His park landscapes with tiny, elegant figures in court attire are especially charming. Other, carefully executed landscapes with great oak-trees are still painted from a high viewpoint, as are village streets, churches and imaginary castles. The finch (Dutch *vink*) which can be seen on his pictures as well as on those of many other Flemish painters is not intended as a signature.

Literature: J. Held, "Notes on D. Vinckboons," *Oud Holland*, 1951, p. 243; K. Goosens, *D. Vinckboons*, Antwerp, 1954; A. Czobor, "D. Vinckboons," *Oud Holland*, LXXVIII, 1963, p. 151; F. C. Legrand, *Les Peintres flamands de genre*, Brussels, 1963.

Vinne, Vincent Laurensz. van der

b. Haarlem 1629,
d. 1702
1313

Dutch painter and draughtsman, member of a large Frisian family of artists. A pupil of Frans Hals, but he adopted nothing of his style; he was active at Haarlem and entered the Guild there in 1649. In 1652–1655 he went on a journey to Germany, Switzerland and France with C. Bega, D. Helmbreker and W. Dubois; the resulting diaries, with many sketches, have been preserved. In 1655 he was back at Haarlem. He seems chiefly to have painted signboards, such as are visible in the street scenes of J. van der Heyden. His *Vanitas* pieces are similar to those of H. Andriessen, J. de Claeuw, E. Collier and J. Vermeulen; open volumes, and sheets of paper with writing on them, play a large part. (One such picture, in the Louvre, shows a sheet of paper with a likeness of Charles I of England.) His genre pictures of musical parties or itinerant musicians are rare. His portraits are somewhat coarsely painted, with broad planes and a yellowish-brown tonality. The Frans Hals Museum at Haarlem possesses a self-portrait painted by him about 1654, and a portrait of him by Judith Leyster.

Vitringa, Wigerus

w: viritinga
F...t.

b. Leeuwarden 1657,
d. Wirdum
(near Leeuwarden) 1725
1314, 1315

Dutch sea-painter and draughtsman, also advocate at the Fries-land court; member of the Guild at Alkmaar, 1696–1706. His seascapes recall those of L. Backhuysen, but are somewhat coarser and, especially in his later period, less elaborately com-posed. The waves have a glassy look. Like L. Backhuysen he often paints dark figures on a light strip of shore in the fore-ground. He also painted southern ports with a strong architec-tural element (Gulf of Genoa, Venice). He did little work after 1712, owing to the aggravation of an eye complaint. Despite a lifelong career as an eminent lawyer he found time to produce a large quantity of watercolour drawings and paintings. These were much admired in his day and were afterwards often ascribed to W. van de Velde, partly on account of the similar monogram. He may be confused with L. Backhuysen.

Literature: J. Belonje, *Oud Holland*, LXXIV, 1959, pp. 29–37 and 161.

Vlieger, Simon de

S DE VLIEGER

b. Rotterdam about 1600,
d. Weesp 1653
1316, 1317, 1318, 1319

Versatile Dutch sea and landscape painter. A pupil of Jan Por-cellis, he adopted the latter's "grey" style of sea-painting but enriched and diversified it with strong contrasts of light and reflections and larger quantities of shipping of different types. The fantastic rocks looming out of a rough sea with ships in danger belong to his early period and recall A. van Eertvelt and Hendrik Vroom. In his best years he painted a calm or slightly ruffled sea with fishing-boats skilfully distributed. The beach with jetties and landing-stages is depicted in detail and often forms a coulisse adroitly enhancing the effect of distance. The fully manned rowing-boats and frigates form a transition to similar themes in the work of Jan van de Cappelle and Aelbert Cuyp. His beach and dune pictures of the 1640s are characterized by the disposition of figures in groups extending well into the background. The perspective thus gained, together with inten-sified light effects, gives a convincing impression of the infinite remoteness of the horizon.

His late works include commissioned pictures of historical events (sea-battles, landings and embarkations); these are com-plicated in structure. He also occasionally painted forest land-scapes with huntsmen or travellers, in the manner of the Ruisdael circle. His rarer genre scenes and portraits exhibit his manifold

and prolific talent in these fields also. He was the forerunner of his eminent pupils Willem van de Velde and Jan van de Cappelle.

Literature: F. C. Willis, *Die Niederländische Marinemalerei*, Leipzig, 1911; J. Kelch, dissertation, Berlin, 1963; N. MacLaren, *National Gallery Catalogues, Dutch School*, London, 1960, p. 442; W. Stechow, *Dutch Landscape Painting of the Seventeenth Century*, London, 1968.

Vliet, Hendrik van

H van Vliet 1661

b. Delft 1611, d. there 1675
1320, 1321

Delft painter of church interiors and portraits. A pupil of his uncle Willem van Vliet and M. J. van Mierevelt, he painted mediocre portraits in the latter's style. After some genre pictures with candle-light effects (Caravaggio) he turned to interior painting. The church scenes almost all represent the Oude or the Nieuwe Kerk at Delft, and are scarcely inferior to E. de Witte or G. Houckgeest. The sense of depth is enhanced by light and shade effects and the plastic rendering of architecture. The painterly perspective is convincing. His pictures, in upright format, are often closed at the top by a dark-brown semicircle. An open sepulchre is to be seen in many of his churches. As with E. de Witte, the sense of depth and dignity is heightened by figures in black cloaks, standing in quiet attitudes with their backs to the spectator.

Literature: H. Jantzen, *Das Niederländische Architekturbild*, Leipzig, 1910.

Vliet, Willem van

w. van der vliet

b. Delft about 1584, d. there 1642
1322

Rare Delft portrait painter in the style of M. J. van Mierevelt and J. A. van Ravesteyn. His portraits are light in hue and somewhat prosaic; the sitters, usually in half or three-quarter length, are pale in countenance; the colouring in general is particularly delicate and well-chosen. His conversation pieces in elegant interiors, somewhat reminiscent of late works by P. de Hooch, are rare. He instructed his nephew Hendrik van Vliet in portrait-painting.

Literature: N. MacLaren, *National Gallery Catalogues, Dutch School*, London, 1960, p. 444.

Voet, Karel Borchaert

voet

b. Zwolle 1670, d. 1743
1323

Dutch still-life painter. At the age of nineteen he was employed by the Earl of Portland, whom he accompanied to England several times. Member of the Guild at The Hague in 1692, he afterwards lived in Dordrecht. In the manner of the early eighteenth century he chiefly painted plants and fruit, insects,

wild and tame birds and other small animals. In 1735, at Dordrecht, he began to publish a sumptuous work on insects. His finest works are his large bouquets painted in the open air, often with guinea-pigs playing amongst them. These pictures bear a resemblance to those of C. Roepel and the German F. W. Tamm. Small creatures and objects of all kinds are depicted with especial care and scientific accuracy, as they were by his Rotterdam predecessor J. Goedaert. Two kitchen still lifes by him were in the museum at Schwerin.

Vois, Arie de

b. Utrecht about 1632,
d. Leiden 1680
1324, 1325, 1326

Leiden "fine painter" and pupil of A. van den Tempel. As a follower of G. Dou and Frans van Mieris he painted scenes of gallantry, genre-type single figures (drinking, smoking, hunting and fencing) and Arcadian landscapes with mythological figures (Venus and Adonis, Diana and Actaeon, nymphs bathing). His small, very lively portraits, of miniaturelike elegance, were formerly much prized. Portraits of a courtly type, set in a park landscape at evening, correspond to the later work of N. Maes and Caspar Netscher. He shared with the latter an extreme virtuosity in rendering silk damask.

Volder, Joost de

b. Haarlem about 1600
1327

Rare Haarlem landscape painter (member of St Luke's Guild there in 1632), in the manner of Jan van Goyen between 1635 and 1640 and of Salomon van Ruysdael. The landscapes known to be by him are in brownish-yellow tones and skilfully drawn; the effect of depth is increased by dark areas with figures in the foreground. Many works by him are no doubt still among those ascribed to Jan van Goyen and Salomon van Ruysdael.

Literature: B. J. A. Renckens, "J. de Volder," *Oud Holland,* LXXXI, 1966, pp. 58 and 268; W. Stechow, *Dutch Landscape Painting of the Seventeenth Century,* London, 1968.

Vonck, Elias

b. Amsterdam 1605,
d. there 1652
1328

Amsterdam still-life painter, father of Jan Vonck. In his hunting still lifes he chiefly painted dead game birds (partridges, swans etc.), occasionally adding the figure of a huntsman, a cook or a female vendor, and enlivening the picture with a snuffling dog or prowling cat. The influence of F. Snyders and Melchior

d'Hondecoeter is discernible, as is Rembrandt's. Owing to the similarity of theme his works were frequently attributed to Jan Weenix; they were also confused with the more detailed still lifes of birds by his son Jan Vonck.

Vonck, Jan

b. Amsterdam about 1630,
d. about 1662
1329

Amsterdam painter of hunting still lifes, especially dead birds and hares, in the style of his father and teacher Elias Vonck or A. van Utrecht. Reminiscences of Flemish style are also noticeable in his large hunting scenes, imitated from Snyders. His fish still lifes are rarer and belong to the Amsterdam school.

Voorhout, Jan

b. Uithorn 1647,
d. Amsterdam before 1723
1330

Amsterdam painter of the late period: genre, historical scenes and portraits. His large mythological and Biblical scenes, with their somewhat cursory drawing of bodies, are reminiscent of J. van Noordt, whose pupil he was. His small genre pieces (children playing in a park landscape) are imitations of Caspar Netscher; they have in many cases darkened with time. His son, of the same name, continued his work in a similar style.

Voort, Cornelis van der

b. Antwerp about 1576,
d. Amsterdam 1624
1331, 1332

Flemish-Dutch portrait painter in the manner of J. A. van Ravesteyn. His portraits (generally half or three-quarter length) are still rather stiff, but effective in their careful characterization, glowing light and delicate tones. Local colour plays a minor part. He also painted lifelike regent pieces. N. Elias and T. de Keyser were influenced by him. He may be confused with P. Moreelse and M. J. van Mierevelt.

Literature: J. Six, "C. van der Voort," *Oud Holland,* XXIX, 1911, pp. 129-33.

Vos, Cornelis de

b. Hulst 1585, d. Antwerp 1651
1333, 1334

Flemish painter of portraits and historical pieces, brother of the animal painter Paul de Vos. Besides religious and allegorical

compositions, on a large canvas and with large figures (the execution reveals occasional collaboration with Jakob Jordaens and Rubens), his chief works are good individual and group portraits. Elegant family groups are disposed with much inventiveness indoors or in the open air with a view of a park behind; the individuals are but loosely related to one another. His attractive portraits of children, girls more often than boys, have always been highly prized: they are full of freshness and truth to nature, and their charm is increased by the colourful finery of fashionable costume. His vivid portraits of adults – generally as far as the hip, the sitter in three-quarter view, with a neutral background – are characterized by sincerity, faithful representation and a subtle technique. The modelling of the face and hands is not especially emphasized; the subject's gaze is always fixed intently on the spectator. His best work of this middle period was often ascribed to A. van Dyck. His later pictures – none are known to have been painted much after 1640 – are weaker. Genre-like individual portraits of girls or youths in the open air with flowers and fruit are rare. The warm tones of many of his portraits have often been spoilt by restorers. Of his pupils only Simon de Vos attained a certain celebrity.

Literature: J. Muls, *C. de Vos,* Antwerp, 1933; E. Greindl, *C. de Vos,* Brussels, 1944.

Vos, Jan de

b. Leiden 1593,
d. 1649
1335

Rare Leiden landscapes painter. His dune landscapes in yellow-brown tones show some affinity with P. de Molijn or C. van der Schalcke.

Vos, Paul de

b. Hulst about 1595,
d. Antwerp 1678
1336, 1337

Flemish painter of animals and still lifes; brother of Cornelis de Vos and brother-in-law of F. Snyders. He is said to have collaborated from time to time with Jacob Jordaens and Rubens (hunting scenes, game, still lifes of weapons) and also F. Snyders, to whom some of his good pictures are still attributed. His animated scenes of animals fighting or dogs chasing game reveal personal talent but are sometimes cursory in execution. The slender, graceful bodies of animals are shown in full movement and in warm tones of light brown or grey, not in strong local colour as in the work of F. Snyders. The expression of the hounds and other animals reflects their activity of the moment. His extremely flowing style and inventiveness influenced the hunting scenes of J. Fyt, P. Boel and the German C. Ruthart.

Jan van den Hoecke occasionally supplied large figures for his animal still lifes. He may easily be confused with F. Snyders; many crude imitations of the latter's pictures of the chase are ascribed to Paul de Vos.

Literature: E. Greindl, *Les Peintres flamands de nature morte,* Brussels, 1956.

Vos, Simon de

b. Antwerp 1603,
d. there 1676
1338

Flemish painter of historical and genre scenes and portraits; pupil of Cornelis de Vos and influenced by Rubens and T. van Thulden. Besides large altar-pieces in the general style of those masters he painted, often on copper, small Biblical, historical and genre pictures: David and Abigail, the Adoration of the Shepherds, the Works of Mercy, the Prodigal Son, a gipsy woman telling fortunes. His most engaging pictures are of cheerful companies: numerous figures with strong local colour, in sumptuous halls with perspective vistas. His rare, decorative portraits are usually painted against a light, cool background.

Literature: E. Greindl, *C. de Vos,* Brussels, 1944; F. C. Legrand, *Les Peintres flamands de genre,* Brussels, 1963.

Voskuyl, Huygh Pietersz.

b. Leiden 1592,
d. Amsterdam 1665
1339, 1340

Dutch portraitist and figure painter, pupil of Pieter Isaacsz.; active at Amsterdam. His portraits, somewhat reminiscent of T. de Keyser, belong to the highly developed Amsterdam school of the mid-century. Typical examples are the two pictures of Ph. Denys and his wife (1640) in the Rijksmuseum. His subjects are seen in dignified poses, in black attire with gloves or a fan in their hand, often leaning against a table covered with a Persian rug. His pictures of Biblical themes with large figures are rare.

Vosmaer, Daniel

Delft, second half
of the seventeenth century
1341, 1342

Delft landscape painter, best known – like E. van der Poel – for his many representations of the gunpowder explosion at Delft, and for somewhat cursory pictures of fires in villages and towns.

His decorative views of towns seen in the distance or across a stream are distinguished by a curious perspective and bluish-green foliage. He excels at depicting architecture and masonry.

Literature: S. Donahue, "D. Vosmaer," *Vassar Journal*, XIX, 1964, pp. 18ff.

Vosmaer, Jacob

b. Leiden or Delft 1584,
d. 1641
1343

Dutch flower-painter, member of an old Delft family of artists. He returned from a journey to Italy in 1608, and was head of the Delft Guild in 1633. A pupil of J. de Gheyn, whose style of flower-painting he adopted. Like him, he favoured a strictly economical composition of bouquets against a dark background (niches), often with the addition of shells or lizards. Also like De Gheyn, he is distinguished by broad, confident brushwork and a somewhat mannered treatment of the flowers themselves; in both these respects they stand in contrast to the wide Bosschaert circle. The bouquets are in glass or earthenware jugs, adorned with relief work in the style of Raeren stoneware. Only a few of these flower pieces are known; they are charmingly individual and mark the inception of Dutch flower painting. A typical nosegay dated 1615 is in the Metropolitan Museum, New York. Another, of 1616, is privately owned at Rotterdam, and a third is in the museum at Orléans.

Literature: I. Bergström, *Dutch Still Life Painting*, London, 1956.

Vrancx, Sebastian

b. Antwerp 1573,
d. there 1647
1344, 1345, 1346, 1347

Early Flemish landscape and genre painter. The figures in his outdoor scenes of popular life – village streets, fairs and kermesses – are better painted than drawn, with bright individual colouring. They often represent Biblical or allegorical characters. He appears also to have contributed figures of this type to landscapes by Joost de Momper and Jan Brueghel. He painted numerous cavalry skirmishes, scenes of attack, pillage and army camps, which were often repeated by his pupil P. Snayers. The riders and their heavy-looking horses are seen in full movement; the horrors of war are vividly portrayed. His wide range extended to historical cavalry battles, winter scenes of towns with numerous figures sporting on the ice, Roman architecture and ruins; these last are often ascribed to Willem van Nieulandt. He rarely painted church interiors, street scenes and the Italian carnival, with admirable Renaissance buildings. Most of his works bear the interlaced monogram SV; his full signature is rare.

Literature: F. C. Legrand, *Les Peintres flamands de genre*, Brussels, 1963.

Vree, Nicolaes de

b. Amsterdam 1645,
d. Alkmaar 1702
1348

Rare Dutch painter of landscapes, animals and flowers; pupil of J. Wynants, whom at times he closely resembles. His hilly landscapes with trees and conspicuous buildings are browner in tone and are related to Wynants' later period. He also followed the latter's custom of placing a tree-trunk prominently in the foreground.

Vrel, Jacobus

Delft and Haarlem,
second third of the seventeenth century
1349, 1350, 1351

Rare Dutch painter of interiors, quiet streets and courtyards in the manner of P. de Hooch; however, his perspective is less certain, and so especially is the drawing of his rather plain figures. His pictures are extremely delicate in tone, full of atmosphere and marked by sober restraint and a sense of stillness. They are mostly interiors with an old woman at the fireside or by the window; sometimes a weaver's workshop. His views of Delft streets with a few figures used to be ascribed to Jan Vermeer of Delft. Only about 25 of his pictures are so far known, and they were not distinguished from those of Vermeer, P. de Hooch and their circle until the past few decades. Nevertheless, they can easily be recognized by their somewhat amateurish, primitive charm. Their gravity of mood, reminiscent of I. Koedyck, sets them apart from the bourgeois cosiness of E. Boursse; while the rich, elegant interiors of Pieter Janssens are closer than Vrel's to the work of P. de Hooch.

L terature: R. Valentiner, *Art in America*, 17, 1928, pp. 87–92; A. Brière-Misme, "J. Vrel," *Revue des Arts Anciens*, LXVIII, 1935, pp. 97 and 157; E. Plietzsch, *Zeitschrift für Kunst*, Leipzig, 1949, pp. 248–63.

Vries, Abraham de

b. Rotterdam about 1590,
d. The Hague before 1662
1352

Dutch portrait painter in the manner of J. A. van Ravesteyn, influenced at a distance by T. de Keyser and Rembrandt. His best portraits – half-lengths, usually against a dark background – are skilful and engaging but lack characterization. As a rule his portraits are signed in full and dated.

Vries, Michiel van

M·V·Vries 1656

active at Haarlem,
d. before 1702
1353, 1354

Dutch landscape painter in the style of the Haarlem artists
C. Decker and S. Rombouts. He paints houses with crumbling
masonry in exactly the same way as Decker, but is closest to
Roelof van Vries in his dune landscapes with peasants' cottages
under trees (Göttingen University) or village church among
trees (Braams collection, Muller, Amsterdam, 1918). Like Claes
Molenaer he painted houses under trees and quiet canals with
fishing-boats. Many of his pictures have probably been errone-
ously attributed to Roelof van Vries.

Vries, Roelof van

R. v vries.

b. Haarlem about 1631,
d. Amsterdam after 1681
1355, 1356, 1357

Haarlem landscape painter belonging to Jakob van Ruisdael's
circle and influenced by C. G. Decker and Salomon Rombouts;
his work often closely resembles that of these two artists. His
early work, which is also his best, is fresh and cool in tone,
depicting dune and forest landscapes with gentle hills; the
construction is usually diagonal, with a distant view of the
outskirts of Haarlem. Inns under tall groups of trees, old cottages
or ruined towers beyond a peaceful stream form similar subjects
to those of Claes Molenaer. His later pictures, which are often
large and browner in tone, deviate into a more romantic and
decorative style, and the winding paths among dunes have a less
natural effect. Less often he painted simple scenes of cattle in a
Dutch landscape or winter games on a city moat. Adriaen van
de Velde and J. Lingelbach occasionally supplied him with
figures. Those that he painted himself are used sparingly and
have a certain stiffness. His monogram – a contracted VR – and
his full signature were often turned by forgers into the mono-
gram of Jakob van Ruisdael.

Literature: N. MacLaren, *National Gallery Catalogues, Dutch School*, London,
1960, p. 445.

Vromans, Isaak

J. Vroomans

b. Delft about 1655, d. 1719
1358

Dutch still-life painter, son of the landscape and figure painter
Pieter Pietersz. Vromans; active chiefly at Schiedam and The
Hague. He was nicknamed the "snake-painter" on account of
the extremely well painted snakes which are prominent in his
still lifes of plants and herbs, along with mice, frogs and spiders.
The subject of these works recalls paintings by O. Marseus van

Schrieck; there is a mysterious tension between the vegetable
world, seen at dusk, and the animals threatening or being
threatened. Occasionally he painted flowers and fruit enlivened
by butterflies. His still lifes may be confused with the work in
similar vein of N. Lachtropius, Rachel Ruysch, K. B. Voet and
M. Withoos.

Vromans the Younger, Pieter Pietersz.

b. Delft about 1612
1359

Dutch landscape and figure painter, member of a large Delft
family of artists; member of the Delft Guild in 1635. His land-
scapes with Old and New Testament figures show pronounced
dependence on L. Bramer's works of the 1630s. His figures are
elongated and not especially well drawn; the handling of light
and the style of painting are somewhat restless. Like J. de Wet,
he makes much use of a strong vermilion hue amid a dark-brown
tonality. (Solomon's idolatry, the Adoration of the Shepherds,
Christ driving the money-changers from the Temple.) There
were three painters named Pieter Vromans; this one was the
father and teacher of the still-life painter Isaak Vromans. He is
often confused with L. Bramer, A. Verdoel, Adriaen Gael and
J. de Wet.

Literature: H. Wichmann, *L. Bramer*, Berlin, 1923, p. 66; A. Bredius, *Zeit-
schrift für Bildende Kunst*, 64, 1930, pp. 254ff.

Vroom, Cornelis

CROOM f
1630

b. Haarlem about 1591,
d. there 1661
1360, 1361

Haarlem landscape painter; son of the sea-painter Hendrik
Vroom, and an important predecessor of Jakob van Ruisdael.
His early work was influenced by A. Elsheimer. His best paint-
ings are forest and river landscapes in tones ranging from
silvery grey to strong green; these are spacious, with a quiet
diagonal construction and unobtrusive figures. Later he came
under the influence of Jakob van Ruisdael, so that his works of
this period, which are less successful, often go under the latter's
more famous name. Vroom's early pictures were imitated by
G. Dubois, whose forest and river scenes are similar in tone but
less inventive. His later works, with large oak-trees bordering a
forest and with figures on horseback, may occasionally be con-
fused with pictures by Salomon Rombouts.

Literature: J. Rosenberg, "C. H. Vroom," *Jahrbuch der Preussischen Kunst-
sammlungen*, XLIX, 1928, pp. 102–10; J. G. van Gelder, "Een
onbekend Landschap," *Oud Holland*, LXXVIII, 1963, pp. 77ff.;
N. MacLaren, *National Gallery Catalogues, Dutch School*, London,
1960, p. 446; W. Stechow, *Dutch Landscape Painting of the Seven-
teenth Century*, London, 1968.

Vroom, Hendrik

VROOM 1623

b. Haarlem 1566,
d. there 1640
1362, 1363

Early Dutch sea-painter; father of the landscape painter Cornelis Vroom. The rough sea with dull-green, regular waves is seen from a high point of vision. The big merchant ships and frigates are drawn rather than painted; the light is treated from the point of view of contrast only, and the clear blue sky is of secondary importance; neither produces any effect of atmosphere. The dramatic sea-fights and explosions of powder-magazines, in which every detail is treated with equal care, are of interest chiefly from the point of view of art history, especially as they mark the beginning of Dutch marine painting. His harbour scenes and map-like views of towns are rarer. A similar old-fashioned, naively objective style was displayed by A. van Antum and A. van Eertvelt.

Literature: F. C. Willis, *Die Niederländische Marinemalerei*, Leipzig, 1911.

Vucht, Gerrit van

gerrit van vucht

active at Schiedam
1648–1697
1364, 1365

Dutch still-life painter; lived mostly at Schiedam, where he was a member of St Luke's Guild for many years. His still lifes show an affinity, in colour and composition, with those of Harmen and Pieter van Steenwijck. Books, a globe, vases and bottles are painted in careful detail on the corner of a table with a cloth crumpled in a characteristic fashion. The general tone is as a rule yellowish-brown and the background light-grey. The objects, closely piled together, sometimes have an allegorical significance *(Vanitas)*. His still lifes of grapes and other fruit in a bowl are rare. His pictures are usually small and easy to recognize, but they have only recently been distinguished from the work of other still-life painters. While an inventory of 1648 mentions 57 of his pictures, only about 30 are known today.

Literature: Rapps Konsthandel, *Dutch exhibition*, Stockholm, 1955, pp. 33 ff.; B. Haak, *Oud Holland*, LXXII, 1957, p. 115, with list of works.

Vucht, Jan van

C. v. Vucht.

b. Rotterdam 1603,
d. 1637
1366

Dutch painter of architecture, and a speculator in real property; at The Hague from 1632. As a rule he painted interiors of Renaissance churches and halls, usually symmetrically composed with a view of an altar beneath a dome, a monument or the open

air. In the Hermitage at Leningrad there is a picture by him of the Boy Jesus in the Temple (1631). The figures, sparingly introduced, are said to have been painted on occasion by A. Palamedesz. Only about ten dated pictures of his are known: they belong to the years 1628–1635. He signed in full or used the monogram J. V. Many of his unsigned works are probably still ascribed to D. van Deelen or J. van Baden. A. de Lorme, also a painter of architecture, was his pupil.

Literature: H. Jantzen, *Das Niederländische Architekturbild*, Leipzig, 1910.

Wabbe, Jakob

active 1602,
d. Hoorn 1634
1367, 1368

Dutch painter, especially of portraits in the "representative" style of North Holland. He shows unmistakably the influence of P. Moreelse, which was diffused through many of the latter's pupils. His historical and Old Testament scenes are rare. Houbraken mentions a picture on the subject of Jephthah; there was one of Jacob and Rachel in the Hermitage, Leningrad. He also wrote his name Waben; few of his pictures are signed, and doubtful attributions make it hard to distinguish his work. Owing to the similarity of the monogram, but for no other reason, he is often confused with the portrait painter J. J. Westerbaen.

Wael, Cornelis de

b. Antwerp 1592,
d. Rome 1667
1369

Flemish-Italian painter of small canvases depicting battles, seascapes and peasant scenes: rustic festivities, quack doctors, fights between archers and cavalry. Less often he painted Biblical themes with numerous tiny figures, rather sketchily drawn. His pictures are hardly ever signed, and most of them are attributed to other artists such as Palamedes Palamedesz. Views of the port of Genoa, and market scenes in the manner of P. van Laer, belong to his Italian period; they are often much darkened owing to the use of a strong bolus ground.

Literature: F. C. Legrand, *Les Peintres flamands de genre*, Brussels, 1963.

Walscapelle, Jacob van

b. Dordrecht 1644,
d. Amsterdam 1727
1370, 1371

Dutch still-life painter, probably a pupil of the still-life painter Cornelis Kick. He was a follower of Jan Davidsz. de Heem,

independent in style and a delightful colourist: fruit pieces, flower garlands, and bouquets in vases on stone tables. The work is diversified with all kinds of insects, reproduced with great skill. Less often he painted breakfast pieces with oysters, wicker-bottles, wineglasses and grapes, the prevailing tone being an elegant cool greyish-blue. The treatment of foliage in all his still lifes is very accurate. The construction is well planned and there is a good effect of depth.

Literature: J. Knoef, "J. van Walscapelle," *Oud Holland*, LVI, 1939, pp. 261–5; I. Bergström, *Dutch Still Life Painting*, London, 1956; N. MacLaren, *National Gallery Catalogues, Dutch School*, 1960, p. 446.

Waterloo, Anthonie

b. Lille about 1609,
d. Utrecht 1690

1372, 1373

Rare Dutch landscape painter, a follower of Jakob van Ruisdael. His brown-toned forest landscapes in hilly country, sometimes with a calm expanse of water, recall Jan Vermeer van Haarlem the Elder, A. Verboom and J. Looten. The foliage of the trees is treated in a summary, inaccurate fashion. His works, for which Jan Weenix occasionally provided figures, are seldom signed. He is more important as a draughtsman than as a painter.

Wautier, Michaelina

active in the mid-seventeenth
century

1374

Rare Flemish painter of portraits and religious subjects (some signed examples in the Brussels and Vienna museums), also still lifes. A picture of a flower garland between skulls, animated with numerous insects, shows her to have been a member of Daniel Seghers' circle.

Weenix, Jan

b. Amsterdam c. 1642,
d. there 1719

1375, 1376, 1377

Amsterdam painter of still lifes, landscapes and large portraits; pupil of his father Jan Baptist Weenix and his uncle Gysbert d'Hondecoeter. A prolific and versatile painter, chiefly of still lifes with hunting trophies: the characteristic dead hare, its fur reproduced with masterly skill, dead game birds, swans (in the manner of Elias Vonck), partridges with guns and a game-bag, leather gear and a hunting-horn (as with W. G. Ferguson). The

background is often formed by a park landscape in evening light with large carved stone vases, or Roman-type buildings with a vista beyond. He is distinguished from Melchior d'Hondecoeter by his coloration, which is more uniform and more in the Italian style. He is closest to his father in Italianate landscapes with elements of classical architecture and genre-like shepherds and shepherdesses in evening sunlight. His lively compositions always have something appealing and decorative about them: this is also true of the enormous hunting scenes with which he furnished many princely palaces. His sumptuous portraits are rare, as are his flower pieces with a dark background. He sometimes contributed figures and game to pictures by A. Waterloo and B. van der Helst. His pupil and successor was Dirk Valkenburg, who occasionally collaborated with him and often painted dead hares in his manner.

Literature: N. MacLaren, *National Gallery Catalogues, Dutch School*, London, 1960, p. 447.

Weenix, Jan Baptist

b. Amsterdam 1621,
d. about 1660

1378, 1379, 1380

Dutch painter of landscapes, genre and still life, father of Jan Weenix; pupil of N. Moyart and Abraham Bloemaert. His Italian landscapes and ports with rich merchants are skilfully animated with brightly coloured figures. The golden-yellow sunlight produces strong contrasts of light and shade which display his great talent as a colourist. Fairly large figures are seen in the southern light among ruins which give a picturesque effect of depth. His frequent still lifes are masterly compositions of dead game, a hare, red deer, birds or a sportsman with his bag. Many artists imitated him in this field, including his son and pupil Jan Weenix and his pupil Melchior d'Hondecoeter. His eloquent portraits recall K. Dujardin by their strong, one-sided illumination. He occasionally collaborated with J. Asselyn and Dirck Stoop, as is shown by joint signatures. He often signed his Christian name in the Italian form "Gio. Batt.a." His son Jan conformed to his style and themes, so that his work can sometimes be distinguished only by its date.

Literature: Hoogewerff, *Maandblad voor Beeldende Kunsten*, XVIII, 1941, pp. 257 ff.; W. Stechow, "J. B. Weenix," *Art Quarterly*, XI, 1948, pp. 181 ff.; N. MacLaren, *National Gallery Catalogues, Dutch School*, London, 1960, p. 448.

Werff, Adriaen van der

b. Rotterdam 1659,
d. there 1722

1381, 1382

Late Rotterdam painter of genre, landscapes and portraits. Pupil of Eglon van der Neer, whom he helped to paint costumes. His

young, graceful beauties, wearing wigs in the French style, are sumptuously dressed. His portraits are in the manner of Caspar Netscher and Frans van Mieris, and are so delicately painted that scarcely a brushstroke is discernible. His mythological, Biblical and allegorical pieces met the fashionable taste of the time with their extreme accuracy of drawing and the enamel-like treatment of flesh tints. His shift towards French-style classicism is marked by the use of theatrical illumination and dramatic poses. His admirable small pictures of children belong to his early period. His brother Pieter van der Werff copied a number of his pictures and is said to have worked with him a good deal; later his initial P was often fraudulently changed to an A and these pictures then went under the name of the better-known brother. H. van Limborch and B. Douven are believed to have been among his pupils.

Literature: C. Hofstede de Groot, *Catalogue raisonné*, vol. x, Esslingen, 1928; N. MacLaren, *National Gallery Catalogues, Dutch School*, London, 1960, p. 450.

Werff, Pieter van der

b. Rotterdam 1665,
d. there 1722
1383

Dutch genre and portrait painter, brother and pupil of Adriaen van der Werff, with whom he collaborated from time to time; the two brothers treated the same range of themes and their work can scarcely be distinguished. Pieter's figures are somewhat harder and less "pretty"; his treatment of landscape and materials is less painstaking. He made copies of many of Adriaen's pictures, signing them with his own name. The Christian name in his signature was often changed into that of his better-known brother. He may be confused with Eglon van der Neer, B. Douven and Adriaen's pupil H. van Limborch.

Westerbaen the Younger, Jan Jansz.

b. The Hague about 1631,
d. there after 1669
1384

Dutch portrait painter; pupil of his father, who was also a portraitist, and of A. Hanneman (1648). In 1656 he was a founder-member of the celebrated Hague Confrérie. His sitters are generally shown in three-quarter profile, often in an upright oval; the painted surfaces are large and the light effects strong. The conception is somewhat dry and there is no deep characterization. His portraits are rare and many are known today only from engravings. The monogram J. W. has sometimes caused his pictures to be ascribed to J. Wabbe or J. van Wyckersloot.

Westhoven, Huybert van

active 1668–99
1385

Rare Dutch still-life painter. He groups Delft ware, Venetian glasses, fruit and frequently a lobster on a marble table covered with a carpet. The lobster with the hanging claw is often found in exactly the same position, e. g. on a picture in a private Danish collection and on another in the New York Historical Society. In subject-matter and in execution his work is related to that of Barent Vermeer and Juriaen van Streeck.

Wet, Jakob Willemsz. de

b. Haarlem about 1610,
d. after 1675
1386, 1387

Haarlem landscape and genre painter of Rembrandt's circle; he was probably the latter's pupil. His yellowish-brown landscapes mostly form the background to Biblical scenes, sometimes mythological ones; the figures are notable for glowing red colours and white clothing, and there is generally one seen from the back. His interiors are rarer; they are mainly New Testament scenes set in the Temple and illuminated in a Rembrandtesque fashion. These may be confused with the work of W. de Poorter. Jakob de Wet the Younger continued his father's work.

Literature: N. MacLaren, *National Gallery Catalogues, Dutch School*, London, 1960, p. 454.

Weyerman, Jacob Campo

b. Breda 1677,
d. The Hague 1747
1388

Dutch flower-painter, etcher and art critic; pupil of Ferdinand Kessel at Breda, T. van der Wilt at Delft and the flower painter S. Hardimé at Antwerp. Active in Breda, Antwerp, Paris, Italy, Switzerland, Germany and England, also in various towns of Holland: Rotterdam, Amsterdam, The Hague, Leiden. He wrote numerous satirical poems, for which he was imprisoned. His chief work is the four-volume *Lives of Dutch Artists* (1729 and 1769), to which we owe many biographical data. Apart from hunting and fruit still lifes, which are rare, he mostly painted bouquets of flowers, in which Flemish influence is noticeable. They are centrally constructed against a dark background; as was the fashion in the first half of the eighteenth century, the flowers are in fantastic vases of glass or metal. The colours are bright and somewhat hard, with strong contrasts of light and shade. He usually signed his still lifes "Campovivo."

Wieringen, Cornelis Claesz. van

CCX ieRmgen.

b. Haarlem about 1580,
d. there 1633
1389, 1390, 1391

Dutch artist who painted and drew landscapes, pictures of the sea and coast in the style of his teacher H. C. Vroom; together they rank as founders of Dutch sea-painting. At this early period his sea-battles may easily be confused with his master's (Battle off Gibraltar, 1621, commissioned by the Dutch Admiralty, Museum of Maritime History, Amsterdam.) He was especially fond of painting large warships in careful detail and with bright local colour; the sea and sky are merely a background. He painted with a wealth of figures historical scenes such as Spanish warships arriving off the American coast, the capture of coastal fortresses, receptions etc.; in pictures of this type H. C. Vroom and A. Antum are superior to him. His marines later became truer to nature and greyer in tone, like those of S. de Vlieger. His wash drawings in pen and ink are often met with, but his paintings are rare. His monogram is very similar to those of his son Claes Cornelisz. van Wieringen and the sea-painter C. C. Wou, so that confusions are frequent.

Literature: Voorb. Cannenburg, *Onze Marine*, 1945, pp. 16–18.

Wildens, Jan

I. WILDENS FECIT. 1656

b. Antwerp 1586,
d. 1653
1392, 1393

Flemish painter of landscapes, sometimes as the background to works by Rubens, Jacob Jordaens, F. Snyders, Paul de Vos and C. Schut. They are fresh and luxuriant, with a conspicuous green hue; the sky is often bright blue with white clouds. Foliage is painted with a broad brush. The extensive landscape is composed with great sureness in light, strong colours. Human figures always play a prominent part: riders and sportsmen with dogs, raids, peasants dancing, herdsmen with cattle. P. Avont occasionally supplied groups of children for his landscapes. Between tall, light-coloured trees a distant prospect is seen of a broad countryside traversed by rivers. In the foreground gnarled trunks, bramble-bushes and the foliage of small plants are depicted with accuracy. His figure paintings properly so called belong to the school of Rubens and Van Dyck. He sometimes made freehand copies of Rubens landscapes; these make a strongly personal impression owing to his distinctive colouring and subtlety of execution. As he seldom signed his pictures, inferior Flemish landscapes are often attributed to him.

Literature: Y. Thiéry, *Le Paysage flamand*, Brussels, 1953; H. Gerson, *Art and Architecture in Belgium*, 1960; G. Martin, *National Gallery Catalogues, Flemish School*, London, 1970, p. 285.

Willaerts, Abraham

BW.

b. Utrecht 1603,
d. there 1669
1394, 1395

Dutch-Flemish sea-painter and portraitist; son of Adam Willaerts and pupil of J. van Bylert. His animated pictures of sea and shore, with fantastic northern rocks, are in the same style as his father's. The skilfully drawn figures of boatmen and fishermen on the sandy stretch in the foreground have a Flemish look; their squatness and bright colours sometimes recall Joost de Momper. Willaerts' works are frequently monogrammed; owing to the identical initials they are hard to distinguish from his father's.

Literature: F. C. Willis, *Die Niederländische Marinemalerei*, Leipzig, 1911.

Willaerts, Adam

A Willarts ft 1633

b. Antwerp 1577,
d. Utrecht 1664
1396

Early Flemish-Dutch sea-painter, father of Abraham Willaerts. He began by painting, in the style of Hendrik Vroom, historical sea-battles, harbours and fantastic shipwrecks on rocky coasts with turbulent waves; the ships are drawn with much care. Later came beach scenes, smaller in size, with cliffs rising to either side and surmounted by ancient castles. The brightly coloured fishermen and seamen on the shore are in the style of Jan Brueghel and Joost de Momper. The crests of the waves generally run obliquely to one side, and their cast shadows have a stereotyped effect. Less often he painted harbours in Norway or the colonies, with Dutch frigates lying at anchor. His son Abraham Willaerts continued this type of painting, and as the initials are the same their pictures are hard to tell apart. W. Ormea often contributed large still lifes of fish to the foreground of his beach scenes.

Literature: F. C. Willis, *Die Niederländische Marinemalerei*, Leipzig, 1911.

Willeboirts, Thomas

T. WILLEBOIRTS.

b. Bergen op Zoom 1614,
d. Antwerp 1654
1397

Flemish painter, draughtsman and etcher, also surnamed Bosschaert. In 1628 he was a pupil of the figure painter G. Seghers at Antwerp, and in 1637 a member of the Guild there. He spent many years travelling in Germany, Italy and Spain. In 1641, in Holland, he painted on commission seventeen mythological

scenes. He was strongly influenced by Rubens and Van Dyck, and occasionally collaborated with P. Thys. The subjects of his numerous pictures, with large figures, are mostly taken from mythology, history or the New Testament (Mars and Venus, Venus and Cupid, Adoration of the Holy Family, an angel drawing the arrows from St Sebastian's wounds; allegories). From time to time he also copied Rubens and Van Dyck with small alterations (St Cecilia, Augsburg, Dominican church). The compositions are adroit and tasteful; the figures, which are sometimes life-size, are well drawn and carefully executed. Some of these pictures have been preserved at the Grunewald shooting lodge near Berlin, the Neues Palais at Potsdam and the Royal Palace, Stockholm. He painted a few individual and group portraits, such as one of the engraver Pieter de Jode with his family. He contributed figures to the still lifes of J. Fyt, and the Antwerp painter Frans Ykens painted flowers for a Flora by him. The still-life painter P. van der Willigen and the portraitist H. Berckmans were pupils of his. Many of his pictures are probably still concealed among those attributed to Rubens or Van Dyck.

Literature: Oud Holland, LII, 1935, pp. 34–7, and LXIV, 1948, pp. 40–56; B. J. A. Renckens, Oud Holland, LXIX, 1954, pp. 184ff.

Willigen, Claes Jansz. van der

b. Rotterdam about 1630,
d. 1676

1398

Dutch painter, son of a sculptor; little is known of his life. His landscapes are rare: broad river valleys, "Rhine landscapes" with towns on the banks and castles and ruins on the hills above. The foreground is characteristically occupied by large deciduous trees. The composition is clear and appealing, the colours light. A view of the Rhine in the Brussels Museum was formerly attributed to S. de Vlieger; another, painted in 1665, is in the Boymans-Van Beuningen Museum at Rotterdam. In the Mauritshuis at The Hague there is a marine ascribed to him, with Rotterdam in the background. The later Rotterdam artist D. Verburgh imitated the composition of his river landscapes.

Literature: H. Gerson, Kunsthistorische Mededelingen, I, 1946, pp. 53–6.

Willigen, Pieter van der

b. Bergen op Zoom 1635,
d. Antwerp 1694

1399

Flemish painter of landscapes, portraits and still lifes; pupil of T. Willeboirts at Antwerp, where he became a master in the Guild in 1655. He is chiefly known for his numerous *Vanitas* pieces, in which a skull is the central feature. Exquisitely painted

gold and silver vessels, music-sheets and instruments, soap-bubbles, shells and a bouquet of flowers are the usual accessories of this type of allegory, which was popular with so many painters: H. Andriessen, J. de Claeuw, J. Vermeulen, N. L. Peschier, L. van der Vinne.

Literature: Oud Holland, LXV, 1950, p. 159.

Wils, Jan

b. Haarlem about 1600,
d. 1666

1400, 1401, 1402

Haarlem painter, later of the Italianate school; a follower of Jan Both and teacher of N. Berchem, who was his son-in-law. His pictures are rare; some are attributed to Jan Both or Willem de Heusch. N. Berchem occasionally painted figures for his landscapes.

Wilt, Thomas van der

b. Piershil 1659,
d. Delft 1733

1403

Delft genre painter in the style of his teacher Jan Verkolje or of G. P. van Zyl. A "fine painter" of the late period, characterized by the hard, painstaking reproduction of surfaces of all kinds. He occasionally resembles Eglon van der Neer. His genre-like group portraits against a park background in evening light recall Caspar Netscher or Adriaen van der Werff, but they are less tonal in quality.

Withoos, Matthias

b. Amersfoort 1627,
d. Hoorn 1703

1404, 1405

Rare Dutch painter of still lifes with landscape background, in the style of O. Marseus and A. Begeyn. The foreground depicts part of a forest in evening light, with lifelike animals producing a genre effect: beavers, fish, reptiles and insects, interspersed with plants and mushrooms in a somewhat hard light. These works have a curiously tense, mysterious atmosphere and high artistic quality. Occasionally he painted flowers in park-like landscapes, views of towns and harbours that are topographically exact, and portraits. His pictures are usually signed in full and dated.

Witte, Emanuel de

b. Alkmaar about 1617,
d. Amsterdam 1692
1406, 1407, 1408, 1409, 1410

Important Dutch painter of interiors – mostly churches – landscapes and marines. In his favourite subject of church interiors he is superior to Hendrik van Vliet and G. Houckgeest. The interiors are on a grand scale, and the elaborate perspective, strong sunlight and painterly colour effects combine to give a convincing impression of space. His chief colours are white with yellowish tones in the sun and grey to deep black in the shade. While his early pictures can be recognized by the distribution of light in patches and stronger local colours, the illumination later becomes more uniform and shimmering, the colours more tonal. His relatively large figures are especially characteristic: they are lifelike and disposed with care, generally grey-blue and with little other colouring, perhaps a soft green or red. Less often he painted imaginary Catholic churches and synagogues, the light-filled halls of elegant bourgeois houses, craftsmen's workshops in the style of P. de Hooch, mythological and genre pieces (some by candle-light). His versatility is also shown in his rare marine and winter landscapes. A masterly chiaroscuro enhances the effect of his lively, genre-like pictures of fish markets, which are superior to those of H. M. Sorgh, the other Rotterdam painter in this field. De Witte's only pupil, Hendrick van Streeck, conformed to his later style.

Literature: Thieme-Becker, *Künstler-Lexikon*, vol. XXXVI, 1947; I. Manke, *E. de Witte*, Amsterdam, 1963; N. MacLaren, *National Gallery Catalogues, Dutch School*, London, 1960, p. 455.

Witte, Gaspard de

b. Antwerp 1624, d. 1681
1411

Flemish painter of Italianate landscapes with ruins and figures. His mother owned a shop of painters' materials, which he continued after her death. He spent a considerable time in Italy and France and returned in 1651 to Antwerp, where he is mentioned in the Guild. His landscapes, which seem to be painted from nature, often show a lake among wooded hills. Monuments, antique fountains and ruined buildings are rendered with care, and in his early work the riders and herdsmen are painted with great accuracy; his later technique is more flowing and cursory. This type of landscape was continued by C. Huysmans, who is believed to have been his pupil. His pictures were much admired in his own day, and are often to be seen in paintings of art cabinets and galleries. About 25 of his works are known, mostly signed.

Literature: Y. Thiéry, *Le Paysage flamand*, Brussels, 1953; C. Brossel, *Revue Belge d'Archéologie et d'Histoire de l'Art*, XXVIII, 1959, pp. 211–23, with list of works.

Wittel, Gaspar Adriaensz. van

b. Amersfoort 1653,
d. Rome 1736
1412, 1413

Dutch-Italian painter and draughtsman; pupil of M. Withoos. From the age of nineteen he lived in Italy, at Venice, Naples and especially Rome, where he was a member of the *Bent* (under the name of Vanvitelli) and a friend of the landscapist A. Genoels. He seems to have spent the last years of his life in or near Rome, where he produced topographically exact *vedute*, usually with important architecture. These views of the city, with well known antique and other buildings, are in excellent perspective and animated with small lively figures. About a hundred of his pictures are known; many were reproduced as copper engravings.

Literature: C. Lorenzetti, *G. Vanvitelli*, Milan, 1934; G. Briganti, *Historisch Instituut te Rome*, II, 1943, pp. 119ff.; G. Briganti, *G. van Wittel*, Rome, 1966.

Wolfert, Jan Baptist

b. Antwerp 1625,
d. after 1658
1414, 1415

Netherlandish landscape painter, active at Haarlem for many years. He was in Rome in 1658, and at this time painted landscapes with Italian figures. Most of his pictures are of dune landscapes around Haarlem with thatched cottages, herdsmen and cattle. The type of landscape and the execution are reminiscent of Roelof van Vries and S. Rombouts, with whom confusion is possible. There was a typical landscape of his in the Semenov collection at St Petersburg. His Italianate landscapes of the mid-century are rare.

Wolffsen, Aleida

b. Zwolle 1648,
d. after 1690
1416

Dutch painter of portraits and historical scenes; a pupil of Caspar Netscher, in whose style she painted portraits of women especially. She lived for a long time at Zwolle and also stayed at The Hague, where in 1674 she painted Prince William III (later King of England). Like Netscher she mostly painted her sitters half-length, reproducing in detail the silk damask or embroidered brocade of the elegant French fashions. Long, tapering fingers accord with the contemporary ideal of beauty. The background is formed by the familiar park landscape in evening light or a balustrade ornamented with putti in relief. Many of her portraits

were ascribed to the better-known N. Maes or C. Netscher after removal of the signature. Her work bears close resemblance to that of F. Haagen.

Wou, Claes Claesz.

(· (· IX/0 V

b. about 1592, d. Amsterdam 1665
1417

Early Dutch sea painter. Warships and fishing-boats battle with the storm, lying obliquely to the high, surging waves. The sea in the foreground is in dark shadow with white foaming crests; the representation of water and sky is somewhat schematic. The construction and technique of these pictures recall A. van Eertvelt, H. C. Vroom and C. C. van Wieringen. His later marines belong to the school of "grey sea-painting." Examples may be seen in the Rijksmuseum Twenthe at Enschede and the Emden and Stockholm museums.

Wouters, Frans

F Wuiter · P
1630

b. Lierre 1612,
d. Antwerp 1659
1418, 1419, 1420

Flemish painter of genre and historical scenes and landscapes with figures of religious or mythological significance. An art dealer and son of a cabinet-maker, he was a pupil of P. van Avont and Rubens after 1629 and a master in the Antwerp Guild in 1634; in 1636 he was at the court of Ferdinand II at Vienna. In 1637 he came into contact with A. van Dyck in London; in 1641 he returned to Antwerp, where he worked with P. van Avont. Landscape came to assume an importance of its own in his work, with a well-balanced composition. It is characterized by deciduous woods with broadly treated foliage under a bright blue sky with white clouds. Venetian influence is discernible. The mythological and Biblical figures are harmonious and varied; the frequent amoretti are reminiscent of Van Dyck and P. van Avont. Landscapes properly so called, without figures, are rare.

Literature: G. Glück, *Rubens, van Dyck und ihr Kreis,* Vienna, 1933, pp. 222 ff.; G. Martin, *National Gallery Catalogues, Flemish School,* London, 1970, p. 286.

Woutersz., Jan, called Stap

I· W· STAP

b. Amsterdam 1599,
d. there about 1633
1421, 1422, 1423

Dutch figure painter who worked chiefly in Amsterdam, where he went by the name of Stap. Initially he painted religious subjects, subsequently more genre scenes: notaries' and bursars' offices, bankers weighing gold, poultry vendors and aged teachers with boys – mostly large half-length figures with serious, rather stiff expressions and gesticulating hands. He was very fond of realistic still-life accessories. These works are strongly influenced by the early Netherlandish painters Massys, Van Roemerswaele and Van Hemessen, and J. Woutersz. was formerly thought to have been a Netherlandish artist of the sixteenth century; he did not adopt the new style which set in around 1600. About fifteen of his works are known.

Literature: A. van Schendel, *Oud Holland,* LIV, 1937, pp. 269–82, with list of works.

Wouwerman, Jan

b. Haarlem 1629, d. there 1666
1424, 1425

Haarlem landscape painter, brother of the better-known Philips and of Pieter Wouwerman. In contrast to the former's many-sided work, the only pictures we know of his are Haarlem dune landscapes with low hills, isolated trees and a few figures of riders or wayfarers. Tree-trunks lying in the foreground, thatched half-timbered cottages and the vaporous distance are reminiscent of J. Wynants, to whom many of his pictures are probably still ascribed owing to the similar initials. Typical are the sandy patches which shine with a somewhat hard light among the dunes, and the strong grey-blue of the overall tonality. The similarity of theme may lead to confusion with the superior early work of his brother Philips.

Literature: N. McLaren, *National Gallery Catalogues, Dutch School,* London, 1960, p. 462.

Wouwerman, Philips

b. Haarlem 1619,
d. there 1668
1426, 1427, 1428, 1429, 1430, 1431, 1432

Important Haarlem painter of horses, landscape and genre; brother of the landscape painters Jan and Pieter Wouwerman, and probably a pupil of Frans Hals and P. Verbeeck. His early works, rather in the style of P. Verbeeck, are landscapes of the dune country around Haarlem, with a few horses and riders; they are seen from a high point of vision and depend on tone rather than colour. Later the composition becomes richer, the figures move towards the foreground, and dogs, pigs, ducks and chickens are added as well as horses. Italian elements make their appearance, and the colouring becomes stronger. Scenes of riders on the move or resting, the chase, cavalry engagements and stables are more and more populated with figures representing both ordinary and fashionable society. A basic feature is his expertness in depicting horses and riding. A white or grey horse often forms the focus of the picture. In this field and above all in the effortless, lively combination of ever-new motifs, he was

not surpassed by any contemporary or subsequent imitator. Single trees with loose, shimmering foliage or withered boughs are delineated in a masterly fashion. In his late work, which is somewhat crowded with human and animal figures, the contrast of light and shade is often exaggerated, and the red bolus ground shows through in the sky. With versatile talent he also painted beach scenes, kermesses and winter landscapes; less often historical and Biblical subjects with peasant-like figures in a Dutch landscape. He occasionally contributed masterly, colourful figures to landscapes by C. Decker, Jakob van Ruisdael and J. Wynants. His work had an exceptionally strong influence on all later horse-painting, including hunting scenes and cavalry fights. Many painters followed him in this domain: A. Hondius, J. van Huchtenburgh, J. Lingelbach, D. Maas, Dirck Stoop and H. Verschuring. Occasionally cavalry fights by J. Martsen, Palamedes Palamedesz. and Pieter Post were attributed to him. His immediate pupils were his brother Pieter Wouwerman, later B. Gael and E. Murant. Among his many eighteenth-century imitators were K. Falens and the German A. Querfurt.

Literature: C. Hofstede de Groot, *Catalogue raisonné*, vol. II, Esslingen, 1908; N. MacLaren, *National Gallery Catalogues, Dutch School*, London, 1960, p. 462; W. Stechow, *Dutch Landscape Painting of the Seventeenth Century*, London, 1968.

Wouwerman, Pieter

b. Haarlem 1623,
d. Amsterdam 1682

1433, 1434, 1435

Haarlem painter of horses and landscapes in the style of his celebrated elder brother Philips Wouwerman. He maintained the range of subjects and style of his brother's early period, and sometimes adopted the latter's compositions. Trees with dense foliage are characteristic of his work; his horses are less correct anatomically than his brother's and stiffer in movement. He also painted horses drinking at a pond, hunting scenes and excursions on horseback. His figures and animals are fewer, the lighting somewhat harder and the rendering of detail less delicate. His best works are usually attributed to Philips, although their monograms are quite different. He has nothing in common with his brother Jan except that they both painted views of the Dutch dunes.

Wtewael, Joachim Antonisz.

b. Utrecht 1566, d. there 1638

1436, 1437, 1438

Versatile Netherlandish painter of the Utrecht academic group. His historical and mythological scenes resemble those of his Utrecht contemporary Abraham Bloemaert. The small figures of gods and nymphs, executed with the delicacy of a miniature, are ingeniously composed; their attitudes are lively and somewhat affected, their gestures dramatic. His Biblical subjects are rarer (St John the Baptist preaching, the Adoration, the Virgin and Child), as are his lively and tasteful portraits. He usually signed in full and dated his works. He may be confused with the German artists B. Spranger, J. Heintz and M. Gondelach.

Literature: C. M. A. A. Lindeman, *J. A. Wtewael*, Utrecht, 1929.

Wyck, Jan

b. Haarlem about 1640,
d. Mortlake 1700

1439

Dutch painter of battles, riders and animals; was a pupil of his father Thomas Wyck, but did not adopt his style. He accompanied his father to England about 1660 and remained there for the rest of his life. He painted spacious hilly landscapes with good figures – mostly huntsmen with numerous hounds chasing their quarry; these are prominent yet fit well into the picture. The animals are accurately drawn and lively in movement. There is some resemblance to the work of Dirck Maas, due in part to the late period and the similarity of theme.

Wyck, Thomas

b. Beverwijk about 1616,
d. Haarlem 1677

1440, 1441

Haarlem landscape and genre painter of the Italianate school. His interiors with alchemists or philosophers – less often peasants – are somewhat reminiscent of C. Bega. A sharp light falls through a side-window on the accessories – books, apothecary's implements and tools, stuffed animals hanging from the ceiling; light reflexes sparkle here and there. Many of the pictures have darkened, but the rendering of materials is accurate. His open-air scenes with figures of travellers resting or merchants in front of a Roman tavern or under an arch (Italian fairs, Oriental seaports) sometimes recall A. Pynacker or P. van Laer by their strong contrasts of light and shade. He painted the Great Fire of London several times.

Wyckersloot, Jan van

active at Utrecht 1643–1683

1442

Dutch portrait painter; head of the Utrecht Guild, 1658–70. His stately and elegant portraits with curtains or architecture in the background, in the broad style of portraiture of the second third of the century, mark him as a follower of Gerard van Honthorst.

His religious, historical and genre scenes are less often met with than his portraits; a Descent from the Cross (1665) is in the Lakenhal museum at Leiden. He may be confused with other portraitists of the Honthorst circle at Utrecht. He occasionally used the monogram J. W., and this, though not his style of painting, has led to confusion with the portrait painter J. Westerbaen.

Wyhen, Jacques van der

b. about 1588, d. after 1658
1443

Flemish landscape painter and art dealer, mentioned at Amsterdam till 1638. His rare landscapes belong to the remoter Brueghel succession, and he occasionally shows affinities with G. van Coninxloo. A path leads through a forest of tall oaks past thatched cottages; the figures of mounted soldiery recall S. Vrancx, to whom many of Wyhen's works are probably still ascribed. However, the latter's landscapes, which are rigorously composed and not overdetailed, have an independent, individual air. The height of his figures is characteristic.

Literature: Oud Holland, LV, 1938, pp. 274–5.

Wynants, Jan

b. Haarlem before 1630,
d. Amsterdam 1684
1444, 1445, 1446

Haarlem landscape painter. His early works are shady forest landscapes with views of cottages or sheds under trees, rather in the style of J. Vermeer van Haarlem the Elder. His principal works depict the hilly dune landscape with its trees and bushes and winding sandy paths animated with villagers, herdsmen, riders and sportsmen. The mountainous background sometimes has a southern character, as do the accessory houses or ruins. The foreground is often occupied by a felled tree-trunk, a large stump and plants with big leaves. The prevailing tone is a delicate brownish grey. His best work is distinguished by a silvery, harmonious interplay between the atmosphere, the cloudy sky and the forest depths. The large pictures of his late period, with a foreground of withered oaks, are somewhat theatrical. He painted no figures himself: those in his early works are generally by B. Gael or Philips Wouwerman, the later ones by J. Lingelbach or Adriaen van de Velde. D. Wyntrack often painted waterfowl or houses in the foreground of his pictures. Adriaen van de Velde was among Wynants' pupils, as was the rare artist N. de Vree, who imitated his late works. Wynants' dune pictures may be confused with those of Jan Wouwerman.

Literature: C. Hofstede de Groot, *Catalogue raisonné*, vol. VIII, Esslingen, 1923; N. MacLaren, *National Gallery Catalogues, Dutch School*, London, 1960, p. 471; W. Stechow, *Dutch Landscape Painting of the Seventeenth Century*, London, 1968.

Wynen, Dominicus van

b. Amsterdam 1661
1447

Dutch-Roman painter of mythological, religious and allegorical scenes, also draughtsman. He studied at The Hague in 1674 and was active in Rome from 1680 to 1690; there he portrayed the activities of the *Schildersbent*, among whom his nickname was Ascanius. His mythological and allegorical scenes show exceptional knowledge of ancient sources; from these he sometimes drew out-of-the-way themes for fantastic compositions of many figures, in which the main action in the central part of the picture is emphasized by light effects. The latter, and especially the background architecture, show Venetian influence. The figures or the numerous hovering putti are very well drawn. The Budapest museum has a picture by him on the theme, unusual in the seventeenth century, of Don Quixote.

Literature: Mededelingen van het Nederlandsche Instituut te Rome, III, 1923, pp. 235 ff.

Wyntrack, Dirk

b. Drenthe before 1625,
d. The Hague 1687
1448, 1449

Animal painter of The Hague. His chief subject was water-fowl (ducks). He also painted kitchens and barns with poultry, similar to the work of the Rotterdam circle of Cornelis Saftleven and Hubert van Ravesteyn. His cows, sheep and goats sometimes have a rather wooden look. His chief activity was to paint poultry in pictures by J. van der Haagen, Jakob van Ruisdael, M. Hobbema and J. Wynants; when doing so he occasionally added his signature.

Wytmans, Mattheus

b. Gorkum about 1650,
d. Utrecht about 1689
1450, 1451

Dutch still-life painter and portraitist; was a pupil of H. Verschuring and J. van Bylert, but diverged from their style. His still lifes belong to the wider circle influenced by De Heem. His half-length portraits, in which the sitters are often seen playing cards or musical instruments, are reminiscent of Caspar Netscher. Genre scenes (e.g. a woman telling fortunes) in an Italianate landscape accord with the taste of his time.

Ykens, Frans

b. Antwerp 1601,
d. Brussels before 1693
1452, 1453

Flemish still-life painter, nephew and pupil of O. Beert the Elder. Like Daniel Seghers he depicted wreaths of flowers and fruit around baroque cartouches, the religious themes in the centre being painted in by another hand. His still lifes are simple in composition and have a more personal quality – tables with vegetables and fruit heaped in a Delft bowl: in this type of picture he resembles J. van Hulsdonck. Less often he painted flowers loosely arranged in a plain glass vase on an oak table-top. The style of painting is somewhat hard; there are signs of the influence of Daniel Seghers and J. van Thielen, but Ykens' compositions are more economical and the general effect is darker.

Literature: M. L. Hairs, *Les Peintres flamands de fleurs*, Brussels, 1955; E. Greindl, *Les Peintres flamands de nature morte*, Brussels, 1956.

Zeelander, Pieter de

active at Haarlem
in the mid-seventeenth century
1454

Dutch sea-painter and draughtsman. He lived for some time in Rome, where his *Bent* name was Kaper ("pirate"). He belongs to the group of "grey sea-painters," and his work shows a connection with P. Mulier. His marines are usually not large; they are seldom signed, and have therefore probably often been attributed to better-known artists. Some typical pictures by him are in the Historical Museum at Frankfurt, and a pair in the Bamberg gallery.

Zuylen, Jan Hendriksz. van

active at Utrecht
in the mid-seventeenth century
1455, 1456

Dutch still-life painter; pupil of his father, who bore the same name. His breakfast still lifes with a few large vessels – glass goblets set in silver-gilt, glass *flûtes*, sumptuous Nuremberg goblets and Rhenish stone pitchers – are admirably drawn and in good perspective, with a light-grey background. The composition is well thought out. His *Vanitas* pieces are rare.

Literature: A. Vorenkamp, *Bijdragen tot de Geschiedenis van het hollandsche Stilleven*, 1933, p. 36; N. R. A. Vroom, *De Schilders van het Monochrome Banketje*, Amsterdam, 1945.

Zyl, Gerard Pietersz. van

b. Haarlem about 1607,
d. Amsterdam 1665
1457

Dutch genre painter and portraitist; pupil of J. Pynas, though he adopted nothing of his style, and later of A. van Dyck, who was also a friend of his. He chiefly painted elegant conversation pieces, most of which are small, and was much admired in his own day. As he hardly ever signed his pictures, they passed afterwards under better-known names. Only recently has it been possible to identify some of his work by comparison with engravings and with a signed painting *The Letter*.

Literature: J. H. J. Mellaert, "G. P. van Zyl," *Burlington Magazine*, XLI, 1922, p. 147.

PLATES

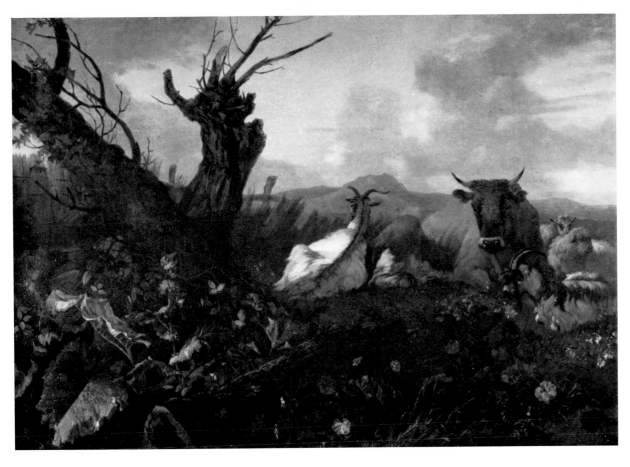

Willem Romeyn

MOUNTAIN LANDSCAPE
WITH COWS

Signed
Canvas, 51.5×62.5 cm.
Budapest, Museum of Fine Arts
No. 276.

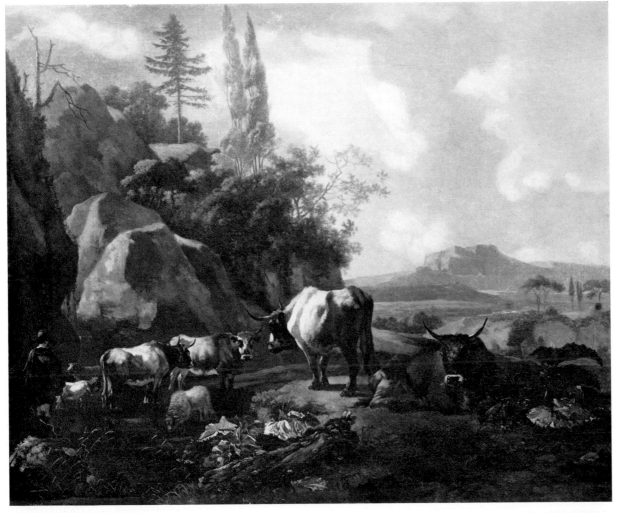

Willem Romeyn

LANDSCAPE WITH CATTLE

Signed
Canvas, 66×90 cm.
Lausanne, art trade.

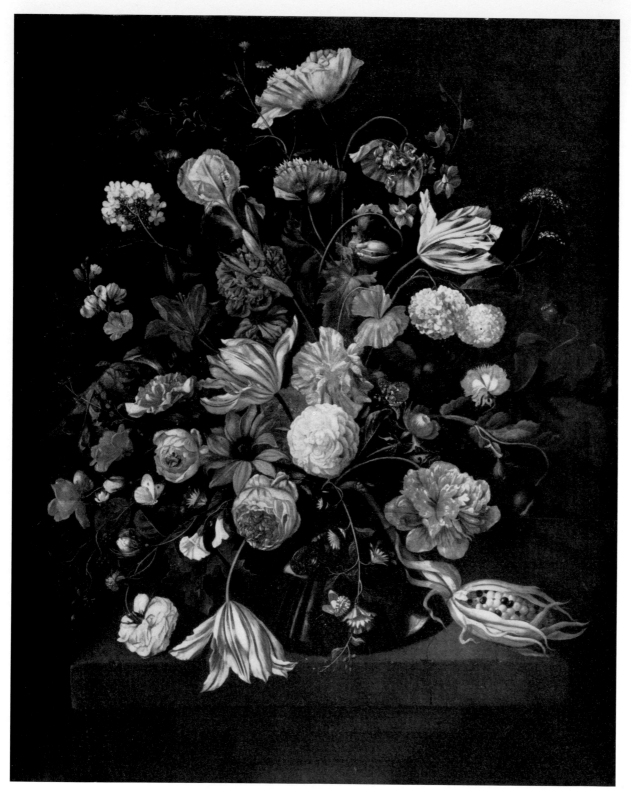

Jakob Rootius

FLOWERS IN A GLASS VASE

Signed and dated 1674
Canvas, 95×75 cm.
Amsterdam, art trade, 1935.

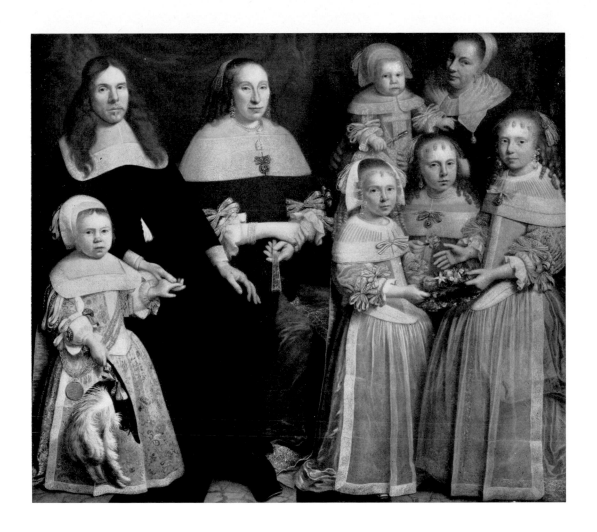

Jan Albertsz. Rootius

MEYNDERT SONCK WITH HIS
WIFE AND CHILDREN

Signed and dated 1662
Canvas, 148.3 × 173.3 cm.
Antwerp,
Musée Mayer van den Bergh
No. 4.

Jan Albertsz. Rootius

BREAKFAST STILL LIFE

Signed and dated 165.
Wood, 58 × 81.5 cm.
Amsterdam, Rijksmuseum
No. 2059.

Willem F. van Royen

HUNTSMAN WITH GAME

Signed and dated 1706
Canvas, 121 × 97 cm.
Brunswick,
Herzog-Anton-Ulrich Museum
No. 443.

Willem F. van Royen

FRUIT STILL LIFE

Signed and dated 1705
Canvas, 45 × 38 cm.
Oxford, Ashmolean Museum
No. 62.

Pieter des Ruelles

Landscape with
Watch Tower

Signed
Wood, 89×122 cm.
New York, private collection.

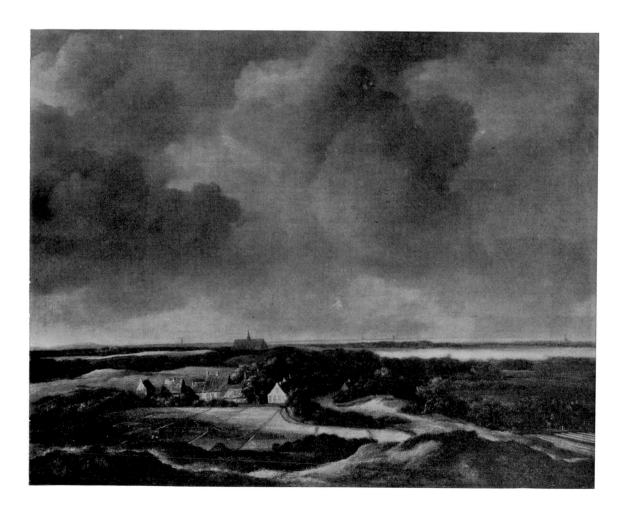

Jakob van Ruisdael

Flat Landscape
near Haarlem

With monogram
Canvas, 34.5×42,3 cm.
New York,
Metropolitan Museum of Art.
No. 110.

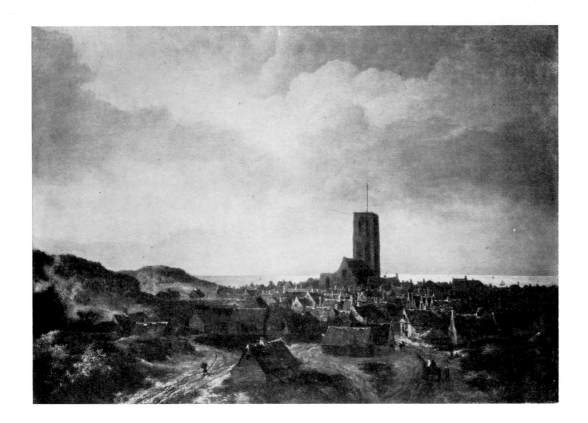

Jakob van Ruisdael

VIEW OF THE TOWER
OF KATWIJCK

With monogram
Wood, 49.4×67 cm.
Glasgow, Art Gallery
No. 878.

Jakob van Ruisdael

HET IJ IN STORMY WEATHER

Signed
Canvas, 62.5×79.3 cm.
London, Lord Northbrook
Collection.
No. 94.

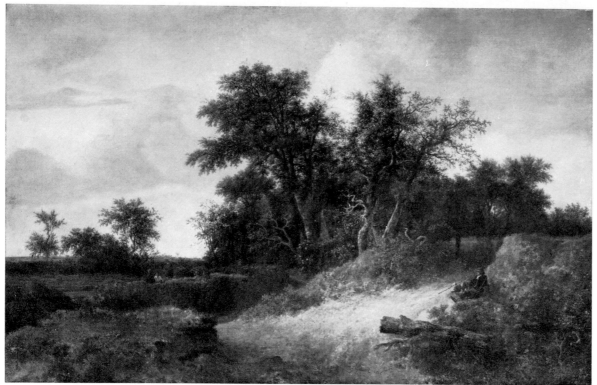

Jakob van Ruisdael

Wooded Dune

Signed and dated 1646
Canvas, 105 × 163 cm.
Leningrad, Hermitage
No. 939.

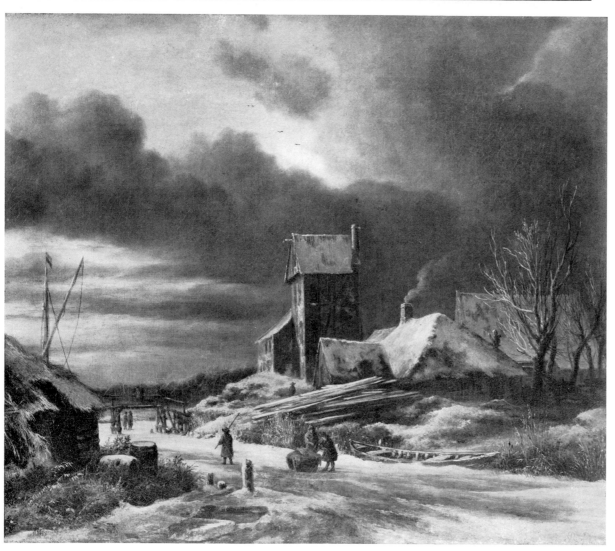
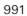

Jakob van Ruisdael

Winter Landscape

Signed
Canvas, 42 × 49.7 cm.
Amsterdam, Rijksmuseum
No. 2079.

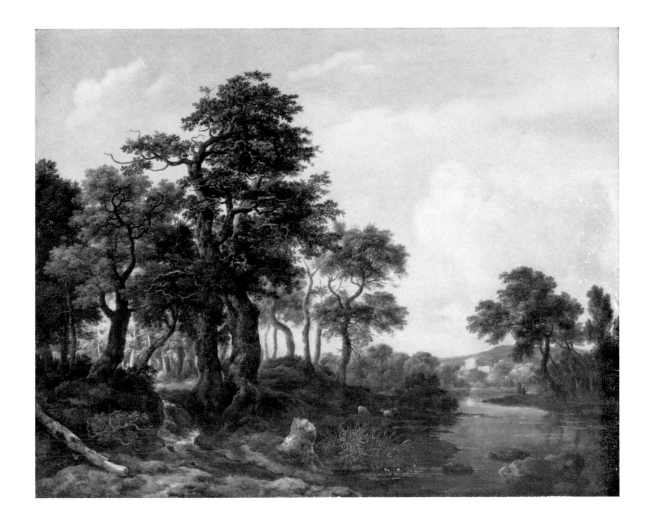

Jakob van Ruisdael

OAK WOOD BY A CALM STREAM

Signed
Canvas, 75 × 96.2 cm.
New York, private collection.

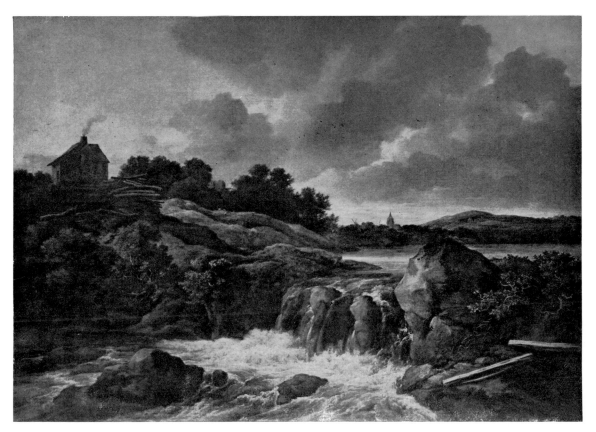

Jakob van Ruisdael

THE WATERFALL

Signed
Canvas, 102,3 × 141,7 cm.
London, Wallace Collection
No. 56.

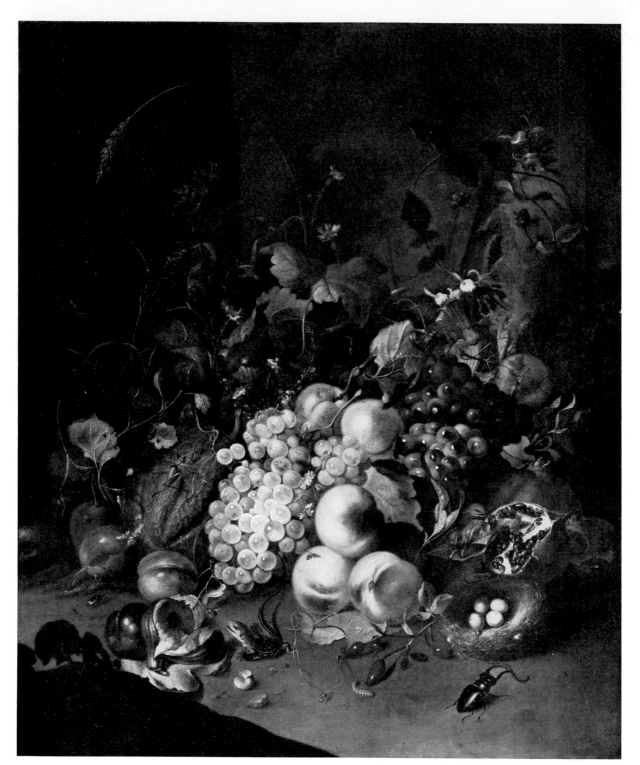

Rachel Ruysch

FRUIT STILL LIFE WITH
BIRD'S NEST AND STAG BEETLE

Signed and dated 1718
Copper, 74×61.5 cm.
Dresden, Gallery
No. 1692.

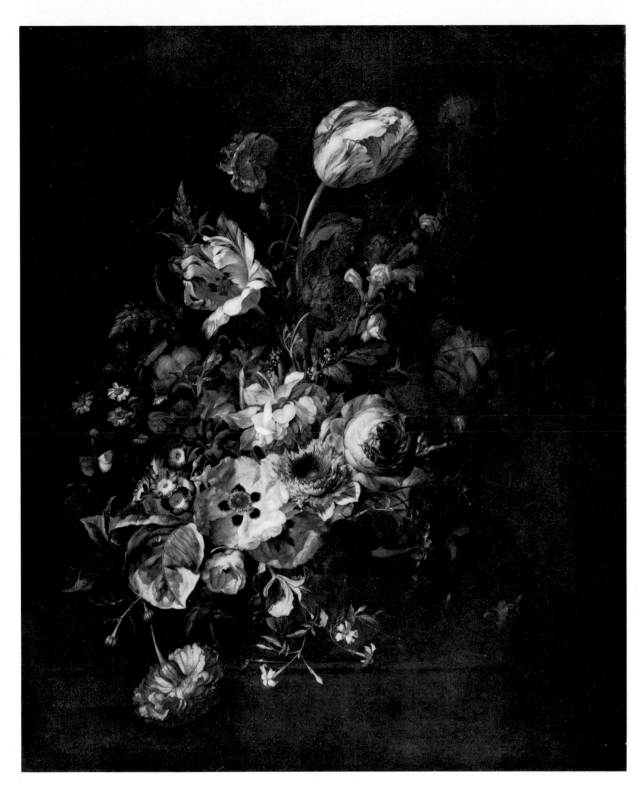

Rachel Ruysch

GLASS WITH TULIPS

Signed
Copper, 73.5×61.5 cm.
Dresden, Gallery
No. 1693.

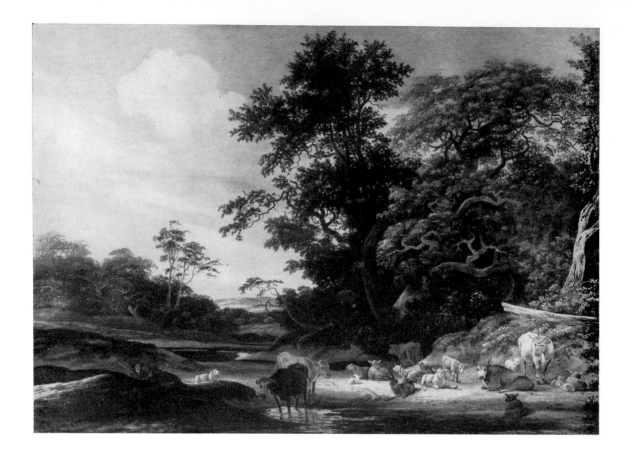

Jakob Salomonsz.
van Ruysdael

FOREST LANDSCAPE
WITH CATTLE

With monogram
Wood, 55×80 cm.
Augsburg, private collection.

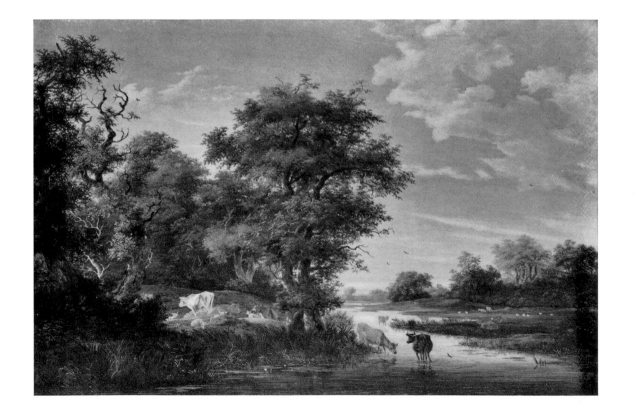

Jakob Salomonsz.
van Ruysdael

FOREST LANDSCAPE WITH COWS

With monogram
Wood, 50.5×69 cm.
Berlin, art trade.

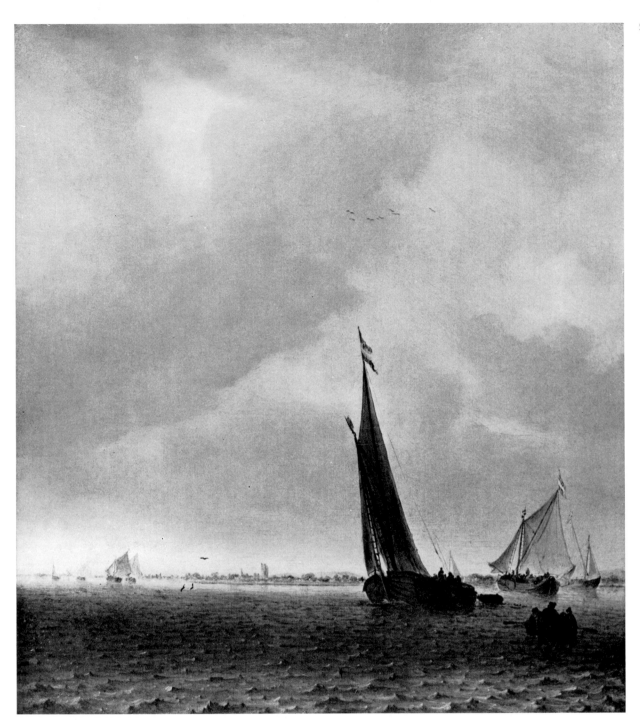

Salomon van Ruysdael

LARGE SAILING BOAT
ON A CALM SEA

With monogram
Wood, 36×32.5 cm.
Denmark, private collection.

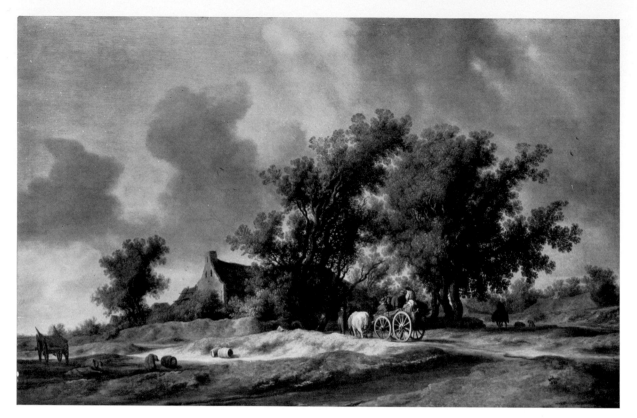

Salomon van Ruysdael

AFTER THE RAIN

With monogram, dated 1631
Wood, 56×86.5 cm.
Budapest, Museum of Fine Arts
No. 260.

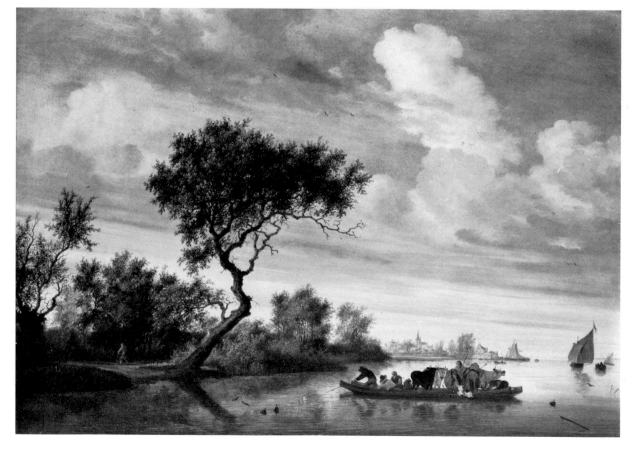

Salomon van Ruysdael

RIVER BANK WITH FERRY

Signed
Wood, 75×106 cm.
Formerly Munich,
Alte Pinakothek
No. 2076.

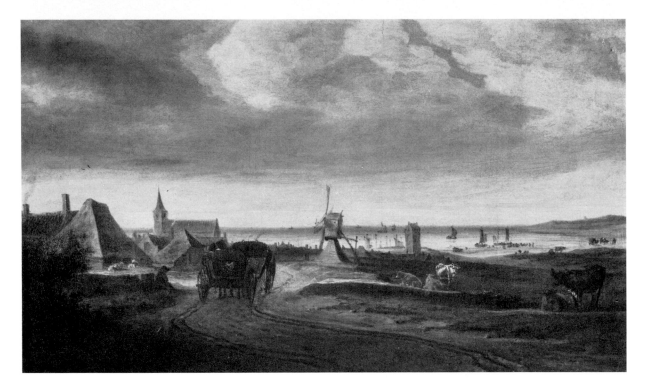

Salomon van Ruysdael

SEA SHORE WITH WINDMILL

Signed and dated 1663
Canvas, 44.5 × 76 cm.
London, sale 23 February 1934.

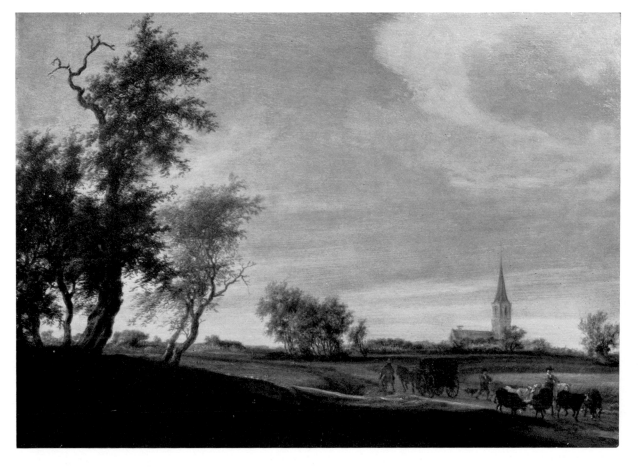

Salomon van Ruysdael

LANDSCAPE WITH
TRAVELLING COACH

With monogram, dated 1647
Wood, 37.2 × 52 cm.
Munich, private collection.

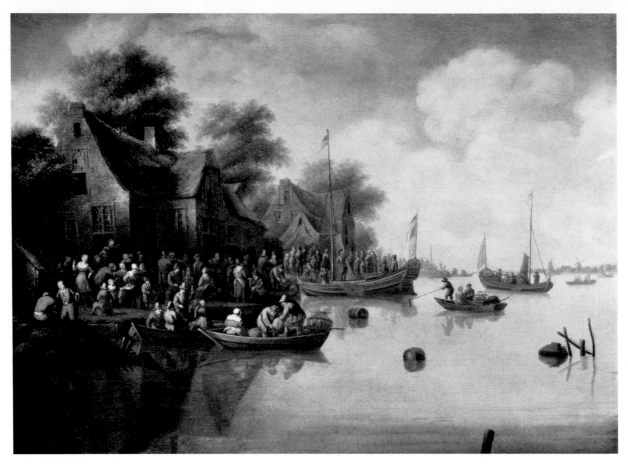

E. Ruytenbach

RIVER BANK AND VILLAGE

Signed
Canvas
Amsterdam, art trade.

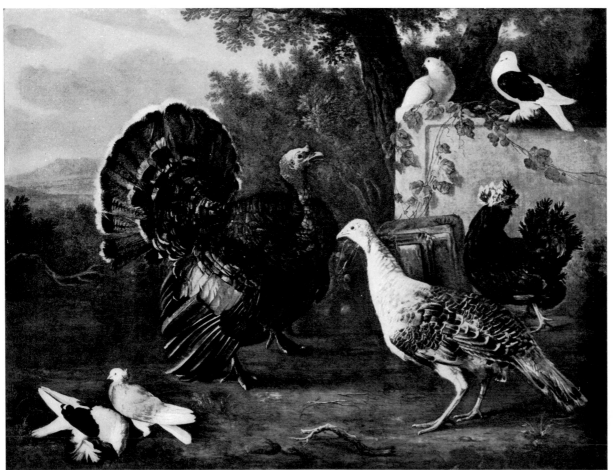

Cornelia de Ryck

PEACOCK AND OTHER BIRDS

Signed
Canvas, 133 × 173 cm.
Budapest, Museum of Fine Arts
No. 361.

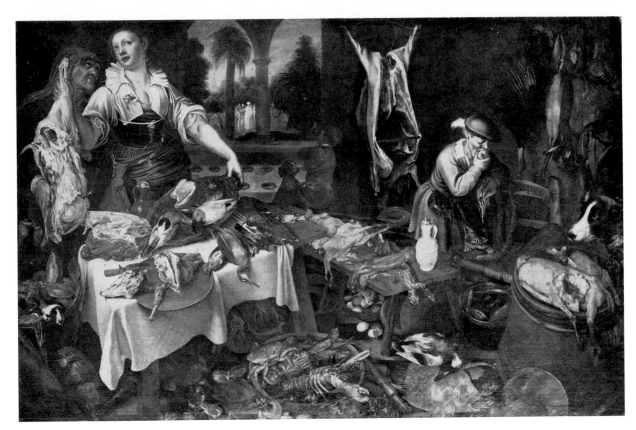

Pieter Cornelisz. van Ryck

LARGE KITCHEN PIECE

Signed and dated 1604
Canvas, 189×288 cm.
Brunswick,
Herzog-Anton-Ulrich Museum
No. 205.

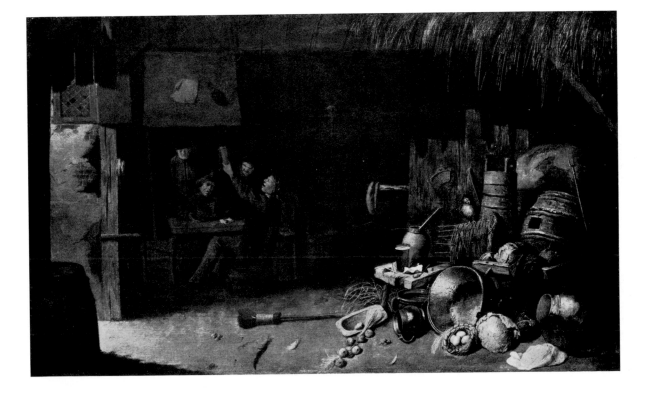

David Ryckaert the Younger

PEASANTS IN A COTTAGE

Signed and dated 1638
Wood, 50.5×80.5 cm.
Dresden, Gallery
No. 1092.

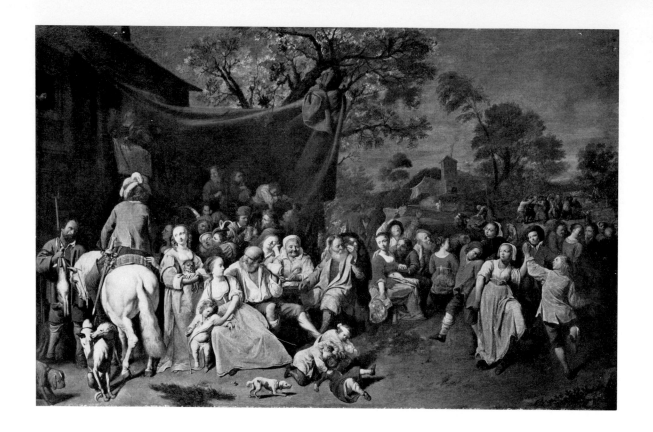

**David Ryckaert
the Younger**

PEASANT KERMESSE

Signed
Canvas, 120×175 cm.
Vienna,
Kunsthistorisches Museum
No. 1127.

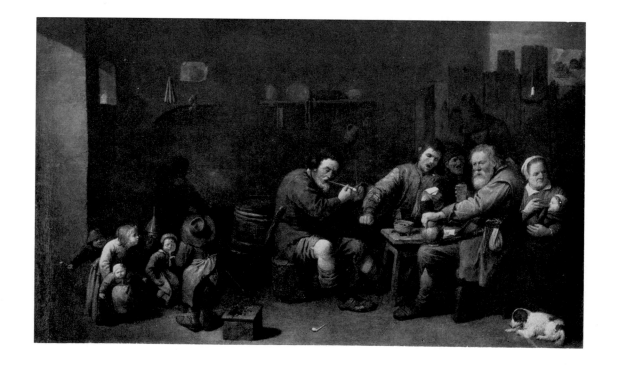

**David Ryckaert
the Younger**

THE PEASANT FAMILY
AS ALLEGORY

Signed 1642
Wood, 64.5×101 cm.
Dresden, Gallery
No. 1093.

**David Ryckaert
the Younger**

WITCH AND HORDE OF DEMONS

Wood, 47.5 × 63 cm.
Vienna,
Kunsthistorisches Museum
No. 1128.

Marten Ryckaert

LANDSCAPE WITH SATYRS

Wood, 9 × 19 cm.
London, National Gallery
No. 1353.

Marten Ryckaert

Village with River

With monogram, dated 1616
Wood, 20 × 26 cm.
Formerly Petersburg,
Semenov Collection.

François Ryckhals

Still Life

Signed and dated 1640
Wood, 64 × 98 cm.
Berlin, Staatl. Museen,
Gemäldegalerie
No. 905 A.

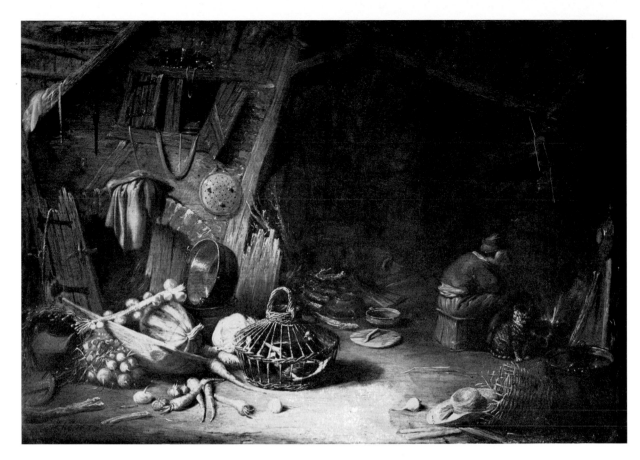

François Ryckhals

PEASANT BARN

With monogram, dated 1637
Wood, 37.5 × 53 cm.
Karlsruhe,
Staatliche Kunsthalle
No. 358.

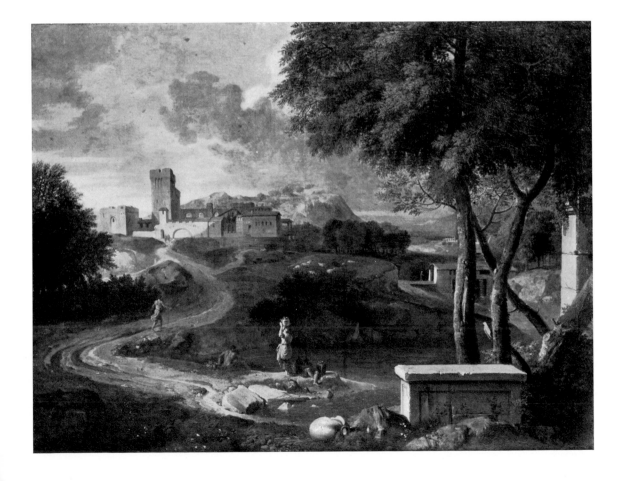

Pieter Rysbraeck

CLASSICAL LANDSCAPE

Pendant signed
Canvas, 88 × 114 cm.
Aschaffenburg, Gallery
No. 152.

Warnard van Rysen

ST. MARY MAGDALEN
IN A GROTTO

With monogram
Wood, 32.5 × 24.5 cm.
Cassel, Gallery
No. 204.

Pieter Saenredam

St. Mary's Church
in Utrecht

Wood, 65.5 × 51.5 cm.
Amsterdam, Six Collection
No. 80.

Pieter Saenredam

S. Maria della Febbre
in Rome

Signed and dated 1629
Wood, 38×70 cm.
Amsterdam,
Frederick Muller sale,
25 November 1924
No. 60.

Pieter Saenredam

The Interior of the
Nieuwe Kerk in Haarlem

Signed and dated 1653
Wood, 86×103 cm.
Budapest,
Museum of Fine Arts
No. 311.

Pieter Saenredam

THE INTERIOR OF ST. BAVO'S
CHURCH IN HAARLEM

Signed and dated 1636
Wood, 95.5 × 57 cm.
Amsterdam, Rijksmuseum
No. 2096.

Cornelis Saftleven

PEASANTS MAKING MUSIC

Signed
Wood, 36 × 28 cm.
Dresden, Gallery
No. 1801.

Cornelis Saftleven

LANDSCAPE WITH CATTLE

Signed and dated 1660
Wood, 36×49 cm.
The Hague, Mauritshuis
No. 538.

Cornelis Saftleven

FEEDING THE CHICKENS
IN A BARN

Signed and dated 1678
Wood, 49.5×66 cm.
Dresden, Gallery
No. 1802.

1023

Cornelis Saftleven

THE ANNUNCIATION
TO THE SHEPHERDS

Signed and dated 1642
Canvas, 67 × 100 cm.
Schleissheim, Gallery
No. 3799.

1024

Herman Saftleven

LANDSCAPE WITH SUNSET

With monogram, dated 1645
Canvas, 127 × 181 cm.
Vienna,
Kunsthistorisches Museum
No. 1228.

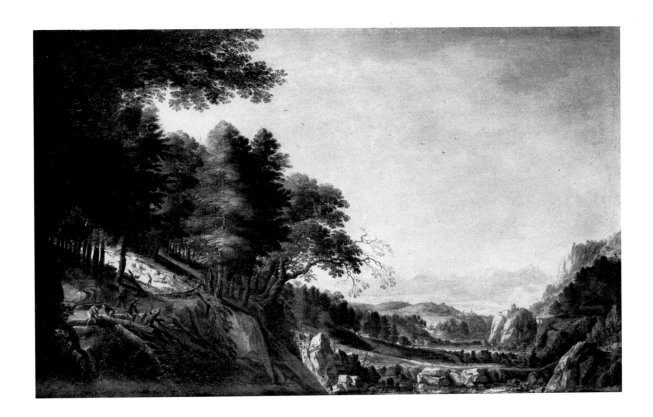

Herman Saftleven

Wooded Mountain
Landscape

With monogram, dated 1641
Wood, 40×62 cm.
Vienna,
Kunsthistorisches Museum
No. 1225.

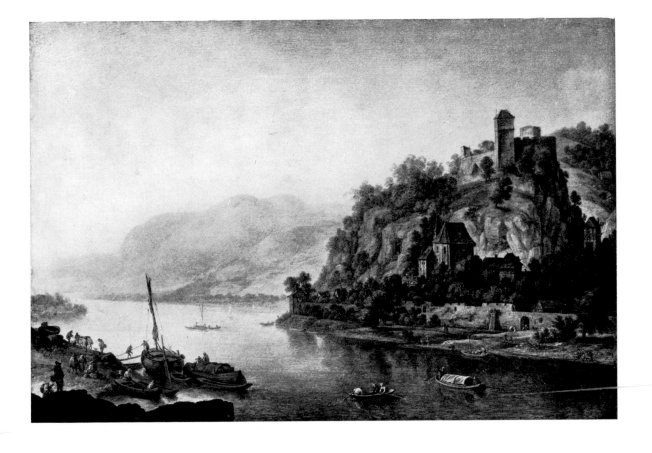

Herman Saftleven

View of Heimbach
on the Rhine

With monogram, dated 1652
Copper, 25×37 cm.
Munich, Alte Pinakothek
No. 573.

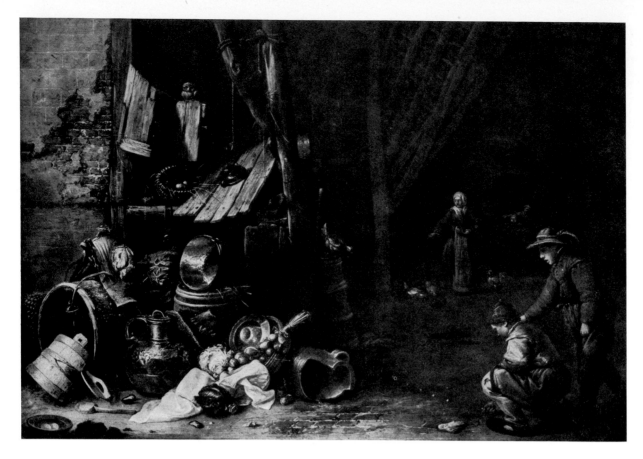

Herman Saftleven

Interior of a Barn

Signed and dated 1634
Wood, 41×47.5 cm.
Brussels, Musée Royal
des Beaux-Arts
No. 407.

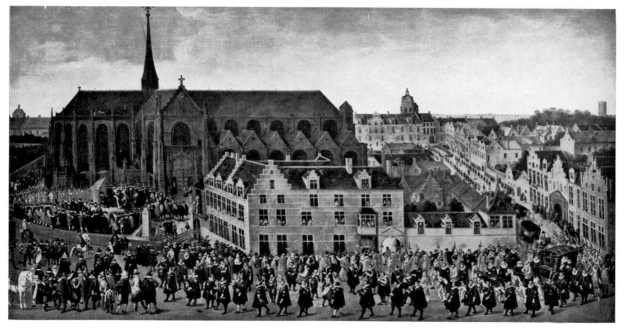

Antoine Sallaert

Large Procession round the Church

Canvas, 180×338 cm.
Brussels, Musée Royal
des Beaux-Arts
No. 409.

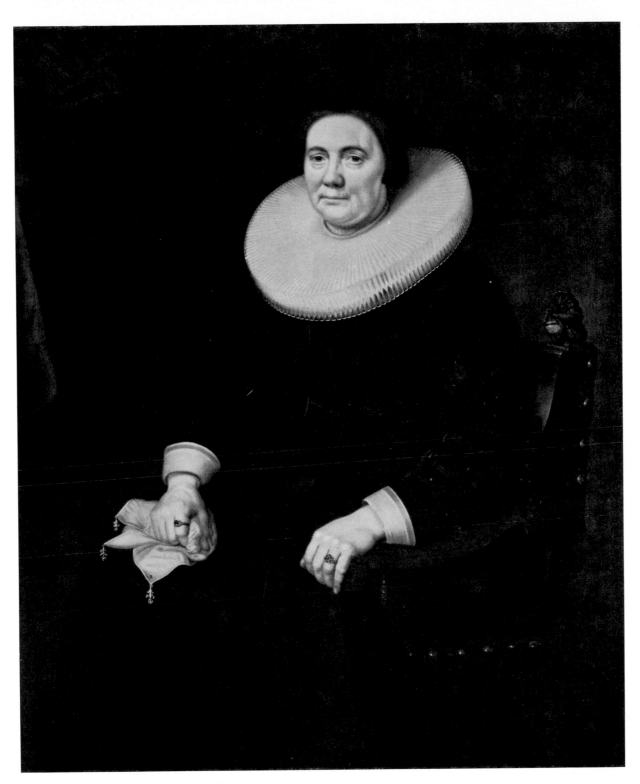

Hercules Sanders

PORTRAIT OF A LADY

Signed and dated 1651
Canvas, 123.5 × 104.5 cm.
Amsterdam, Rijksmuseum
No. 2116.

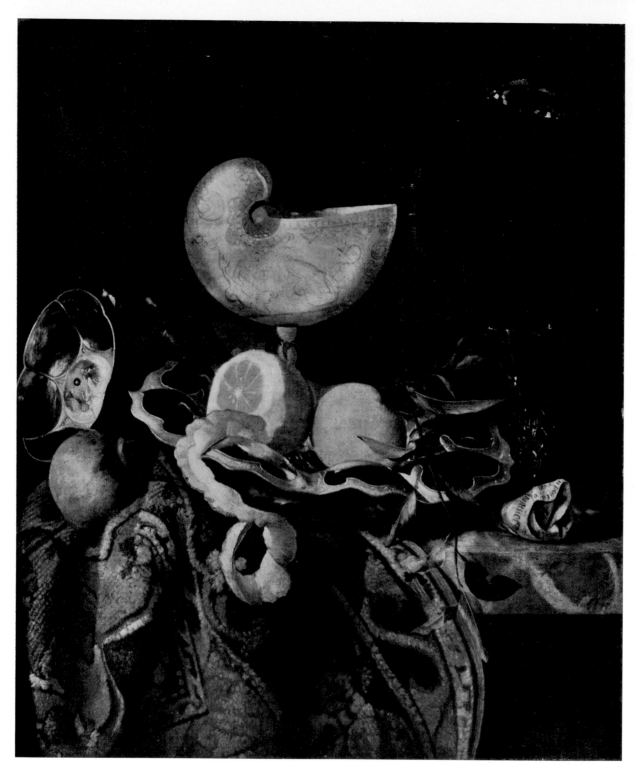

F. Sant-Acker

STILL LIFE
WITH NAUTILUS CUP

Signed
Canvas, 66 × 56.5 cm.
Amsterdam, Rijksmuseum
No. 2125.

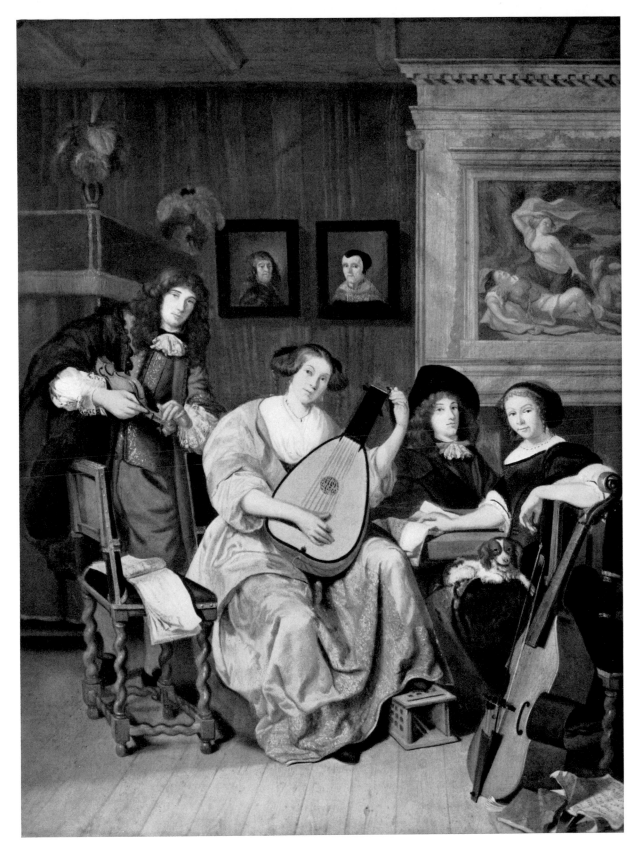

F. Sant-Acker

MUSIC-MAKING

Signed
Wood, 49.5 × 39.5 cm.
The Hague, Bredius Museum
No. 89.

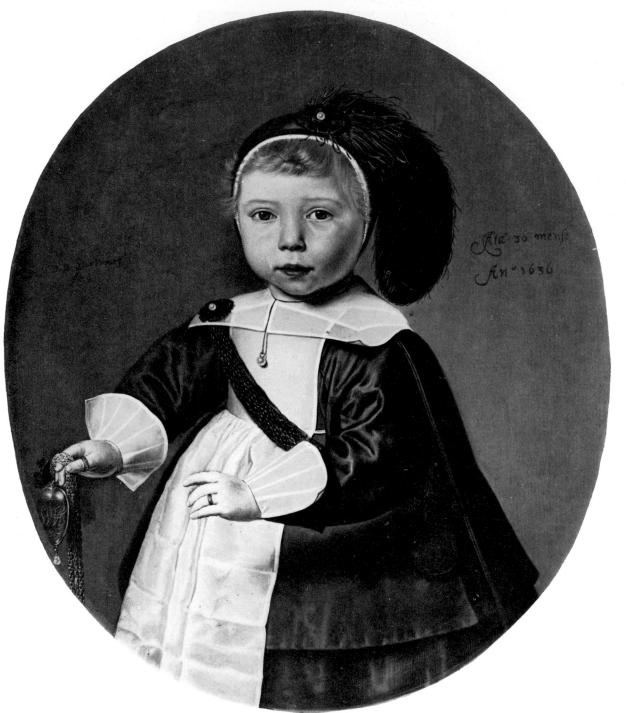

Dirck Santvoort

PORTRAIT OF A GIRL

Signed and dated 1636
Wood, 62×51 cm.
Amsterdam, private collection.

Dirck Santvoort

THE REGENTESSES
OF THE SPINHUIS
IN AMSTERDAM

Signed and dated 1638
Canvas, 187.5 × 214 cm.
Amsterdam, Rijksmuseum
No. 2127.

1034

Pieter Dircksz. Santvort

WINTER LANDSCAPE

Signed
Wood, 30 × 41.5 cm.
Haarlem, Frans Hals Museum
No. 260.

Pieter Dircksz. Santvort

LANDSCAPE WITH ROAD
AND PEASANT COTTAGE

Signed and dated 1625
Wood, 30×37 cm.
Berlin, Staatliche Museen
No. 1985.

Dirck Sauts

STILL LIFE WITH LOBSTERS,
MUSSELS AND RUMMER

Signed
Wood, 24×34.5 cm.
Paris, F. Lugt Collection

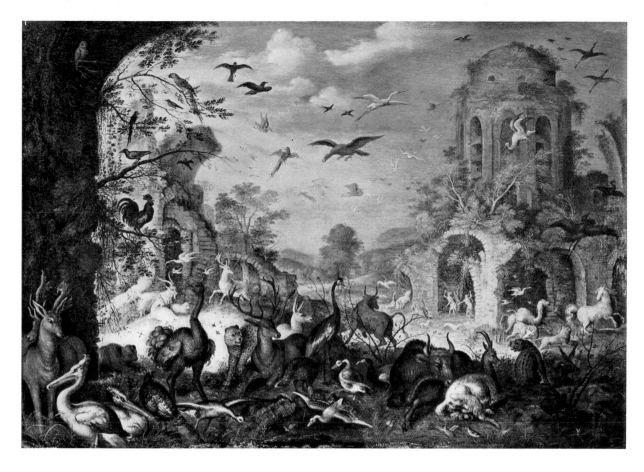

Roelant Savery

LANDSCAPE WITH ANIMALS

Wood, 35 × 49 cm.
Vienna,
Kunsthistorisches Museum
No. 923.

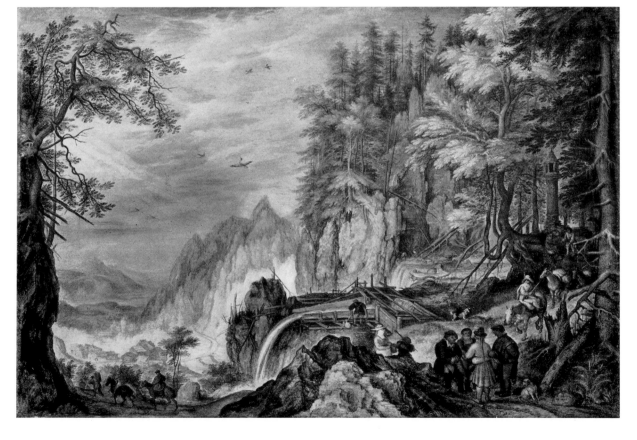

Roelant Savery

MOUNTAIN LANDSCAPE
WITH TRAVELLERS

Signed and dated 1608
Copper, 35 × 49 cm.
Vienna,
Kunsthistorisches Museum
No. 926.

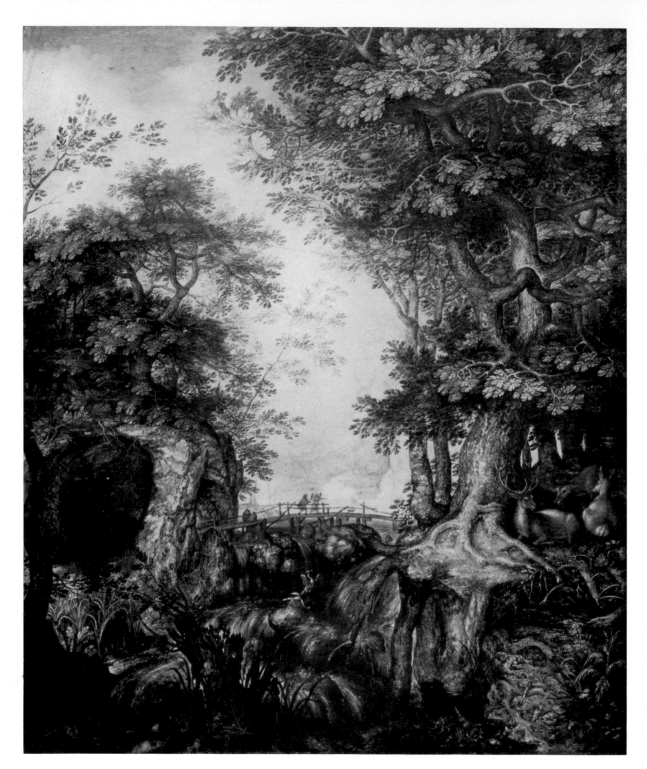

Roelant Savery

Wooded Mountain
Landscape
with Tobias and Angel

Signed and dated 1605
Wood 43,7×37,4 cm.
Dessau, Gallery
No. 386.

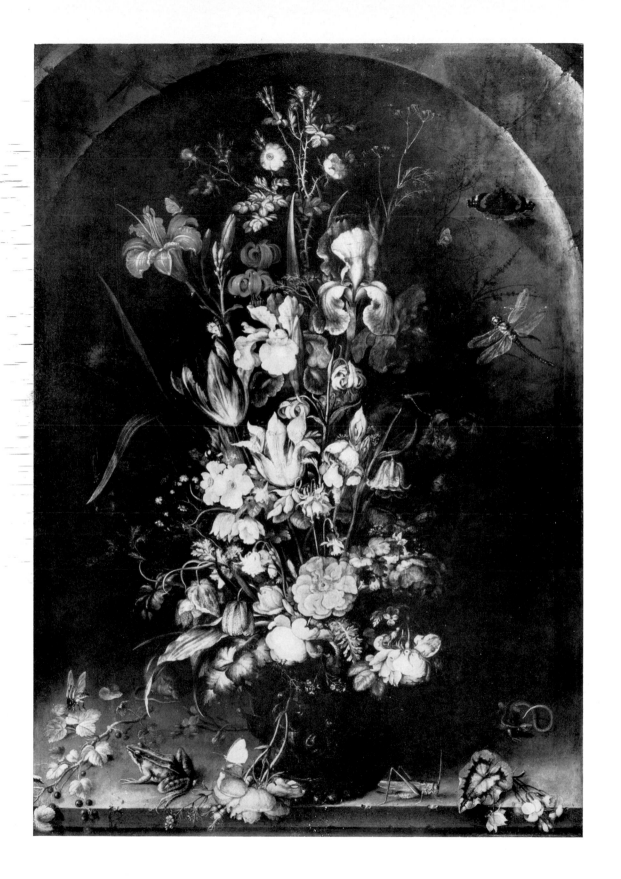

Roelant Savery

FLOWER STILL LIFE

Signed and dated 1617
Wood, 87×59 cm.
Munich, private collection.

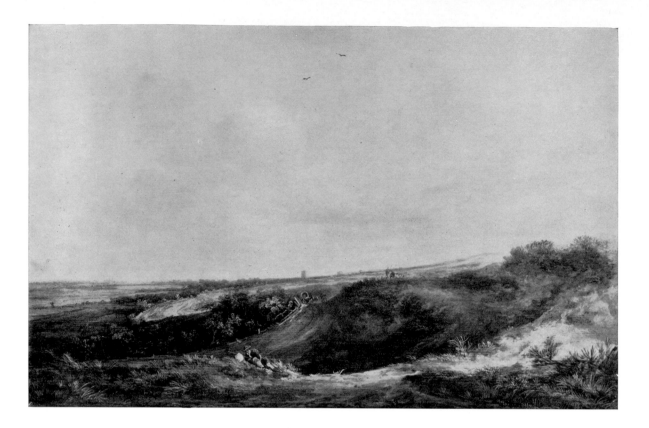

Cornelis S. van der
Schalcke

DUNE LANDSCAPE

Signed and dated 1652
Wood, 40×61 cm.
Berlin, Staatliche Museen
No. 2080.

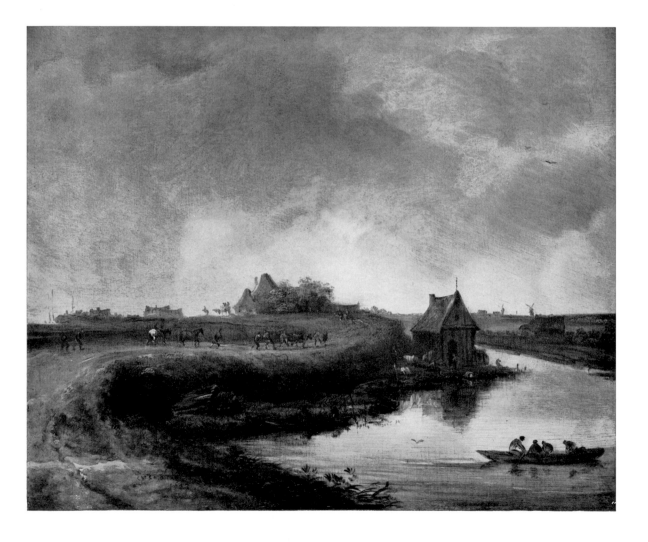

Cornelis S. van der
Schalcke

LANDSCAPE WITH RIVER

Signed and dated 1652
Wood, 26.5×32.5 cm.
Munich, art trade.

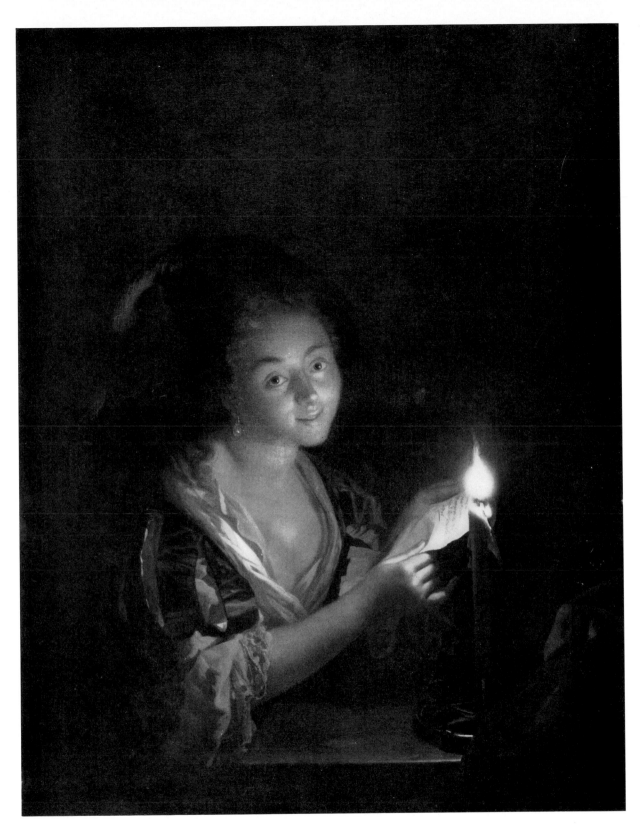

Godfried Schalcken

GIRL READING A LETTER

Signed
Wood, 27×20.5 cm.
Dresden, Gallery
No. 1786.

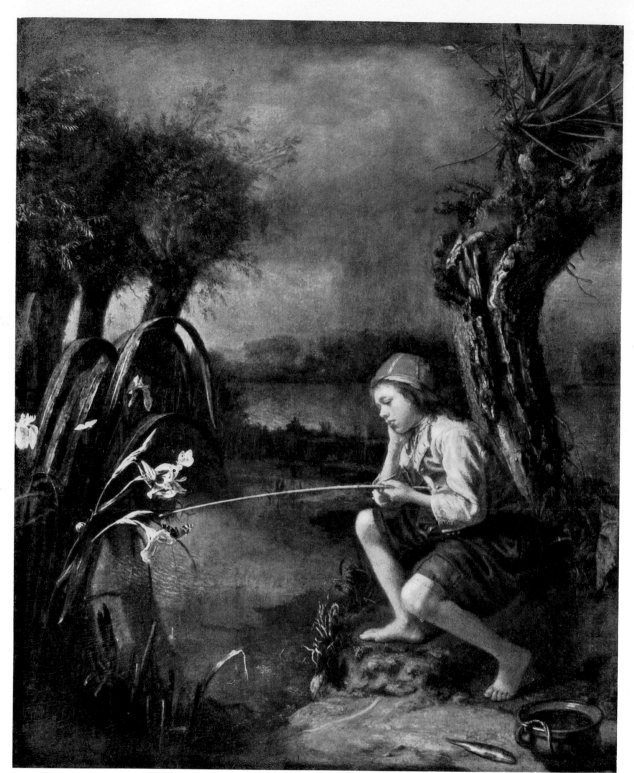

Godfried Schalcken

Boy Angling

Signed
Wood, 31×25 cm.
Berlin, Staatliche Museen
No. 837.

Godfried Schalcken

AN OLD WOMAN
SCOURING A POT

Signed
Wood, 27×21 cm.
London, National Gallery
No. 997.

Willem Schellinks

THE FOUNTAIN

Wood, 63.5 × 52 cm.
Budapest,
Museum of Fine Arts
No. 225.

Johannes Schoeff

RIVER WITH BOATS

Signed and dated 1651
Wood, 45 × 70 cm.
Berlin,
Lepke sale, 18 March 1930
No. 5.

Johannes Schoeff

LANDSCAPE

Signed and dated 1647
Wood, 47 × 71 cm.
Solingen, art trade.

Mathys Schoevaerdts

THE VILLAGE FAIR

Canvas, 39×53 cm.
Berlin, Staatliche Museen
No. 647b.

Mathys Schoevaerdts

FISH MARKET
ON THE SEA SHORE

Signed
Wood, 43×60 cm.
Brussels,
Musée Royal des Beaux-Arts
No. 418.

Hendrick Schoock

PLANT STILL LIFE

Signed
Canvas, 104 × 84 cm.
Copenhagen,
Royal Museum of Fine Arts
No. 250.

Floris van Schooten

BREAKFAST STILL LIFE

With monogram
Wood, 35.5 × 49.5 cm.
Amsterdam, art trade.

Floris van Schooten

BREAKFAST STILL LIFE

Signed
Wood, 52 × 82.5 cm.
Hamburg, Kunsthalle
No. 75.

1054

Floris van Schooten

BRASS VESSELS

Wood, 54×85 cm.
Lucerne, art trade.

1055

Petrus Schotanus

VANITAS STILL LIFE

Signed
Wood, 58×81 cm.
Berlin,
Lepke sale, 10 May 1932
No. 391.

Pieter Schoubroeck

St. John the Baptist
Preaching

Signed
Copper, 47.4×79.5 cm.
Brunswick,
Herzog-Anton-Ulrich Museum
No. 106.

Pieter Schoubroeck

Landscape with Soldiers

Copper, 21×28 cm.
Berlin, Staatliche Museen
No. 2033.

Cornelis Schut

THE ADORATION OF
THE SHEPHERDS

Canvas, 250 × 360 cm.
Nuremberg,
Germanisches Museum
No. 361.

C. W. Schut

SHIPS IN AN ESTUARY

Signed
Wood, 71 × 105.7 cm.
Hamburg, Kunsthalle
No. 164.

Daniel Seghers

Flowers in a
Venetian Glass Vase

Signed and dated 1643
Copper, 85.5 × 64.5 cm.
Dresden, Gallery
No. 1201.

Daniel Seghers

FLOWER STILL LIFE
SURROUNDING A DEAD CHRIST

Canvas
Dessau, Mosigkau Gallery.

Gerard Seghers

THE RAPE OF EUROPA

Canvas, 63×88 cm.
Brunswick,
Herzog-Anton-Ulrich Museum
No. 114.

Gerard Seghers

THE DREAM OF ST. JOSEPH

Canvas, 170×233 cm.
Berlin, Staatl. Museen,
Gemäldegalerie
(destroyed)
No. 722.

Hercules Seghers

MOUNTAINOUS LANDSCAPE
WITH DISTANT PANORAMA

Wood, 55 × 100 cm.
Florence, Uffizi
No. 1303.

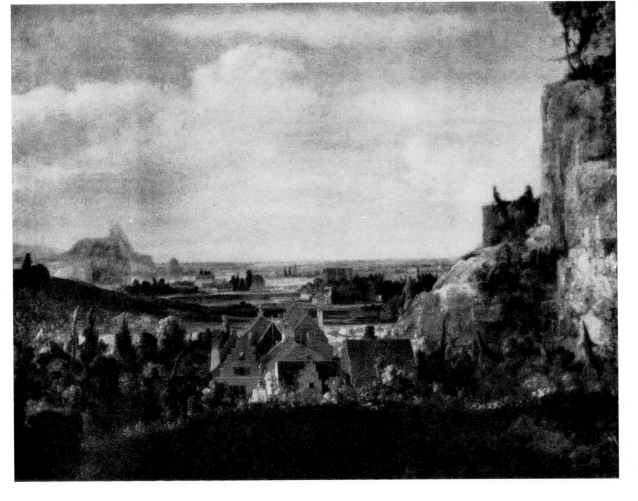

Hercules Seghers

LANDSCAPE IN GELDERLAND

Signed and dated 1655
Canvas, 84 × 127 cm.
Amsterdam,
Frederik Muller sale,
25 October 1927
No. 26.

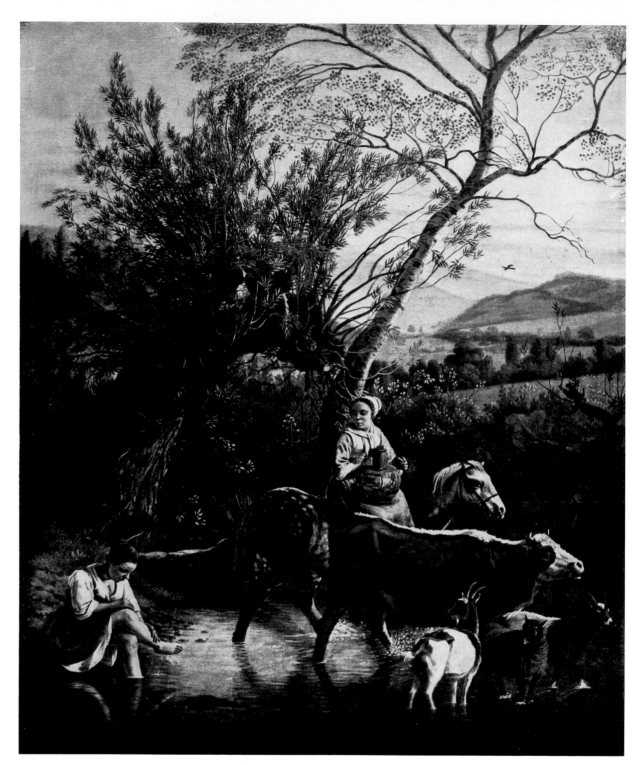

Jan Siberechts

THE FORD

Signed
Canvas, 35.3 × 33.3 cm.
Budapest,
Museum of Fine Arts
No. 4073.

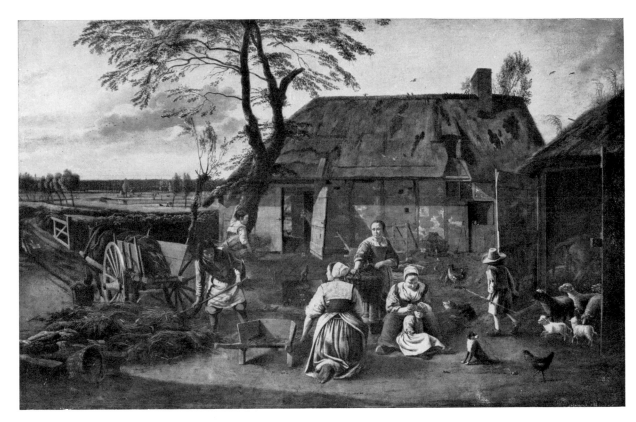

Jan Siberechts

FARMYARD

Signed and dated 1660
Canvas, 121 × 188 cm.
Brussels,
Musée Royal des Beaux-Arts
No. 423.

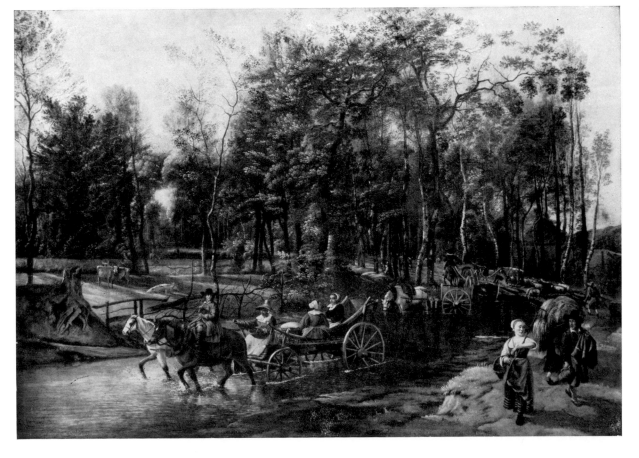

Jan Siberechts

FLOODED FOREST ROAD

Canvas, 150.5 × 205 cm.
Amsterdam, art trade.

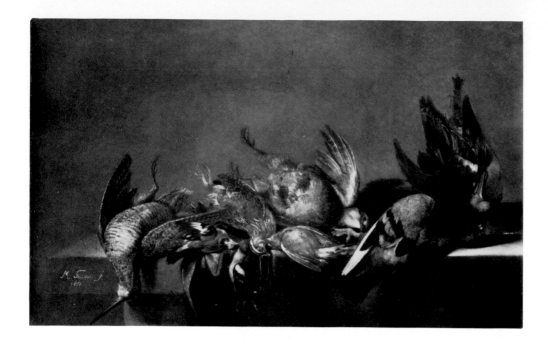

Michiel Simons

STILL LIFE WITH DEAD BIRDS

Signed and dated 1651
Wood, 56×83 cm.
Berlin, Spik, 22 June 1957

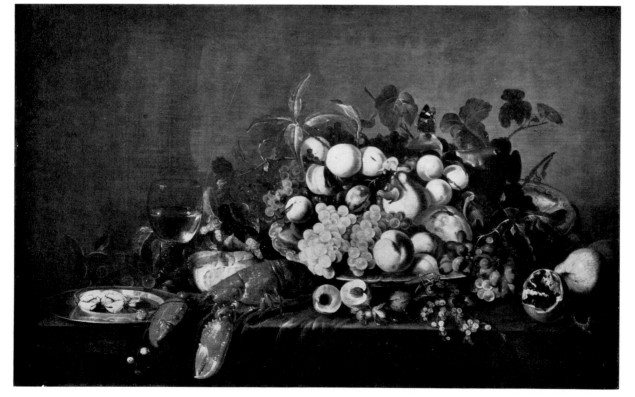

Michiel Simons

STILL LIFE WITH FRUIT
AND LOBSTER

Signed
Canvas, 73×111 cm.
Utrecht, Central Museum
No. 179.

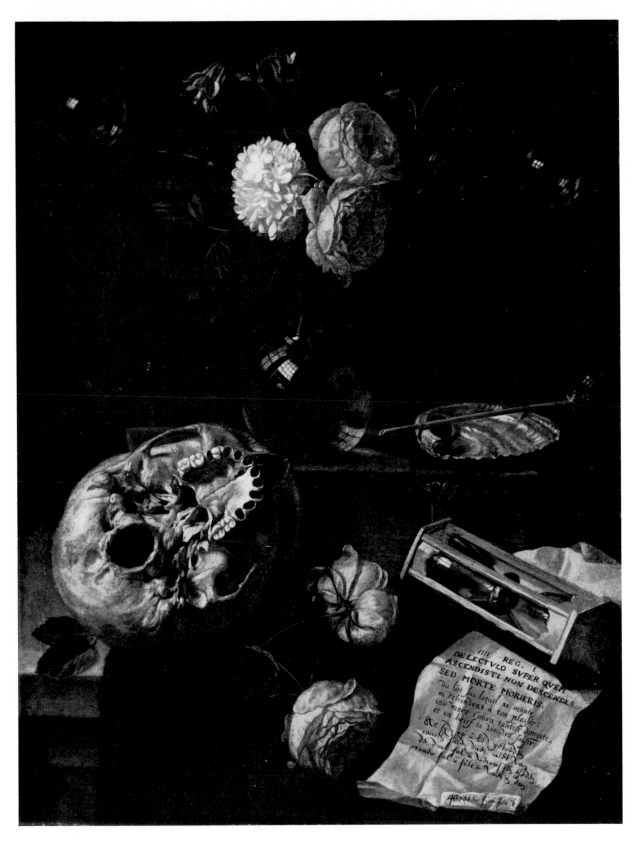

Peeter Sion

VANITAS STILL LIFE

Signed
Canvas, 57×44.5 cm.
Amsterdam, art trade

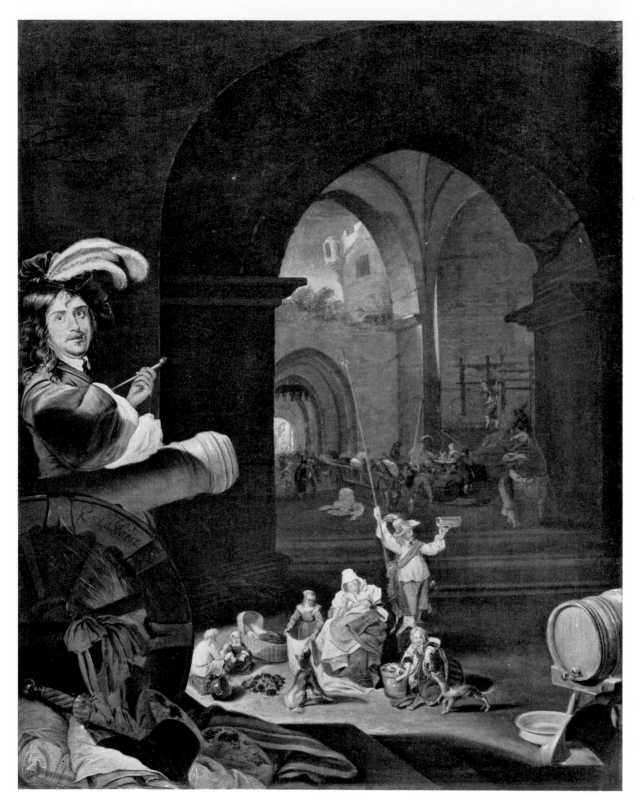

Karel Slabbaert

CAMP SCENE

Signed
Wood, 50.5 × 39 cm.
The Hague, Mauritshuis
No. 410.

Karel Slabbaert

BOY WITH A BIRD

Signed
Canvas, 60 × 51 cm.
Brunswick,
Herzog-Anton-Ulrich Museum
No. 280.

Pieter van Slingeland

<small>The Unmusical Dog</small>

Signed and dated 1672
Wood, 39.5 × 30.5 cm.
Dresden, Gallery
No. 1761.

Pieter van Slingeland

LACEMAKER AND WOMAN
SELLING POULTRY

Signed and dated 1672
Wood, 35.5 × 28 cm.
Dresden, Gallery
No. 1762.

Pieter van Slingeland

PEASANT KITCHEN WITH TWO MUSICIANS

Signed
Wood, 46.5×61.5 cm.
Amsterdam, Rijksmuseum
No. 2203.

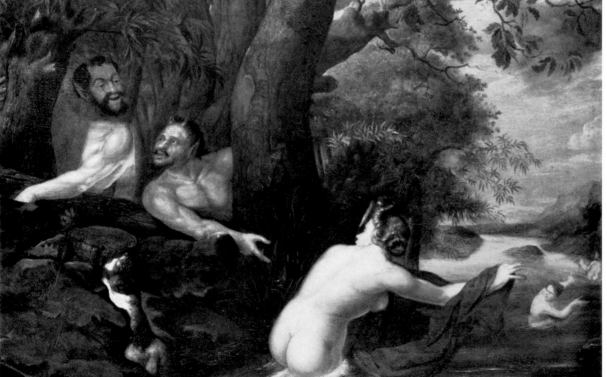

Jacob van der Sluys

NYMPHS AND SATYRS

Signed
Wood, 34×44.4 cm.
Leiden, Lakenhal
No. 400.

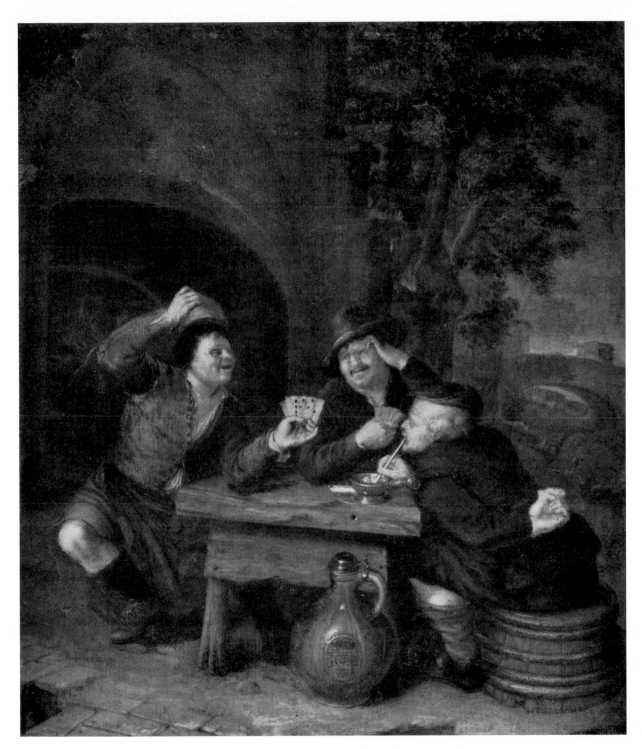

Jacob van der Sluys

<small>Peasants Playing Cards</small>

Signed
Wood, 22 × 17 cm.
Formerly Paris,
A. Schloss Collection
No. 196.

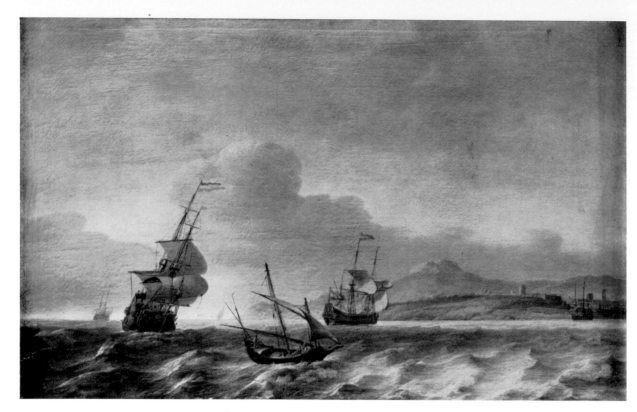

Aernout Smit

ROUGH SEA

Signed and dated 1678
Canvas, 118×155 cm.
Copenhagen,
Royal Museum of Fine Arts
No. 667.

Pieter Snayers

LANDSCAPE WITH
FARM BUILDINGS

Wood, 52×82.5 cm.
Vienna,
Kunsthistorisches Museum
No. 980.

Pieter Snayers

SOLDIERS PLUNDERING
A VILLAGE

Canvas, 82 × 114.5 cm.
Dresden, Gallery
No. 1108.

Andries Snellinck

LANDSCAPE WITH
DIANA HUNTING

Signed
Copper, 66.5 × 92.5 cm.
Luxembourg, private collection

Cornelis Snellinck

LANDSCAPE

Signed
Wood, 115 × 146 cm.
Munich, art trade.

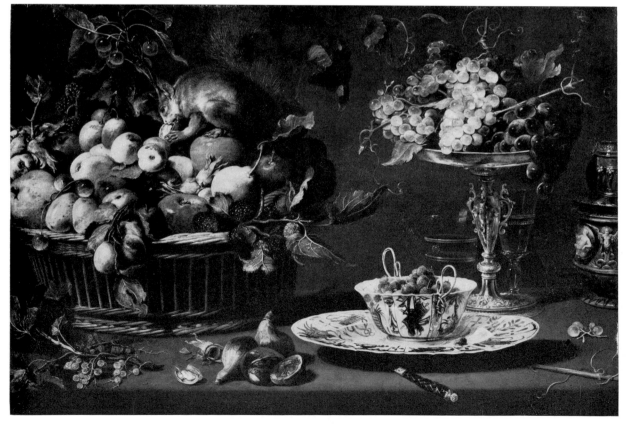

1084

Frans Snyders

FRUIT STILL LIFE
WITH SQUIRREL

Signed
Copper, 57 × 84.7 cm.
Brussels,
R. Chasles sale,
16 Dezember 1929
No. 90.

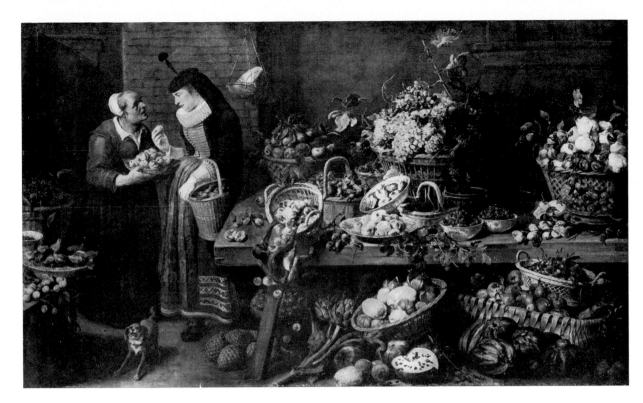

Frans Snyders

WOMAN SELLING
FRUIT AND VEGETABLES

Signed
Canvas, 206×342 cm.
Leningrad, Hermitage
No. 596.

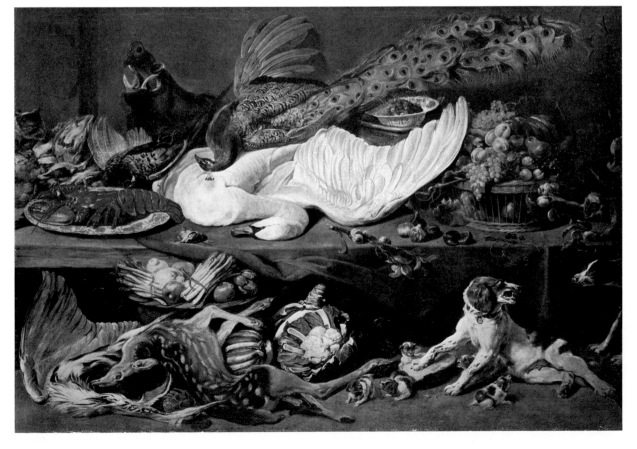

Frans Snyders

STILL LIFE WITH A BITCH
AND HER PUPPIES

Canvas, 171×245.5 cm.
Dresden, Gallery
No. 1192.

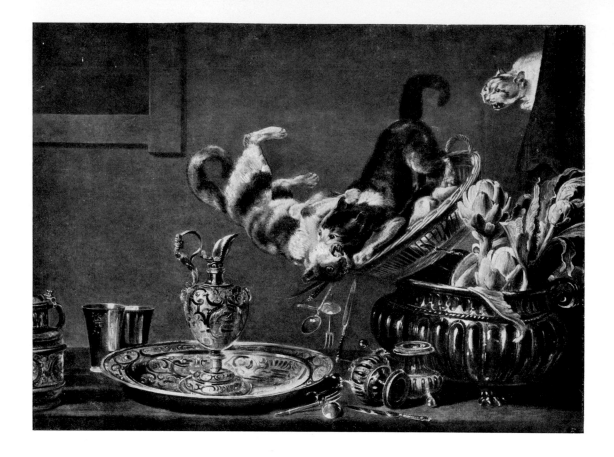

Frans Snyders

<small>STILL LIFE
WITH CATS ROMPING</small>

Canvas, 106.5 × 141 cm.
Munich, art trade.

Frans Snyders

<small>BIRD-CATCHING</small>
(Landscape by Wildens)

Signed
Wood, 64 × 115 cm.
Aachen, Suermondt Museum
No. 166.

Pieter Snyers

STILL LIFE
WITH VEGETABLES
AND LOBSTER

Signed
Canvas, 113×97 cm.
London, National Gallery
No. 1401.

Pieter Snyers

WAYFARER AND CHILD

Signed
Canvas, 179.5 × 170 cm.
Stockholm, National Museum
No. 5527.

Joris van Son

BREAKFAST STILL LIFE

Signed
Wood, 43 × 53 cm.
Vienna, art trade.

Joris van Son

FRUIT AND VEGETABLE
STILL LIFE

Canvas, 47.5 × 64 cm.
Dresden, Gallery
No. 1218.

Jan Sonje

<small>LANDSCAPE</small>

Signed
Canvas, 84×70 cm.
Munich, Bayerische
Staatsgemäldesammlungen.

Jan Frans Soolmaker

THE SHEPHERD

Signed
Canvas, 51×43.5 cm.
Formerly Budapest,
Museum of Fine Arts
Inv. 739.

Jan Frans Soolmaker

ITALIAN LANDSCAPE
WITH SHEPHERDS AND CATTLE

Signed
Canvas, 115 × 133 cm.
The Hague, Mauritshuis
No. 164.

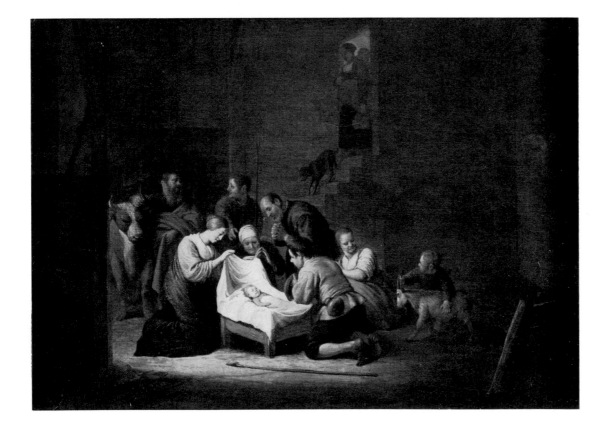

Hendrick Martensz. Sorgh

THE ADORATION OF
THE SHEPHERDS

Signed and dated 1649
Wood, 35.5 × 49 cm.
Budapest,
Museum of Fine Arts
No. 383 (569).

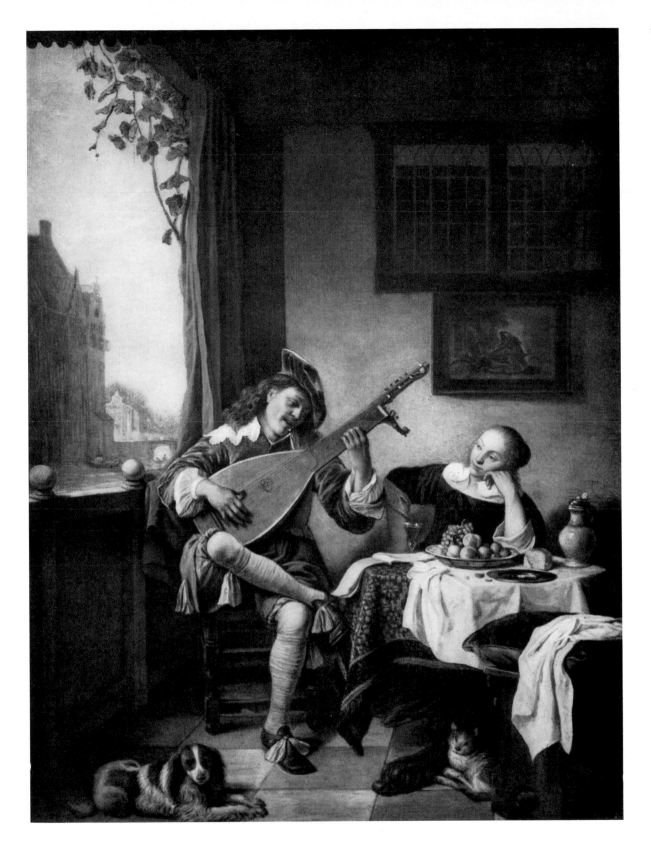

Hendrick Martensz.
Sorgh

THE LUTE-PLAYER

Signed and dated 1661
Wood, 51.5 × 38.5 cm.
Amsterdam, Rijksmuseum
No. 2213.

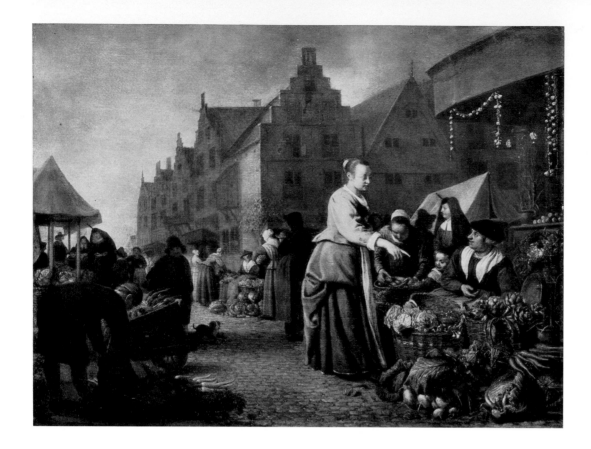

Hendrick Martensz.
Sorgh

THE VEGETABLE MARKET
IN ROTTERDAM

With monogram, dated 1653
Wood, 30×40 cm.
Cassel, Gallery
No. 285.

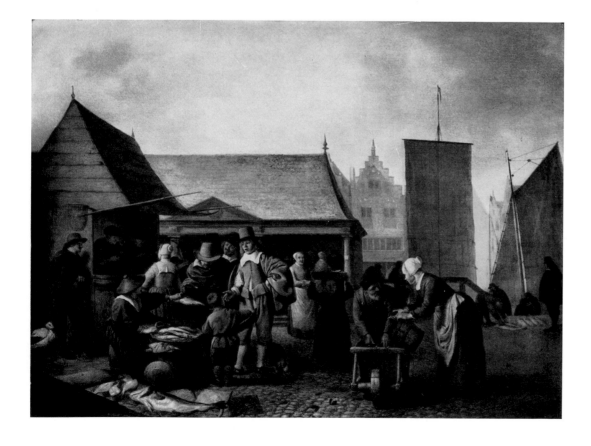

Hendrick Martensz.
Sorgh

THE FISH MARKET

Signed
Wood, 47.5×65 cm.
Amsterdam, Rijksmuseum
No. 2216.

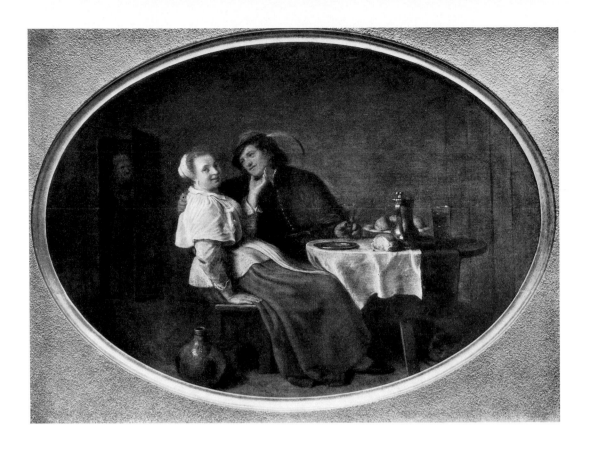

Hendrick Martensz. Sorgh

TWO LOVERS AT TABLE

Wood, 26.4 × 36.4 cm.
London, National Gallery
No. 1056.

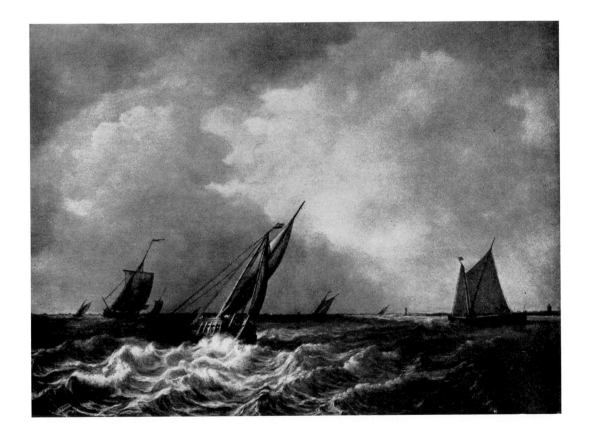

Hendrick Martensz. Sorgh

STORM ON THE MAAS

Signed and dated 1668
Wood, 47.5 × 64.5 cm.
Amsterdam, Rijksmuseum
No. 2215.

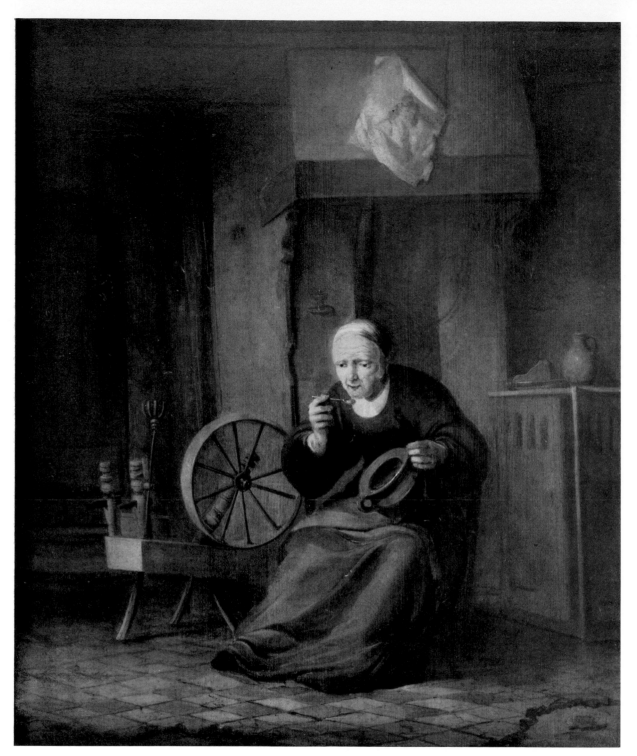

Jacob van Spreeuwen

OLD WOMAN
WITH SPINNING WHEEL

Signed
Wood, 69×58 cm.
Linz, private collection.

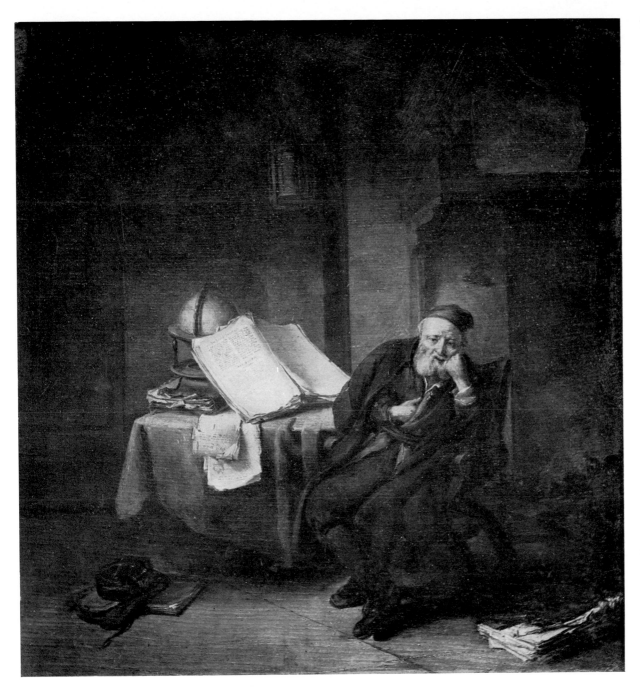

Jacob van Spreeuwen

PHILOSOPHER IN HIS STUDY

Signed and dated 1645
Wood, 35.5 × 32.5 cm.
Amsterdam, Rijksmuseum
No. 2225.

Adriaen van Stalbemt

THE GODS FEASTING
IN A FOREST

Signed and dated 1622
Wood, 51 × 80.5 cm.
Dresden, Gallery
No. 940.

Adriaen van Stalbemt

VILLAGE STREET AND CANAL

Signed and dated 1614
Wood, 30 × 40 cm.
Leipzig, Museum
No. 814.

Pieter Stalpaert

HILLY LANDSCAPE

Signed and dated 1635
Wood, 67.5 × 116 cm.
Amsterdam, Rijksmuseum
No. 2228.

Jan van Staveren

WOMAN SELLING VEGETABLES

Signed and dated 1666
Wood, 40 × 49 cm.
Bremen, private collection.

Jan van Staveren

HERMIT PRAYING

Signed
Wood, 30 × 22 cm.
Berlin, art trade.

Petrus Staverenus

BOY WITH FISH AND SHELLFISH

Canvas, 90×98 cm.
Munich, private collection.

Petrus Staverenus

MAN AT HIS DINNER

Canvas, 83×102 cm.
Amsterdam, art trade.

Jan Steen

THE DOCTOR'S VISIT

Signed
Wood, 60.5 × 48.5 cm.
The Hague, Mauritshuis
No. 168.

Jan Steen

BATHSHEBA RECEIVING
KING DAVID'S LETTER

Signed
Wood, 41.2 × 32.5 cm.
London, art trade.

Jan Steen

The Merry Home-Coming

Signed
Canvas, 68.5 × 99 cm.
Amsterdam, Rijksmuseum
No. 2239.

Jan Steen

Trick-Track Players

Wood, 58 × 68 cm.
Berlin, art trade.

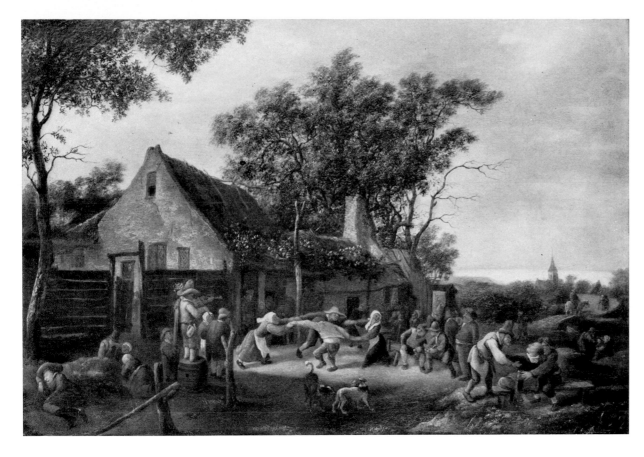

Jan Steen

MERRY-MAKING PEASANTS

Wood, 40 × 58 cm.
The Hague, Mauritshuis
No. 553.

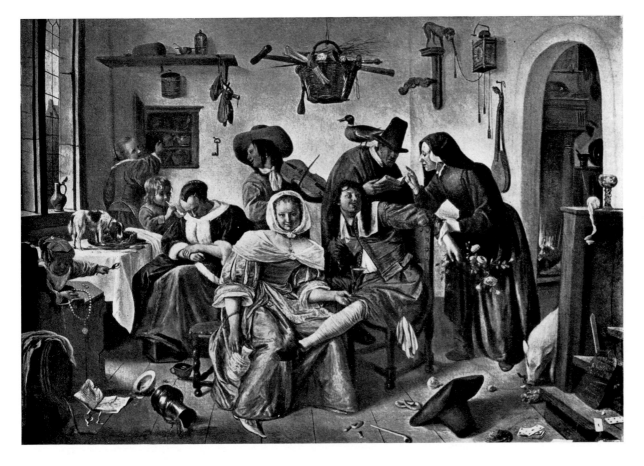

Jan Steen

TOPSY-TURVY WORLD

Signed
Canvas, 105 × 145 cm.
Vienna,
Kunsthistorisches Museum
No. 791.

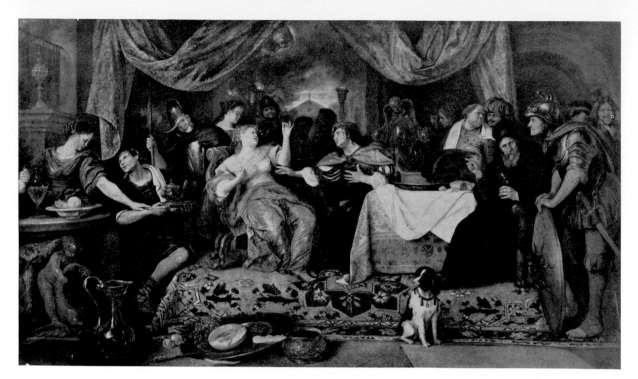

Jan Steen

ANTONY AND CLEOPATRA

Signed
Canvas, 113 × 192 cm.
Amsterdam,
Frederik Muller sale,
15 November 1938
No. 99.

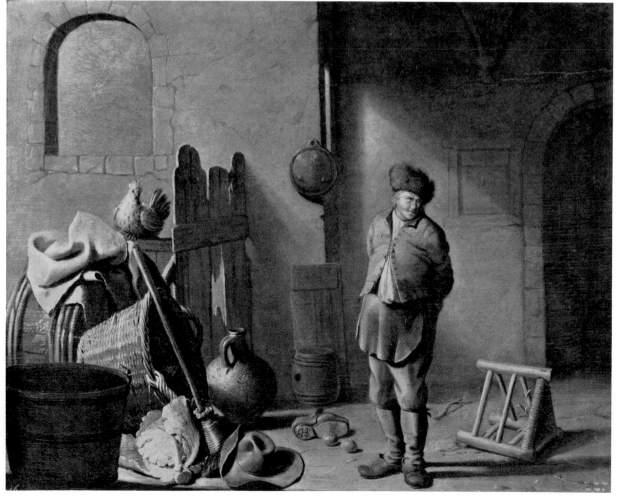

Harmen van Steenwyck

MAN IN A STORE-ROOM

With monogram
Wood, 34.5 × 43 cm.
London, private collection.

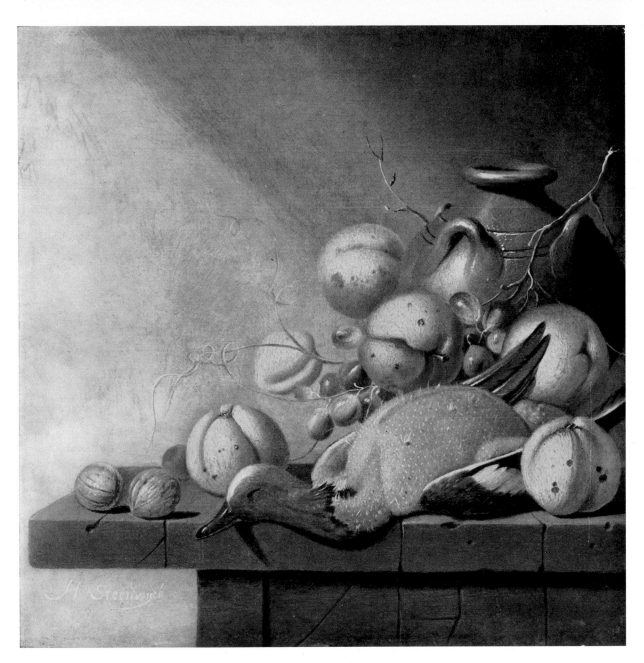

Harmen van Steenwyck

STILL LIFE WITH FRUIT
AND DUCK

Signed
Wood, 24.3 × 24.5 cm.
Frankfurt, Staedel Institute
Inv. 1883.

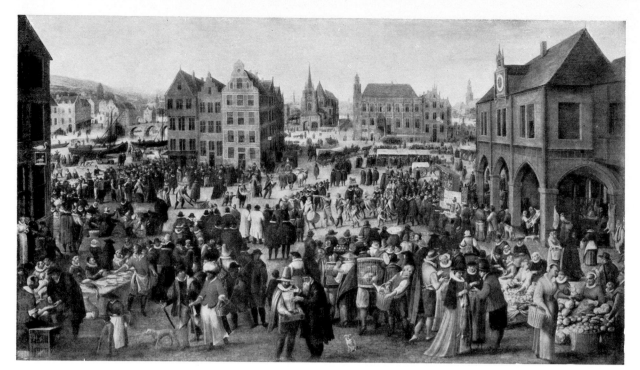

1120

Hendrick
van Steenwyck
the Elder

THE MARKET PLACE
IN AACHEN

Signed and dated 1598
Canvas, 89×152 cm.
Brunswick,
Herzog-Anton-Ulrich Museum
No. 58.

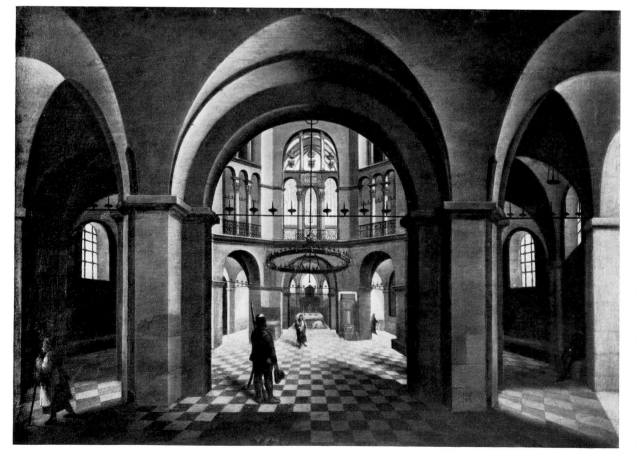

1121

Hendrick
van Steenwyck
the Elder

THE CATHEDRAL OF AACHEN

Signed and dated 1573
Wood, 52×73 cm.
Munich,
Bayerische Staatsgemälde-
sammlungen.

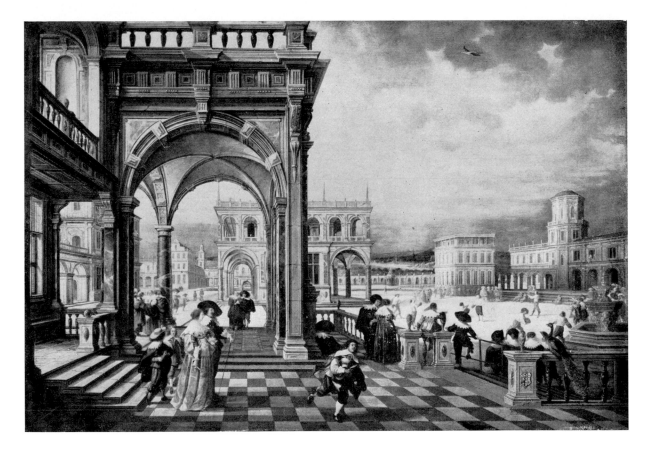

**Hendrick
van Steenwyck
the Younger**

Forecourt of a
Renaissance Palace

Signed and dated 1623
Copper, 54.5 × 80 cm.
Leningrad, Hermitage
No. 432.

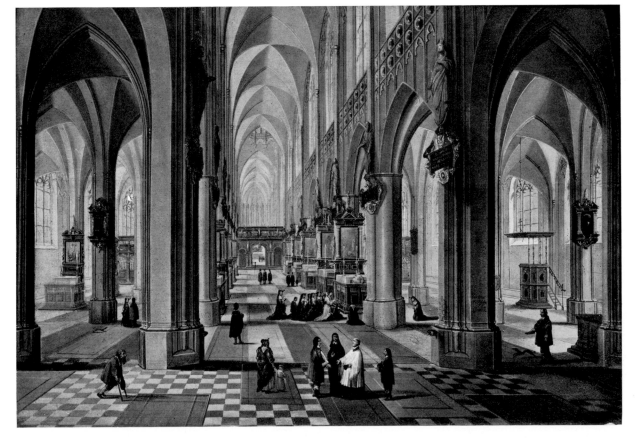

**Hendrick
van Steenwyck
the Younger**

Interior of a
Gothic Church

Signed and dated 1609
Copper, 34.5 × 53.5 cm.
Dresden, Gallery
No. 1184.

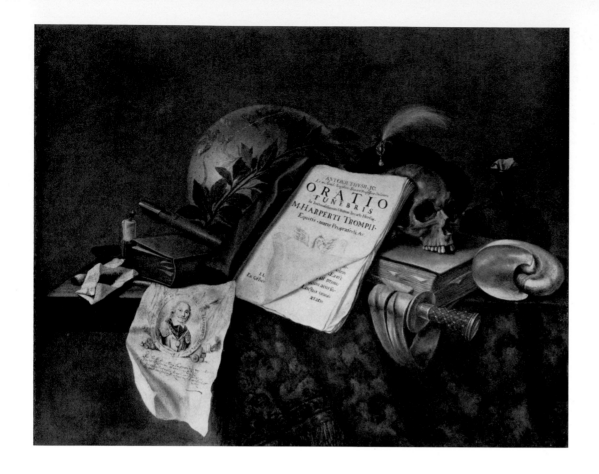

Pieter van Steenwyck

ALLEGORY ON THE DEATH
OF ADMIRAL TROMP (1653)

Signed
Canvas, 79 × 101.5 cm.
Leiden, Lakenhal
No. 409.

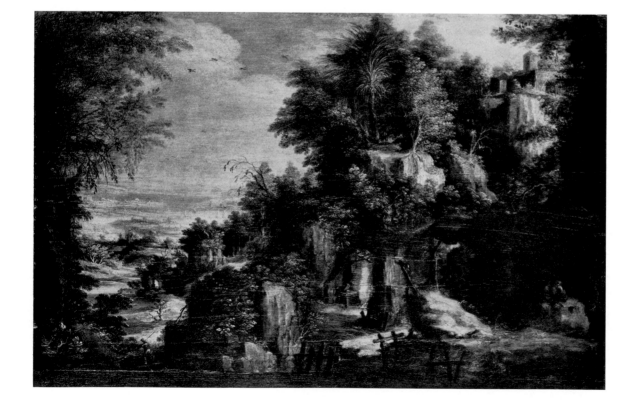

Pieter Stevens

LANDSCAPE WITH HERMIT

Signed and dated 1609
Wood, 47 × 67 cm.
Brunswick,
Herzog-Anton-Ulrich Museum
No. 659.

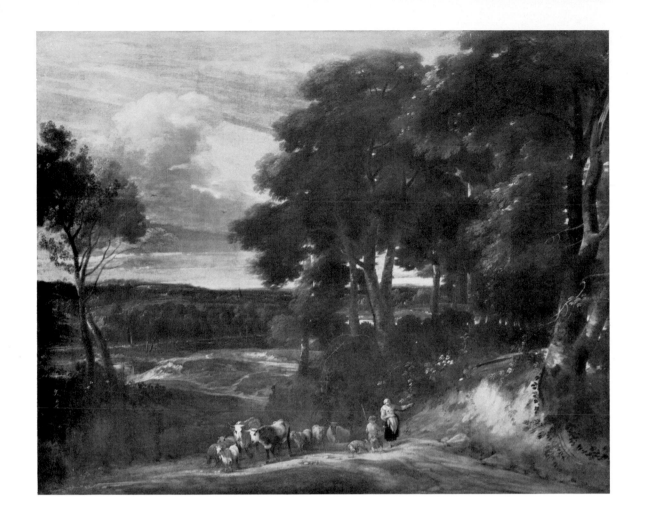

Ignatius van der Stock

LANDSCAPE WITH SHEPHERDS
AND FLOCK

Canvas, 109×132 cm.
Brussels,
Musée Royal des Beaux-Arts
No. 962.

Ignatius van der Stock

THE VIRGIN AND ST. JOSEPH
IN A LANDSCAPE
RETURNING HOME WITH THE
YOUNG CHRIST

Signed and dated 1661
Canvas, 153×268 cm.
Brussels, Church of St. Gudule.

Jan Gerritsz. Stockman

FOREST LANDSCAPE WITH
SWANS ON A RIVER

Signed
Canvas, 61.5 × 84.5 cm.
Munich, art trade.

Jan van der Stoffe

CAVALRY SKIRMISH
NEAR A BRIDGE

Signed and dated 1649
Canvas, 98.5 × 162 cm.
Brunswick,
Herzog-Anton-Ulrich Museum
No. 565.

Dirck Stoop

TRAVELLERS WITH HORSES
AND DOGS

Signed
Wood, 38.5 × 51 cm.
Munich, art trade.

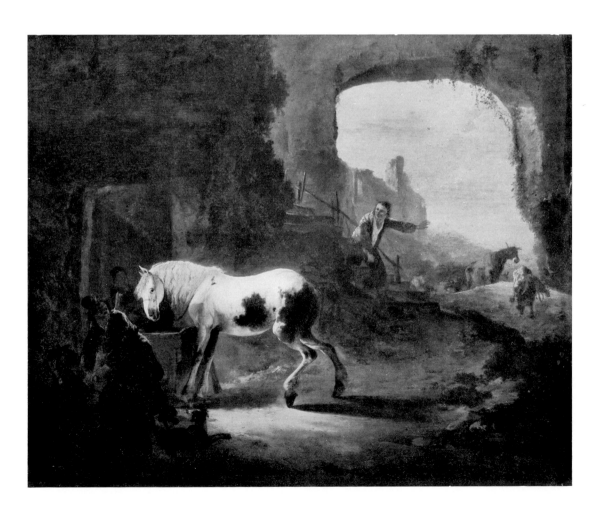

Dirck Stoop

WHITE HORSE AT A FOUNTAIN

Wood, 45 × 54.5 cm.
Munich, art trade.

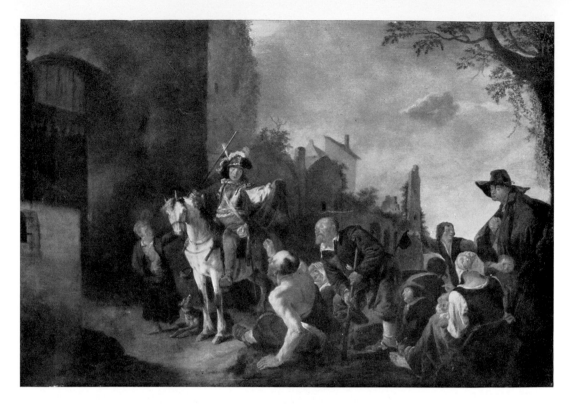

Maerten Stoop

St. Martin and the Beggars

Signed
Wood, 58×86 cm.
Utrecht, Central Museum
No. 181.

Maerten Stoop

Merry Company

Signed
Wood, 59×65 cm.
St. Gilgen,
F. C. Butôt collection.

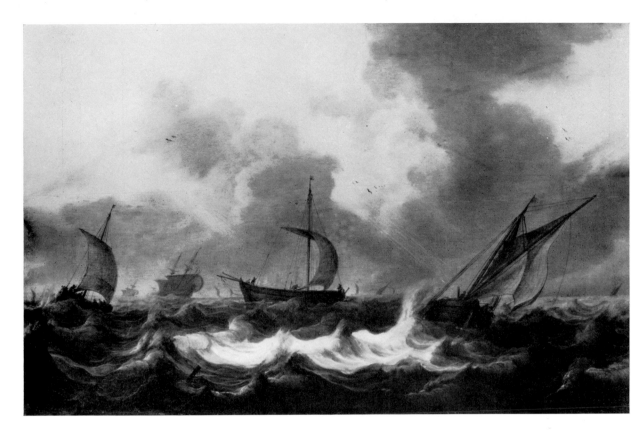

Cornelis Stooter

ROUGH SEA WITH
FISHING BOATS

Signed
Wood, 40×60.5 cm.
Constance, art trade.

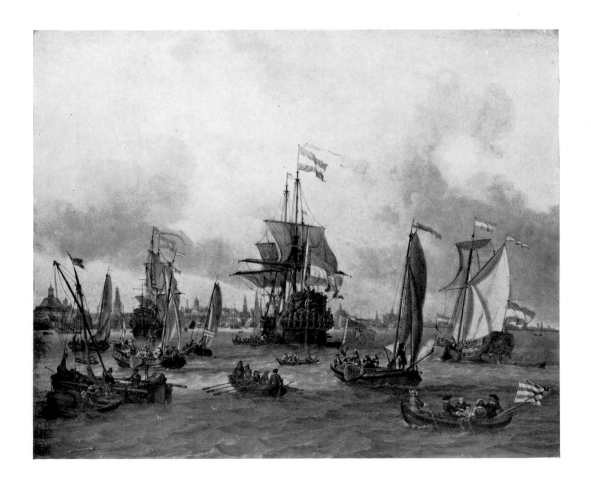

Abraham Storck

THE HARBOUR OF AMSTERDAM

Signed and dated 1689
Canvas, 71×85.5 cm.
Dresden, Gallery
No. 1673.

Abraham Storck

MEDITERRANEAN HARBOUR

Signed and dated
Wood, 29 × 37 cm.
Frankfurt, private collection.

Jacobus Storck

RIVER WITH BOATS

Signed and dated 1693
Canvas, 74.5 × 102 cm.
Copenhagen,
Royal Museum of Fine Arts
No. 692.

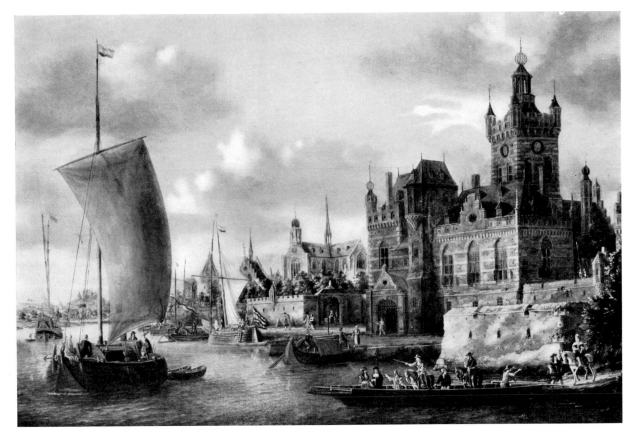

Jacobus Storck

HAREOUR SCENE WITH FERRY

Signed
Canvas, 62×93 cm.
Cologne, art trade.

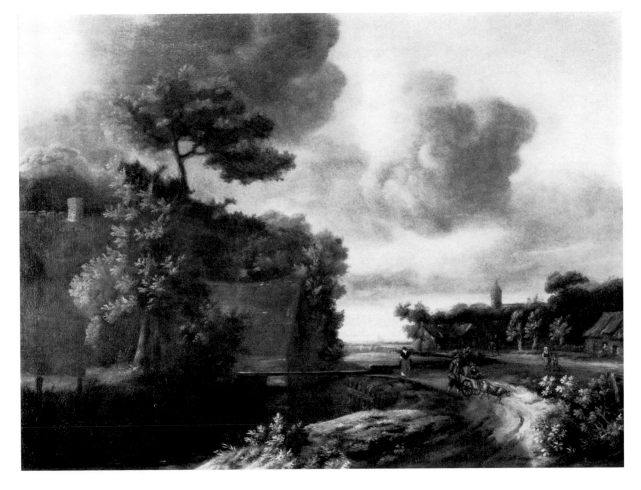

Lambert van Straaten

LANDSCAPE WITH CANAL

Signed and dated 1691
Canvas, 80×106 cm.
Constance, art trade.

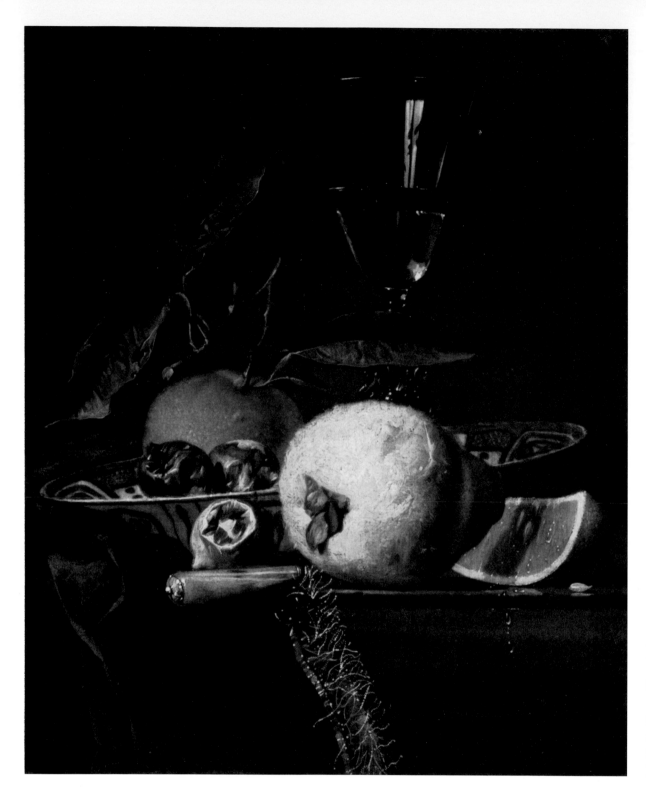

Hendrik van Streeck

STILL LIFE

Signed
Canvas, 40×33 cm.
St. Gilgen,
F. C. Butôt collection.

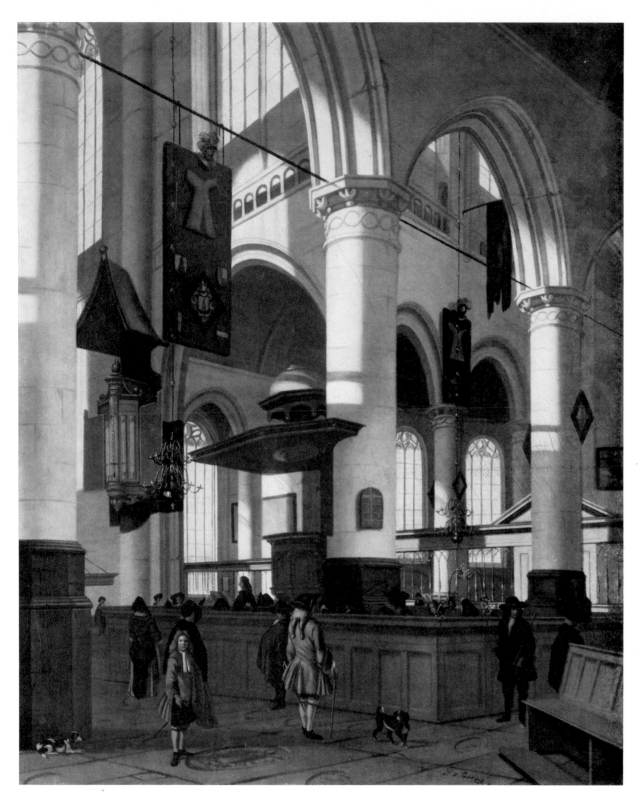

Hendrick van Streeck

INTERIOR OF A CHURCH

Signed
Canvas, 70×56 cm.
Amsterdam,
Historical Museum.

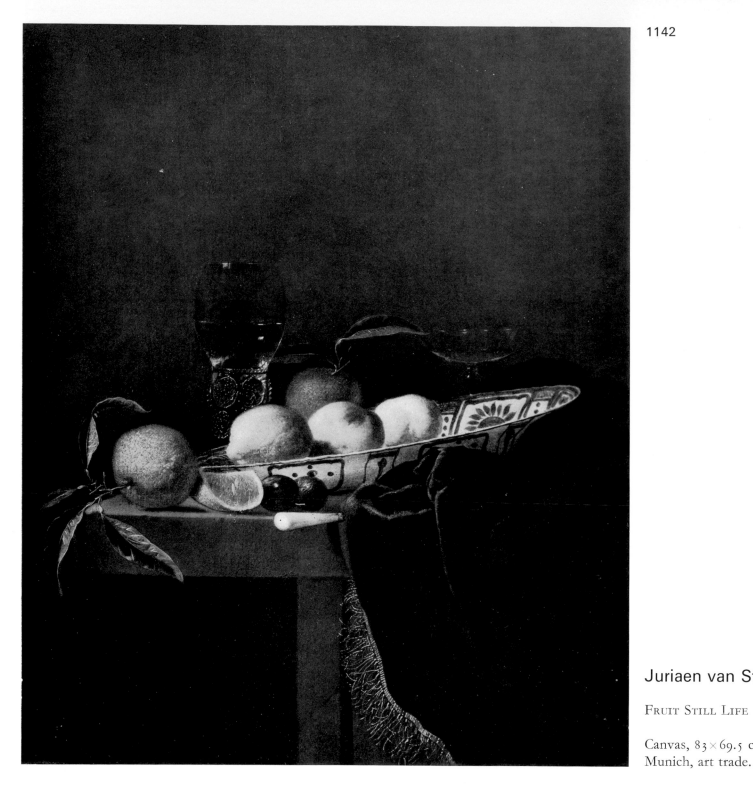

Juriaen van Streeck

FRUIT STILL LIFE

Canvas, 83 × 69.5 cm.
Munich, art trade.

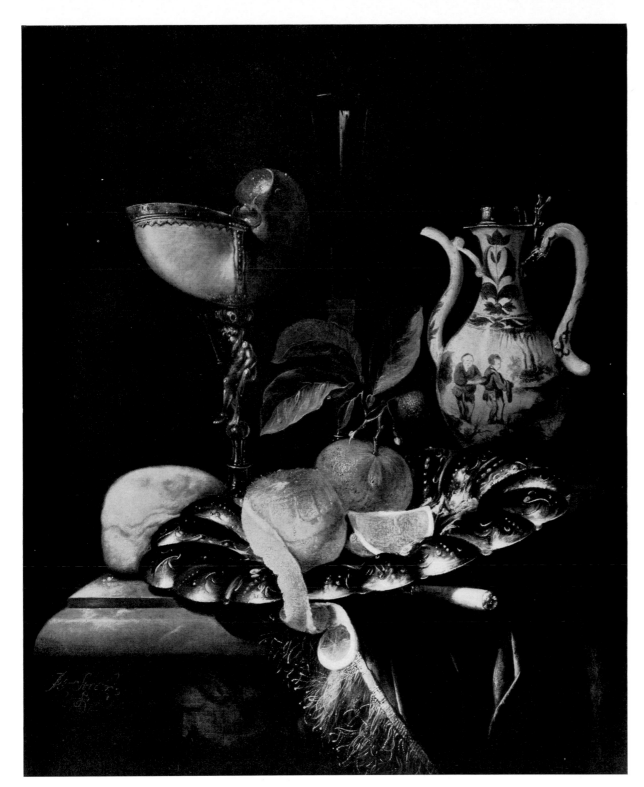

Juriaen van Streeck

STILL LIFE

Signed
Canvas, 70×57 cm.
Sarasota (Florida),
John and Mable Ringling
Museum of Art.
No. 290.

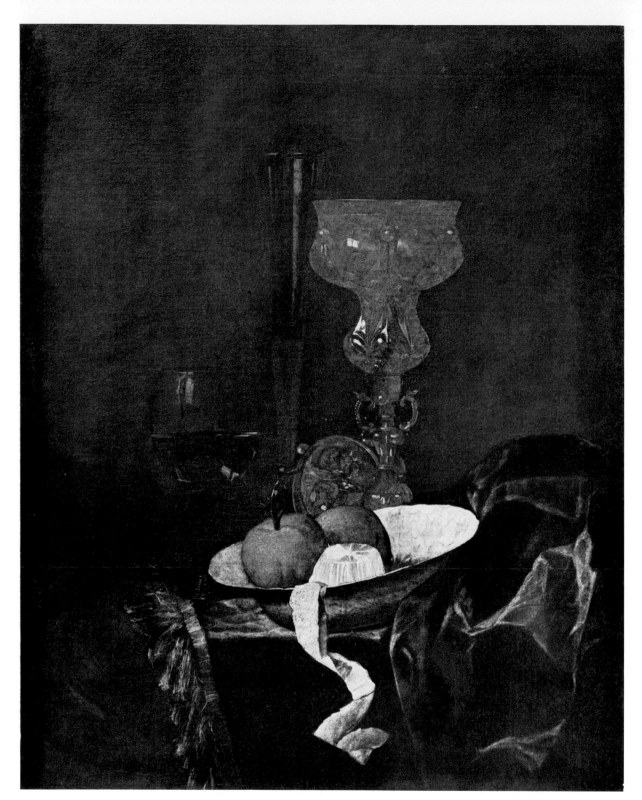

Christian Striep

<small>Breakfast Still Life</small>

Canvas, 78.5 × 60.8 cm.
Vienna,
Kunsthistorisches Museum
No. 1372.

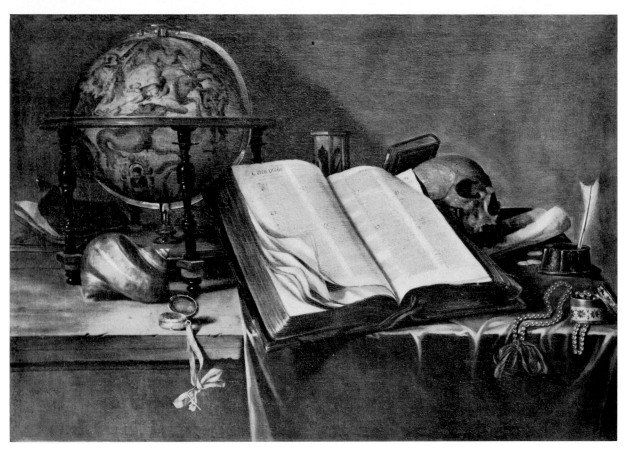

Abraham Susenier

VANITAS STILL LIFE

With monogram, dated 1664
Canvas, 75 × 86 cm.
Gotha, Gallery
No. 173.

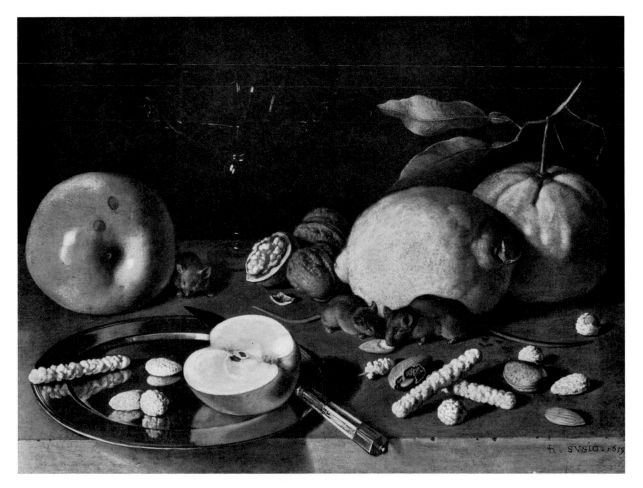

Ludovico de Susio

STILL LIFE

Signed and dated 1619
Wood, 35 × 46.5 cm.
St. Louis (Missouri),
City Art Museum.

Reyer Claesz. Suycker

LANDSCAPE WITH
VIEW OF LEIDEN

With monogram, dated 1624
Wood, 28.8×51 cm.
Bielefeld, private collection.

1148

Jacob Isaacsz. Swanenburgh

VIEW OF THE CASTLE
ST. ANGELO IN ROME

With monogram, 1604
Wood, 48×60 cm.
Formerly Petersburg,
Semenov collection.

Jacob Isaacsz. Swanenburgh

Procession in St. Peter's Square, Rome

Signed and dated 1628
Wood, 57.5 × 109 cm.
Copenhagen,
Royal Museum of Fine Arts
No. 693.

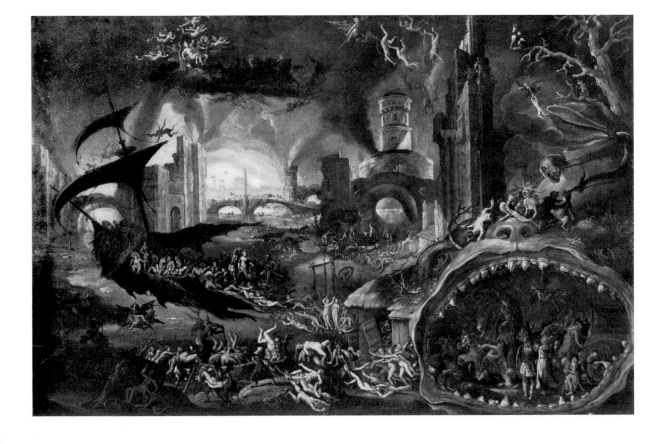

Jacob Isaacsz. Swanenburgh

Inferno

Canvas, 102 × 151 cm.
Brussels, private collection.

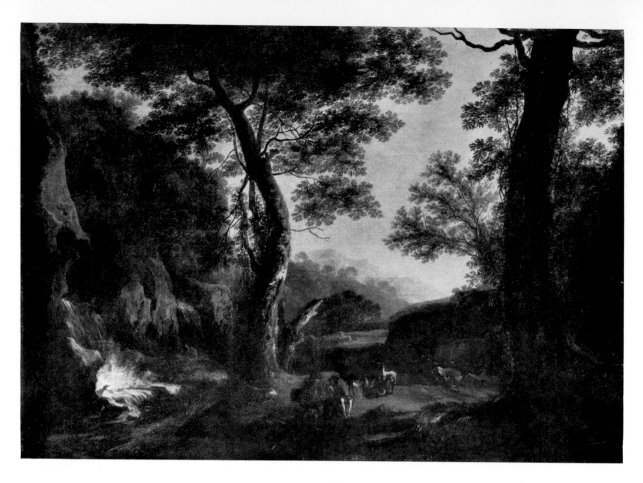

Herman van Swanevelt

LARGE ITALIAN LANDSCAPE
WITH SHEPHERDS

Canvas, 96 × 130 cm.
Brunswick,
Herzog-Anton-Ulrich Museum
No. 346.

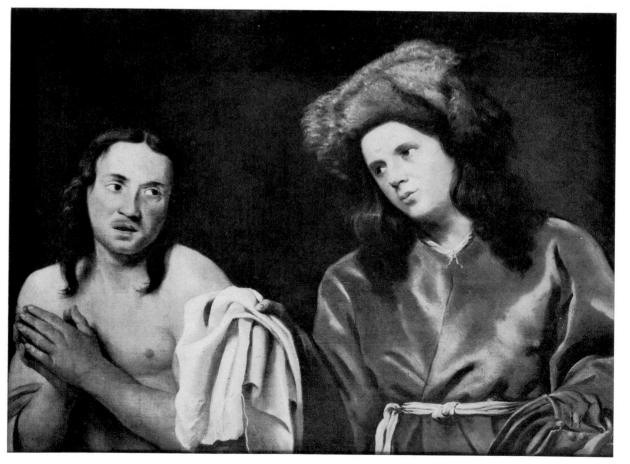

Michiel Sweerts

CLOTHING THE NAKED

Canvas, 102 × 116 cm.
Pommersfelden,
Schönborn Gallery
No. 562.

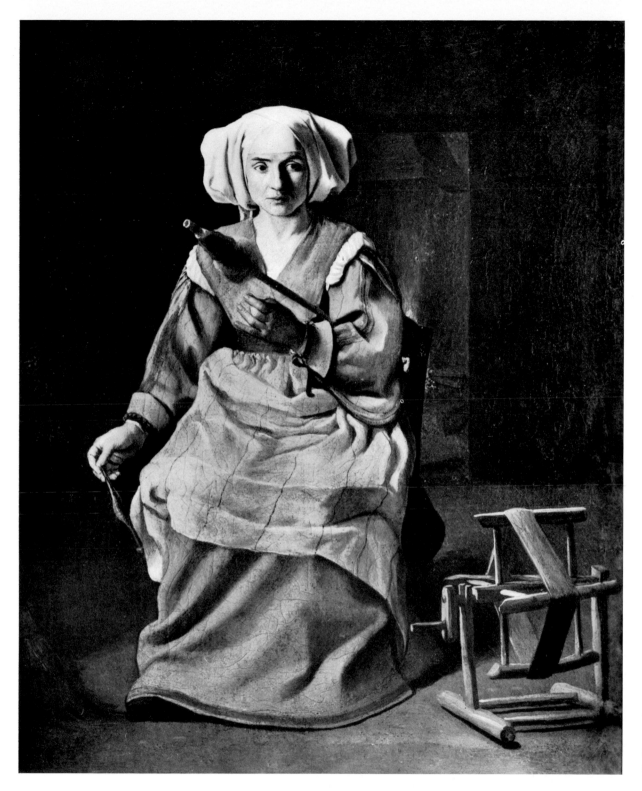

Michiel Sweerts

WOMAN SPINNING

Canvas, 52.5 × 42.5 cm.
Gouda, Municipal Museum.

1154

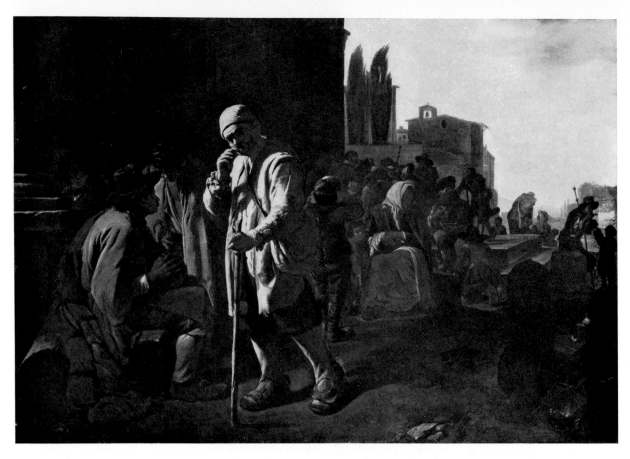

Michiel Sweerts

FEEDING THE HUNGRY

Canvas, 75 × 99 cm.
Amsterdam, Rijksmuseum
No. 2282 A2.

1155

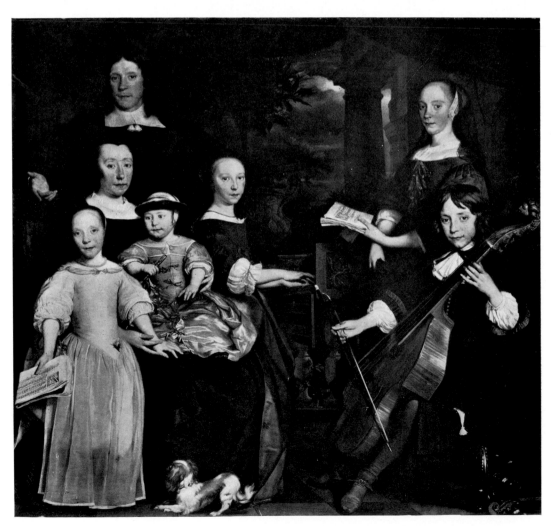

Abraham
van den Tempel

DAVID LEEUW
AND HIS FAMILY

Signed and dated 1671
Canvas, 190 × 200 cm.
Amsterdam, Rijksmuseum
No. 2289.

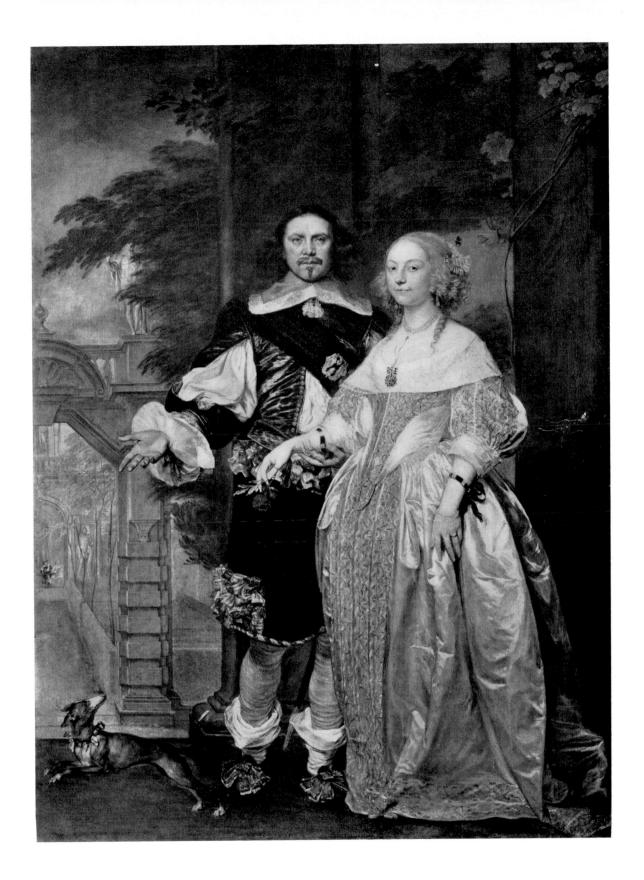

Abraham van den Tempel

A Nobleman and his Wife in a Park

Canvas, 236×172 cm.
Berlin, Staatliche Museen
No. 858.

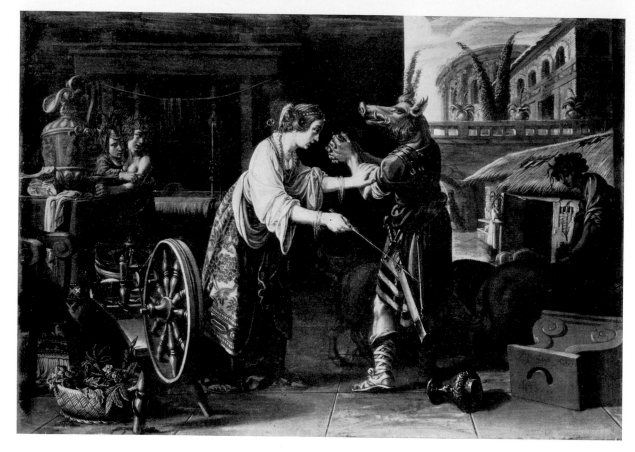

1157

Jan Tengnagel

CIRCE

Signed and dated 1612
Wood, 46.5 × 66.5 cm.
Basle, private collection.

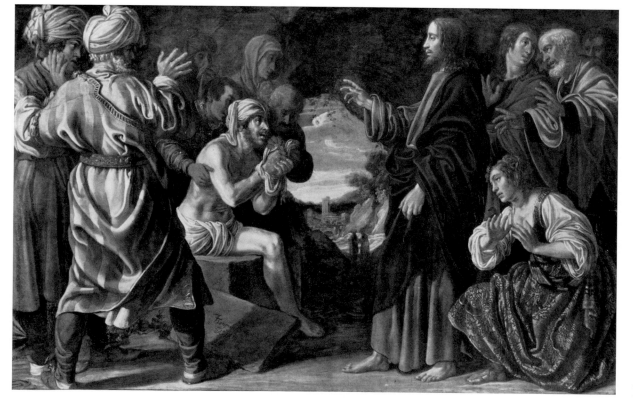

1158

Jan Tengnagel

THE RAISING OF LAZARUS

Signed and dated 1615
Wood, 90 × 139 cm.
Copenhagen,
Royal Museum of Fine Arts
No. 694a.

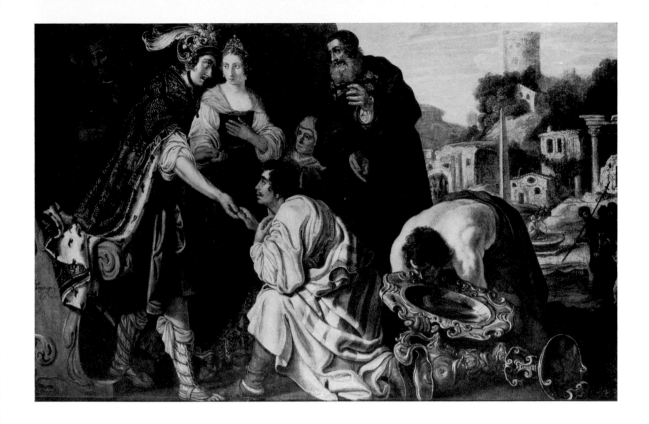

Jan Tengnagel

BIBLICAL SCENE

Signed and dated 1613
Canvas, 108 × 165 cm.
The Hague, private collection.

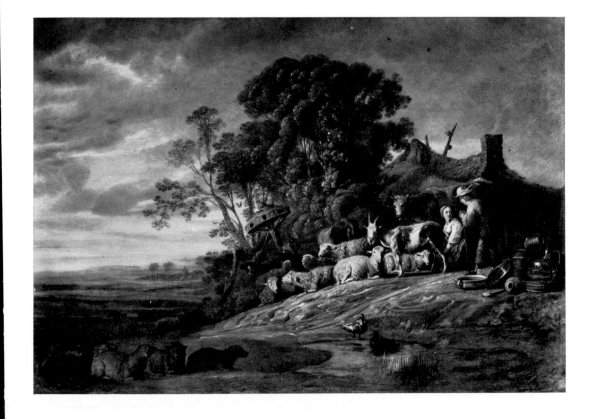

David Teniers

LANDSCAPE WITH SHEPHERDS
AND FLOCK

Signed
Wood, 53.5 × 70.5 cm.
Munich, art trade.

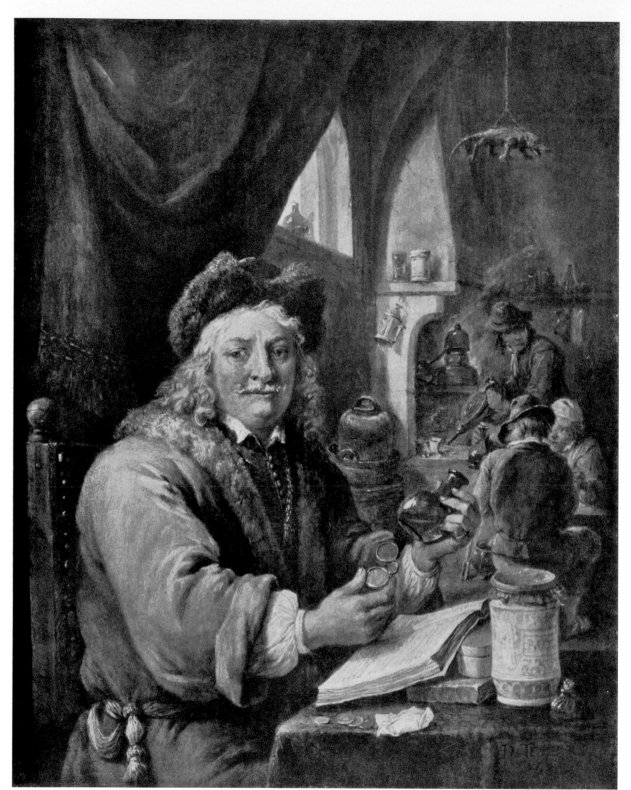

David Teniers

THE ALCHEMIST

Signed and dated 1680
Wood, 24.8 × 19.5 cm.
Munich,
Bayerische Staatsgemälde-
sammlungen
No. 906.

1162

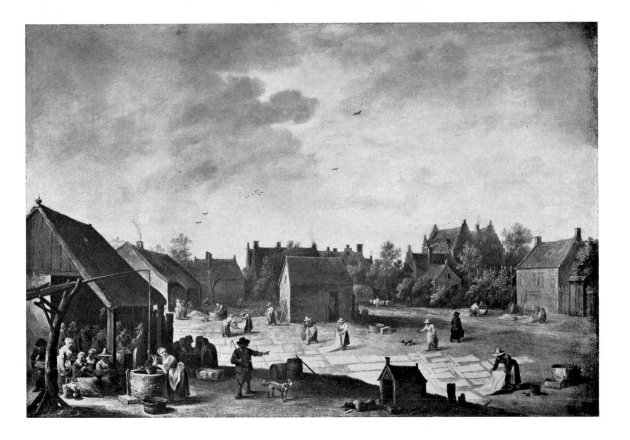

David Teniers

BLEACHING-GROUND

Signed
Wood, 48.5 × 69.5 cm.
Dresden, Gallery
No. 1067.

1163

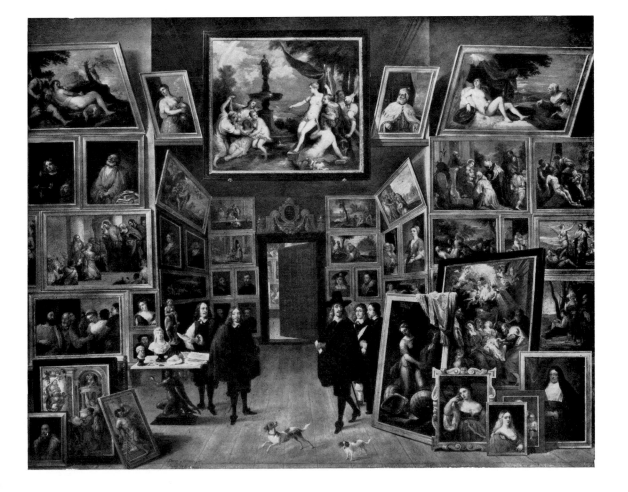

David Teniers

THE PICTURE GALLERY OF THE
ARCHDUKE LEOPOLD WILHELM
IN BRUSSELS

Signed
Copper, 106 × 129 cm.
Madrid, Prado
No. 1813.

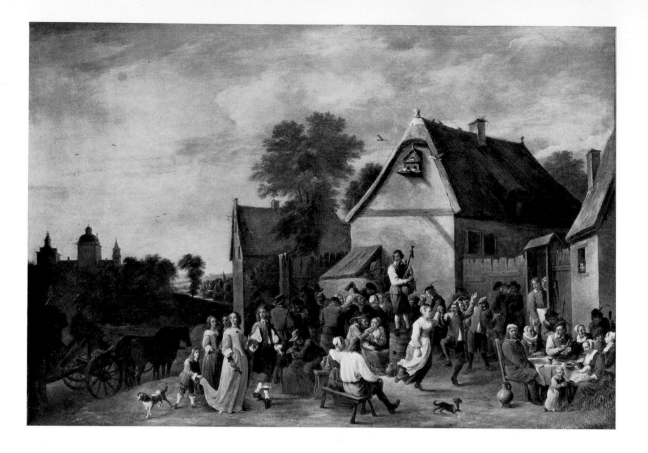

David Teniers

FLEMISH KERMESSE

Signed and dated 1652
Canvas, 157 × 221 cm.
Brussels,
Musée Royal des Beaux-Arts
No. 457.

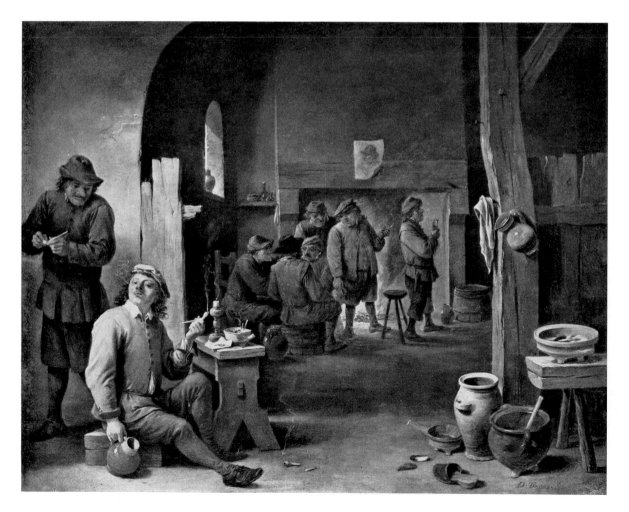

David Teniers

PEASANTS SMOKING AND
DRINKING IN AN INN

Signed and dated 1650
Wood, 35 × 44 cm.
Munich, private collection.

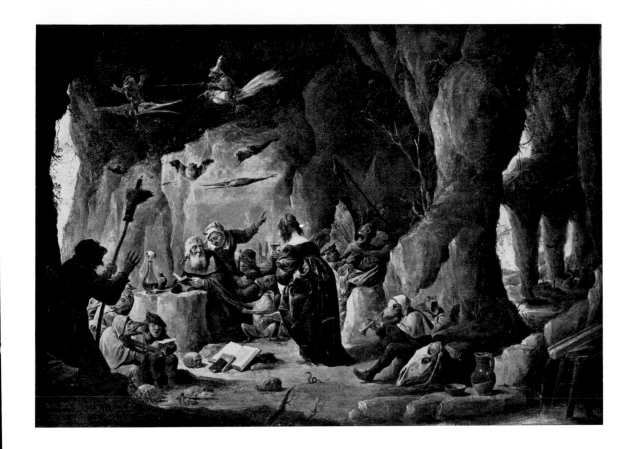

David Teniers

THE TEMPTATION OF
ST. ANTHONY

Signed
Copper, 54×74.5 cm.
Brussels,
Musée Royal des Beaux-Arts
No. 459.

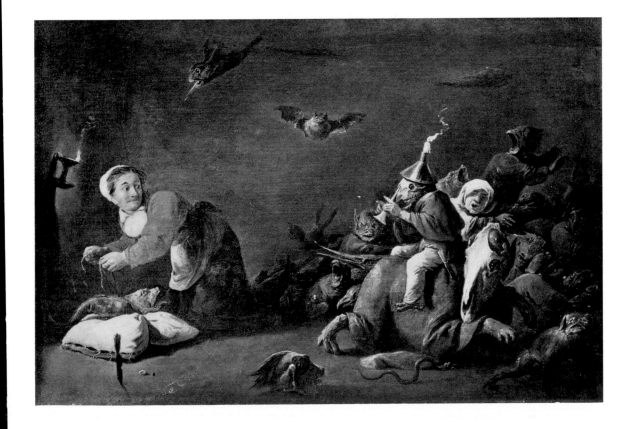

David Teniers

WOMEN FRIGHTENED
BY DEMONS

Signed
Wood, 31×46 cm.
Munich, Alte Pinakothek
No. 919.

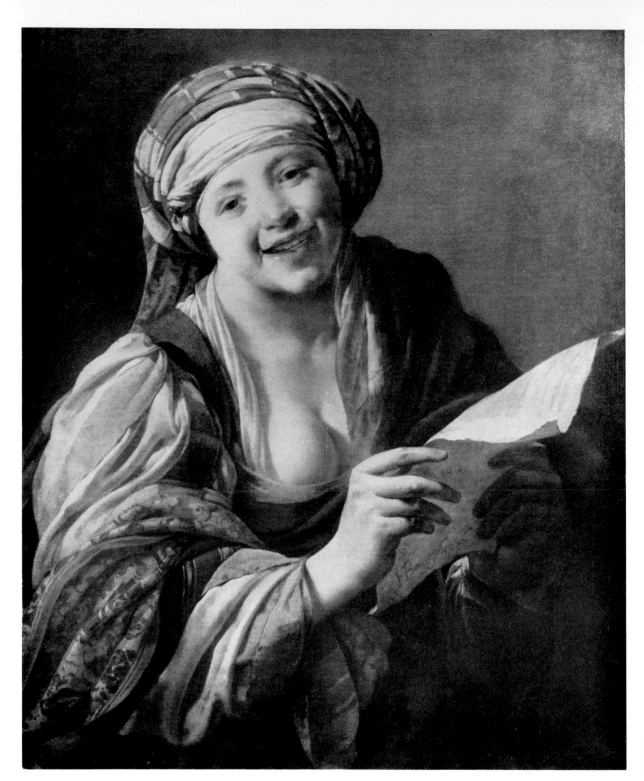

Hendrick Terbrugghen

The Street-Singer

Signed and dated 1628
Canvas, 79×66 cm.
Basle, Kunstmuseum
No. 611.

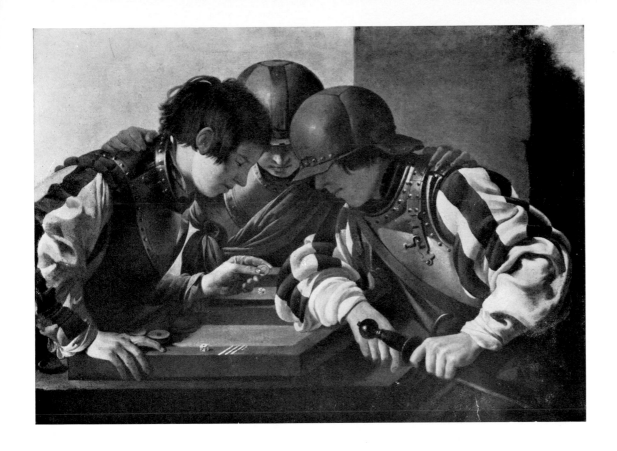

Hendrick Terbrugghen

THE TRICK-TRACK PLAYERS

Signed
Canvas, 85.5×115 cm.
Utrecht, Central Museum
No. 43.

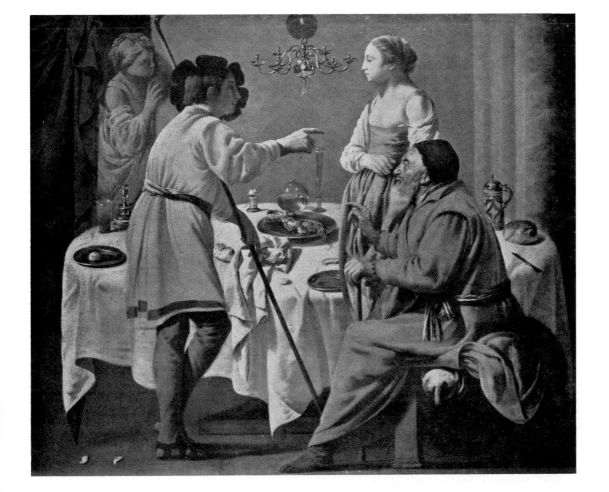

Hendrick Terbrugghen

JACOB, LABAN AND LEAH

Signed and dated 1627
Canvas, 98×115 cm.
London, National Gallery
No. 4164.

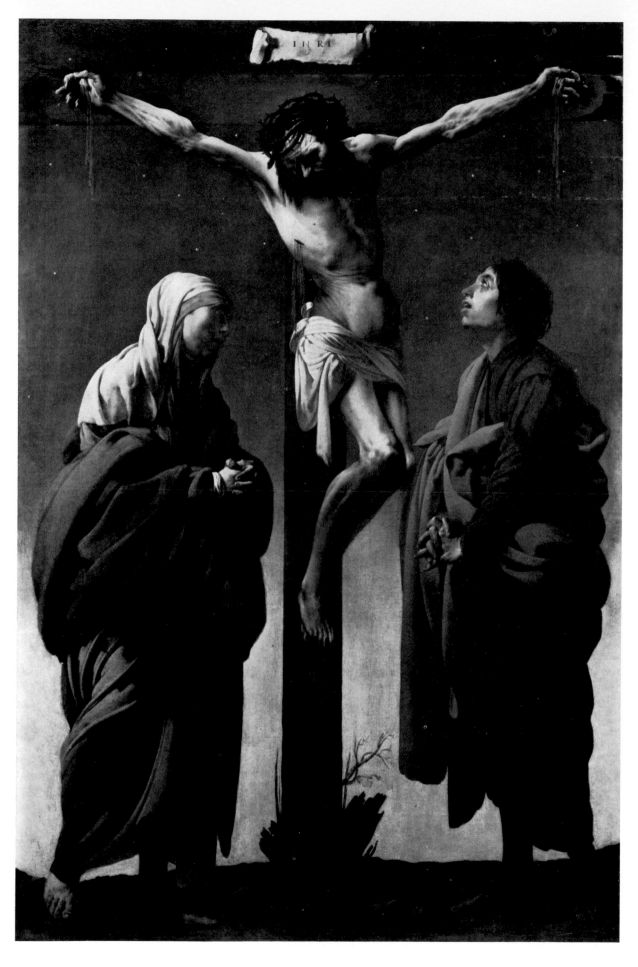

Hendrick Terbrugghen

THE CRUCIFIXION

Signed and dated 1620
Canvas, 154 × 102 cm.
New York,
Metropolitan Museum of Art.

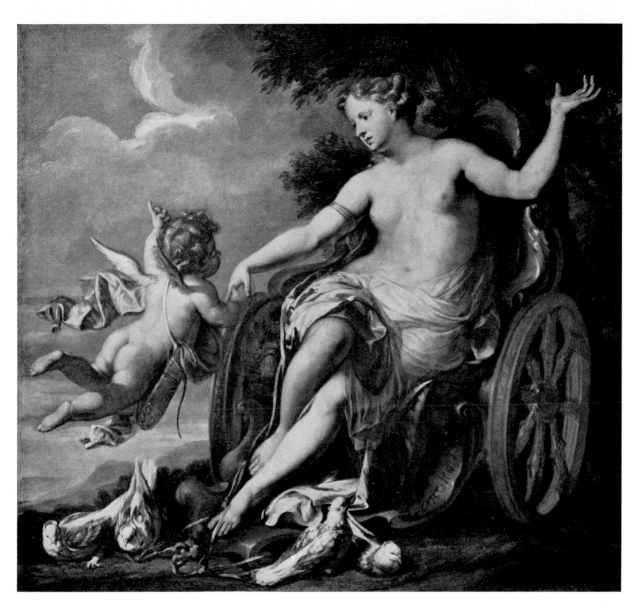

Augustin Terwesten

VENUS AND CUPID

Signed
Canvas, 117×124 cm.
Brunswick,
Herzog-Anton-Ulrich Museum
No. 295.

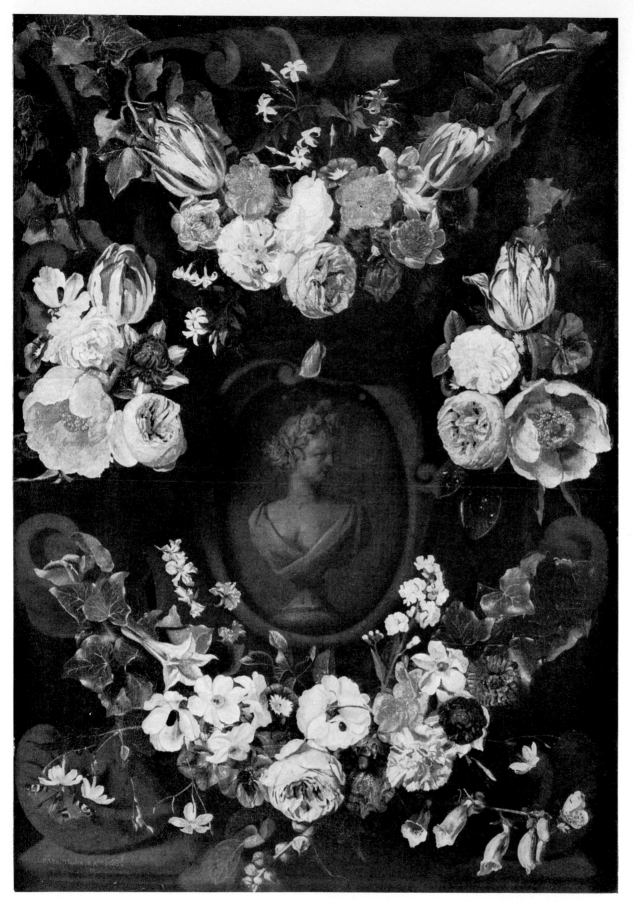

Jan van Thielen

FLOWER GARLANDS
ROUND A BUST OF FLORA

Signed and dated 1665
Canvas, 95 × 65 cm.
Amsterdam, Rijksmuseum
No. 2301.

Gerard Thomas

The Surgery

Canvas, 67 × 84 cm.
Vienna,
Dorotheum,
Graf Brunsvik sale,
25 November 1902.

1175

Theodor van Thulden

Music

With monogram, dated 1636
Canvas.

Theodor van Thulden

MADONNA AND CHILD
BLESSING FLANDERS,
BRABANT AND HAINAULT

Signed and dated 1654
Canvas, 197×177 cm.
Vienna,
Kunsthistorisches Museum
No. 881.

Pieter Thys

PORTRAIT OF THE PAINTER
DAVID TENIERS

Wood, 29 × 24 cm.
Munich, Alte Pinakothek
No. 931.

Pieter Thys

THE TEMPTATION OF
ST. ANTHONY

Signed
Canvas, 253 × 185 cm.
Ghent, Musée des Beaux-Arts
No. S-36.

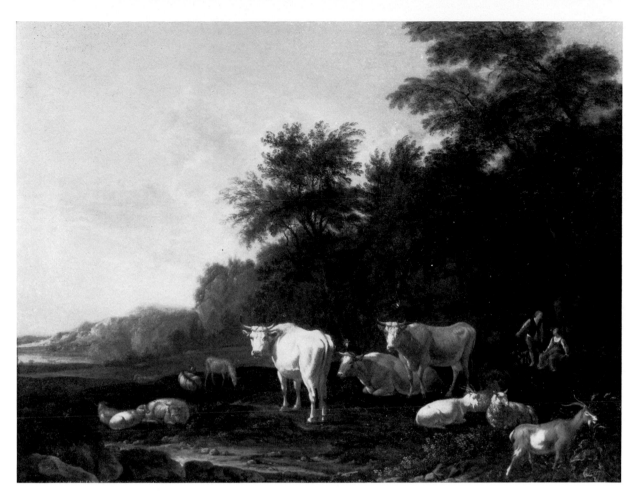

Lodewyck Tieling

LANDSCAPE WITH CATTLE

Signed
Canvas, 67 × 86 cm.
London, art trade.

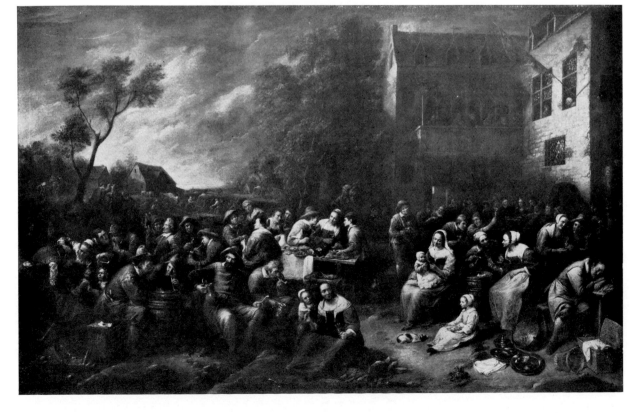

Gillis van Tilborgh

FLEMISH PEASANT WEDDING

Signed
Canvas, 128 × 196 cm.
Dresden, Gallery
No. 1098.

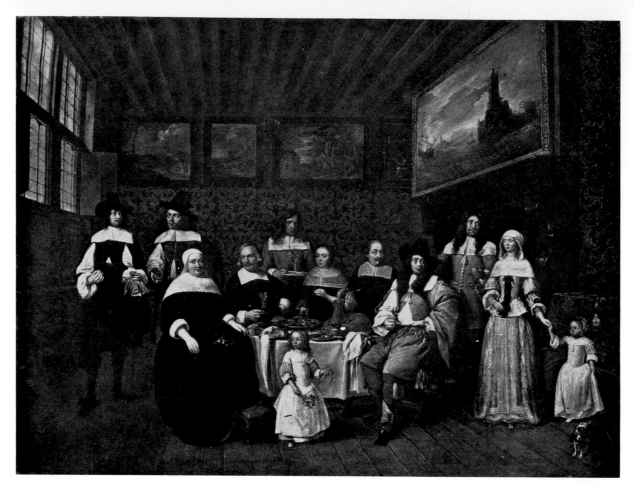

Gillis van Tilborgh

A Family Dinner

Signed
Canvas, 80×104 cm.
The Hague, Mauritshuis
No. 262.

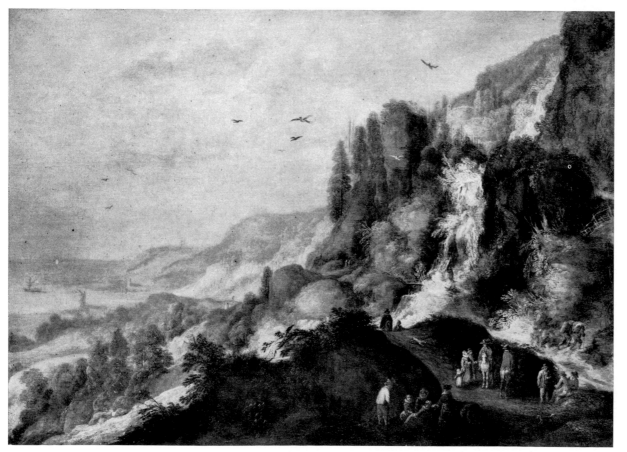

Jan Tilens

Mountain Landscape
with a View of the Sea

Wood, 44×61 cm.
Brunswick,
Herzog-Anton-Ulrich Museum
No. 69.

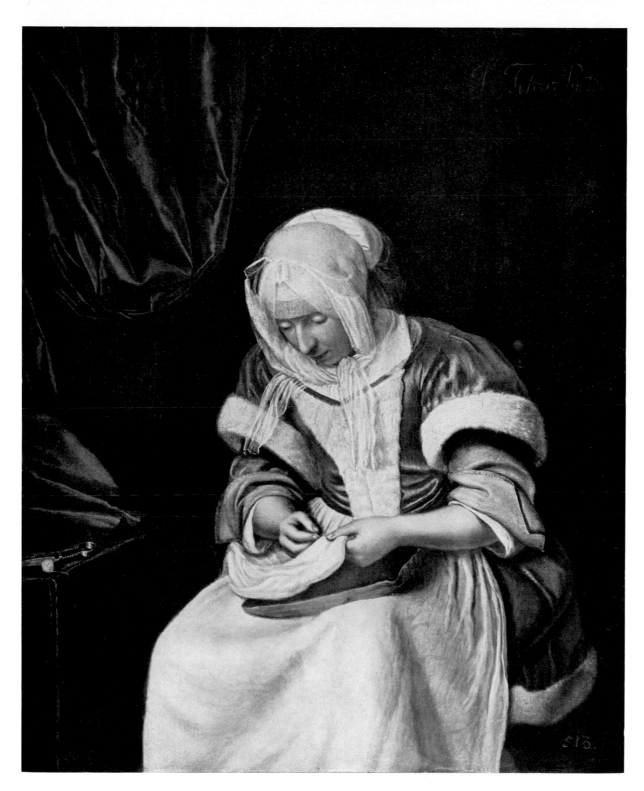

Jan Tilius

WOMAN SEWING

Signed and dated 1681
Wood, 25.5 × 20.5 cm.
Dresden, Gallery
No. 1355.

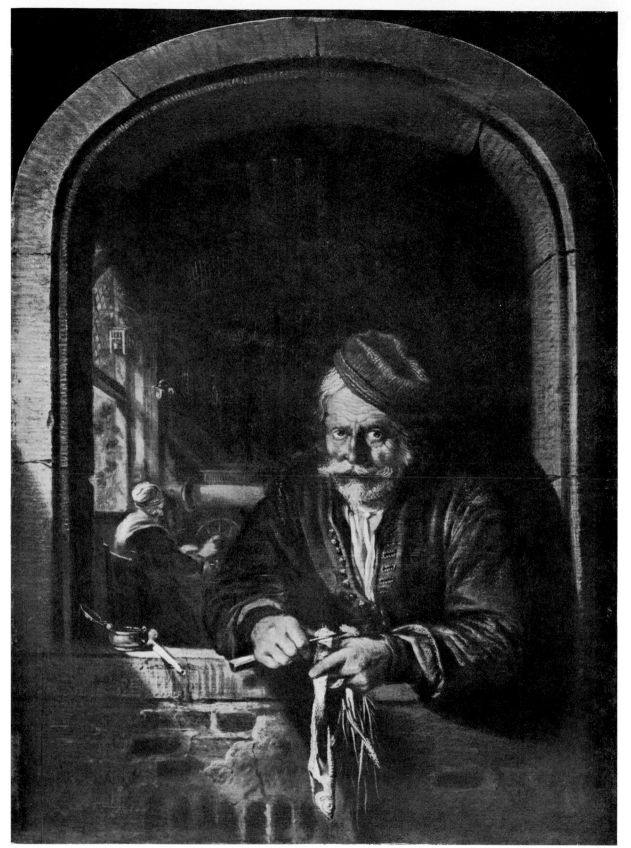

Dominicus van Tol

MAN PREPARING A HERRING

Signed
Wood, 26 × 19 cm.
Dresden, Gallery
No. 1755.

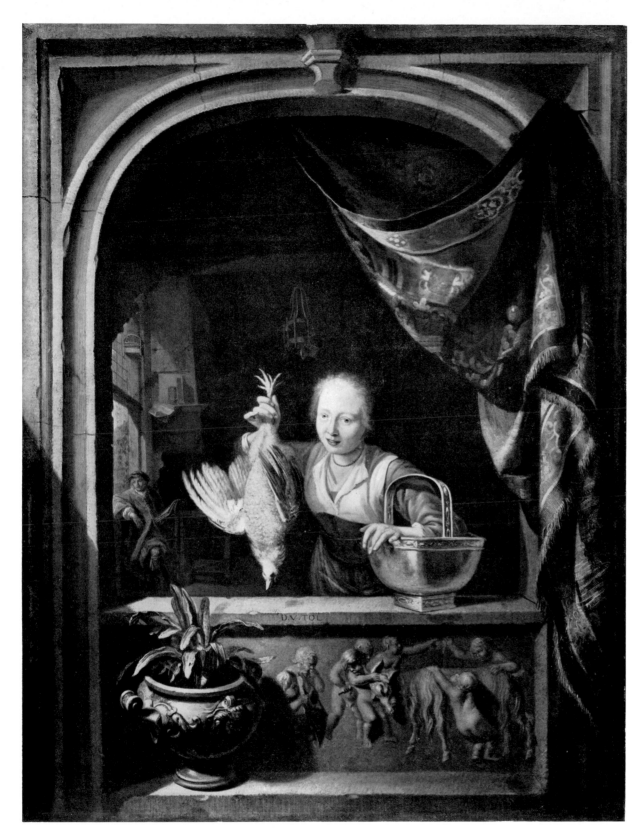

Dominicus van Tol

GIRL HOLDING A CHICKEN

Signed
Wood, 49×37 cm.
Cassel, Gallery
No. 259.

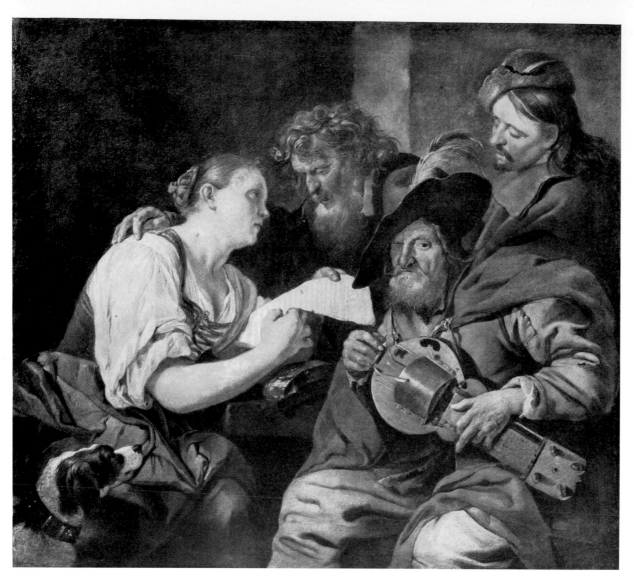

Jacob Toorenvliet

FOUR MUSICIANS

Signed and dated 1678
Copper, 28.5 × 31.5 cm.
Dresden, Gallery
No. 1757.

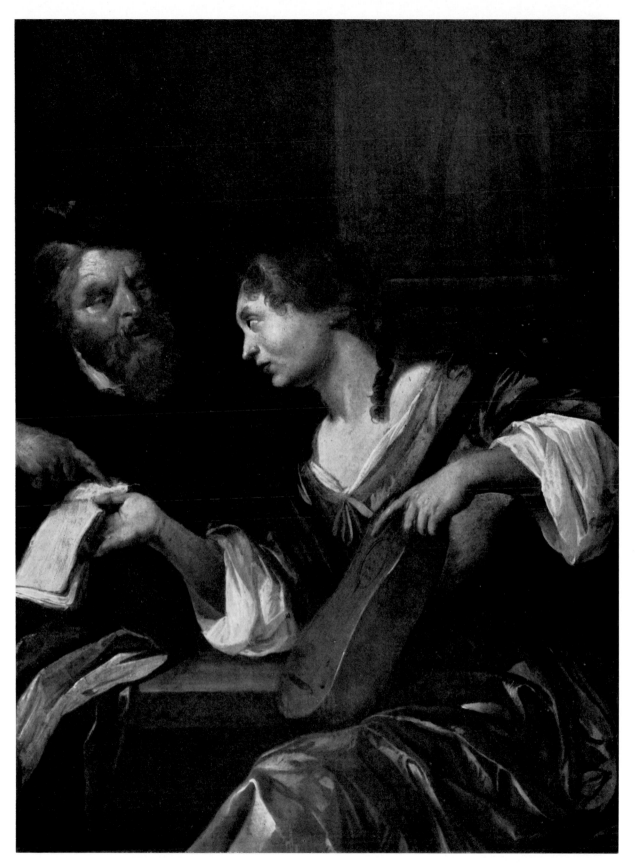

Jacob Toorenvliet

THE MUSIC LESSON

Signed
Wood, 27×20 cm.
Amsterdam, Rijksmuseum
No. 2311.

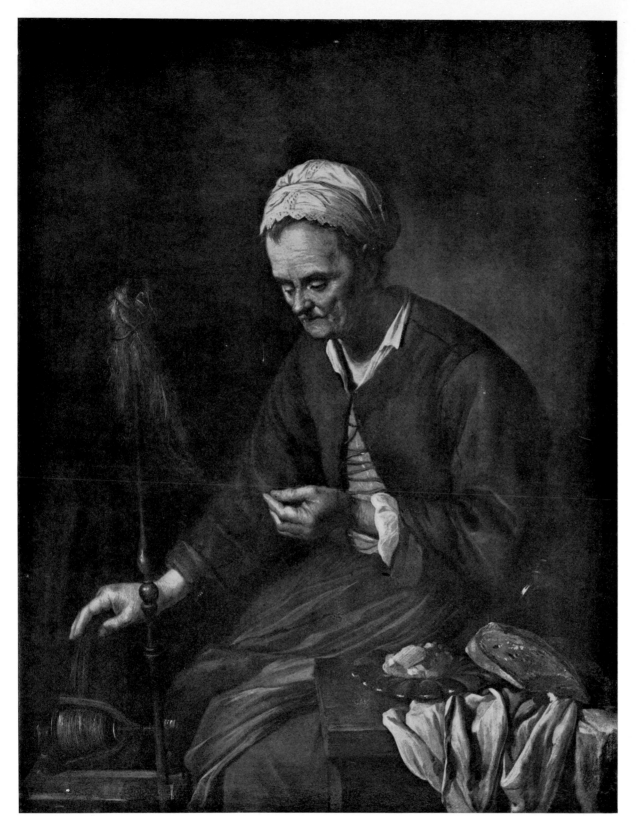

Jacob Toorenvliet

OLD PEASANT WOMAN
WITH DISTAFF

Signed and dated 1667
Copper, 33 × 25 cm.
Karlsruhe, Kunsthalle
No. 271.

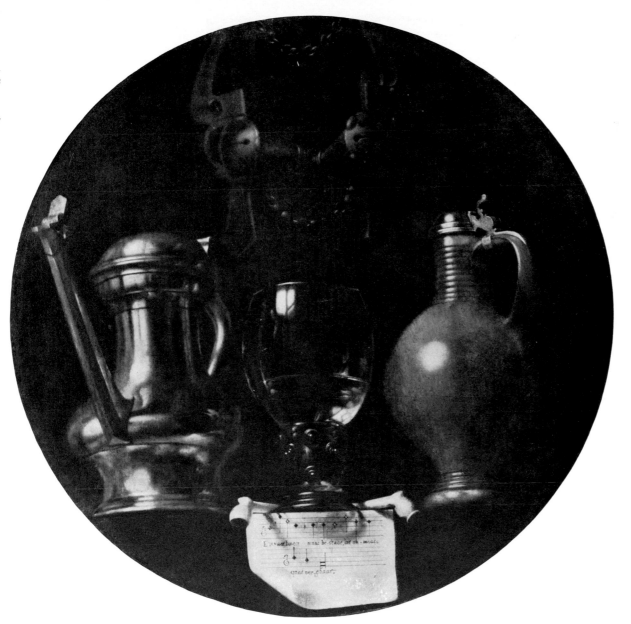

Johannes Torrentius

STILL LIFE

With monogram, dated 1614
Wood, 52 × 50.5 cm.
Amsterdam, Rijksmuseum
No. 2311 D 1.

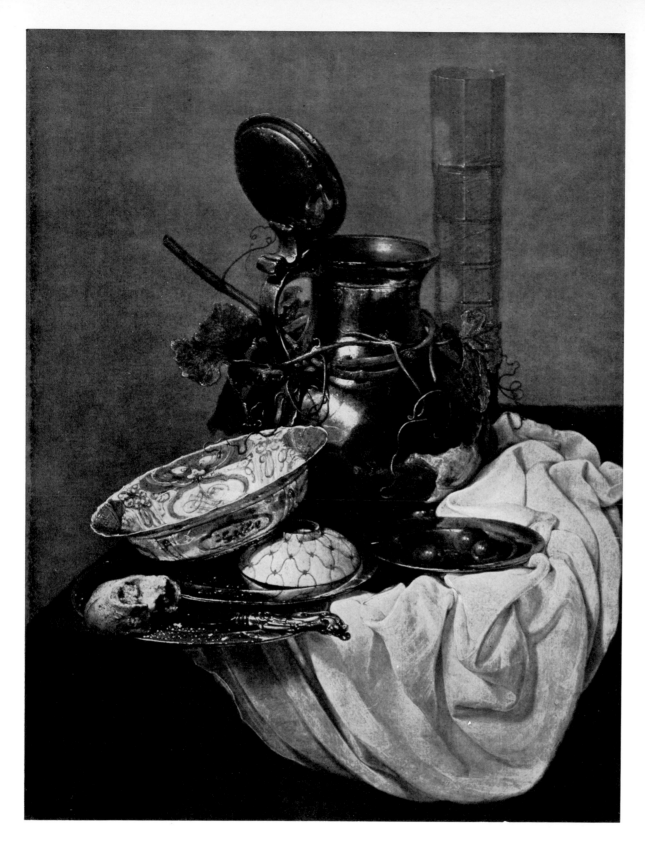

Jan Jansz. Treck

STILL LIFE

Signed and dated 1645
Wood, 66.5 × 50.5 cm.
Budapest,
Museum of Fine Arts
No. 1064 (551).

Jan Jansz. Treck

STILL LIFE

Signed and dated 1652
Canvas, 66×53 cm.
Formerly Berlin,
Kaiser-Friedrich Museum
No. 948 C.

Rombout van Troyen

GROTTO WITH ANCIENT TOMBS

Signed and dated 1641
Wood, 29×39 cm.
St. Gilgen,
F. C. Butôt collection.

1193

Rombout van Troyen

ROCKY LANDSCAPE WITH THE
ADORATION OF THE KINGS

Signed and dated 1648
Wood, 23.5×29.6 cm.
New York, art trade.

Jan Baptist Tyssens

SOLDIERS WITH ARMOUR

Signed
Canvas, 55 × 80 cm.
Munich, Schubart sale,
28 October 1899
No. 72.

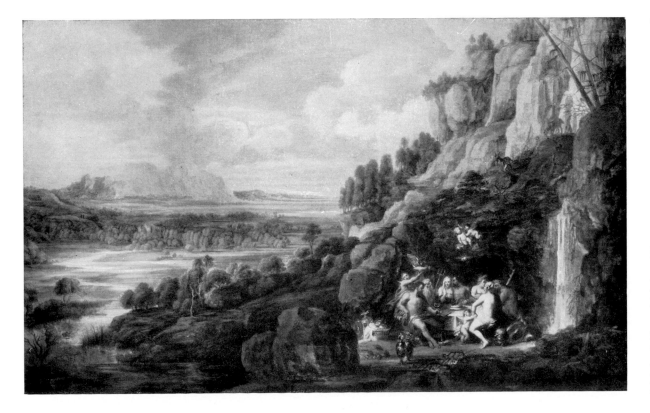

Lucas van Uden

LANDSCAPE WITH
DISTANT VIEW

Signed
Wood, 73 × 116 cm.
Munich, Alte Pinakothek
No. 2072.

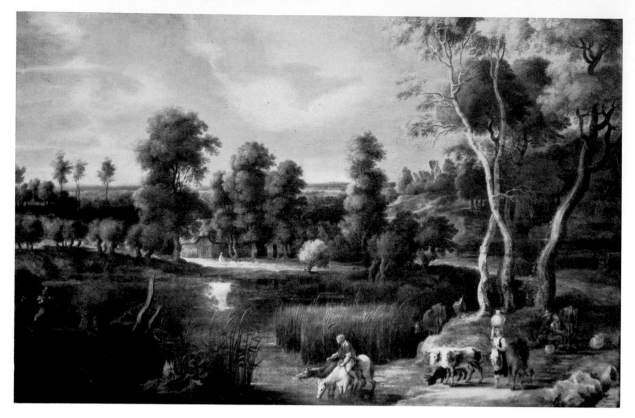

Lucas van Uden

FLAT LANDSCAPE AT SUNSET

Signed
Wood, 52×79 cm.
Munich, Alte Pinakothek
No. WAF. 1092.

Lucas van Uden

LANDSCAPE

Signed
Canvas, 40×59 cm.
Frankfurt, Staedel Institute
No. 1128.

Jakob van der Ulft

Roman Monuments

Wood, 47 × 74.5 cm.
Dresden, Gallery
No. 1847.

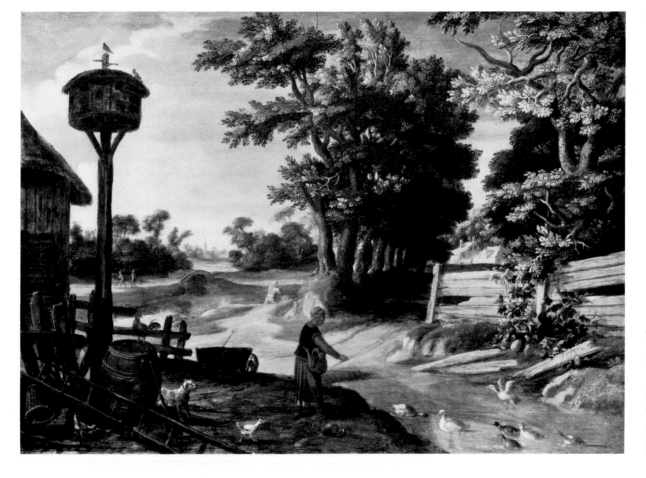

Johannes Urselincx

Landscape

Signed
Wood, 27.5 × 37 cm.
St. Gilgen,
F. C. Butôt collection.

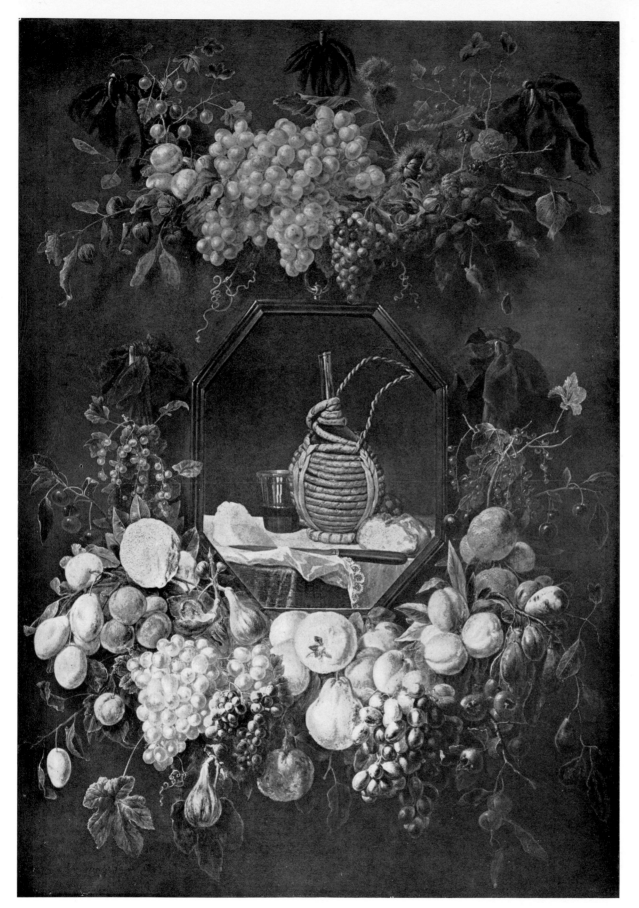

Adriaen van Utrecht

Fruit Garlands

Signed and dated 1644
Wood, 120×82 cm.
Vienna,
Kunsthistorisches Museum.

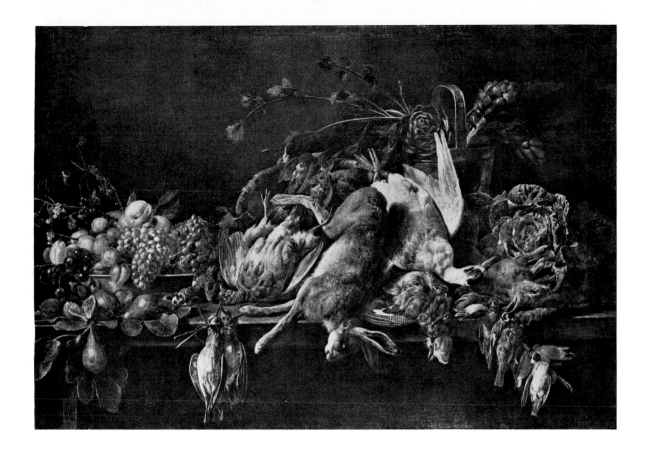

Adriaen van Utrecht

STILL LIFE WITH GAME

Signed and dated 1648
Canvas, 99×142 cm.
Munich, Alte Pinakothek
No. 1252.

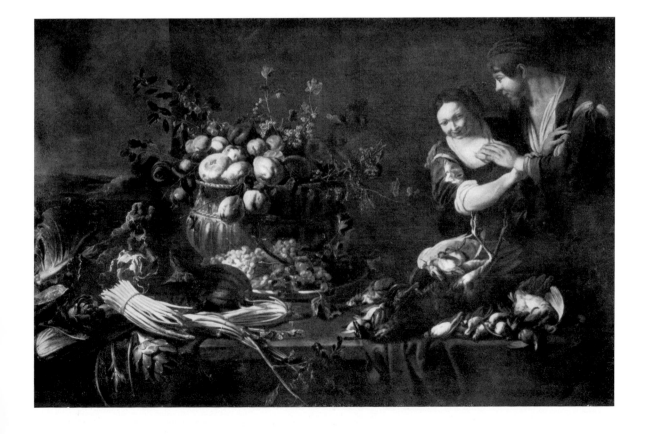

Adriaen van Utrecht

STILL LIFE WITH FRUIT AND
VEGETABLES
(Figures by T. Rombouts)

With monogram, dated 1631
Canvas, 143×213 cm.
Como, private collection.

Jan Jansz. den Uyl

BREAKFAST STILL LIFE

Wood, 131.5 × 116.5 cm.
Munich, art trade.

1204

**Moses
van Uyttenbroeck**

THE JUDGEMENT OF PARIS

Signed and dated 1626
Wood, 38×39 cm.
Cassel, Gallery
No. 190.

1205

**Moses
van Uyttenbroeck**

ARCADIAN LANDSCAPE

Wood, 50×88 cm.
Amsterdam, art trade.

1206

Moses van Uyttenbroeck

BACCHANAL

Signed and dated 1627
Canvas, 125 × 206 cm.
Brunswick,
Herzog-Anton-Ulrich Museum
No. 216.

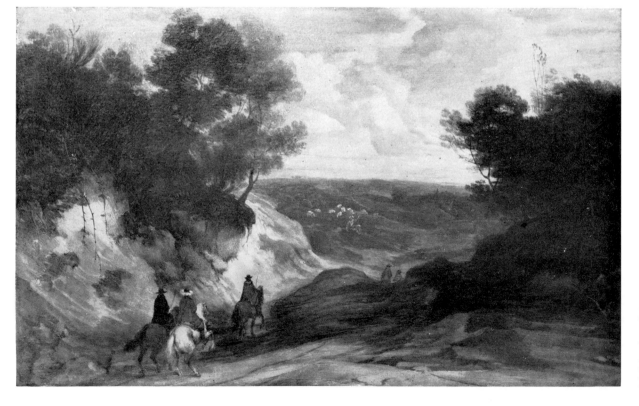

1207

Lodewyk de Vadder

LANDSCAPE WITH RAVINE

Wood, 32 × 51 cm.
Munich, Alte Pinakothek
No. 1051.

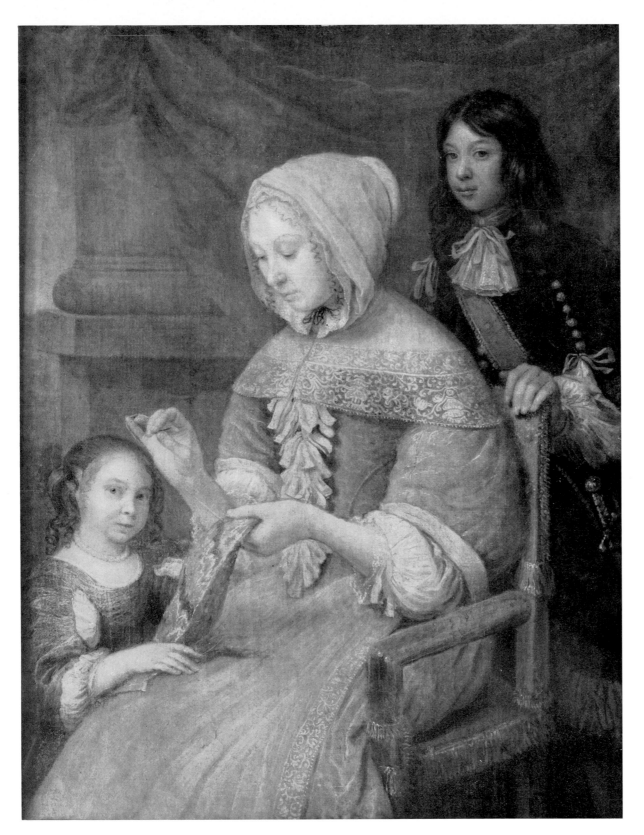

Wallerant Vaillant

Woman Sewing
and Two Children

Canvas, 37 × 29 cm.
Dessau, Amalienstift
No. 117.

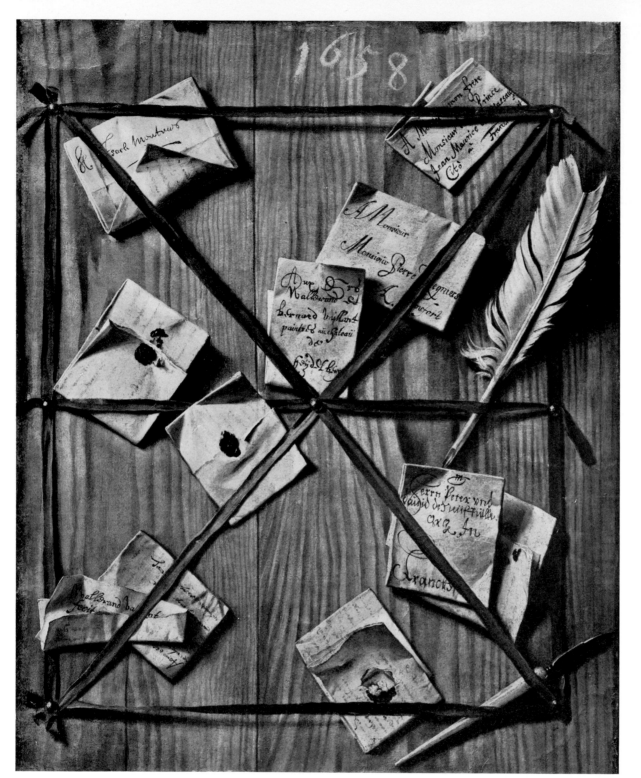

Wallerant Vaillant

BOARD WITH LETTER RACK

Signed and dated 1658
Canvas, 51.5 × 40.5 cm.
Dresden, Gallery
No. 1232.

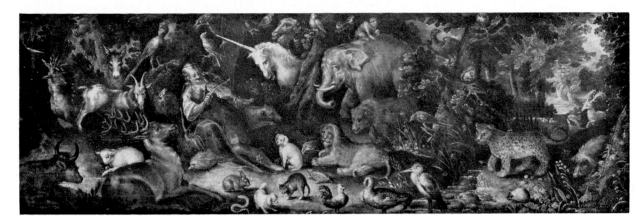

1210

Frederick
van Valckenborch

ORPHEUS CHARMING
THE ANIMALS

With monogram, dated 1601
Wood, 39×115 cm.
Munich, private collection.

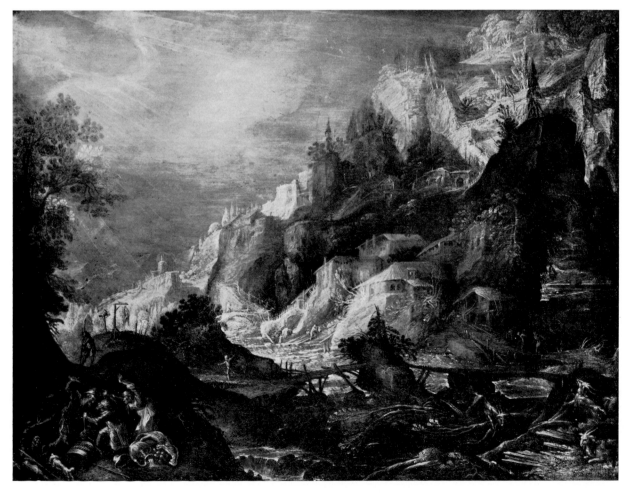

1211

Frederick
van Valckenborch

MOUNTAINOUS LANDSCAPE

Signed and dated 1605
Copper, 27×35 cm.
Amsterdam, Rijksmuseum
No. 2345.

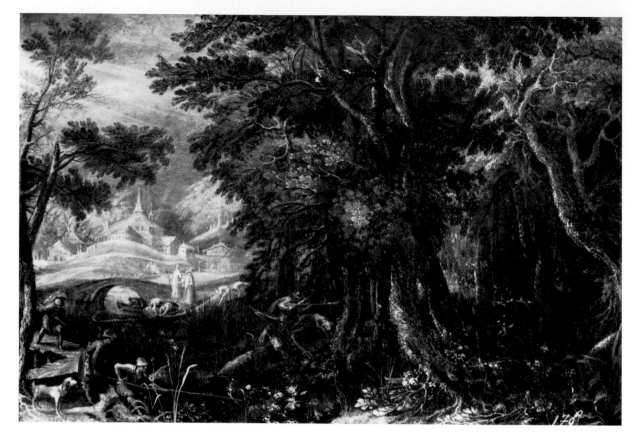

Frederick
van Valckenborch

FOREST LANDSCAPE
WITH HUNTSMEN

Wood, 20×30 cm.
Antwerp,
Musée Royal des Beaux-Arts
No. 994.

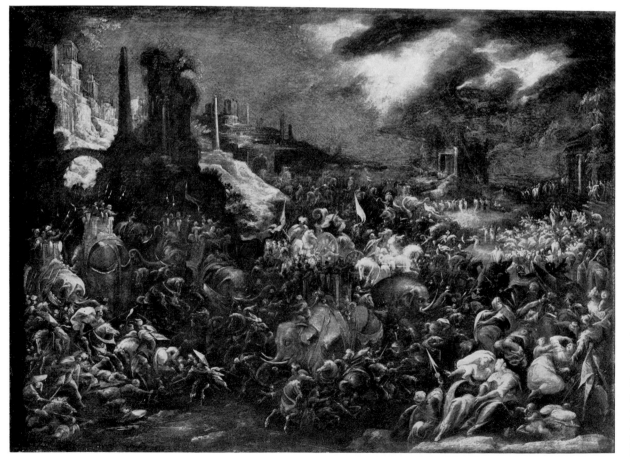

Gillis van Valckenborch

SENNACHERIB'S DEFEAT
AT JERUSALEM

Signed
Canvas, 56×76.5 cm.
Brunswick,
Herzog-Anton-Ulrich Museum
No. 62.

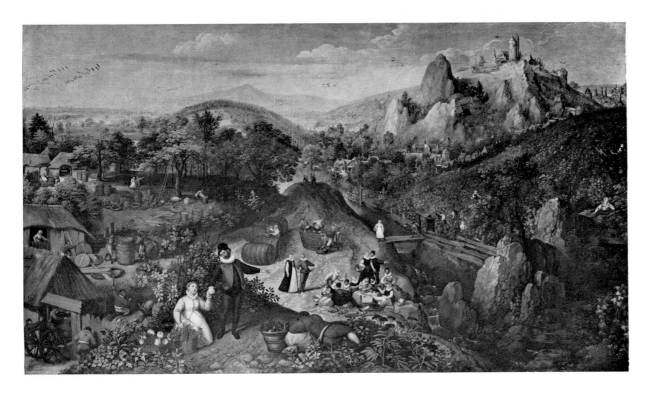

Lucas van Valckenborch

Autumn Landscape
with Grape-Harvest

Signed and dated 1585
Canvas, 116×198 cm.
Vienna,
Kunsthistorisches Museum
No. 1069.

Lucas van Valckenborch

View of Antwerp with
Skaters on the Scheldt

Signed and dated 1590
Wood, 42.5×63.5 cm.
Frankfurt, Staedel Institute
No. 668.

Lucas van Valckenborch

VILLAGE FAIR

With monogram, dated 1595
Wood, 22.5 × 38.5 cm.
Munich, private collection.

Lucas van Valckenborch

ROCKY LANDSCAPE
WITH HUNTSMAN

With monogram, dated 1595
Wood, 45.8 × 66.8 cm.
Brunswick,
Herzog-Anton-Ulrich Museum
No. 52.

Lucas van Valckenborch

VIEW OF LINZ

Signed and dated 1593
Wood, 23.5 × 36 cm.
Frankfurt, Staedel Institute
No. 158.

Martin van Valckenborch

SHEEP-SHEARING
(The Month of June)

With monogram
Canvas, 86 × 123 cm.
Vienna,
Kunsthistorisches Museum
No. 748.

Martin van Valckenborch

THE TOWER OF BABEL

Signed and dated 1595
Wood, 75.5 × 105.5 cm.
Dresden, Gallery
No. 832.

Martin van Valckenborch

WINTER LANDSCAPE WITH
THE ADORATION OF THE KINGS
(The Month of January)

With monogram
Canvas, 86 × 123 cm.
Vienna,
Kunsthistorisches Museum
No. 743.

Werner van den Valckert

CHRIST BLESSING
THE CHILDREN

Signed and dated 1620
Wood, 200×157 cm.
Utrecht,
Archiepiscopal Museum
No. 586.

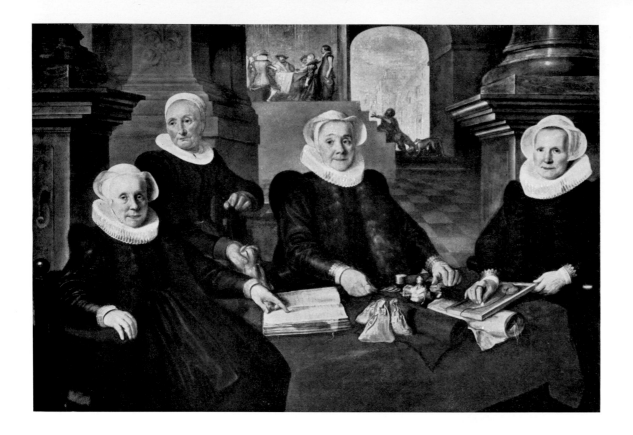

Werner van den Valckert

THREE LADY GOVERNORS AND
THE MATRON OF THE LEPER
HOSPITAL OF AMSTERDAM

Signed and dated 1624
Wood, 134×192 cm.
Amsterdam, Rijksmuseum
No. 2351.

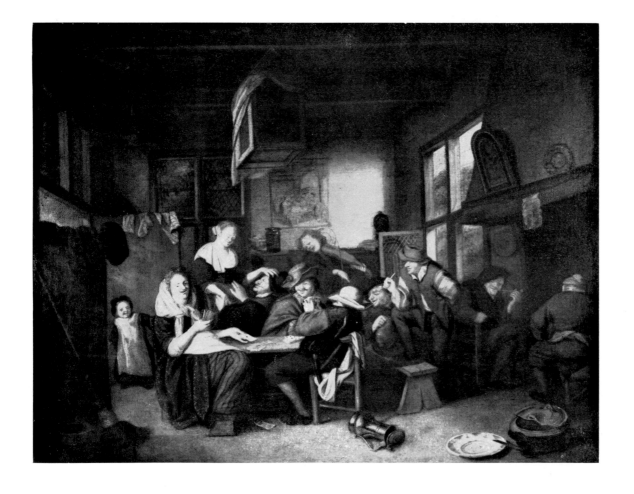

Hendrik de Valk

MERRY COMPANY IN AN INN

Signed
Canvas, 64×78 cm.
Munich, art trade.

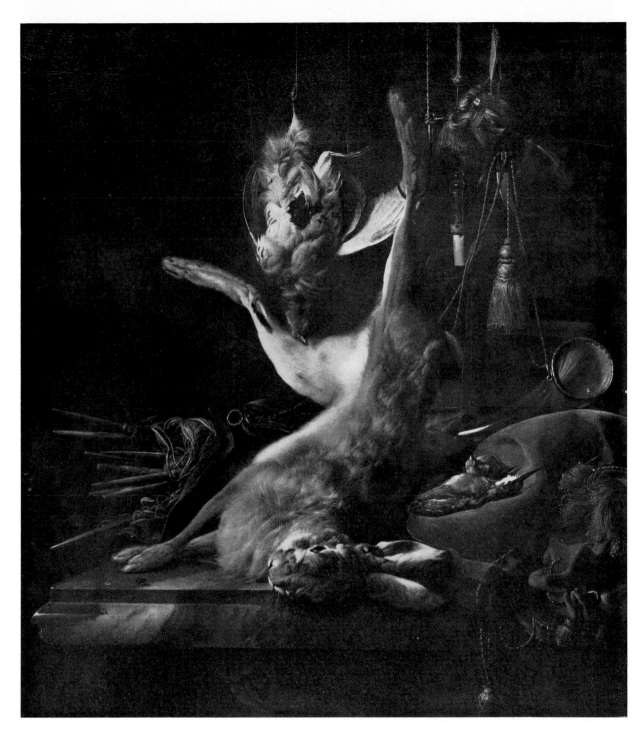

Dirk Valkenburg

DEAD HARE

Canvas, 107×93 cm.
Hanover, Landesmuseum
No. 553.

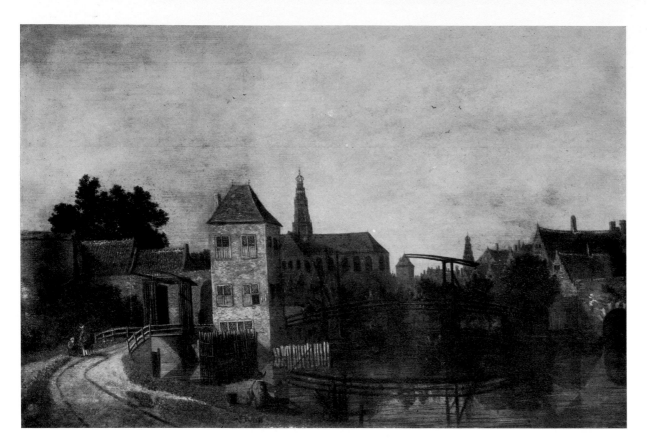

Balthasar van der Veen

THE DUCKS' GATE IN HAARLEM

Signed
Wood, 75 × 110 cm.
Amsterdam, Rijksmuseum
No. 2431.

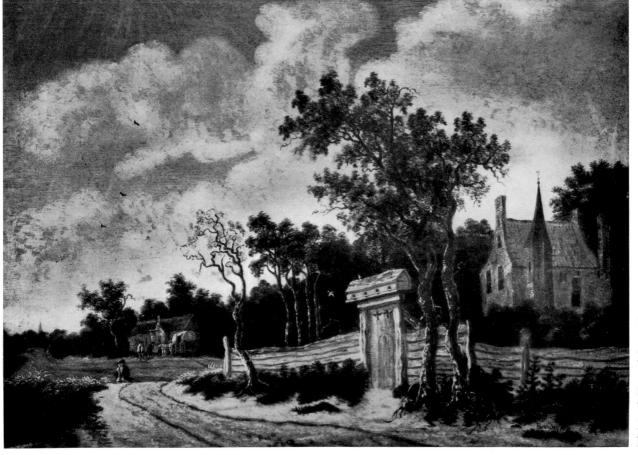

Balthasar van der Veen

LANDSCAPE

Signed
Wood, 47.8 × 65.2 cm.
Leiden, Lakenhal
No. 441.

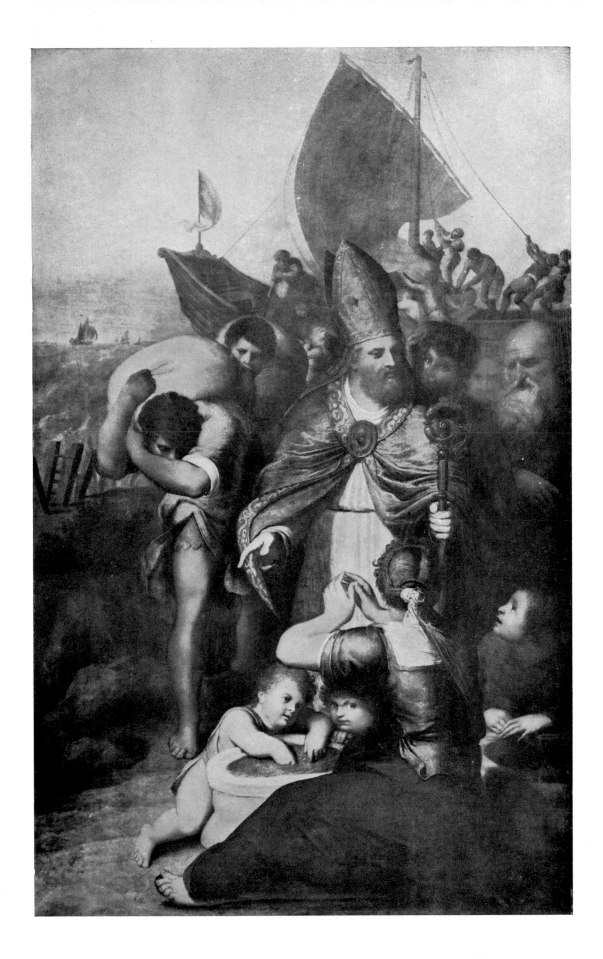

Otto van Veen

St. Nicholas Saving his
Flock from Famine

Wood, 267 × 167 cm.
Antwerp,
Musée Royal des Beaux-Arts
No. 482.

Otto van Veen

THE MYSTIC MARRIAGE OF ST. CATHERINE

Signed and dated 1589
Wood, 183 × 146 cm.
Brussels,
Musée Royal des Beaux-Arts
No. 479.

Johannes de Veer

THE DEATH OF CLEOPATRA

Signed
Canvas, 116×91.5 cm.
Utrecht, Central Museum
No. 327.

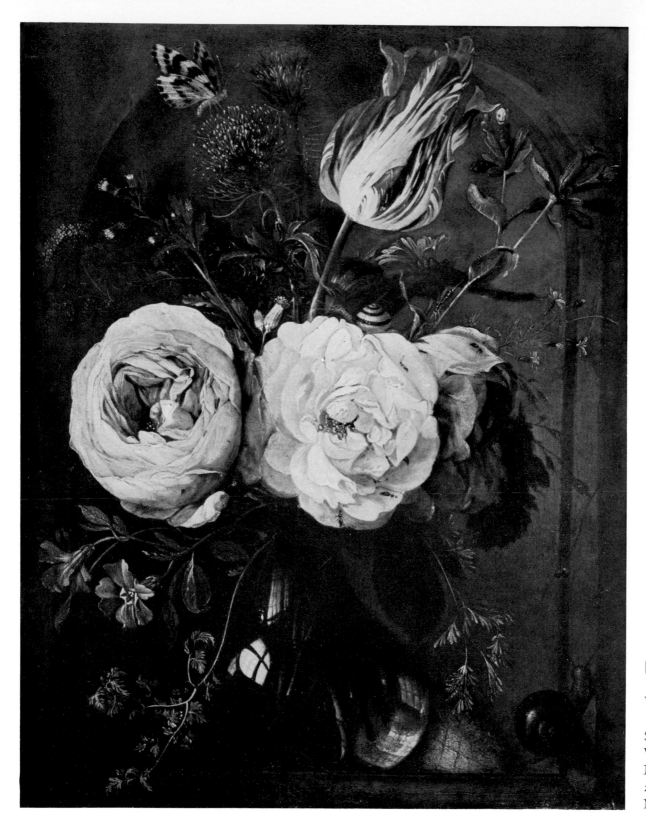

Nicolas van Veerendal

Vase of Flowers in a Niche

Signed
Wood, 26×20 cm.
Munich, J. Böhler sale,
28 October 1937
No. 115.

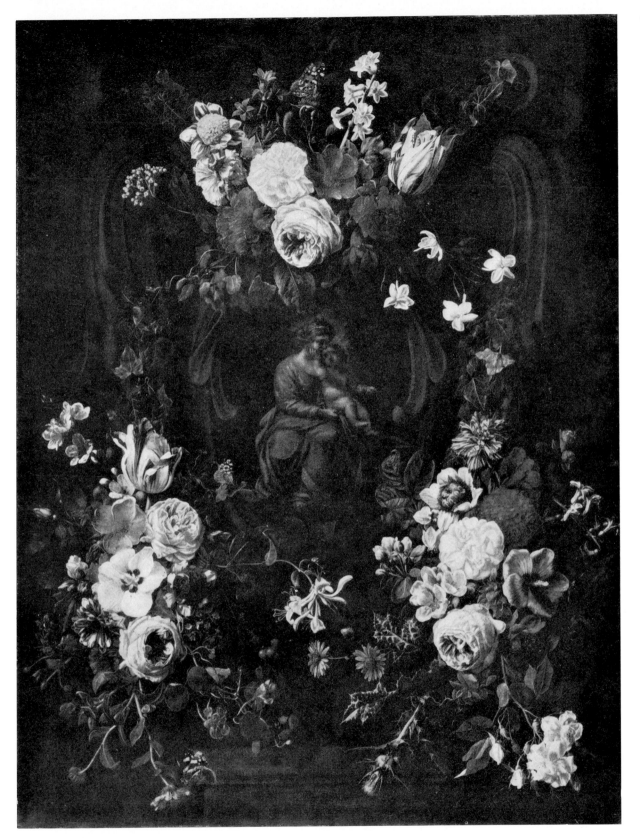

Nicolas van Veerendal

FLOWER STILL LIFE
SURROUNDING A MADONNA

Signed and dated 1670
Canvas, 87×65 cm.
Berlin, Staatliche Museen
No. 977 A.

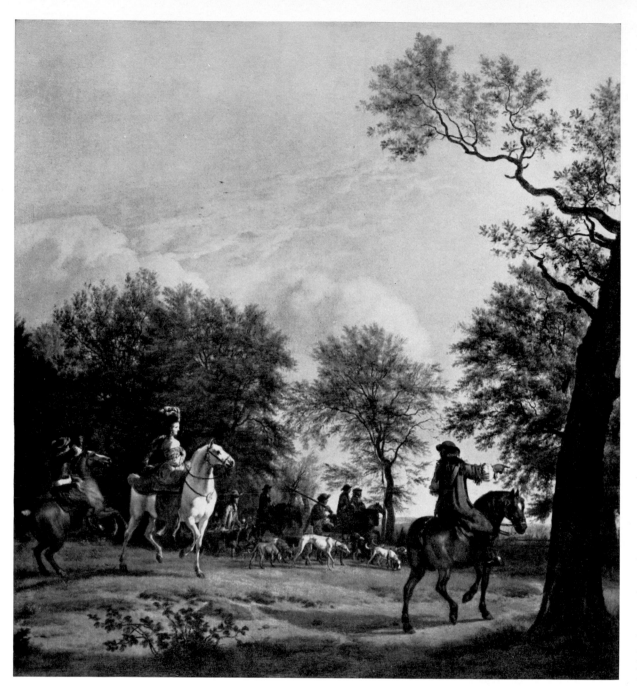

Adriaen van de Velde

HUNTSMEN SETTING OUT

Signed and dated 1666
Wood, 49.2 × 45 cm.
London, Buckingham Palace
No. 59.

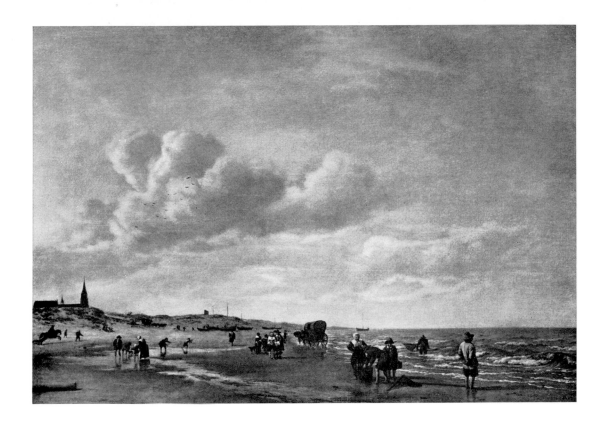

Adriaen van de Velde

The Beach at Scheveningen

Signed and dated 1658
Canvas, 50×74 cm.
Cassel, Gallery
No. 374.

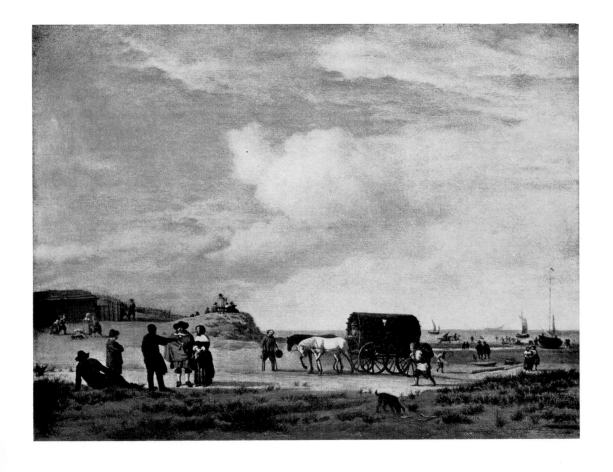

Adriaen van de Velde

Beach Scene with Figures

Signed and dated 1660
Canvas, 37.7×49.2 cm.
London, Buckingham Palace
No. 133.

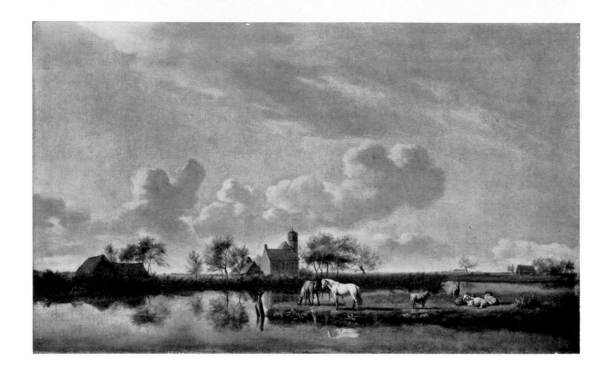

Adriaen van de Velde

FLAT RIVER LANDSCAPE

Canvas, 41×66 cm.
Berlin, Staatliche Museen
No. 922 B.

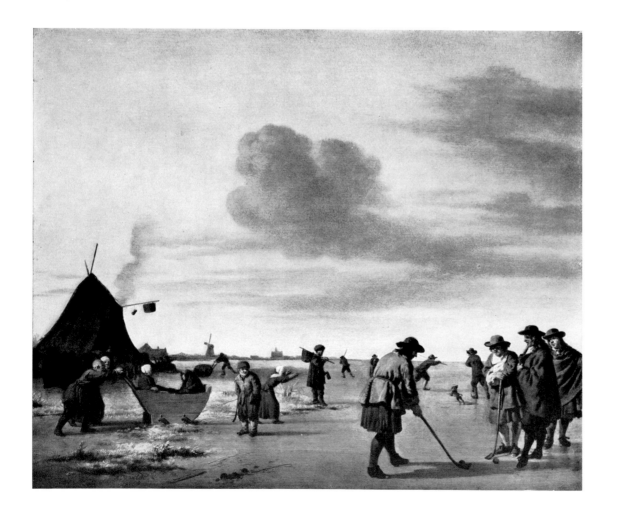

Adriaen van de Velde

GOLFERS ON THE ICE
NEAR HAARLEM

Signed and dated 1668
Wood, 30×36 cm.
London, National Gallery
No. 869.

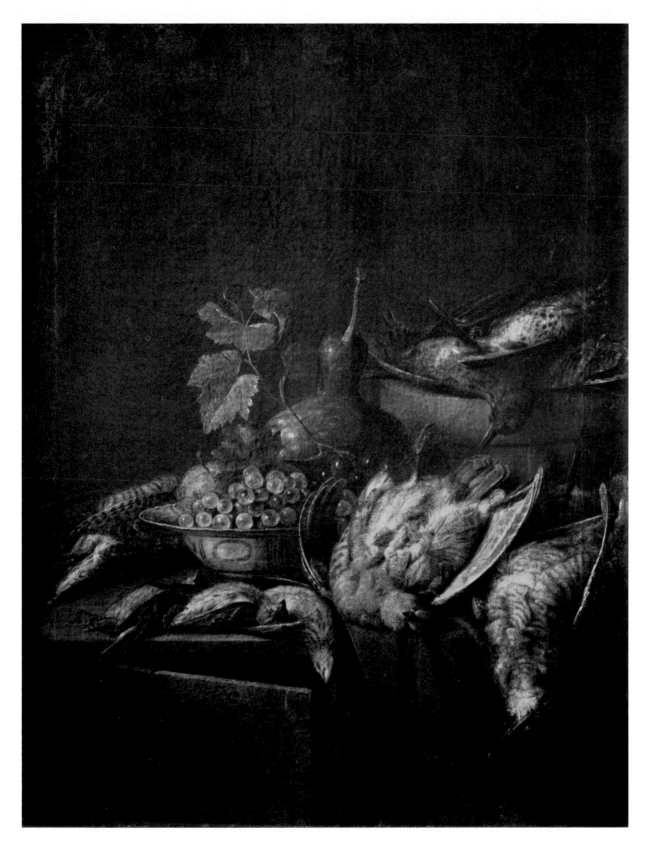

Anthonie Velde II

FRUIT AND GAME BIRDS

Signed and dated 1670
Canvas, 77×60 cm.
Schleissheim, Gallery
No. 3928.

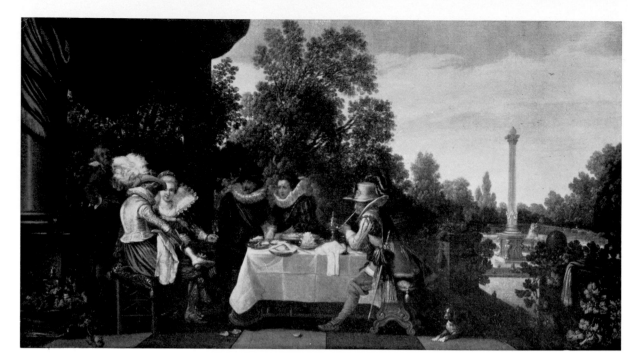

Esaias van de Velde

COMPANY AT TABLE

Canvas, 43×77 cm.
Berlin, Staatliche Museen
No. 1838.

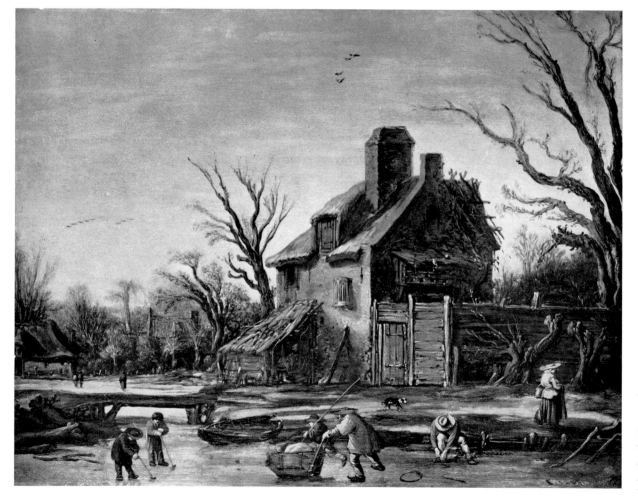

Esaias van de Velde

WINTER LANDSCAPE

Signed and dated 1624
Wood, 26×32 cm.
The Hague, Mauritshuis
No. 673.

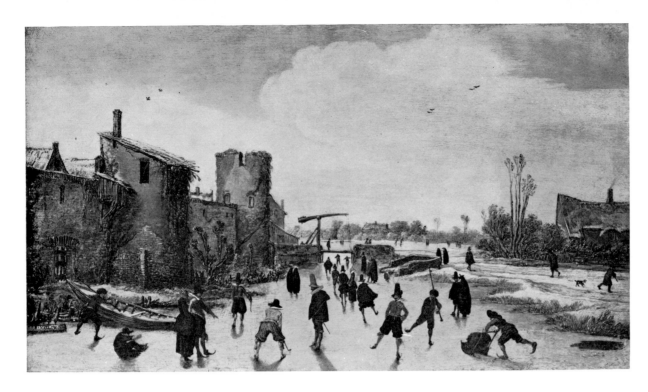

Esaias van de Velde

SKATERS AND GOLFERS
ON THE ICE

Signed and dated 1618
Wood, 29×50 cm.
Munich, Alte Pinakothek
No. 2884.

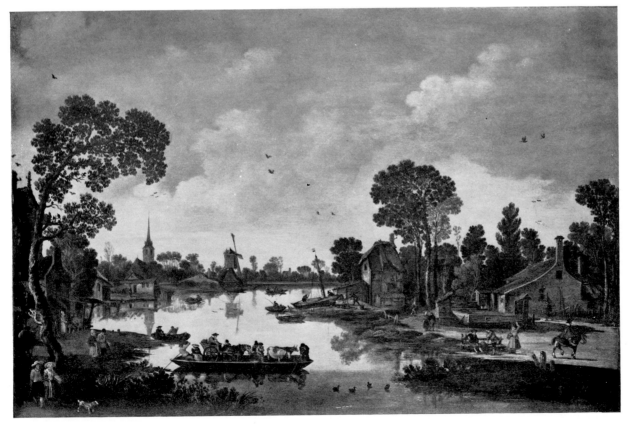

Esaias van de Velde

THE FERRY-BOAT

Signed and dated 1622
Wood, 75.5×113 cm.
Amsterdam, Rijksmuseum
No. 2452.

Jan van de Velde

STILL LIFE

Signed and dated 1655
Wood, 57×46 cm.
Munich, private collection.

Jan van de Velde

STILL LIFE

Wood, 43.4×32.4 cm.
Budapest,
Museum of Fine Arts
No. 190 (499).

Pieter van den Velde

Harbour with Two Frigates

Signed
Wood, 31×41 cm.
Ansbach, Castle Gallery
No. 6.

Pieter van den Velde

Mediterranean Coast
with Castle

Signed
Canvas, 72.5×112 cm.
Vienna, art trade.

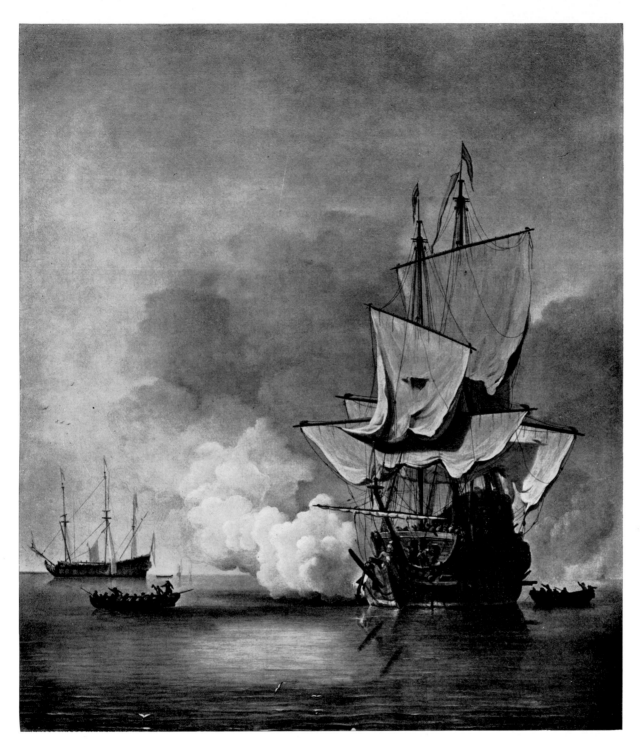

Willem van de Velde the Younger

THE CANNON SHOT

Signed
Canvas, 78.5 × 67 cm.
Amsterdam, Rijksmuseum
No. 2478.

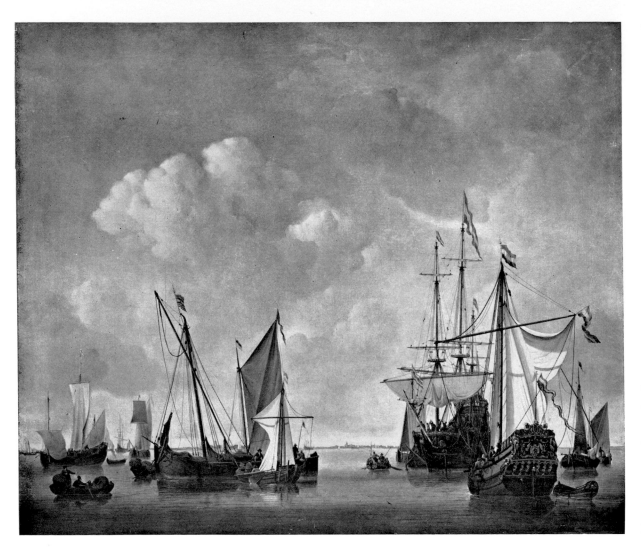

Willem van de Velde the Younger

CALM SEA WITH WARSHIPS

Signed
Canvas, 66.5 × 76 cm.
The Hague, Mauritshuis
No. 200.

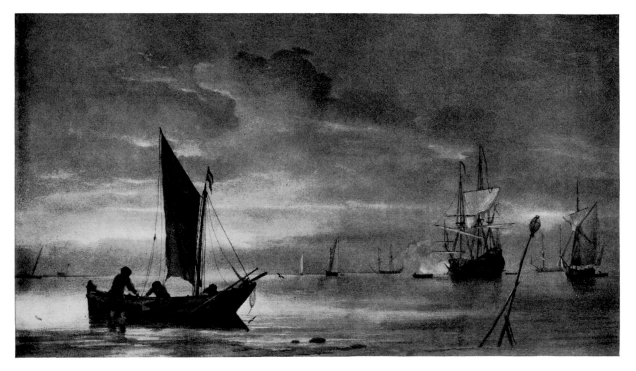

Willem van de Velde the Younger

CALM SEA AT SUNSET

Signed
Canvas, 36 × 61.5 cm.
The Hague, Mauritshuis
No. 563.

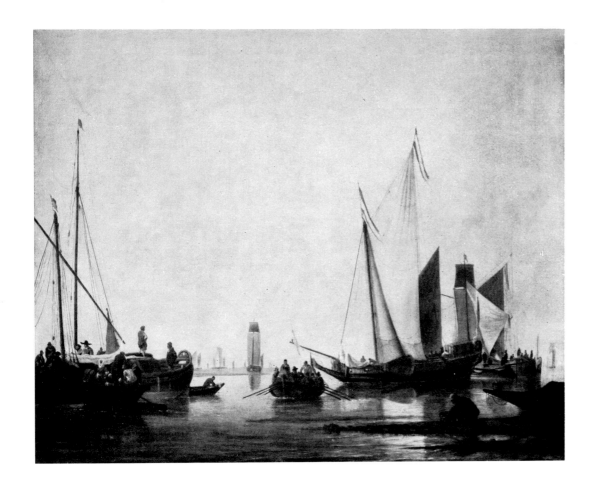

Willem van de Velde
the Younger

MERCHANT SHIPS
AND FISHING BOATS

With monogram
Canvas, 37.5 × 46.2 cm.
London, Lord Northbrook

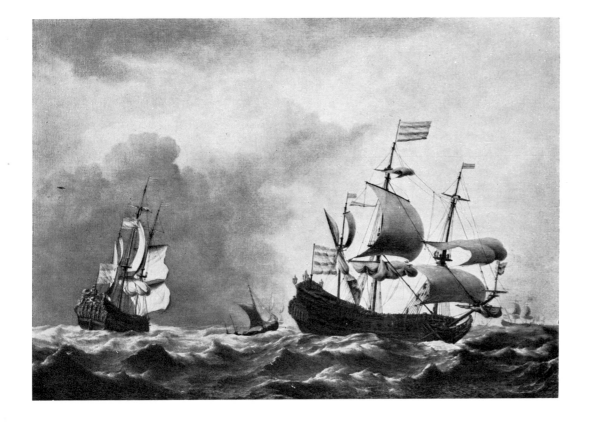

Willem van de Velde
the Younger

TWO WARSHIPS AND FISHING
BOATS ON A ROUGH SEA

Canvas, 60.8 × 83.3 cm.
London, Buckingham Palace
No. 76.

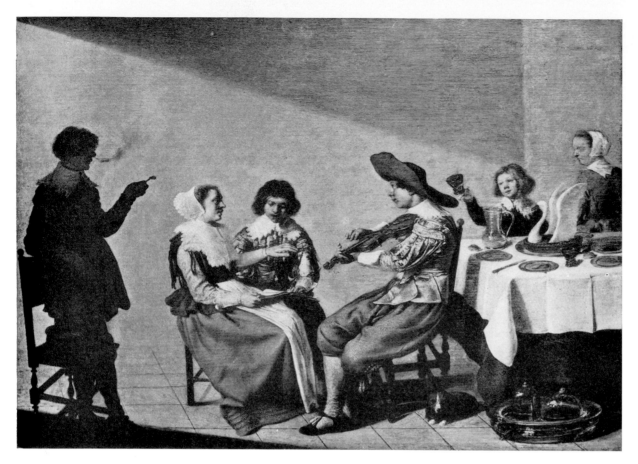

Jacob van Velsen

MUSICAL PARTY

Signed and dated 1631
Wood, 40×55 cm.
London, National Gallery
No. 2575.

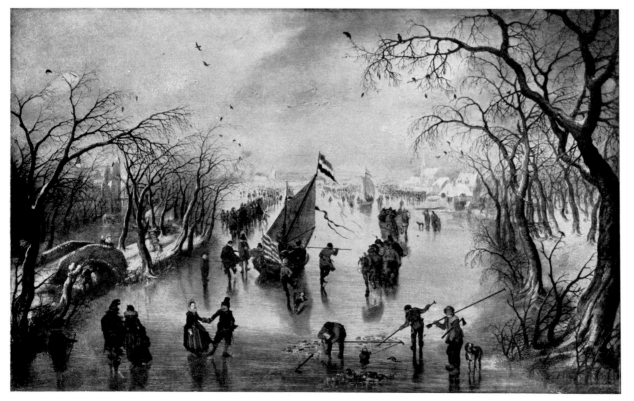

Adriaen Pietersz.
van de Venne

WINTER

Signed and dated 1623
Wood, 42×68 cm.
Berlin, Staatliche Museen
No. 741 B.

Adriaen Pietersz. van de Venne

Fishing for Souls
(Allegory on the Rivalry between Protestants and Catholics)

Signed and dated 1614
Wood, 98 × 189 cm.
Amsterdam, Rijksmuseum
No. 2486.

Adriaen Pietersz. van de Venne

Peasant Carnival

Signed
Wood, 73 × 92 cm.
Amsterdam, Rijksmuseum
No. 2497.

Pseudo van de Venne

Gipsies

Canvas, 112×130 cm.
Brunswick,
Herzog-Anton-Ulrich Museum
No. 211.

Cornelis Verbeeck

Seascape

Signed
Wood, 49×97 cm.
Haarlem, Frans Hals Museum
No. 509.

Pieter Cornelisz. Verbeeck

TWO HORSEMEN
AT A FOUNTAIN

With monogram
Wood, 27.5 × 35 cm.
The Hague, Mauritshuis
No. 611.

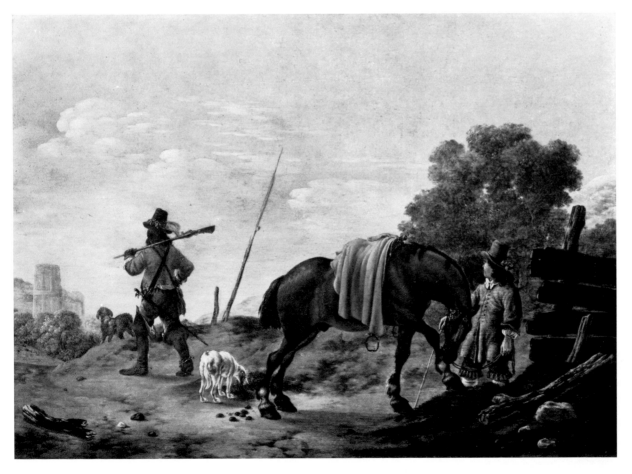

Pieter Cornelisz. Verbeeck

LANDSCAPE WITH HORSEMAN
AND HUNTSMAN

With monogram
Wood, 23 × 31.5 cm.
St. Gilgen,
F. C. Butôt collection.

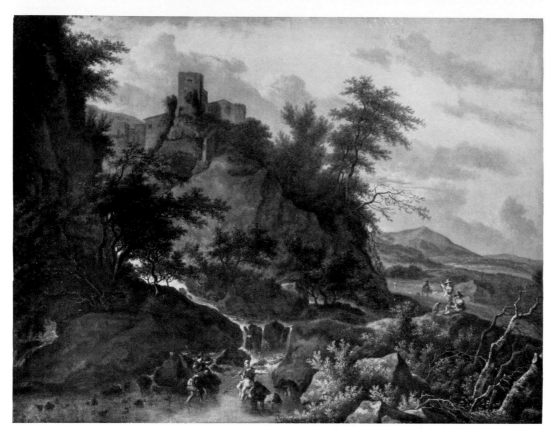

1260

Adriaen Verboom

LANDSCAPE WITH CASTLE

Signed
Canvas, 62.2×80.5 cm.
Munich, art trade.

1261

Adriaen Verboom

FOREST LANDSCAPE
WITH FLOCKS

Canvas, 80×98.5 cm.
London, Lord Northbrook.
No. 143.

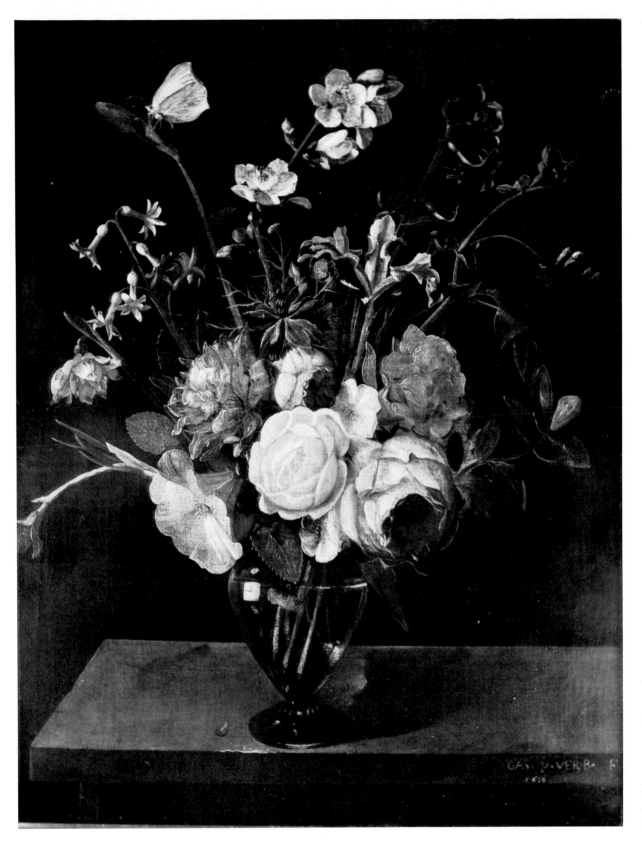

Gaspar Peeter Verbruggen

FLOWERS IN A GLASS VASE

Signed and dated 1654
Canvas, 53×41 cm.
Innsbruck,
Museum Ferdinandeum
No. 747.

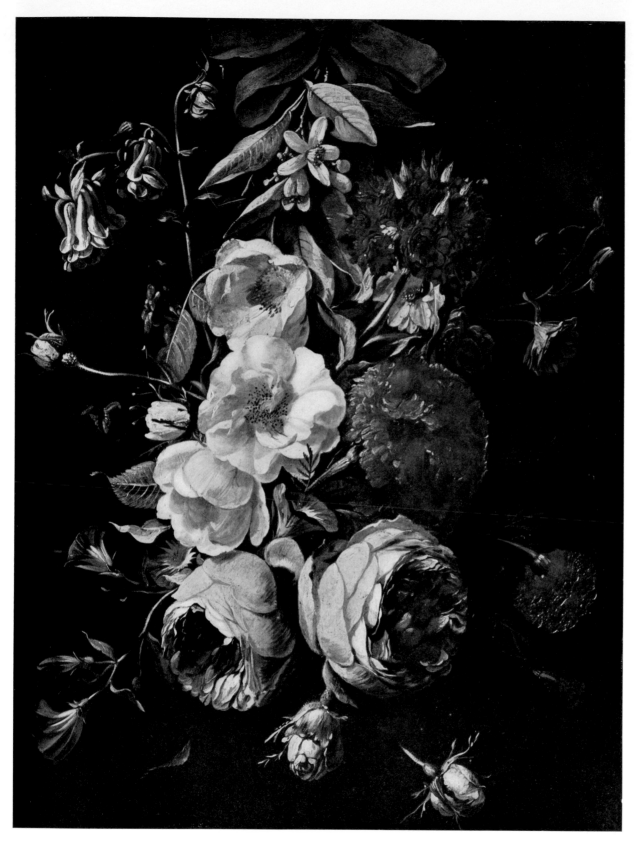

Gaspar Peeter Verbruggen

FLOWER STILL LIFE

Signed
Wood, 42.2 × 32 cm.
Munich, art trade.

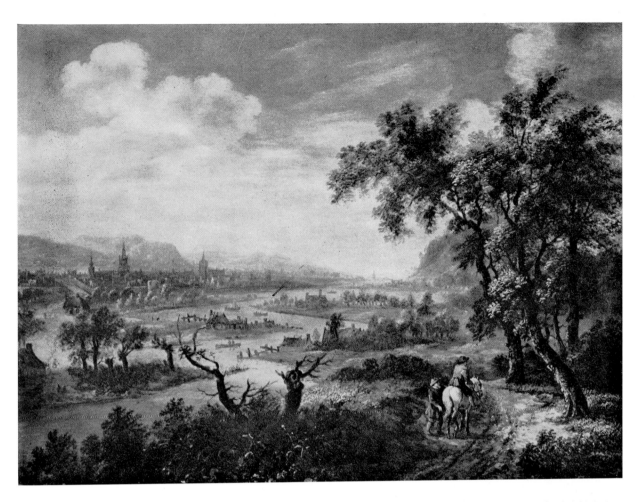

Dionijs Verburgh

RIVER LANDSCAPE

Signed
Wood, 38 × 50 cm.
The Hague,
Van Marle and Bignell sale,
26 July 1943,
No. 73.

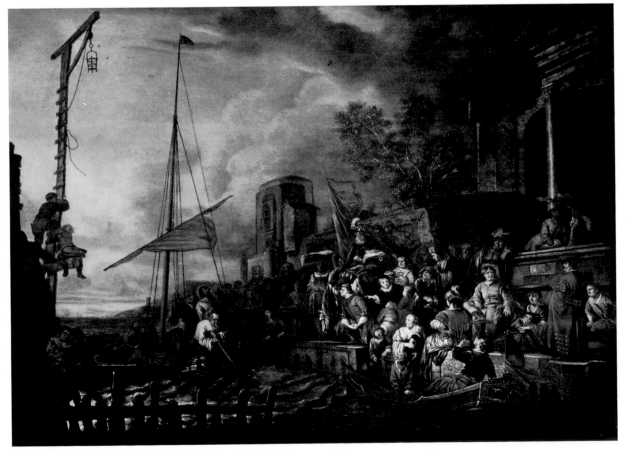

Adriaen Verdoel

CHRIST PREACHING
FROM A BOAT

Signed
Wood
Holland, private collection.

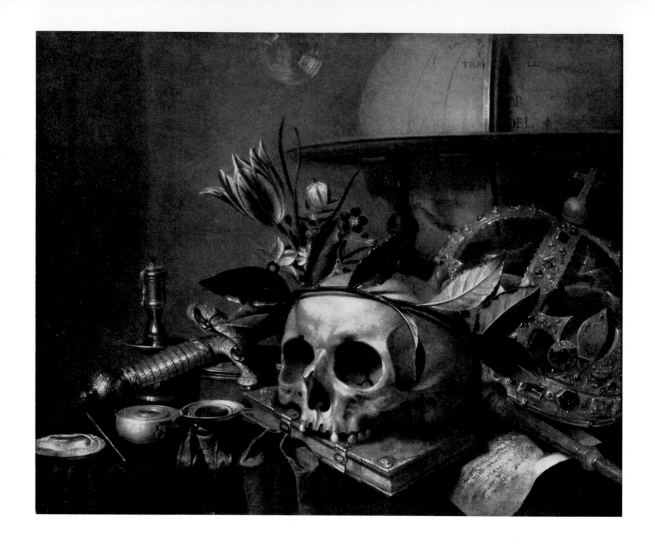

Adriaen Verdoel

VANITAS

Signed
Wood, 54.7×78.8 cm.
London, art trade.

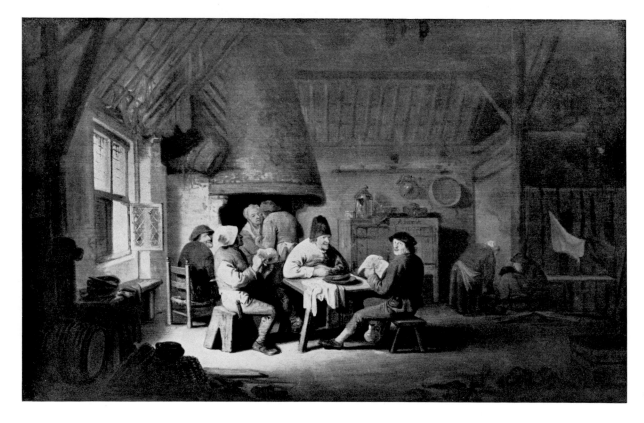

Pieter Verelst

INTERIOR OF A
PEASANT COTTAGE

Signed
Wood, 46×71 cm.
Vienna,
Kunsthistorisches Museum
No. 1286.

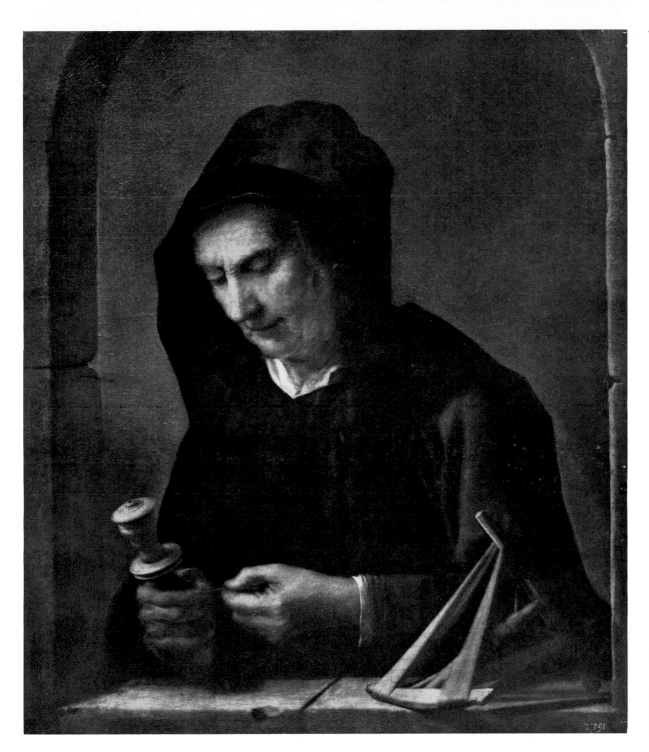

Pieter Verelst

OLD WOMAN WINDING YARN

Canvas, 73×63 cm.
Dresden, Gallery
No. 1343.

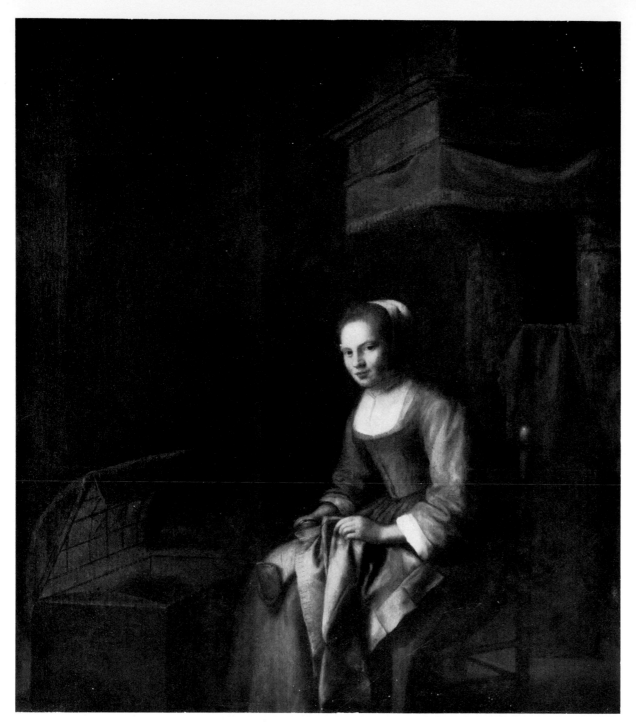

Pieter Verelst

WOMAN SEWING

With monogram
Wood, 34×29.7 cm.
Munich, art trade.

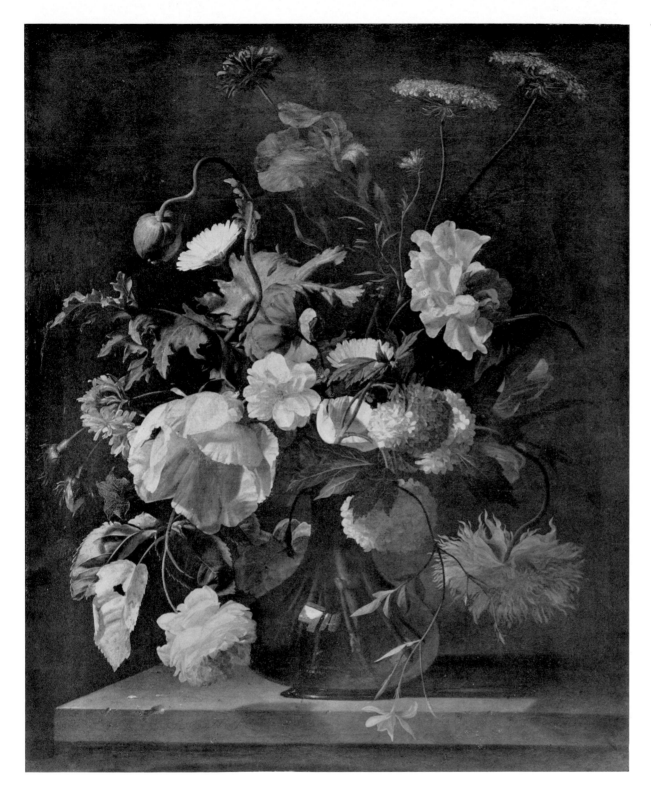

Simon Verelst

FLOWER STILL LIFE

Signed
Canvas, 58 × 47 cm.
Pommersfelden,
Schönborn Gallery
No. 611.

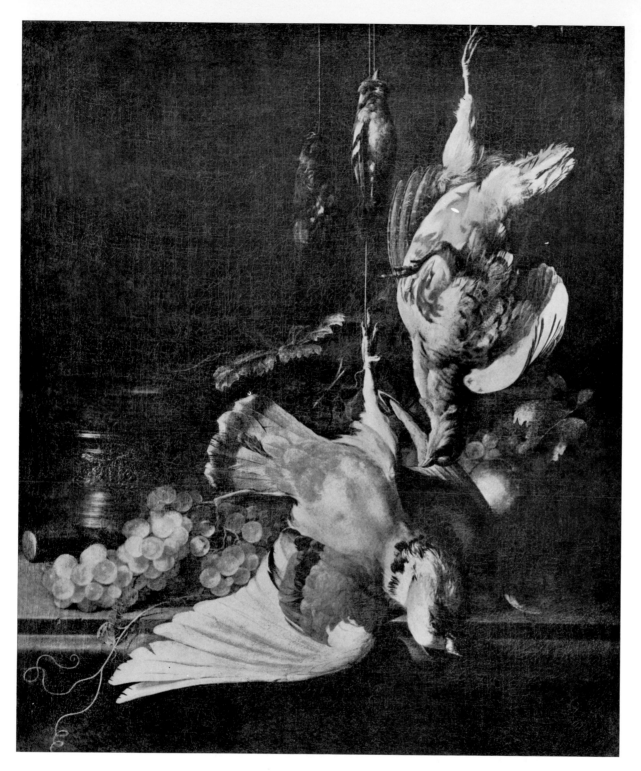

Simon Verelst

STILL LIFE WITH BIRDS

Canvas, 72 × 59 cm.
Munich, Alte Pinakothek
No. 650.

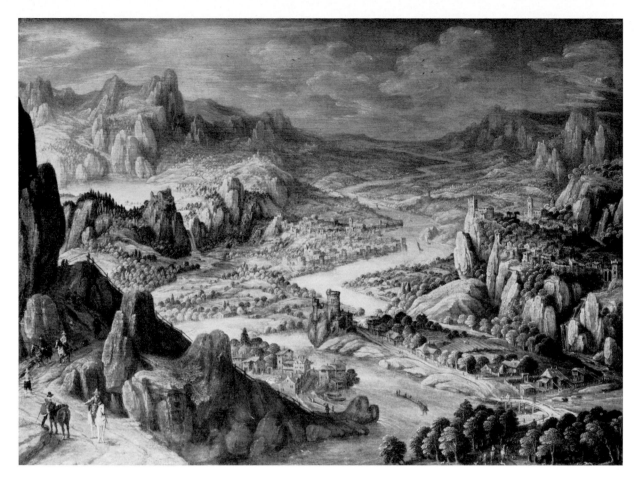

Tobias Verhaecht

ALPINE LANDSCAPE

With monogram,
dated 1612
Wood, 49.5 × 67 cm.
Munich,
Bayer. Staatsgemäldesamml.
No. 9891.

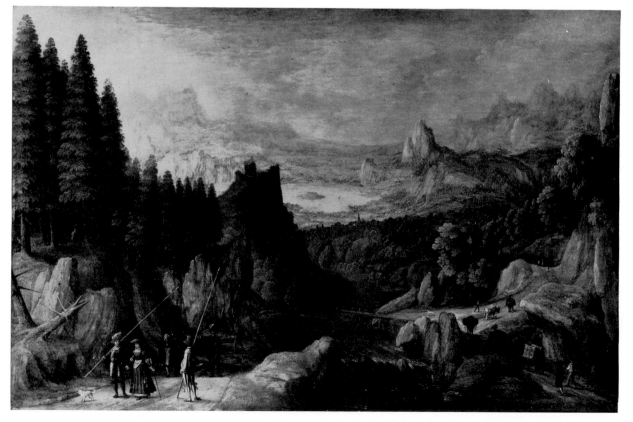

Tobias Verhaecht

RIVER VALLEY
IN THE MOUNTAINS

Wood, 56 × 83 cm.
Berlin, Staatl. Museen,
Gemäldegalerie
No. 2027.

Dirck Verhaert

RIVER LANDSCAPE

With monogram
Wood, 50.5 × 83 cm.
Vaduz, private collection.

Dirck Verhaert

LANDSCAPE WITH
MEDITERRANEAN
ARCHITECTURE

With monogram
Wood, 45 × 64 cm.
Como, art trade.

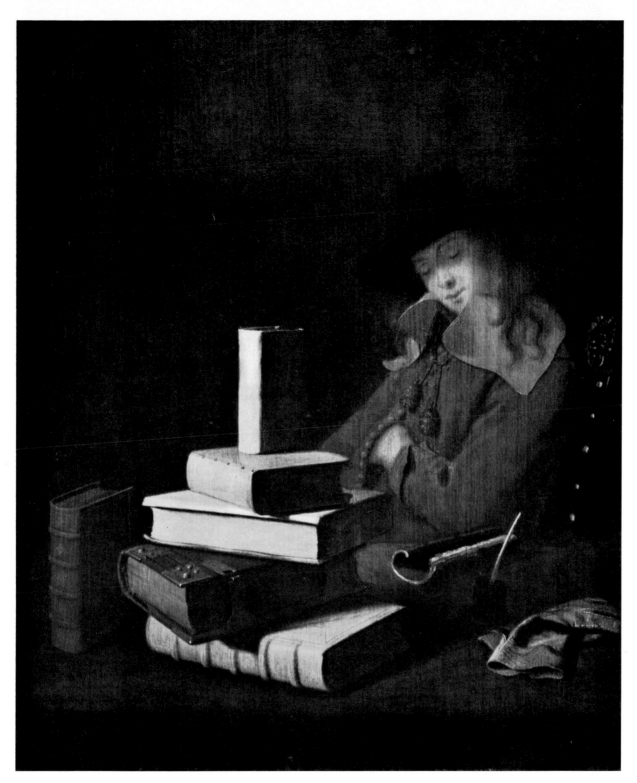

Constantyn Verhout

STUDENT ASLEEP

Signed and dated 1663
Wood, 38×30 cm.
Stockholm, National Museum
No. 677.

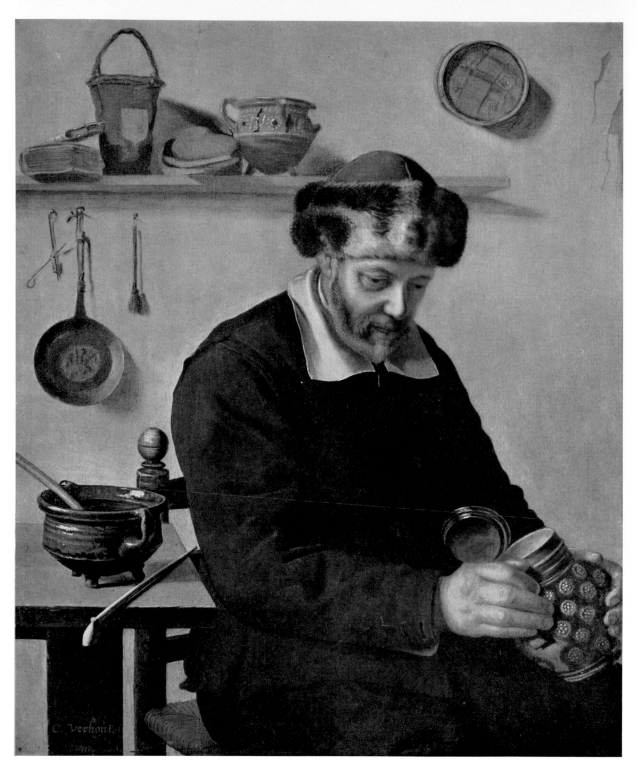

Constantyn Verhout

MAN WITH WINE JUG

Signed
Wood, 34 × 28 cm.
Milwaukee, private collection.

Jan Verkolje

THE TEMPTATION

Signed
Canvas, 70×66 cm.
Dresden, Gallery
No. 1672.

Nicolaes Verkolje

THE GAME-BAG REFUSED

Signed
Wood, 38 × 29 cm.
Berlin, Staatliche Museen
No. 1012.

Barent Vermeer

STILL LIFE AND NEGRO

Signed
Canvas, 149×115 cm.
Munich, Alte Pinakothek
No. 6598.

Jan Vermeer
van Haarlem
the Elder

FOREST PATH

Signed
Wood, 38×30 cm.
Munich, Alte Pinakothek
No. 553.

Jan Vermeer
van Haarlem
the Elder

VIEW FROM THE DUNES

Signed
Wood, 33×63 cm.
Dresden, Gallery
No. 1388 A.

Jan Vermeer
van Haarlem
the Elder

VIEW FROM THE DUNES
NEAR HAARLEM

Wood, 19×25 cm.
Berlin, art trade.

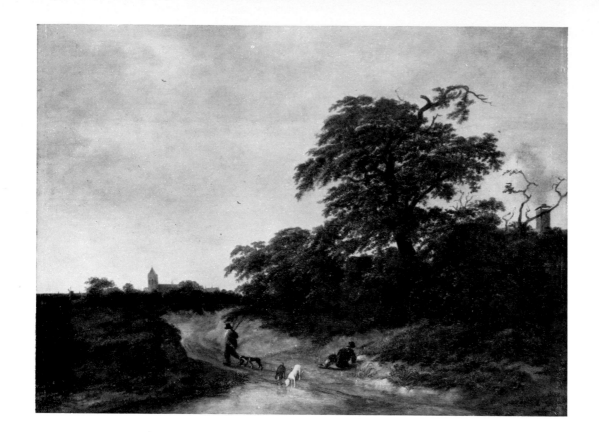

Jan Vermeer
van Haarlem
the Elder

DUNE LANDSCAPE

Signed
Wood, 46×60 cm.
Berlin, H. W. Lange sale
3 December 1940
No. 198.

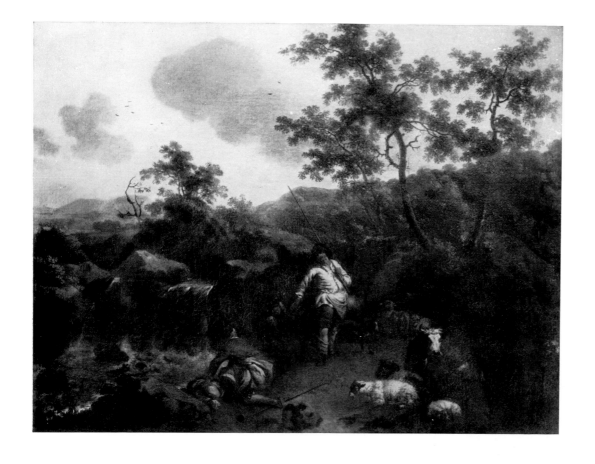

Jan Vermeer
van Haarlem
the Younger

LANDSCAPE WITH FLOCK

Signed and dated 1677
Canvas, 51×66 cm.
Vienna, art trade.

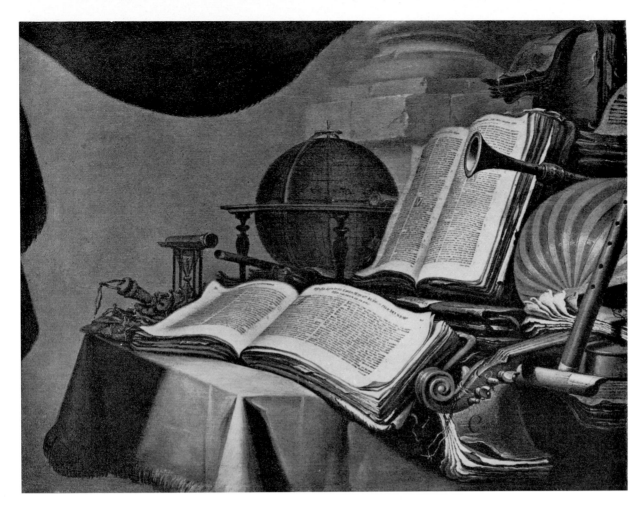

Jan Vermeulen

VANITAS STILL LIFE

Signed
Wood, 30 × 38.5 cm.
The Hague, Mauritshuis
No. 662.

Lieve Verschuier

THE FIRE OF LONDON, 1666

Signed
Canvas, 92.5 × 148 cm.
Budapest,
Museum of Fine Arts
No. 380.

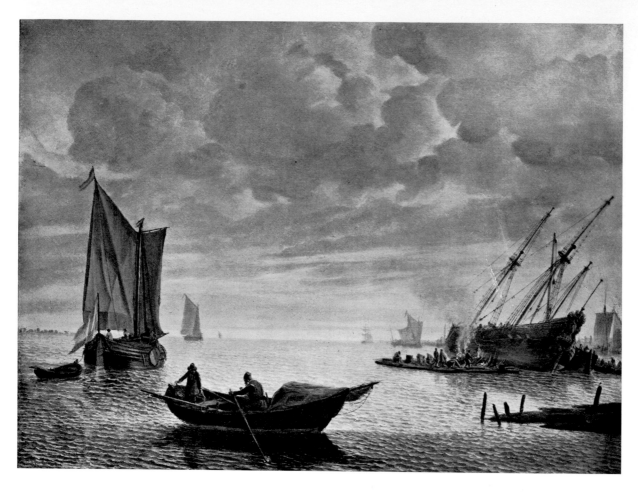

Lieve Verschuier

RIPPLING WATER

Signed
Wood, 37.5 × 49 cm.
Amsterdam, Rijksmuseum
No. 2532.

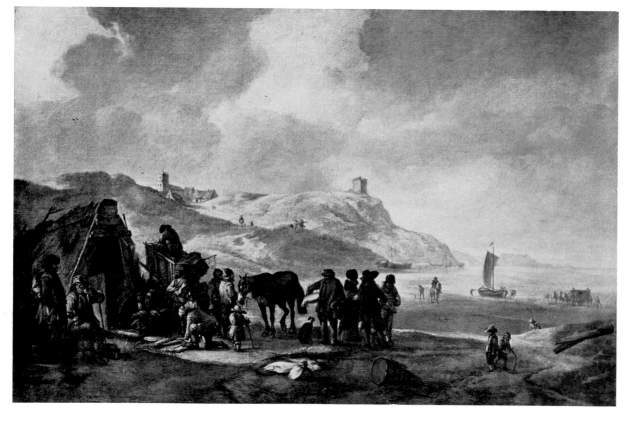

Hendrik Verschuring

BEACH LANDSCAPE

Canvas, 83 × 117 cm.
Munich, Alte Pinakothek
No. 559.

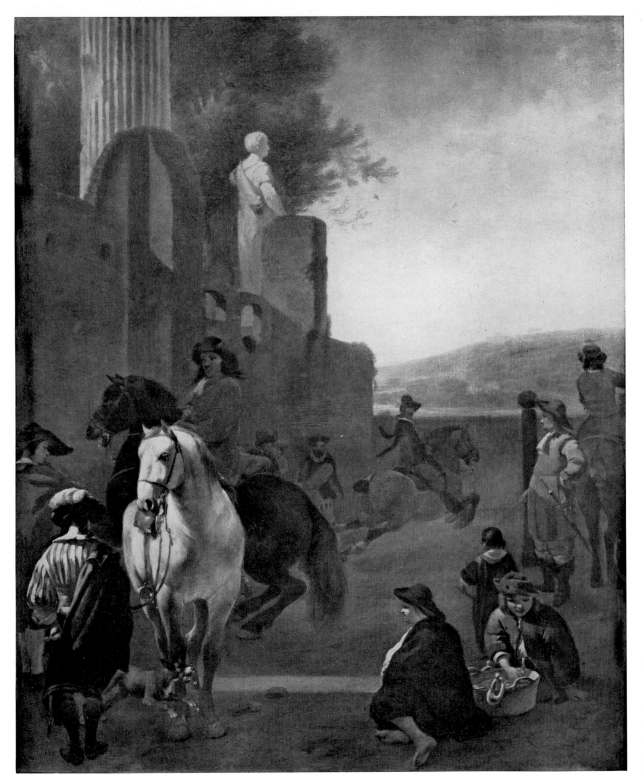

Hendrik Verschuring

RIDING SCHOOL

Signed and dated 1679
Wood, 55 × 44 cm.
Brunswick,
Herzog-Anton-Ulrich Museum
No. 277.

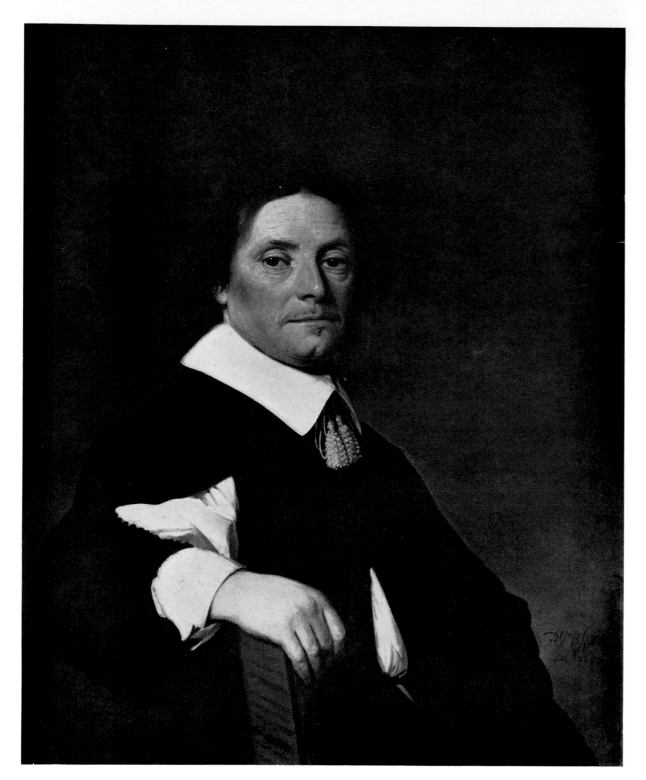

Jan Verspronck

PORTRAIT OF ANDRÉ DE
VILLEPONTOUX

Signed and dated 1651
Wood, 56×44.5 cm.
The Hague,
Portrait Exhibition 1903
No. 126.

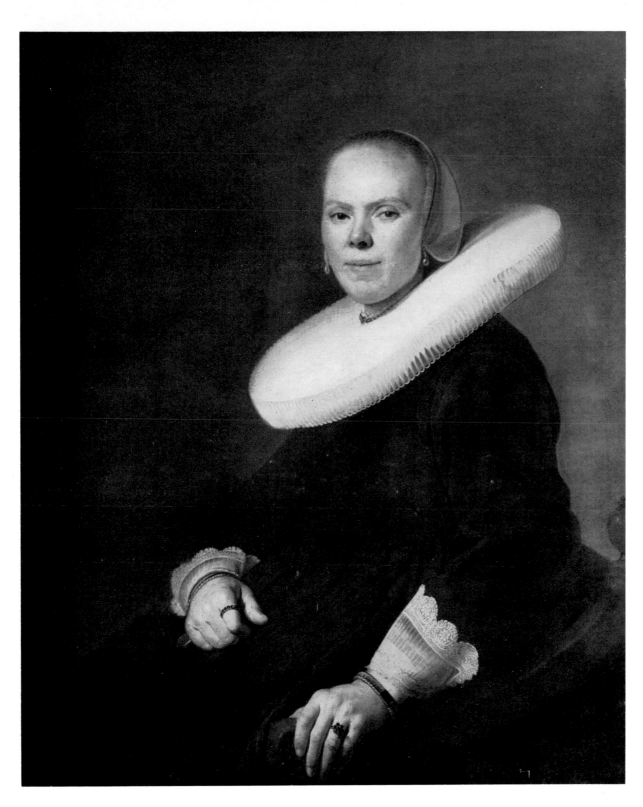

Jan Verspronck

PORTRAIT OF A LADY

Canvas, 98.5 × 80 cm.
Frankfurt, Staedel Institute
No. 177.

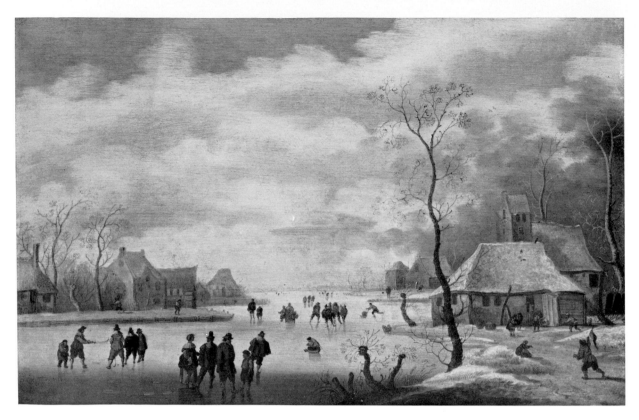

Antonie Verstralen

WINTER LANDSCAPE

Wood, 35 × 53.5 cm.
Amsterdam, art trade.

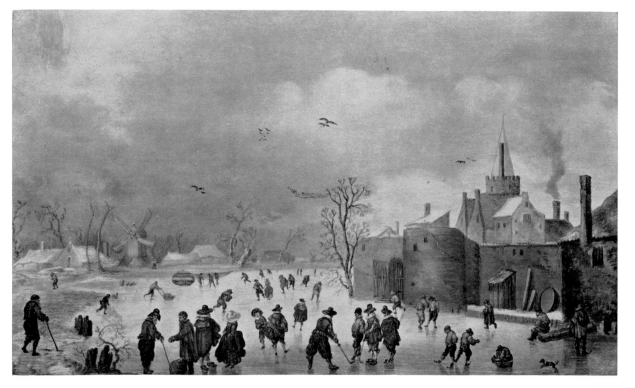

Antonie Verstralen

SKATERS ON THE ICE

With monogram,
dated 1630
Wood, 26 × 43 cm.
The Hague, Mauritshuis
No. 659.

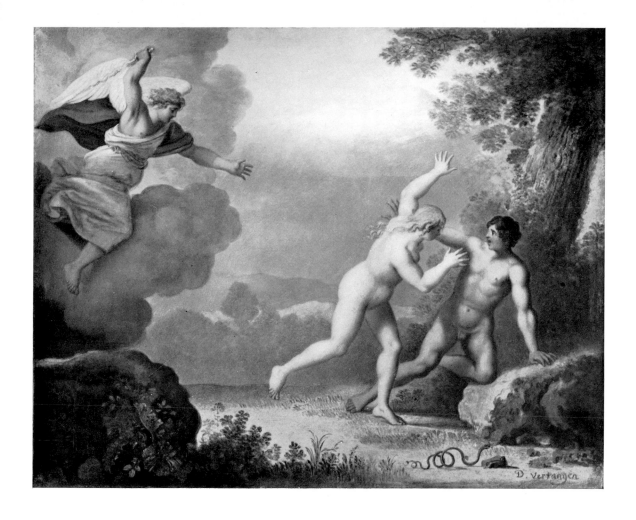

Daniel Vertangen

THE EXPULSION
FROM PARADISE

Signed
Copper, 20 × 24.5 cm.
Dresden, Gallery
No. 1256.

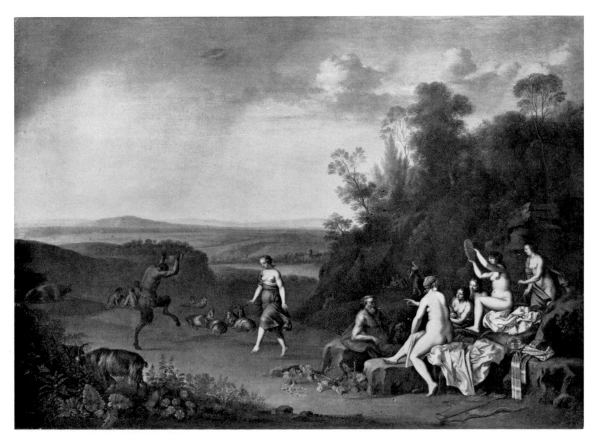

Daniel Vertangen

LANDSCAPE WITH NYMPHS

Signed
Canvas, 72 × 98 cm.
Brunswick,
Herzog-Anton-Ulrich Museum
No. 194.

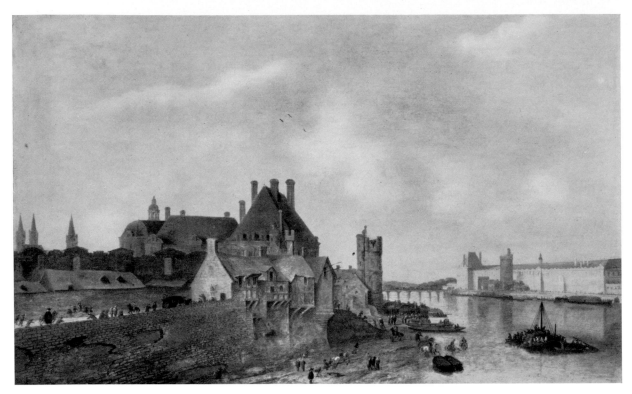

Abraham de Verwer

Hôtel de Nevers
and the Louvre

Signed and dated 1637
Wood, 37×59.6 cm.
Paris, Musée Carnavalet

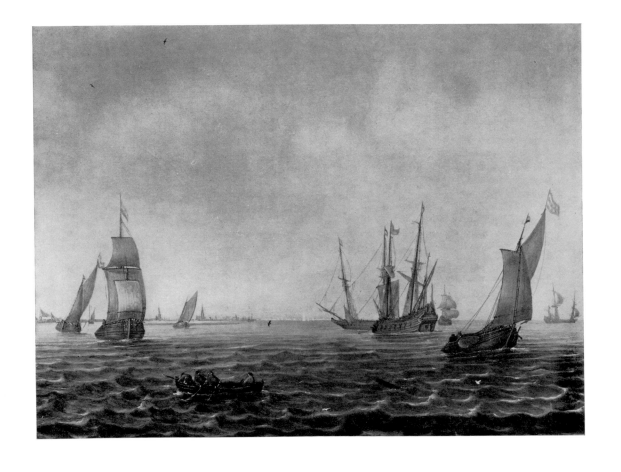

Justus de Verwer

Seascape

With monogram
Wood, 43×58 cm.
Berlin, Dr. Schaeffer
(Exhibition April 1932).

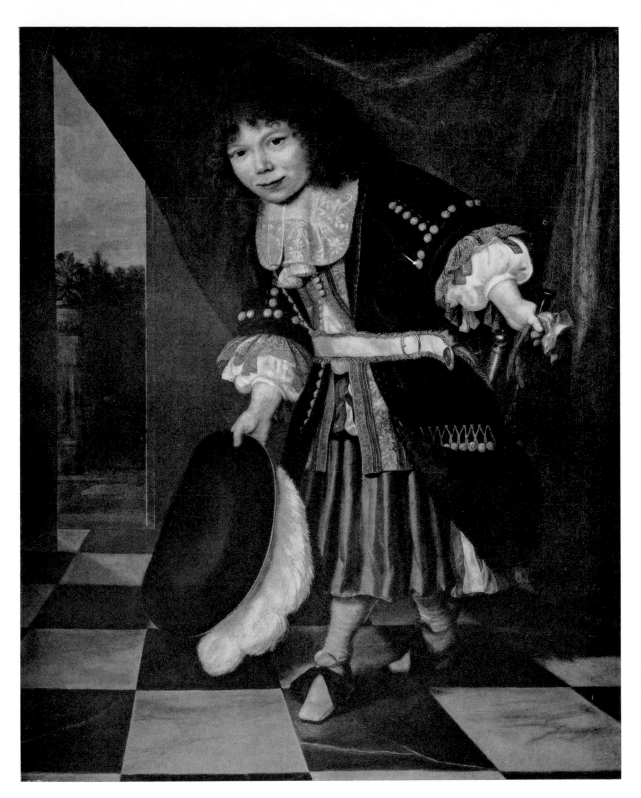

François Verwilt

<small>THE SON OF
ADMIRAL VAN NES</small>

Signed and dated 1669
Canvas, 114×92.5 cm.
Amsterdam, Rijksmuseum
No. 2547.

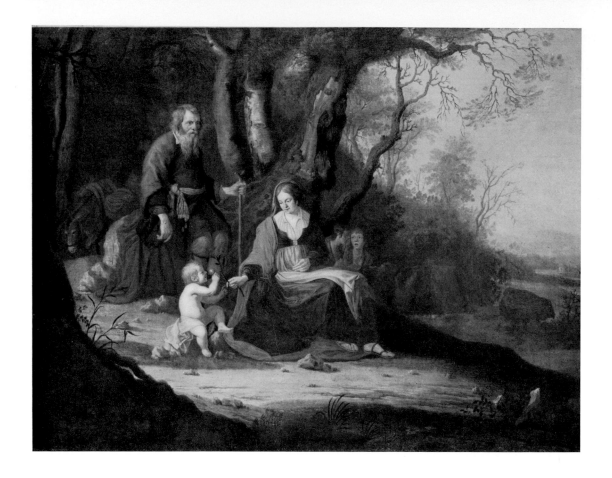

Paulus van Vianen II

THE REST ON THE FLIGHT
INTO EGYPT

Signed and dated 1643
Canvas, 84×110 cm.
Amsterdam, Rijksmuseum
No. 2550.

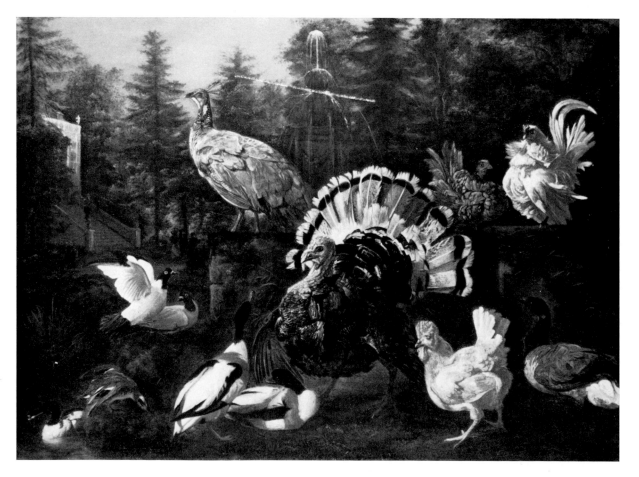

Jacobus Victors

POULTRY
(Background
by J. van Ruisdael

Signed by both artists
Canvas, 52.5×71 cm.
Cologne, art trade.

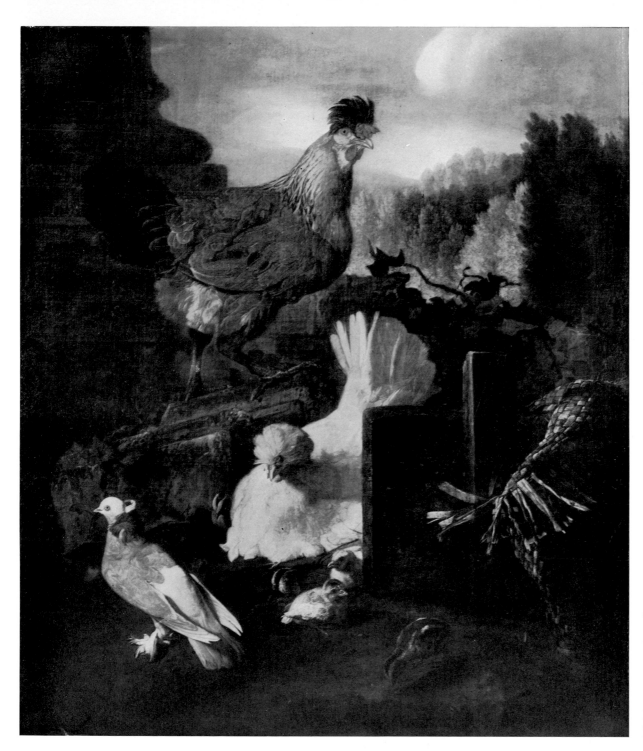

Jacobus Victors

Poultry among Ruins

Signed
Canvas, 112×96 cm.
Dresden, Gallery
No. 1617.

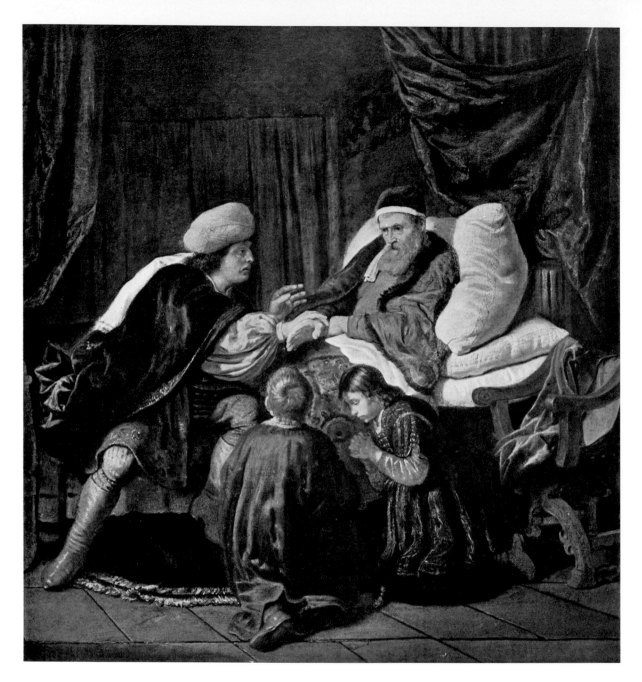

Jan Victors

Jacob Blessing
the Sons of Joseph

Canvas, 81.5 × 77 cm.
Budapest,
Museum of Fine Arts
No. 1344.

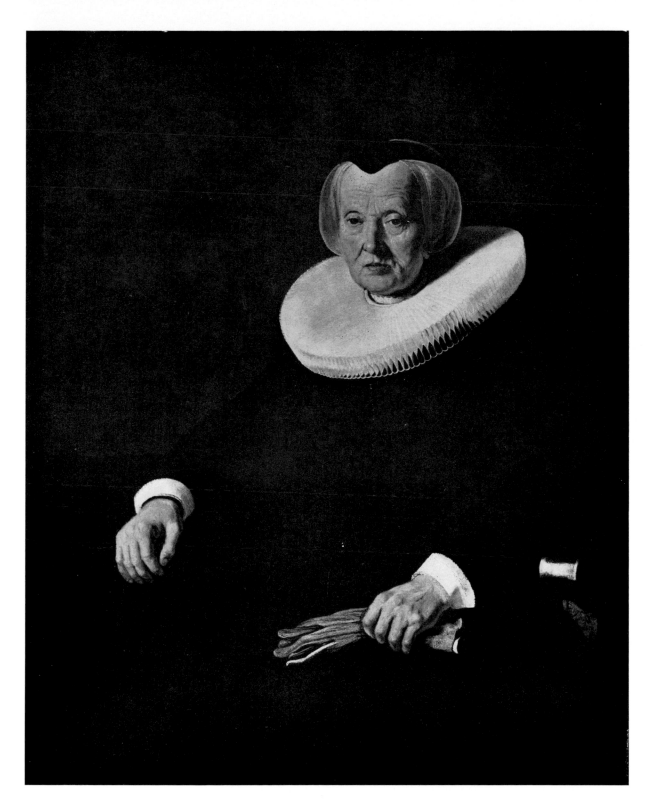

Jan Victors

Portrait
of Maria Caamerling

Signed and dated 1657
Canvas, 101.5 × 83.5 cm.
The Hague,
Portrait Exhibition 1903
No. 130.

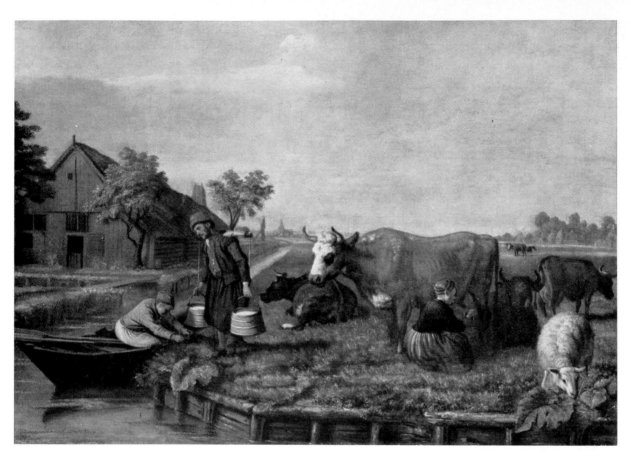

Jan Victors

MILKING-TIME

Signed
Canvas, 90×98 cm.
Berlin, Lepke sale, 7 May 1895.

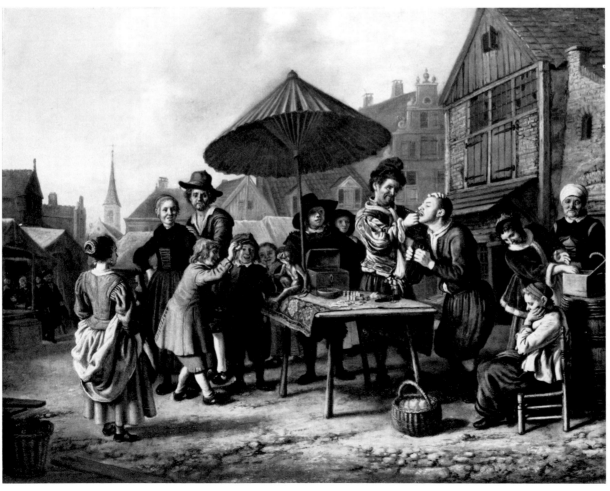

Jan Victors

THE DENTIST

Canvas 75×95 cm
Wiesbaden, art trade.

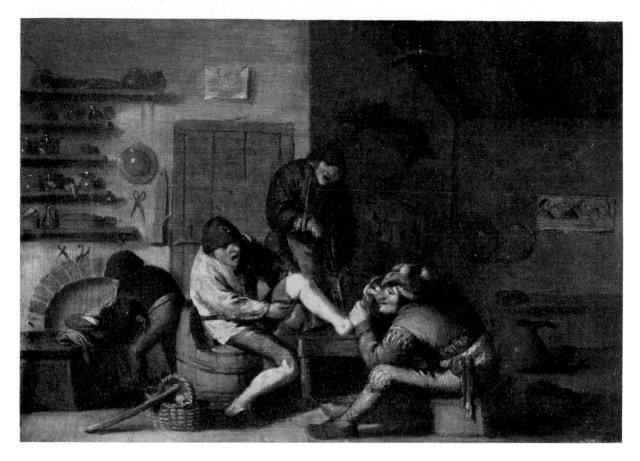

Anthonie Victoryns

THE FOOT OPERATION

Wood, 21 × 30 cm.
Garmisch-Partenkirchen,
private collection.

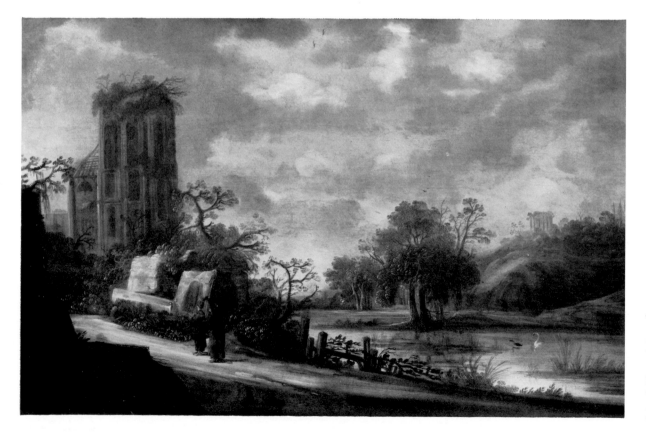

Jacob de Villeers

RIVER LANDSCAPE

Signed
Wood, 64 × 98 cm.
Munich, art trade.

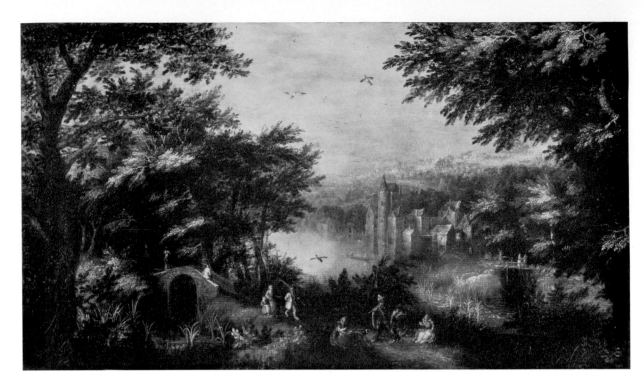

David Vinckboons

LANDSCAPE

Wood, 30×51.5 cm.
Munich, art trade.

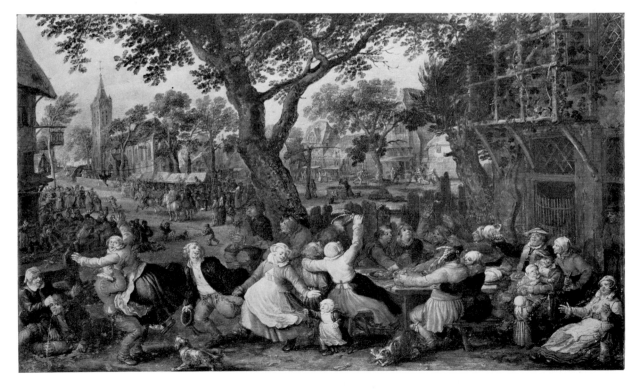

David Vinckboons

VILLAGE FAIR

Signed and dated 1629
Wood, 44.5×67.5 cm.
The Hague, Mauritshuis
No. 542.

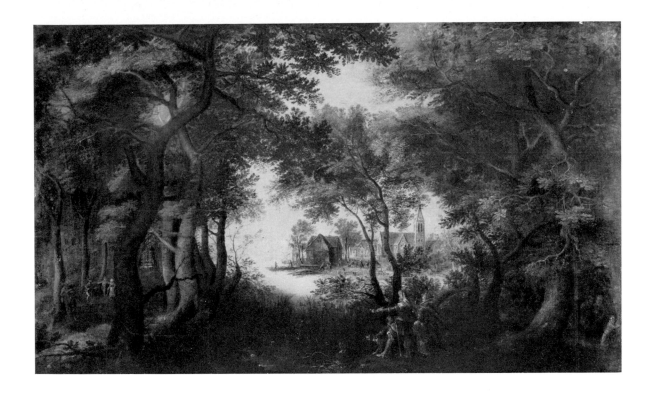

David Vinckboons

RIVER LANDSCAPE
WITH FOREST

Canvas, 64×105 cm.
Berlin, Staatl. Museen,
Gemäldegalerie
No. 2012.
(destroyed)

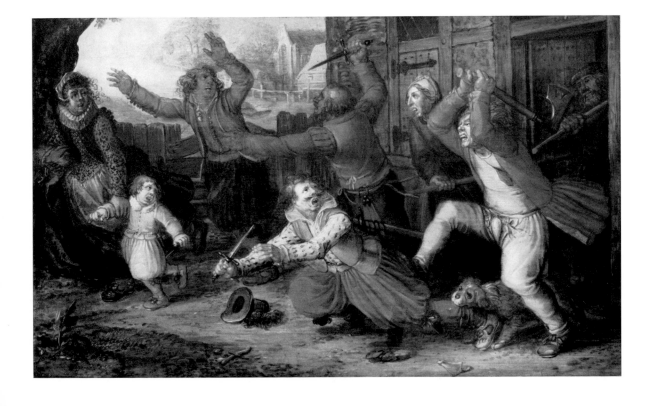

David Vinckboons

PEASANTS DRIVING AWAY
SOLDIERS

Wood, 26.5×42 cm.
Amsterdam, Rijksmuseum
No. 2557.

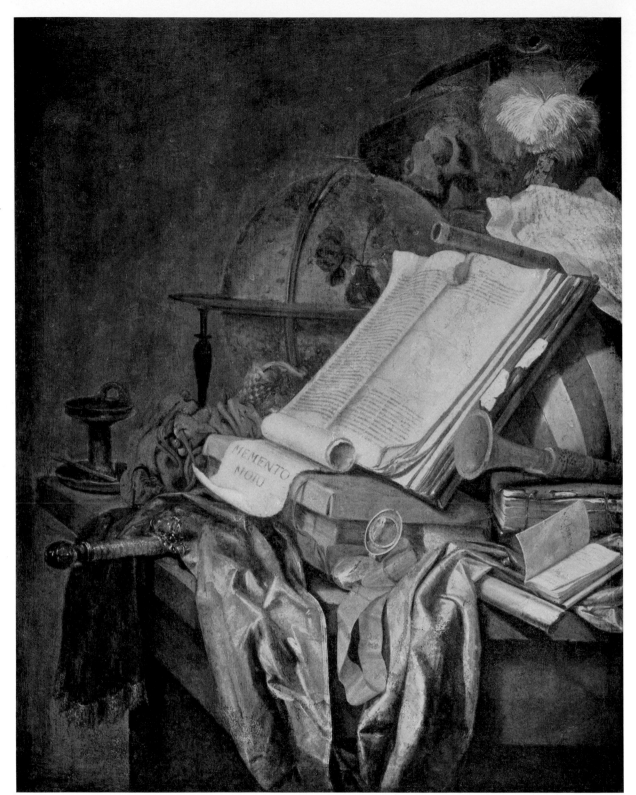

Vincent Laurensz. van der Vinne

VANITAS

Signed and dated 1657
Wood
Amsterdam,
Goudstikker collection
(before 1940).

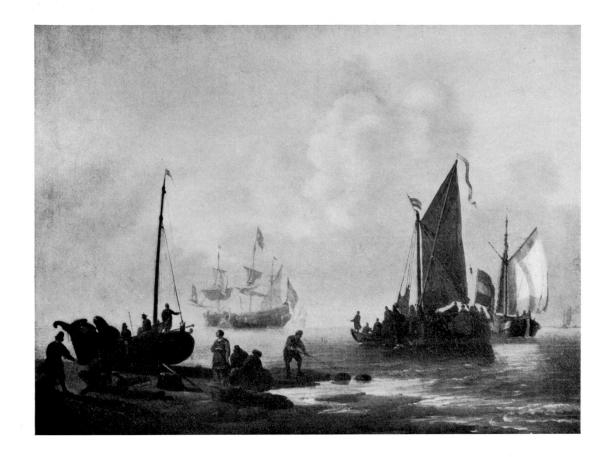

Wigerus Vitringa

SHIPS ON A CALM SEA

Signed and dated 1690
Canvas, 54×71 cm.
Lausanne, art trade

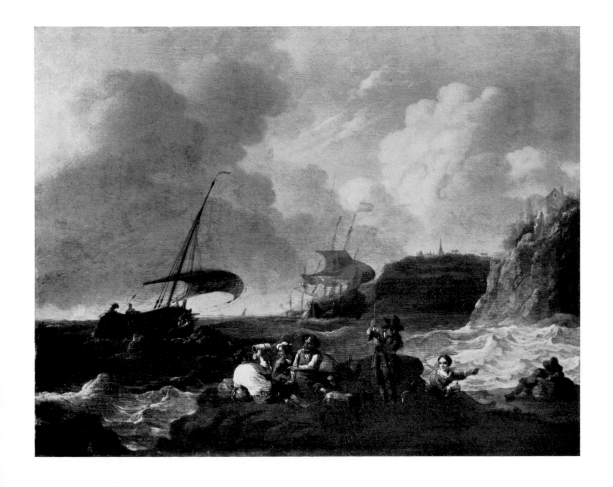

Wigerus Vitringa

SEASCAPE

Signed
Wood, 43×54 cm.
Schleissheim, Gallery
No. 3889.

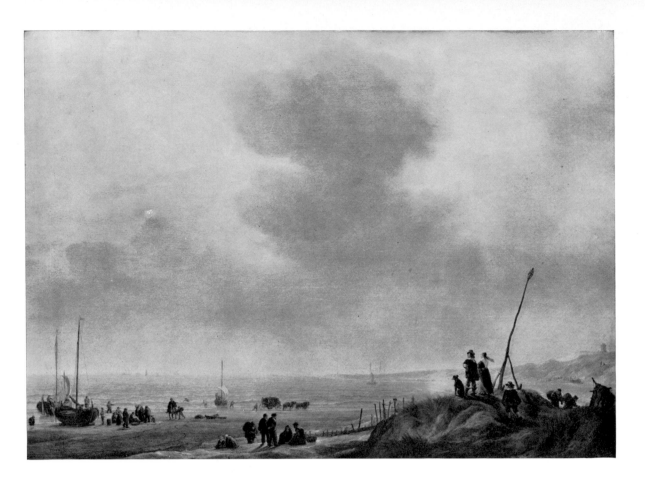

Simon de Vlieger

THE BEACH AT SCHEVENINGEN

Signed and dated 1643
Wood, 60×82.5 cm.
The Hague, Mauritshuis
No. 558.

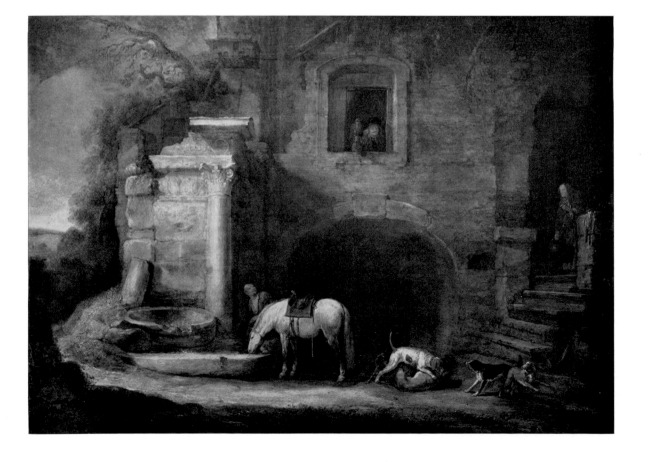

Simon de Vlieger

THE FALCONER'S HOMECOMING

Signed and dated 1637
Wood, 71×95 cm.
Amsterdam, Rijksmuseum
No. 2561

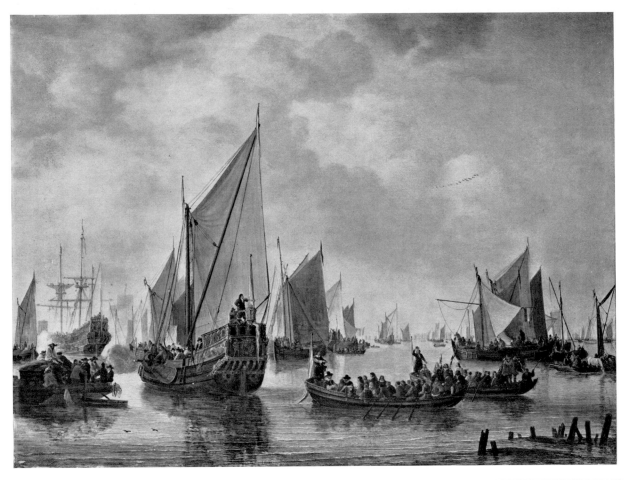

Simon de Vlieger

CALM SEA

Signed and dated 1649
Wood, 71×92 cm.
Vienna,
Kunsthistorisches Museum
No. 1339.

Simon de Vlieger

SEA STORM ON A ROCKY COAST

Signed
Wood, 30.5×39 cm.
Dresden, Gallery
No. 1549.

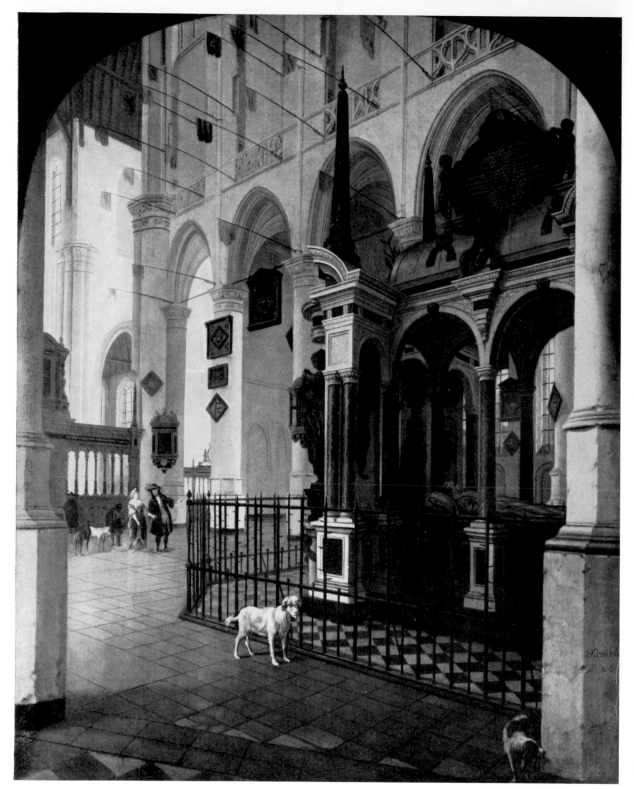

Hendrik van Vliet

THE TOMB OF COUNT WILLIAM
OF NASSAU IN THE
NIEUWE KERK AT DELFT

Signed and dated 1663
Canvas, 82 × 64 cm.
Dessau, Amalienstift
No. 114.

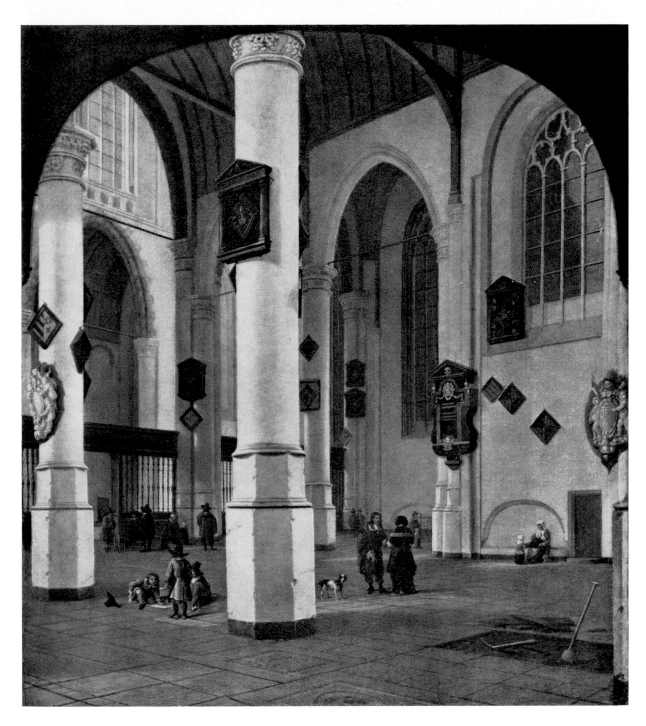

Hendrik van Vliet

THE INTERIOR OF THE
OUDE KERK IN DELFT

Signed
Canvas, 77.5 × 69 cm.
The Hague, Mauritshuis
No. 203.

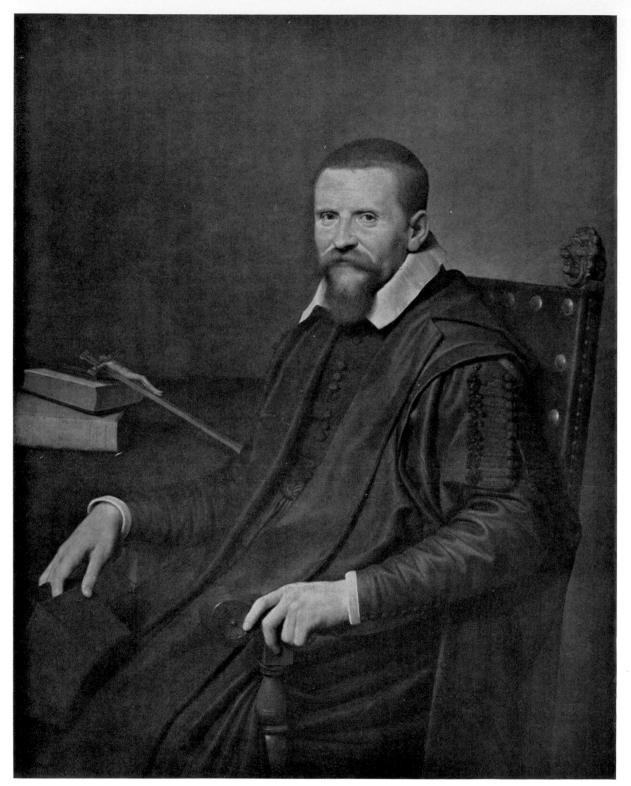

Willem van Vliet

PORTRAIT
OF THE ARCH-PRIEST
SUITBERTUS PURMERENT

Signed
Wood, 114×85 cm.
London, National Gallery
No. 1168.

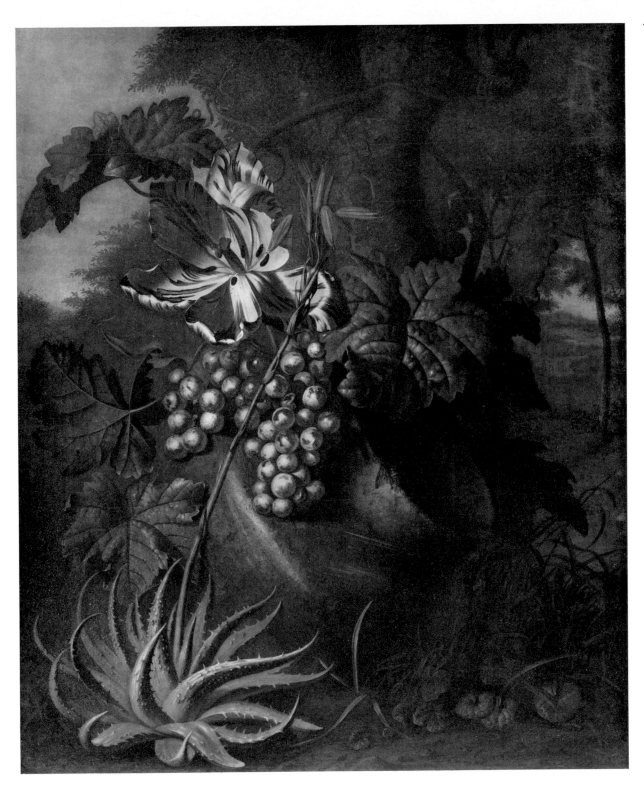

Karel Borchaert Voet

FLOWERING AGAVE,
TULIPS AND GRAPE

Signed
Wood, 65 × 52.2 cm.
The Hague, Municipal Museum
No. 497.

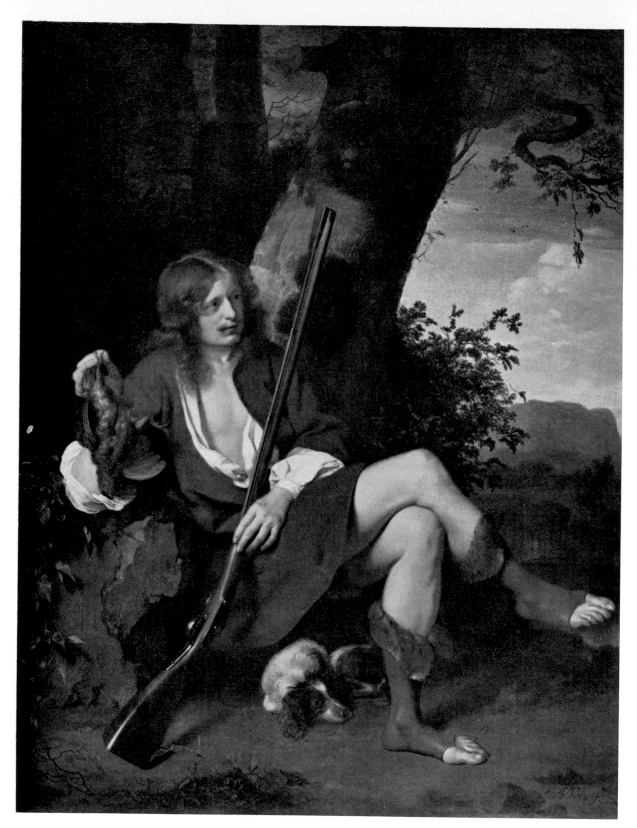

Arie de Vois

SELF-PORTRAIT AS HUNTSMAN

Signed
Wood, 29 × 22,5 cm.
The Hague, Mauritshuis
No. 204.

Arie de Vois

LADY FEEDING A PARROT

Signed
Wood, 27×21 cm.
Amsterdam, Rijksmuseum
No. 2574.

Arie de Vois

LANDSCAPE
WITH AN ELEGANT COUPLE
IN THE GUISE OF MARS
AND DIANA

Signed
Wood, 29×34 cm.
Formerly Linz collection.

Joost de Volder

LANDSCAPE

With monogram
Wood, 52×75 cm.
Rottach, private collection.

Elias Vonck

BOY WITH GAME-BAG

Signed
Wood, 92 × 70 cm.
Amsterdam, art trade.

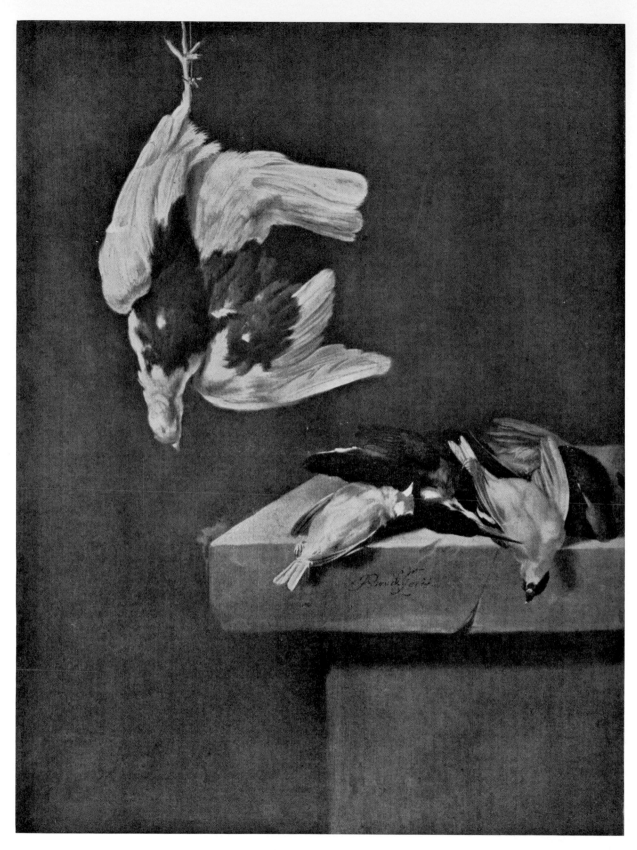

Jan Vonck

DEAD BIRDS

Signed
Canvas, 70 × 52 cm.
Prague, private collection.

Jan Voorhout

THE ANGEL ANNOUNCING
THE BIRTH OF SAMSON
TO MANOAH AND HIS WIFE

Signed
Canvas, 118×85 cm.
Brunswick,
Herzog-Anton-Ulrich Museum
No. 291.

Cornelis van der Voort

PORTRAIT OF A MAN
(PENDANT)

Canvas, 118×84 cm.
Munich, art trade.

Cornelis van der Voort

PORTRAIT OF A WOMAN
(PENDANT)

Canvas, 118 × 84 cm.
Munich, art trade.

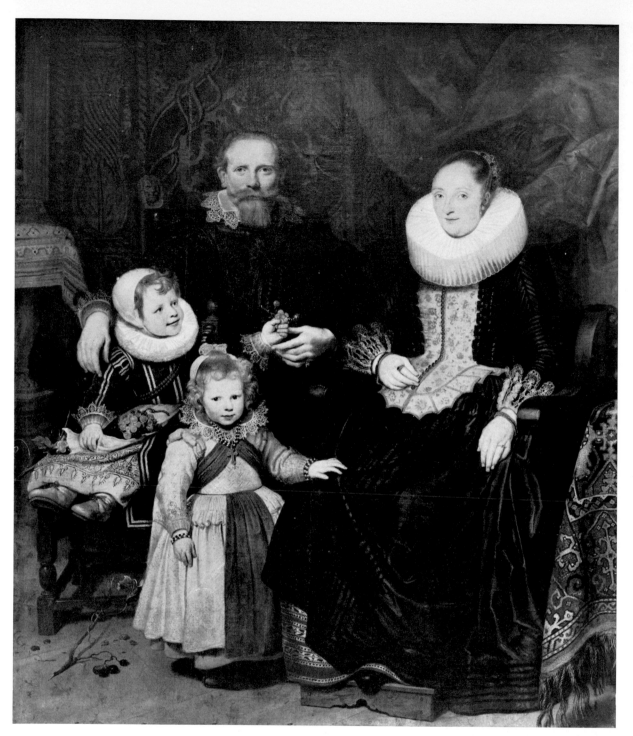

Cornelis de Vos

THE ARTIST AND HIS FAMILY

Signed and dated 1621
Canvas, 188 × 162 cm.
Brussels,
Musée Royal des Beaux-Arts
No. 503.

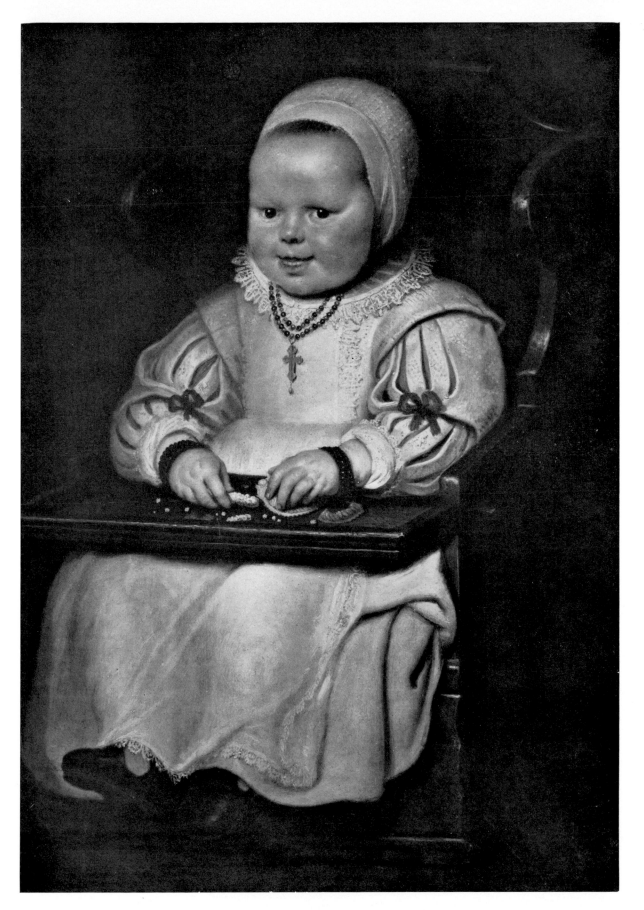

Cornelis de Vos

PORTRAIT OF A CHILD

Signed and dated 1627
Wood, 80×55.5 cm.
Frankfurt, Staedel Institute
No. 131.

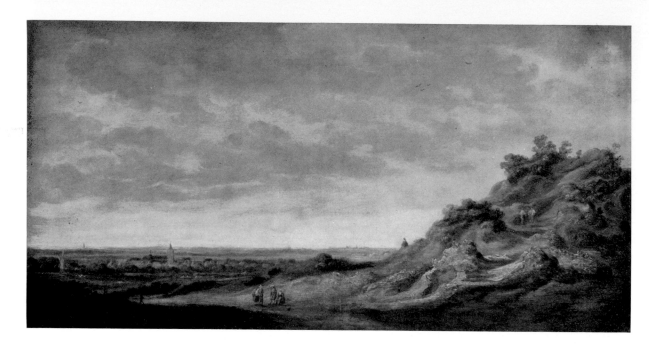

Jan de Vos

LANDSCAPE

Signed and dated 1641
Wood, 44×85 cm.
Munich, art trade.

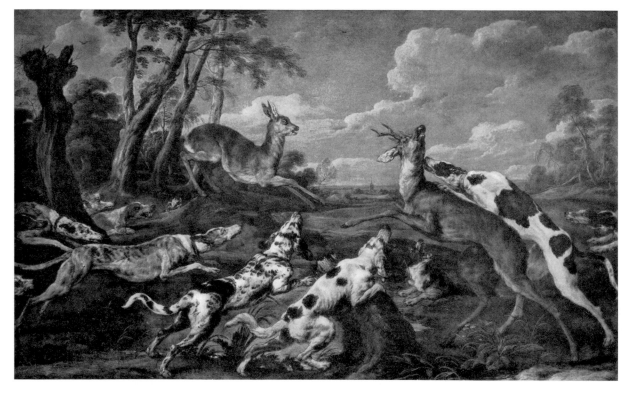

Paul de Vos

STAG HUNT

Signed
Canvas, 212×347 cm.
Madrid, Prado
No. 1870.

Paul de Vos

Still Life

Signed
Canvas, 117×291 cm.
Madrid, Prado
No. 1877.

Simon de Vos

Merry Company

Wood, 53×74 cm.
Berlin, Staatl. Museen
Gemäldegalerie
No. 2007.
(destroyed)

Huyg. Pietersz. Voskuyl

PORTRAIT OF GEERTRUY REAL

Signed and dated 1640
Wood, 123.5×90 cm.
Amsterdam, Rijksmuseum
No. 2595b.

Huyg. Pietersz. Voskuyl

Tobias with the Fish

Signed and dated 1658
Canvas, 122 × 101 cm.
Munich, Alte Pinakothek
No. 11360.

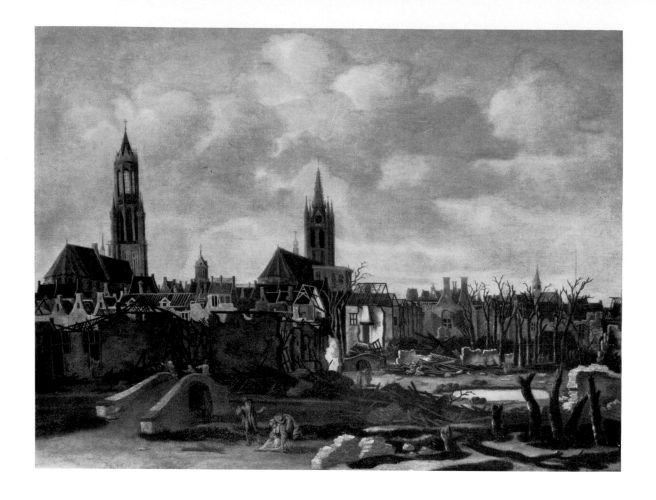

Daniel Vosmaer

THE GUNPOWDER EXPLOSION
IN DELFT

Signed
Canvas, 84×101 cm.
Berlin, H. W. Lange sale,
3 December 1940
No. 203.

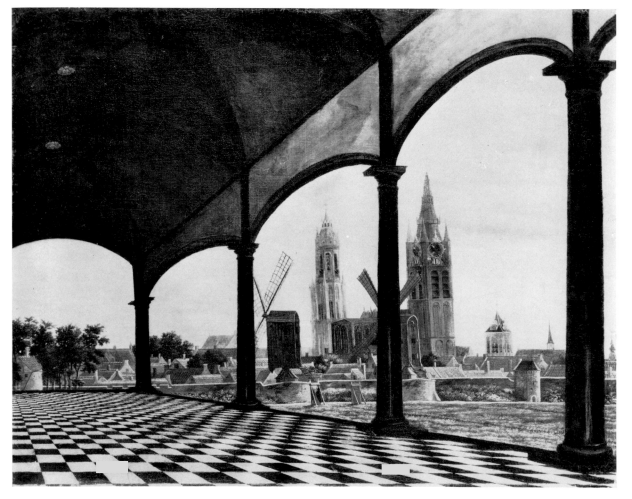

Daniel Vosmaer

VIEW OF DELFT

Signed and dated 1663
Canvas, 90×113 cm.
Amsterdam, art trade.

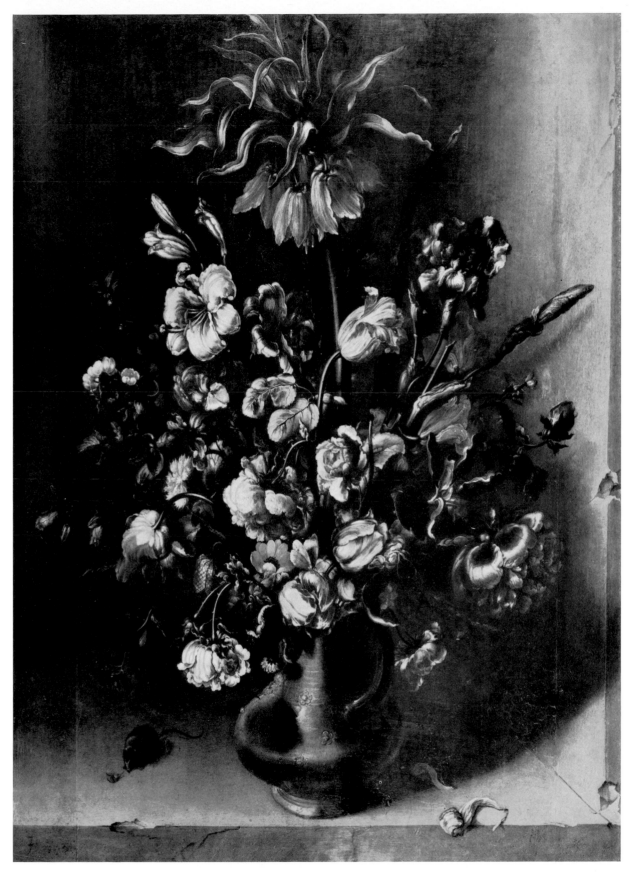

Jacob Vosmaer

BUNCH OF FLOWERS
AND A MOUSE

Signed
Wood, 109 × 79 cm.
Amsterdam,
private collection 1955.

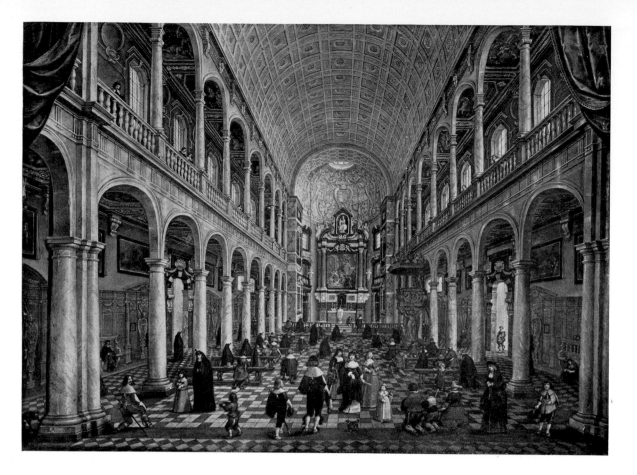

Sebastian Vrancx

THE INTERIOR OF
THE JESUIT CHURCH
IN ANTWERP

Signed
Wood, 52 × 71 cm.
Vienna,
Kunsthistorisches Museum
No. 965.

Sebastian Vrancx

AN AMBUSH

With monogram
Wood, 41 × 54 cm.
Brunswick,
Herzog-Anton-Ulrich Museum
No. 78.

Sebastian Vrancx

RENAISSANCE ARCHITECTURE
(ONE OF THE SEVEN WORKS
OF MERCY)

Wood, 64.5 × 48 cm.
Amsterdam, private collection.

Sebastian Vrancx

LOOTING AFTER A BATTLE

Wood, 59.5 × 111 cm.
Munich, art trade.

Nicolaes de Vree

HILLY LANDSCAPE
WITH HOUSES

Signed
Canvas, 69 × 90 cm.
Munich, art trade.

Jacobus Vrel

THE YOUNG NURSE

Wood, 57×45.5 cm.
Antwerp,
Musée Royal des Beaux-Arts
No. 790.

Jacobus Vrel

MOTHER COMBING
HER DAUGHTER'S HAIR

Signed
Wood, 53×41 cm.
Munich, art trade.

Jacobus Vrel

A QUIET STREET

Signed
Wood, 52 × 40 cm.
Munich, art trade.

Abraham de Vries

PORTRAIT OF SIMON DE VOS

Signed and dated 1635
Wood, 120×93 cm.
Antwerp,
Musée Royal des Beaux-Arts
No. 662.

1353

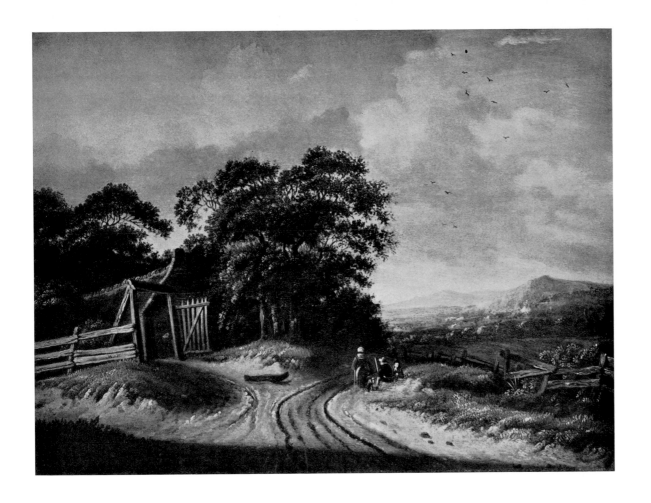

Michiel van Vries

DUNE LANDSCAPE
WITH PEASANT COTTAGE

Signed
Wood, 41 × 53 cm.
Amsterdam, Six sale,
16 October 1928
No. 51.

1354

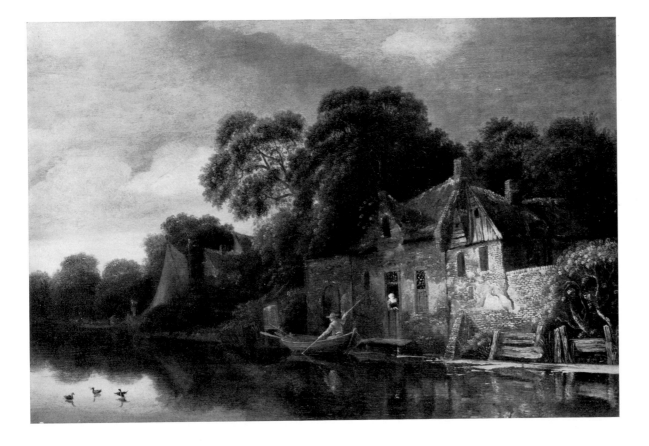

Michiel van Vries

PEASANT COTTAGE BY A CANAL

Signed and dated 1656
Wood, 43 × 62.5 cm.
Amsterdam, Rijksmuseum
No. 2602.

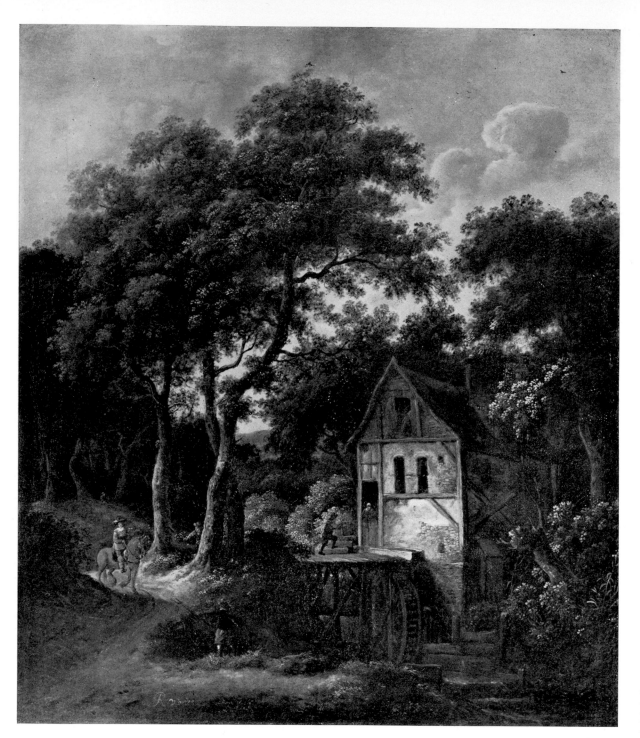

Roelof van Vries

THE MILL IN THE FOREST

Signed
Canvas, 59×51 cm.
Munich, Alte Pinakothek
No. 562.

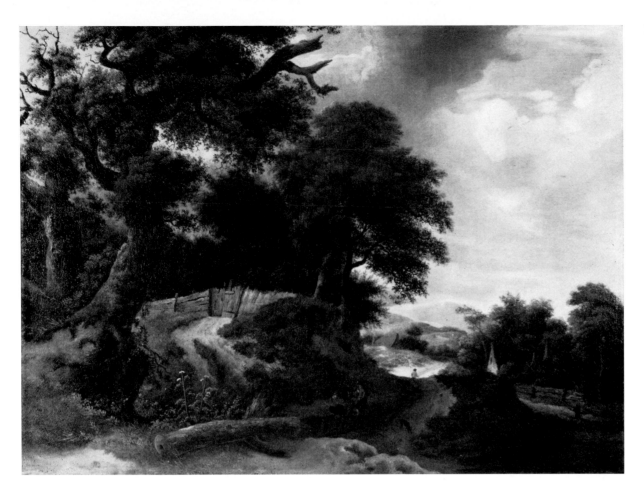

Roelof van Vries

WOODED DUNE LANDSCAPE

With monogram
Canvas, 94×125 cm.
Bremen, private collection.

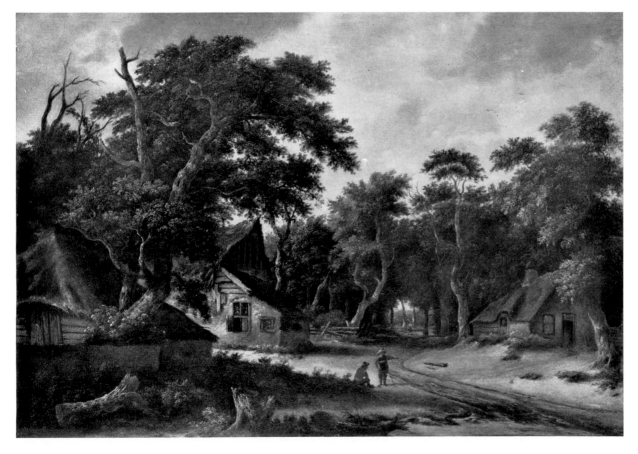

Roelof van Vries

FOREST LANDSCAPE

Signed
Wood, 61×84.5 cm.
Frankfurt, Staedel Institute
No. 265.

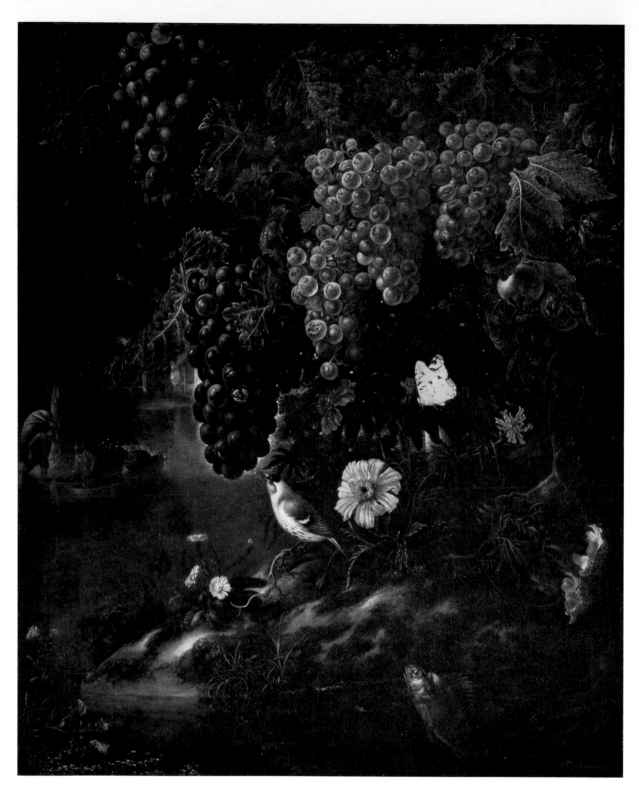

Isaak Vromans

GRAPES AND INSECTS

Signed
Canvas, 65 × 54 cm.
Amsterdam, Rijksmuseum
No. 2607a.

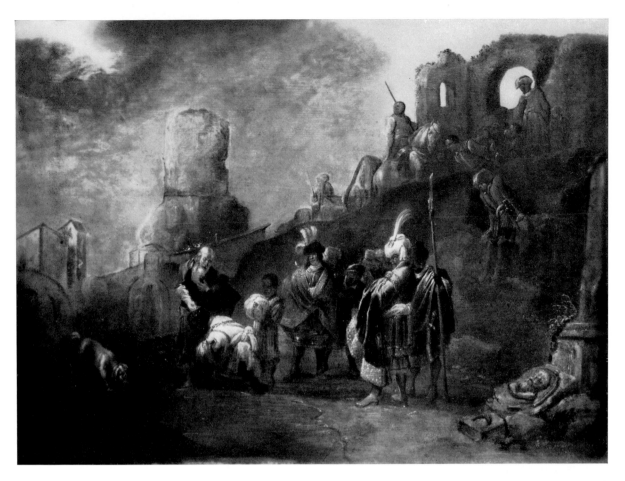

Pieter P. Vromans the Younger

THE BAPTISM OF THE EUNUCH

Signed
Wood, 46.5 × 62 cm.
Goettingen, University
No. 194.

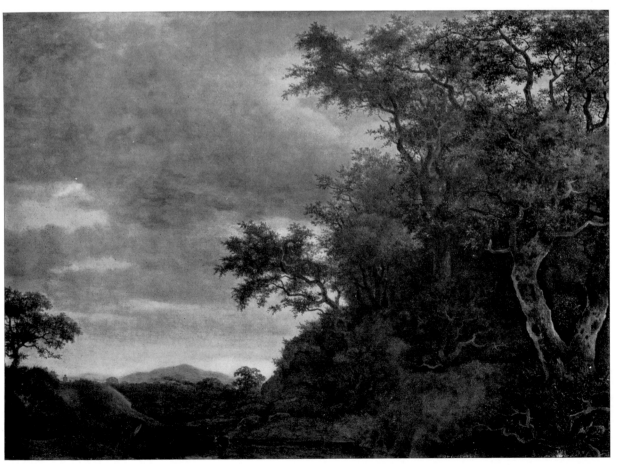

Cornelis Vroom

FOREST LANDSCAPE

Signed and dated 1651
Wood, 49 × 66 cm.
Copenhagen,
Royal Museum of Fine Arts
No. 224.

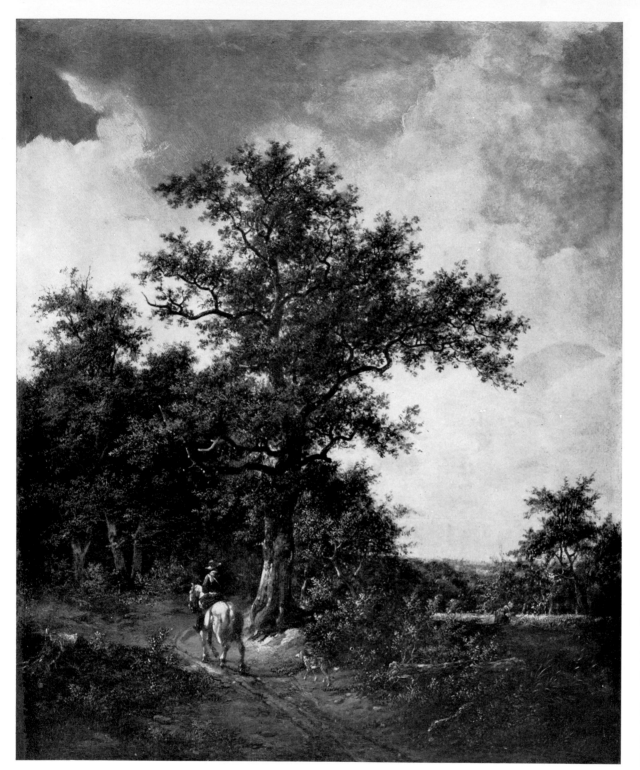

Cornelis Vroom

HUNTSMAN RIDING
IN A FOREST

Signed
Wood, 50×40 cm.
Dresden, Gallery
No. 1381.

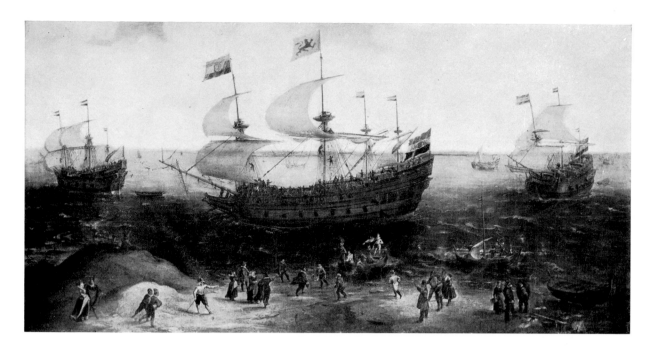

Hendrik Vroom

Dutch Ships
Returning from Brazil

Signed
Canvas, 144×279 cm.
Amsterdam, Rijksmuseum
No. 2606.

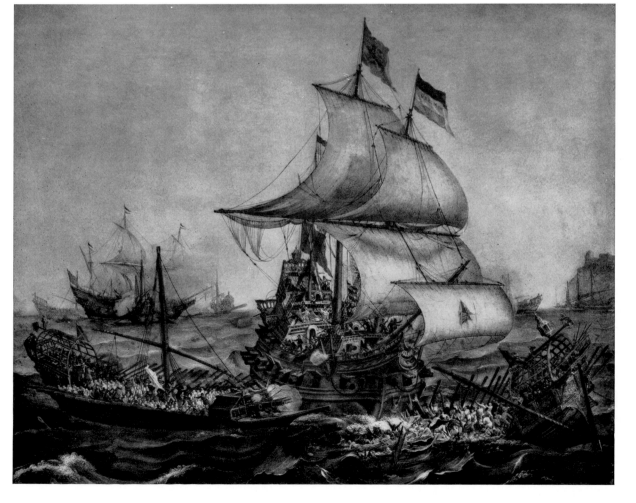

Hendrik Vroom

The Spanish Galleys
Being Sunk off Gibraltar

Signed and dated 1617
Canvas, 119×149 cm.
Amsterdam, Rijksmuseum
No. 2604.

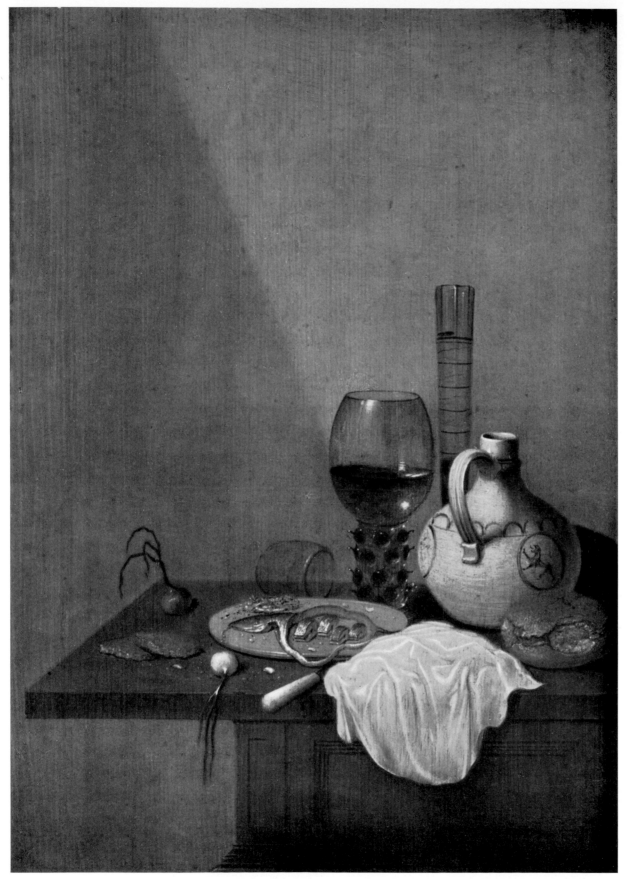

Gerrit van Vucht

Breakfast Still Life

Wood, 32 × 24 cm.
Vienna,
Academy of Fine Arts
No. 1394.

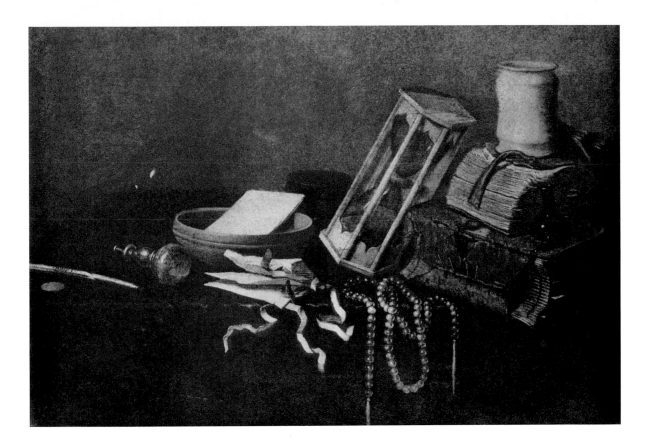

Gerrit van Vucht

VANITAS

Signed
Wood, 32×47.5 cm.
Poznan, National Museum
No. 98.

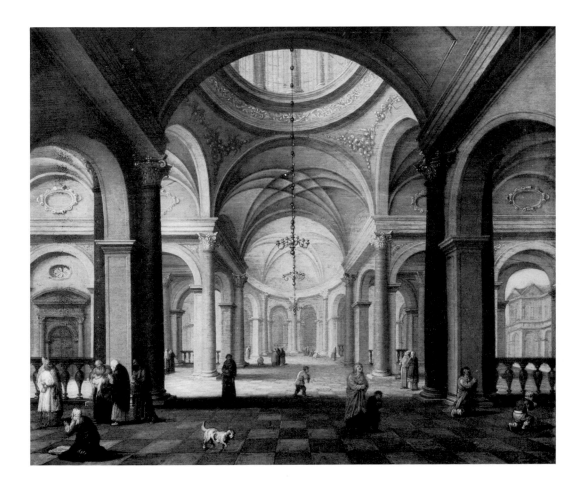

Jan van Vucht

A RENAISSANCE CHURCH

Signed
Wood, 37×46 cm.
Bremen, Kunsthalle
No. 150.

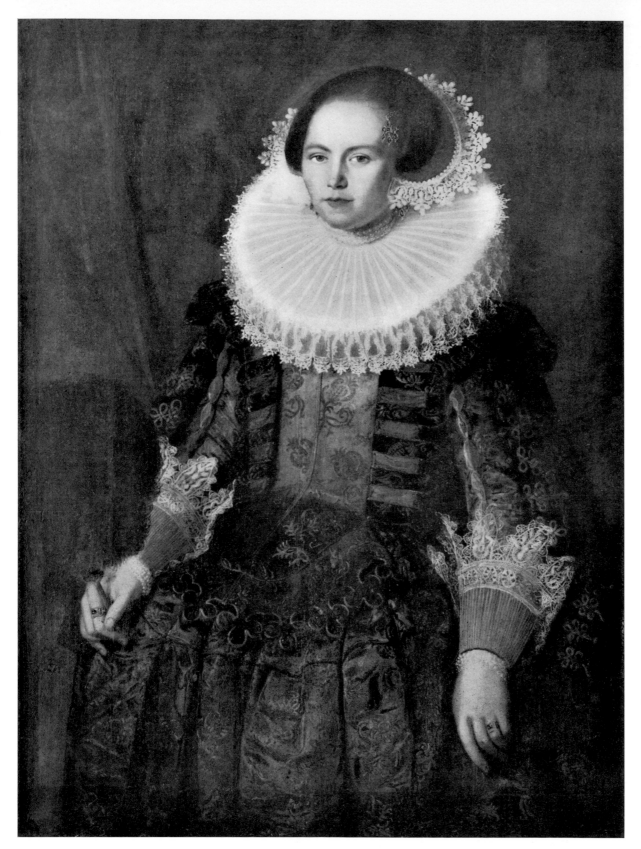

Jakob Wabbe

PORTRAIT OF A LADY

Signed and dated 1631
Wood, 122×95 cm.
Amsterdam, Heeswijk sale,
19 June 1900
No. 106.

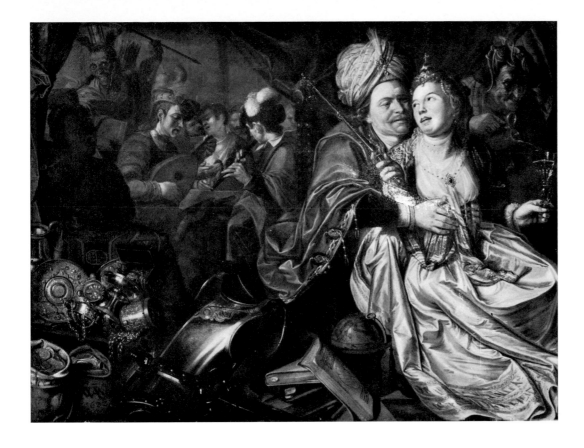

Jakob Wabbe

KING SOLOMON
AND HIS CONCUBINE:
AN ALLEGORY OF TRANSIENCE

Signed and dated 1622
Canvas, 133 × 174 cm.
Düsseldorf, art trade

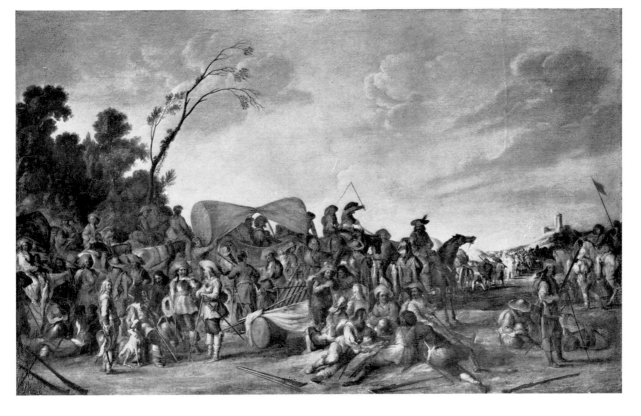

Cornelis de Wael

SOLDIERS' ENCAMPMENT

Canvas, 95 × 148 cm.
Brunswick,
Herzog-Anton-Ulrich Museum
No. 420.

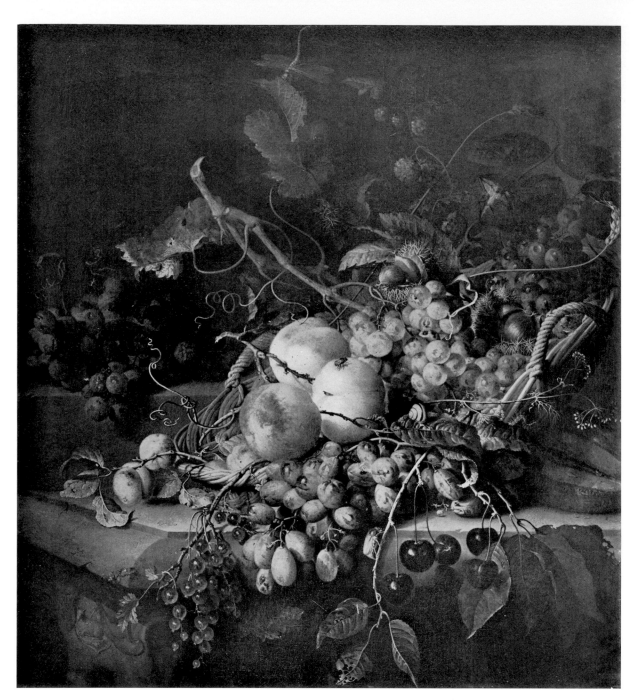

Jacob van Walscapelle

Fruit Still Life

With monogram
Canvas, 68×63 cm.
Amsterdam, Rijksmuseum
No. 2609a.

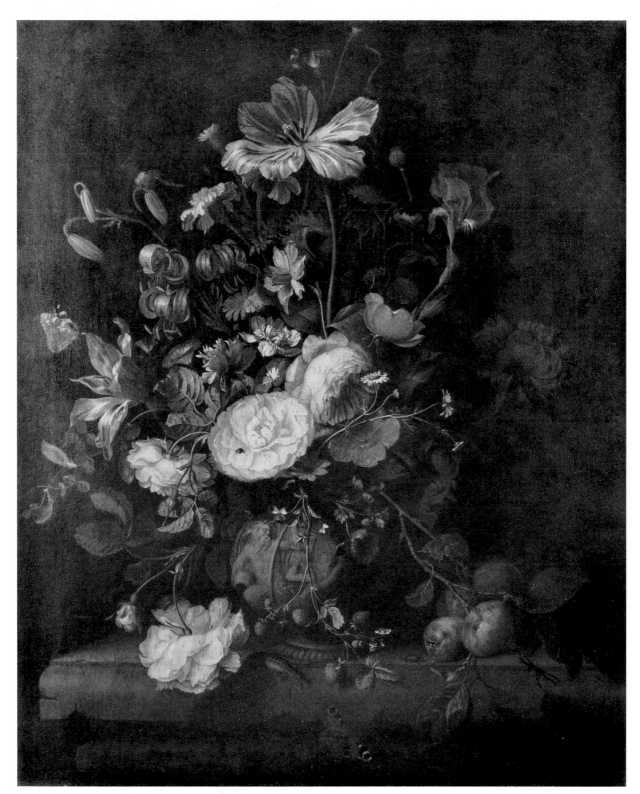

Jacob van Walscapelle

FLOWER-PIECE

Signed and dated 1677
Canvas, 72 × 58 cm.
Frankfurt, Staedel Institute
No. 334.

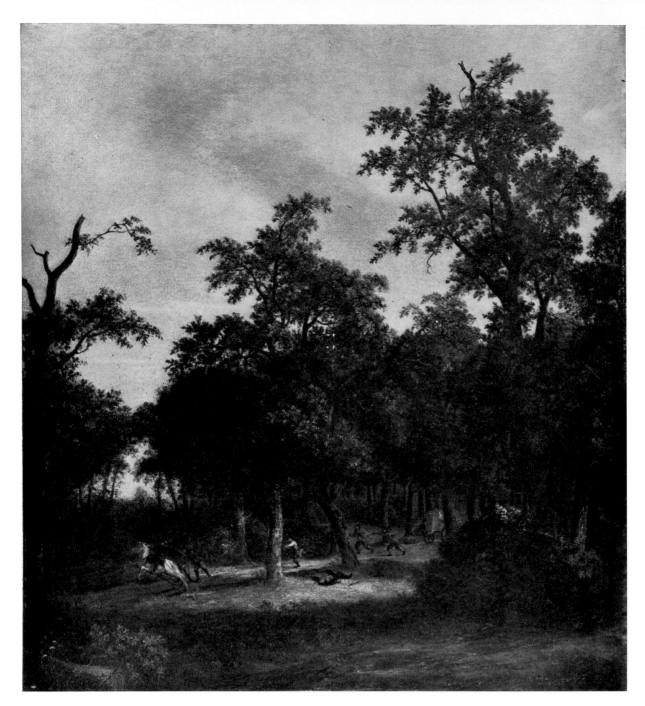

Anthonie Waterloo

FOREST LANDSCAPE
WITH AMBUSH

Signed
Canvas, 86×77 cm.
Munich, Alte Pinakothek
No. 552.

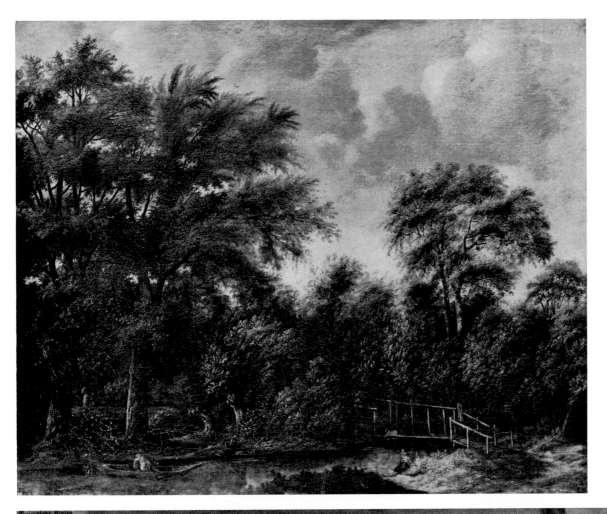

1373

Anthonie Waterloo

FOREST LANDSCAPE

With monogram
Canvas, 57×72 cm.
Gotha, Gallery
No. 189.

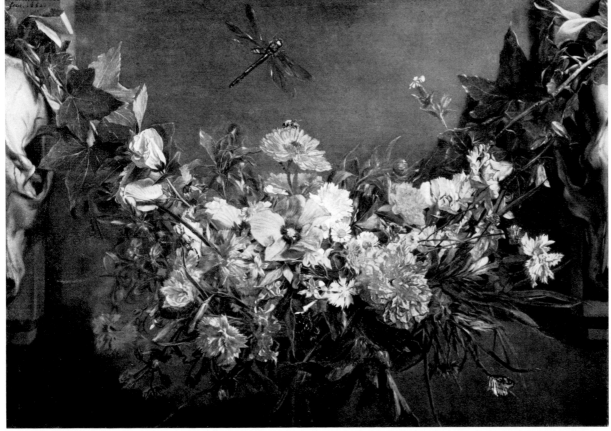

1374

Michaelina Wautier

FLOWER GARLANDS

Signed and dated 1652
Wood, 41.5×57 cm.
St. Gilgen,
F. C. Butôt collection.

Jan Weenix

SLEEPING GIRL

Wood, 45×35 cm.
Munich, Alte Pinakothek
No. 246.

Jan Weenix

LANDSCAPE WITH SHEPHERDS

Signed and dated 1664
Canvas, 77×98 cm.
London,
Dulwich College
No. 47.

Jan Weenix

LARGE STILL LIFE
WITH DEAD HARE

Signed and dated 1690
Canvas, 130×170 cm.
Dresden, Gallery
No. 1667.

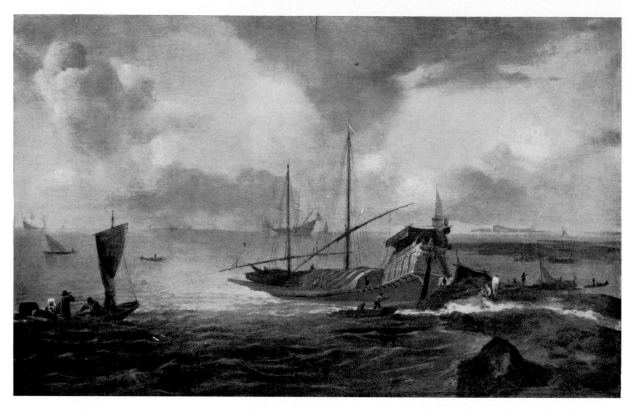

Jan Baptist Weenix

SEASCAPE WITH THE
VENETIAN BUCENTORO

Signed
Canvas, 109 × 171 cm.
Karlsruhe, Kunsthalle
No. 313.

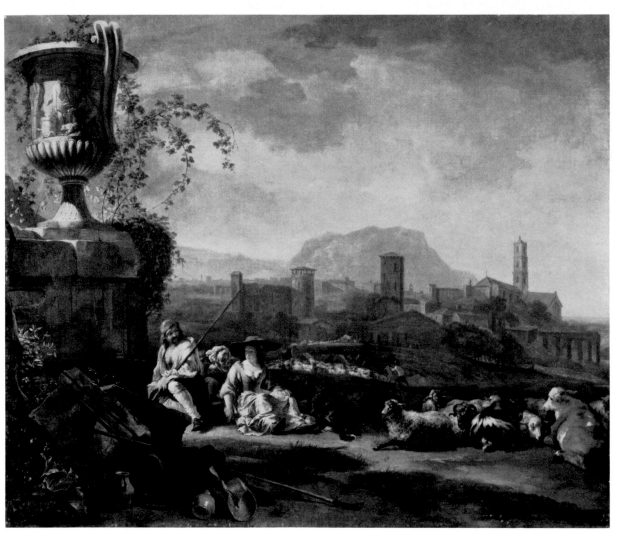

Jan Baptist Weenix

ROMAN LANDSCAPE WITH
SHEPHERDS AND FLOCKS

Canvas, 115.5 × 137.5 cm.
Basle, Kunstmuseum
No. 636.

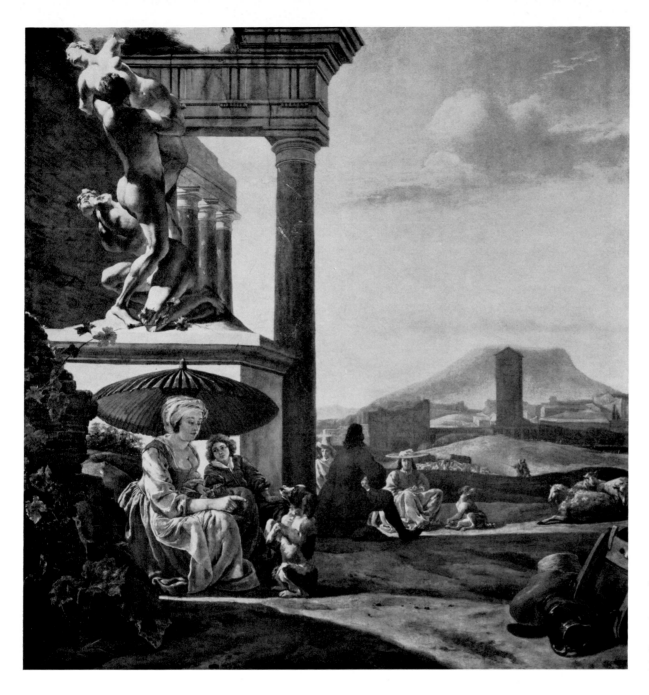

Jan Baptist Weenix

ANCIENT RUINS WITH FIGURES

Canvas, 125 × 120 cm.
Munich, art trade.

Adriaen van der Werff

SELF-PORTRAIT

Signed and dated 1699
Canvas, 81×65.5 cm.
Amsterdam, Rijksmuseum
No. 2626.

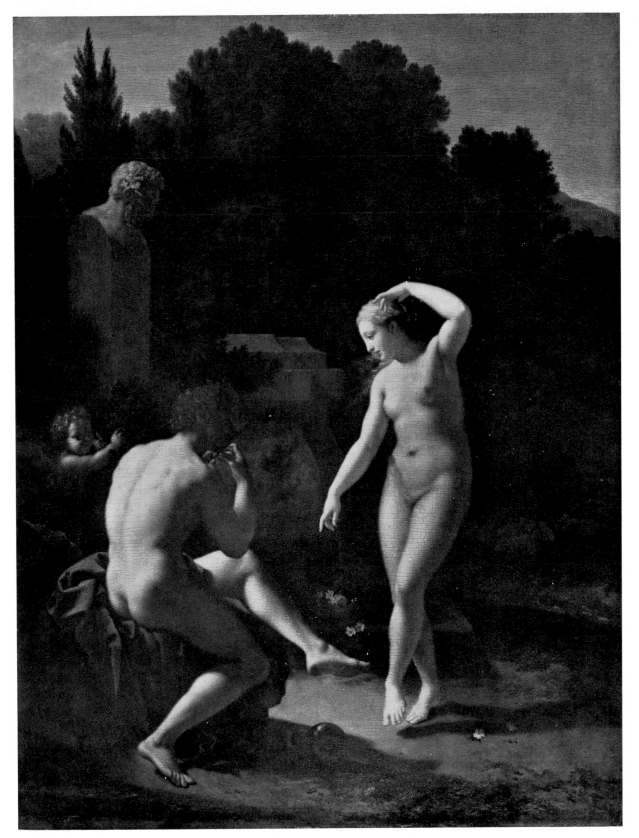

Adriaen van der Werff

MYTHOLOGICAL SCENE

Signed and dated 1718
Wood, 45×33 cm.
Amsterdam, Rijksmuseum
No. 2632.

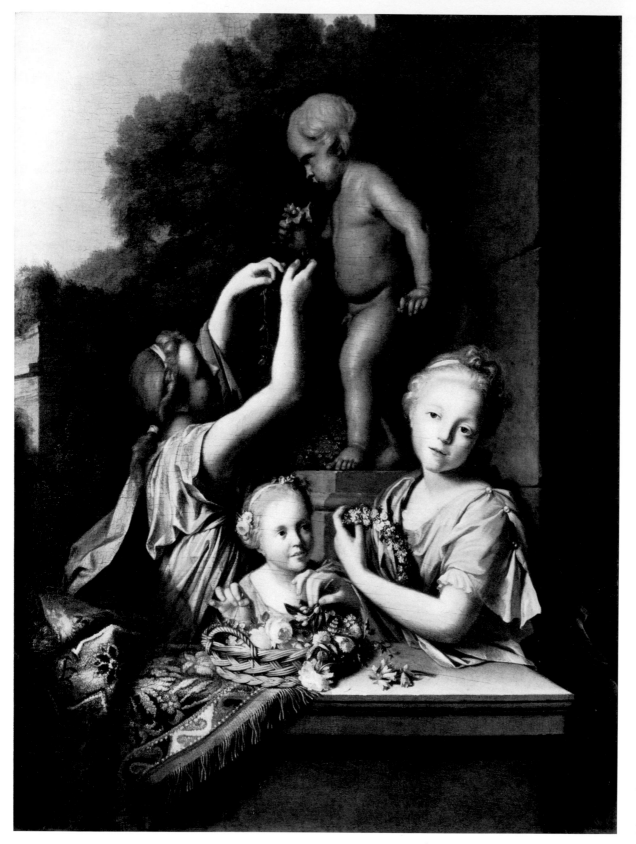

Pieter van der Werff

GIRLS WITH FLOWERS

Signed and dated 1710
Wood, 33.3 × 25.7 cm.
Cassel, Gallery
No. 320.

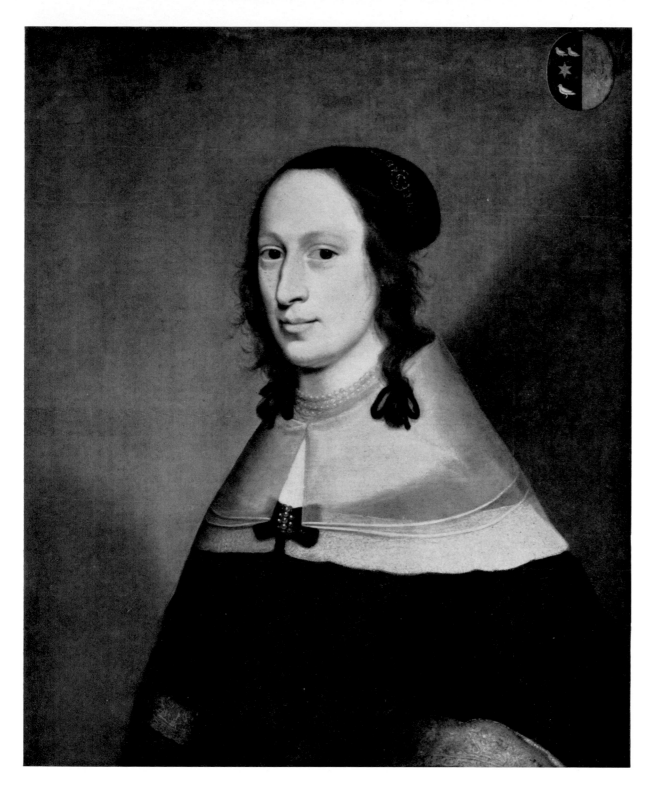

Jan Jansz. Westerbaen the Younger

SOPHIA VAN OVERMEER

With monogram, 1650
Wood, 68 × 57 cm.
Amsterdam, Rijksmuseum
No. 2667a.

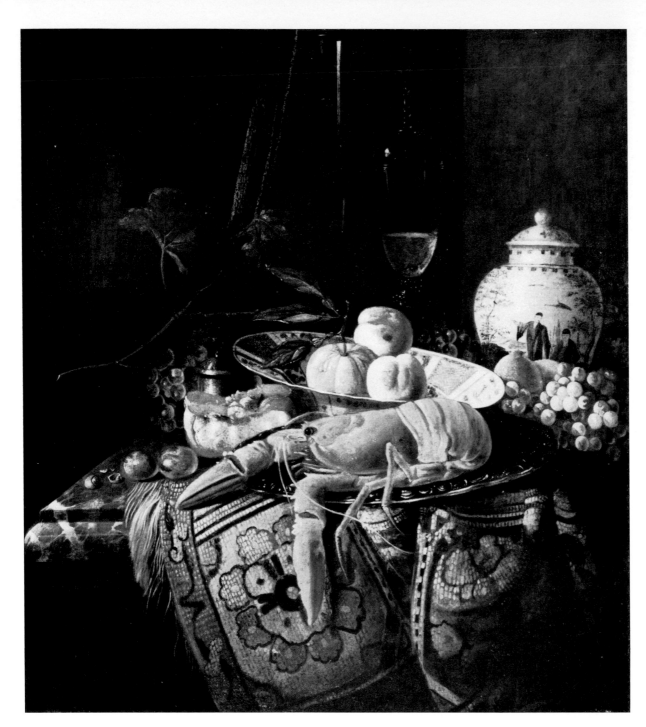

Huybert van Westhoven

BREAKFAST STILL LIFE

Signed
Canvas, 83 × 74 cm.
Recklinghausen,
private collection.

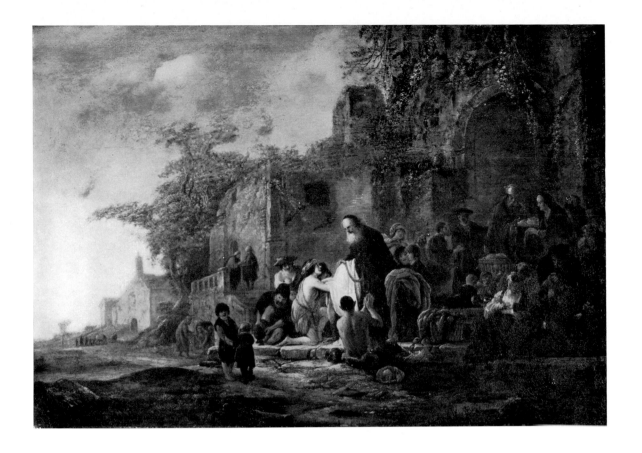

Jakob Willemsz. de Wet

THE SEVEN WORKS OF MERCY
(CLOTHING THE POOR)

Wood, 56×79 cm.
Haarlem, Frans Hals Museum
No. 307.

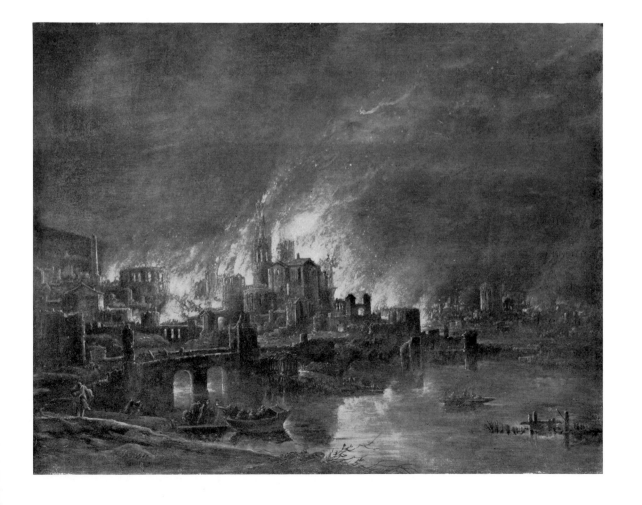

Jakob Willemsz. de Wet

THE BURNING OF TROY

Signed
Wood, 97×122 cm.
Brunswick,
Herzog-Anton-Ulrich Museum
No. 251.

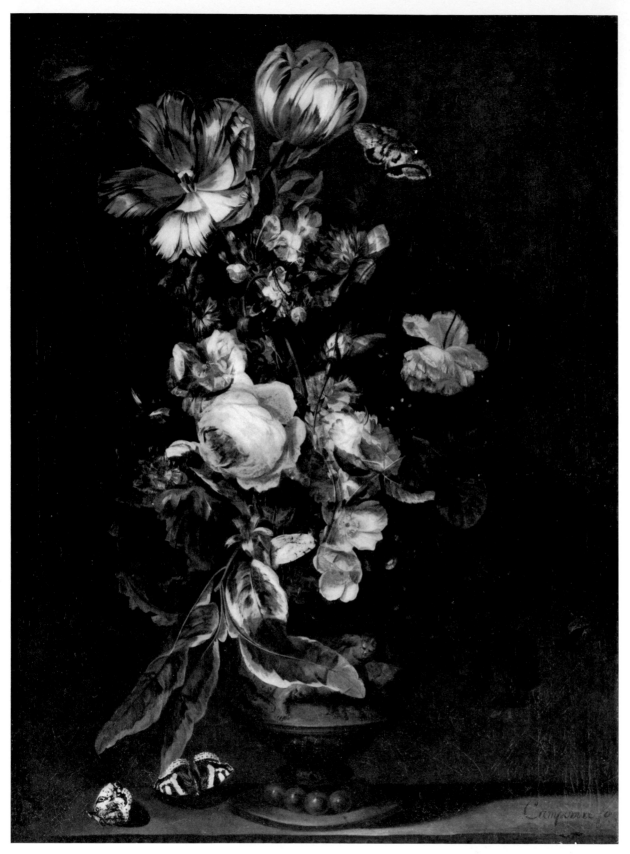

Jakob Campo Weyerman

BOUQUET OF FLOWERS

Signed "Campovivo"
Canvas, 69 × 50 cm.
Karlsruhe, Kunsthalle
No. 382.

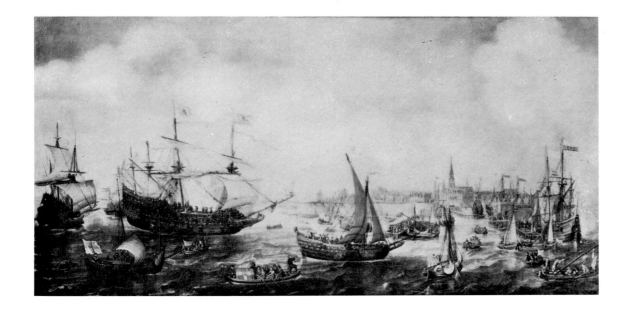

1389

Cornelis Claesz. van Wieringen

Frederick V, Elector Palatine, and his Wife Arriving in Flushing in May 1613

Signed
Canvas, 110×215 cm.
Haarlem, Frans-Hals-Museum
No. 308.

1390

Cornelis Claesz. van Wieringen

The Spanish Armada off the English Coast

With monogram
Canvas, 104×206 cm.
Amsterdam, Rijksmuseum
No. 2678.

1391

Cornelis Claesz. van Wieringen

Naval Battle

With monogram
Wood, 43×90 cm.
Madrid, Prado
No. 2143.

Jan Wildens

LANDSCAPE WITH RAINBOW
AND FORESTERS

Signed and dated 1627
Canvas, 134×100 cm.
Berlin, Staatl. Museen,
Gemäldegalerie
No. 2038
(destroyed).

Jan Wildens

WINTER LANDSCAPE
WITH HUNTSMAN

Signed and dated 1624
Canvas, 194×292 cm.
Dresden, Gallery
No. 1133.

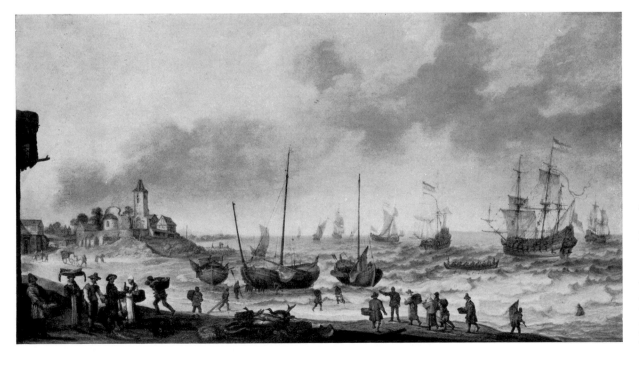

Abraham Willaerts

BEACH WITH CHURCH

Signed and dated 1653
Wood, 48×87 cm.
Brunswick,
Herzog-Anton-Ulrich Museum
No. 184.

Abraham Willaerts

FAMILY GROUP

Signed and dated 1659
Canvas, 152 × 237 cm.
Munich, Alte Pinakothek
No. 1097.

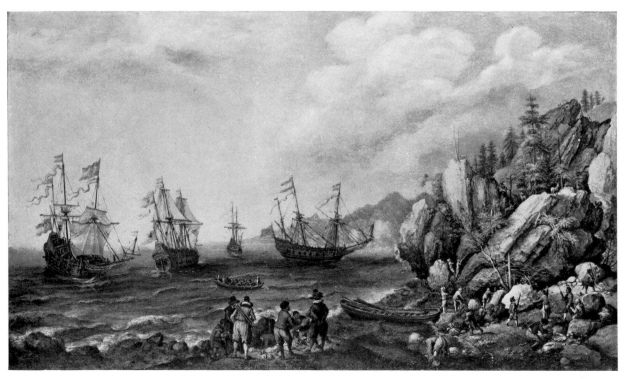

Adam Willaerts

DUTCH SHIPS IN A ROCKY BAY

Signed and dated 1620
Wood, 62 × 104 cm.
Dresden, Gallery
No. 936.

Thomas Willeboirts

CUPID AND THE LION

Canvas, 149×290 cm.
The Hague, Mauritshuis
No. 265.

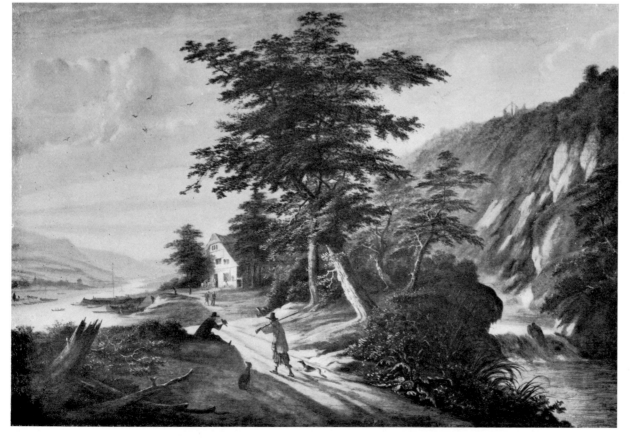

**Claes Jansz.
van der Willigen**

RIVER LANDSCAPE

Wood, 72×107 cm.
The Hague, art trade.

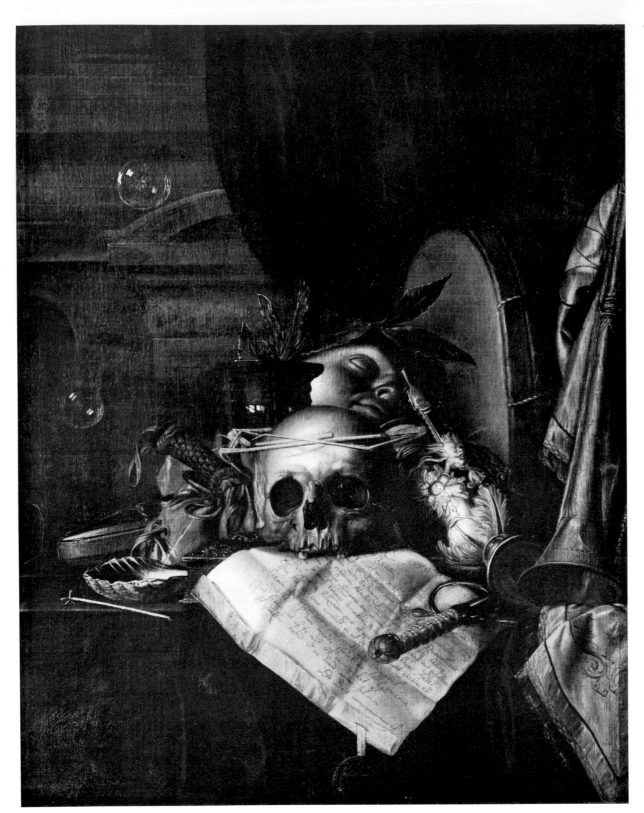

Pieter van der Willigen

VANITAS

Signed
Canvas, 85 × 74 cm.
Bamberg, Municipal Gallery
No. 243.

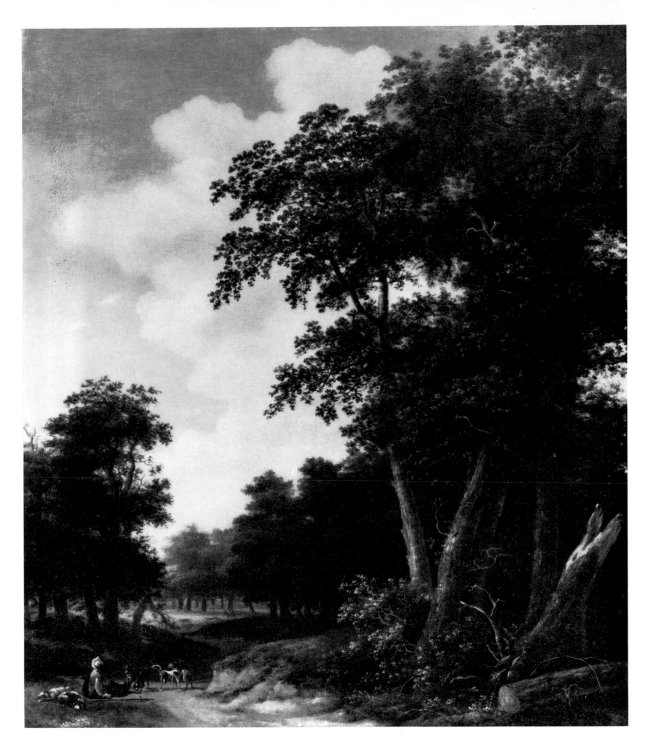

Jan Wils

FOREST LANDSCAPE

Signed and dated 1650
Canvas, 64×53.5 cm.
Zurich, art trade.

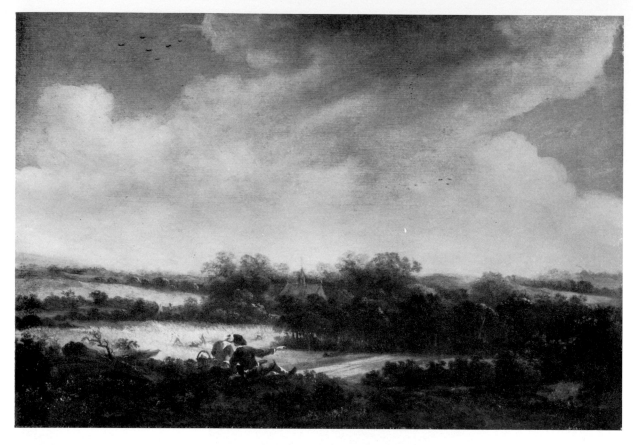

Jan Wils

LANDSCAPE WITH CORNFIELD

Signed
Wood, 27 × 39.5 cm.
Hamburg, Kunsthalle
No. 80.

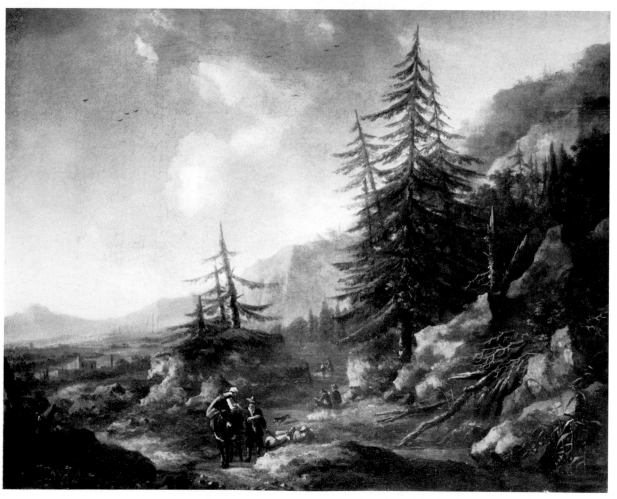

Jan Wils

MOUNTAIN LANDSCAPE

Signed
Canvas, 40 × 48 cm.
St. Gilgen,
F. C. Butôt collection.

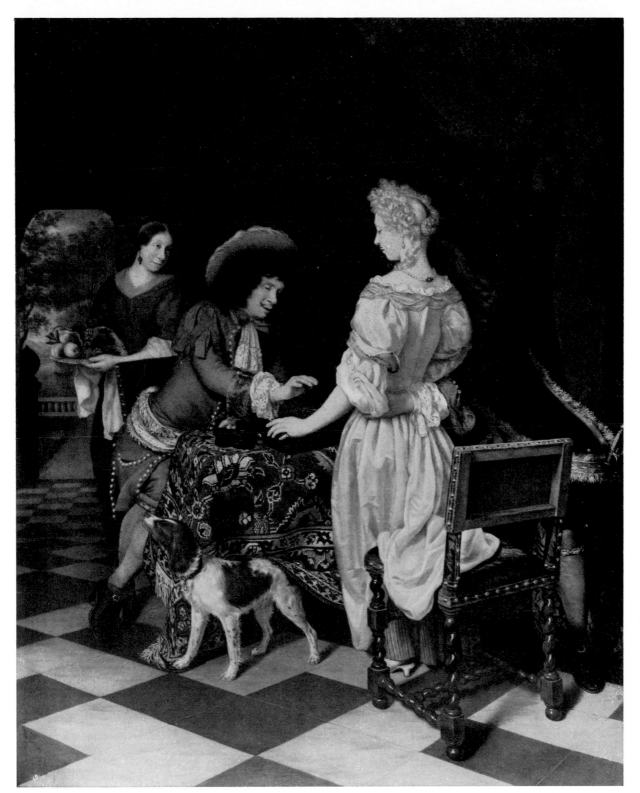

Thomas van der Wilt

LADY AND GENTLEMAN
PLAYING A BOARD GAME

Signed
Canvas, 71 × 57 cm.
Berlin, Staatliche Museen
Gemäldegalerie
No. 1004.

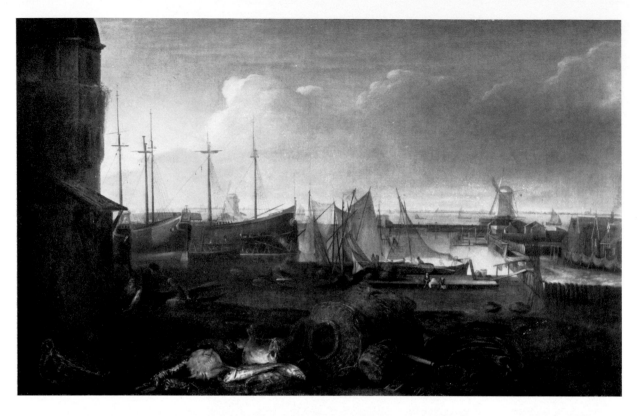

Matthias Withoos

HARBOUR ON THE ZUIDERZEE

Signed and dated 1675
Canvas, 66 × 102.5 cm.
Amsterdam, Rijksmuseum
No. 2696.

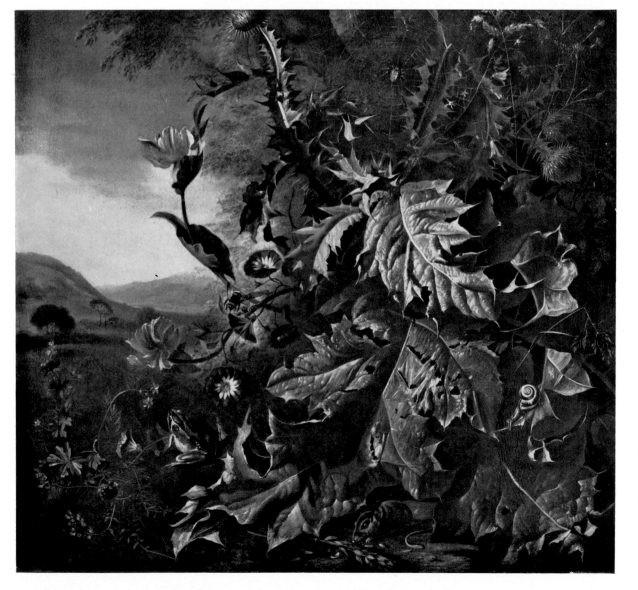

Matthias Withoos

PLANT STILL LIFE

Signed
Canvas, 68 × 65.5 cm.
Vienna, art trade.

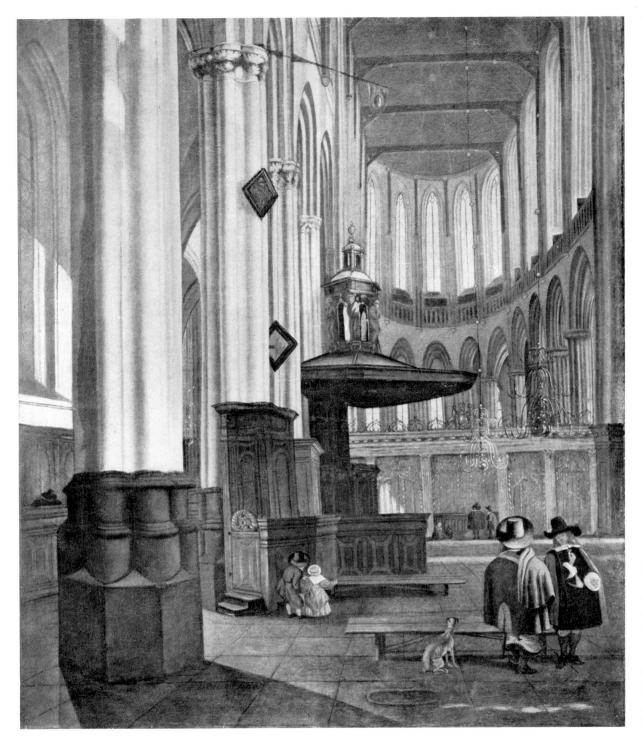

Emanuel de Witte

THE INTERIOR OF THE
NIEUWE KERK IN AMSTERDAM

Signed and dated 1656
Canvas, 99×83 cm.
Brunswick,
Herzog-Anton-Ulrich Museum
No. 427.

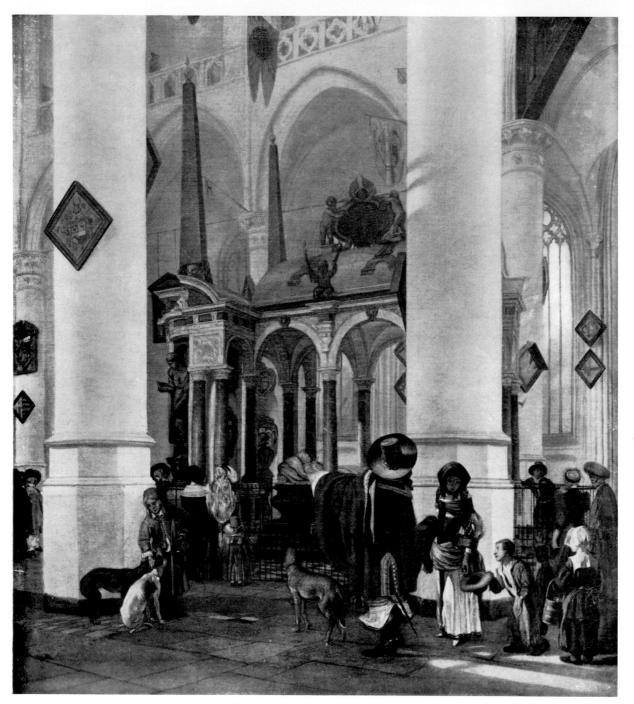

Emanuel de Witte

CHURCH IN DELFT
WITH THE TOMB OF THE
HOUSE OF ORANGE

Signed and dated 1656
Canvas, 97×85 cm.
Lille, Musée des Beaux-Arts
No. 902.

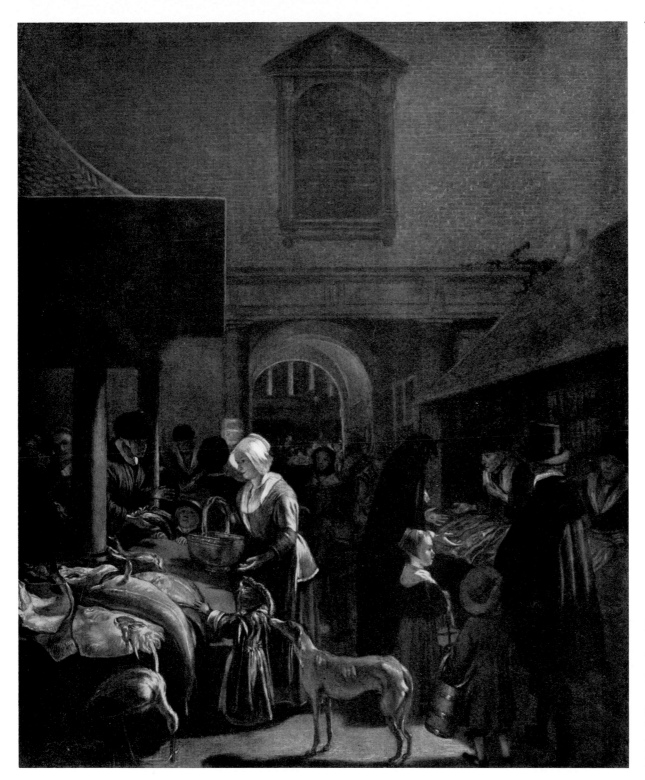

Emanuel de Witte

THE OLD FISH MARKET
IN AMSTERDAM

Signed
Wood, 54.5 × 45 cm.
Lugano-Castagnola,
Rohoncz collection.

Emanuel de Witte

HARBOUR AT SUNSET

Canvas, 42,5 × 64.5 cm.
Amsterdam, Rijksmuseum
No. 2698A2.

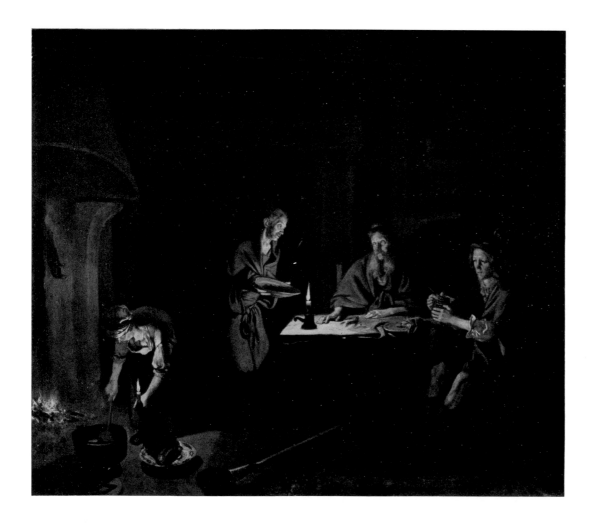

Emanuel de Witte

JUPITER AND MERCURY
VISITING PHILEMON
AND BAUCIS

Signed and dated 1647
Wood, 48 × 62 cm.
Amsterdam, art trade.

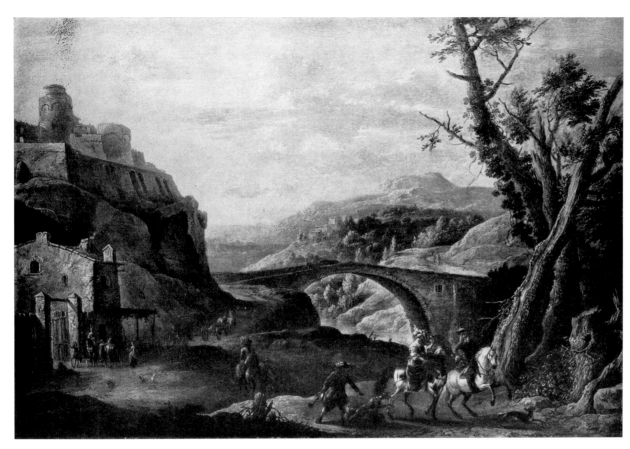

Gaspard de Witte

MOUNTAIN LANDSCAPE
WITH CASTLE AND BRIDGE

Signed
Canvas, 56×81 cm.
Aschaffenburg, Gallery.

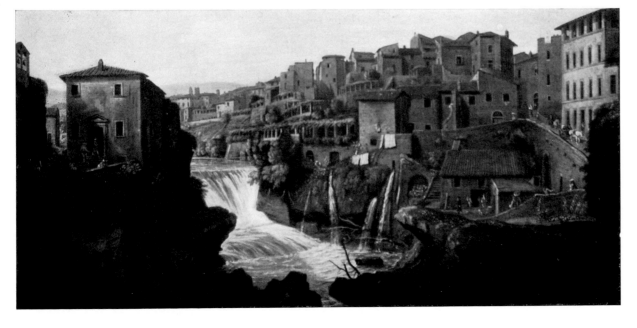

Gaspar Adr. van Wittel

TIVOLI

Canvas, 48×96.5 cm.
Munich, art trade.

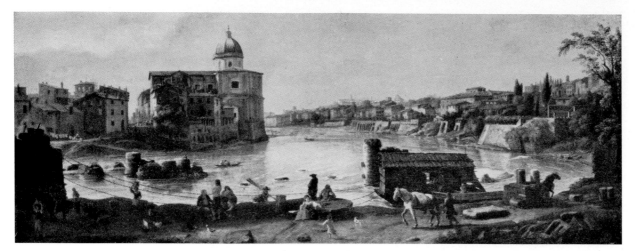

Gaspar Adr. van Wittel

THE TIBER IN ROME

Signed
Canvas, 48 × 122 cm.
London, Christie's sale,
27 May 1960
No. 80.

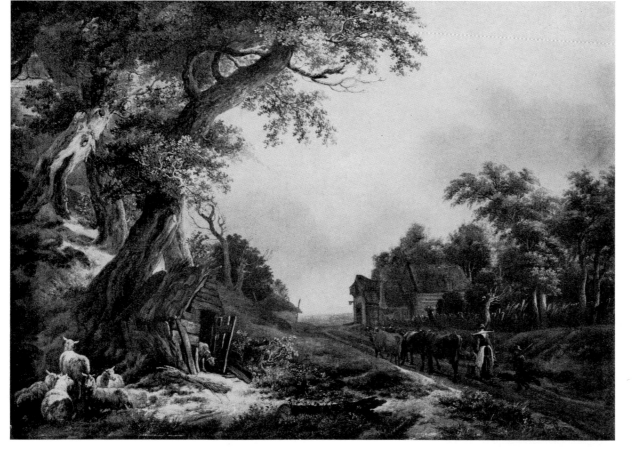

Jan Baptist Wolfert

FOREST LANDSCAPE WITH ROAD

Signed
Canvas, 112 × 156 cm.
Amsterdam, Muller sale,
27 November 1906
No. 202.

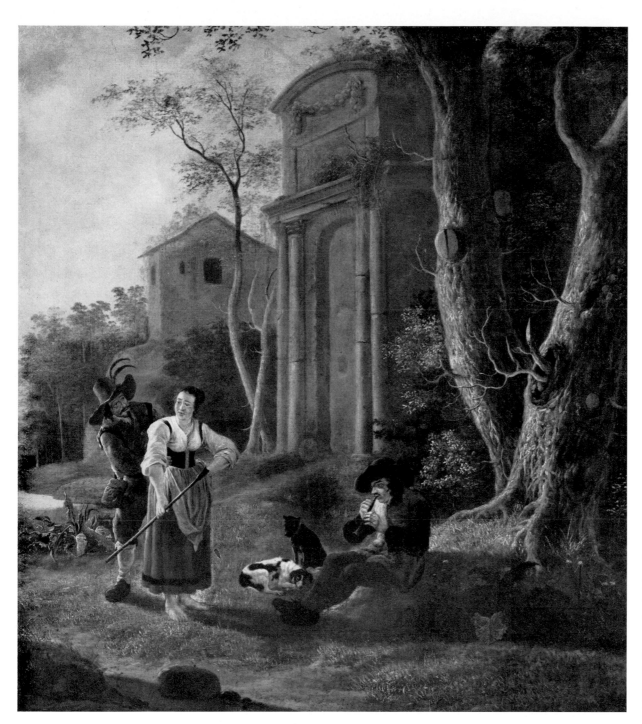

Jan Baptist Wolfert

MEDITERRANEAN LANDSCAPE
WITH MAN PLAYING
THE SHAWM

Signed and dated 1646
Canvas, 75 × 70 cm.
Amsterdam, Rijksmuseum
No. 2700.

Aleida Wolffsen

PORTRAIT OF A LADY

Signed
Canvas, 48.3 × 39.7 cm.
The Hague,
Municipal Museum
No. 530.

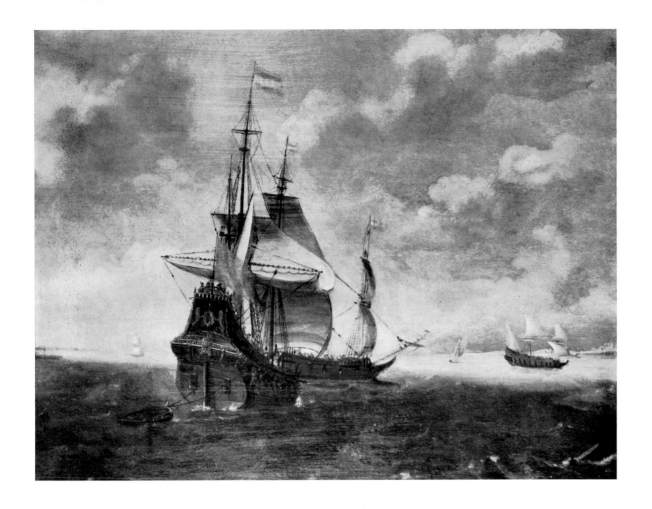

Claes Claesz. Wou

SEASCAPE

Signed
Wood
Graz, Gallery
No. 171.

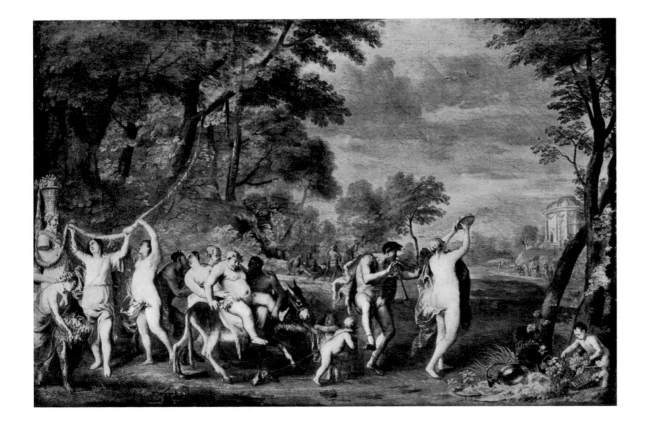

Frans Wouters

THE TRIUMPH OF SILENUS

Canvas, 86×130 cm.
Vienna,
Kunsthistorisches Museum
No. 1104.

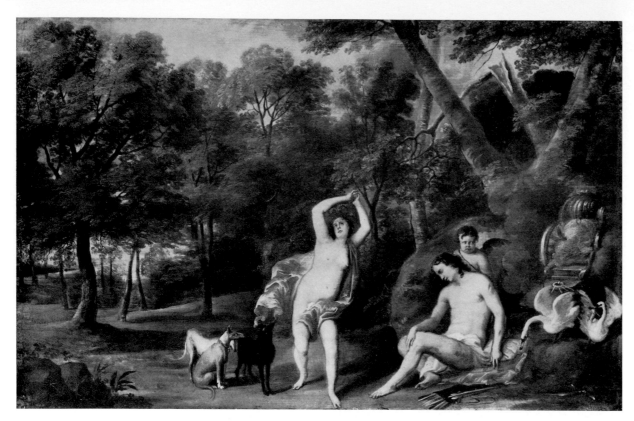

Frans Wouters

Venus Lamenting
the Death of Adonis

With monogram
Wood, 39×61 cm.
Copenhagen,
Royal Museum of Fine Arts
No. 818.

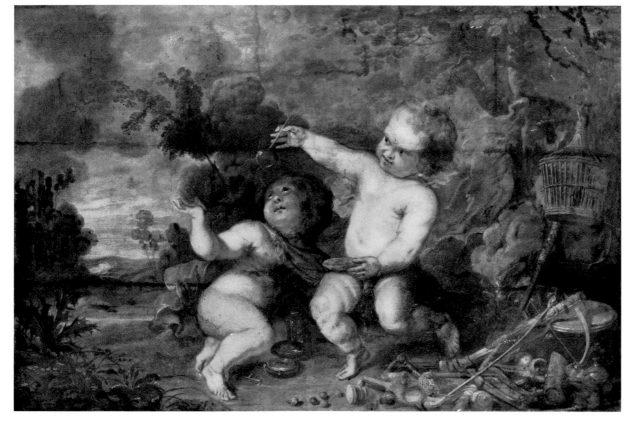

Frans Wouters

Vanitas

Wood, 71×103 cm.
Antwerp,
Musée Royal des Beaux-Arts
No. 602.

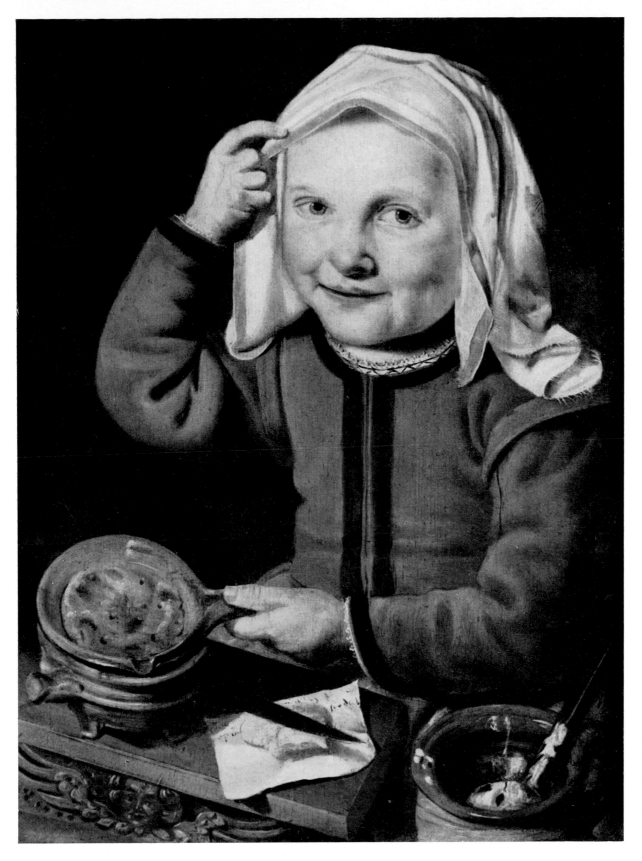

**Jan Woutersz.,
called Stap**

THE YOUNG PASTRY-COOK

Wood, 44×33 cm.
Leipzig, Museum.

1422

**Jan Woutersz.,
called Stap**

SETTLING ACCOUNTS

Signed
Wood, 82 × 113 cm.
München,
Bayer. Staatsgemäldesamml.
No. 3036.

1423

**Jan Woutersz.,
called Stap**

PEASANTS IN THE
STEWARD'S OFFICE

Signed
Canvas, 76 × 107.5 cm.
Amsterdam, Rijksmuseum
No. 2702.

Jan Wouverman

LANDSCAPE

Signed
Canvas, 56.5 × 46.5 cm.
Budapest,
Museum of Fine Arts
No. 3891.

Jan Wouverman

ROCKY GORGE

Signed
Wood, 36 × 32 cm.
Vaduz, Liechtenstein Gallery
No. 546.

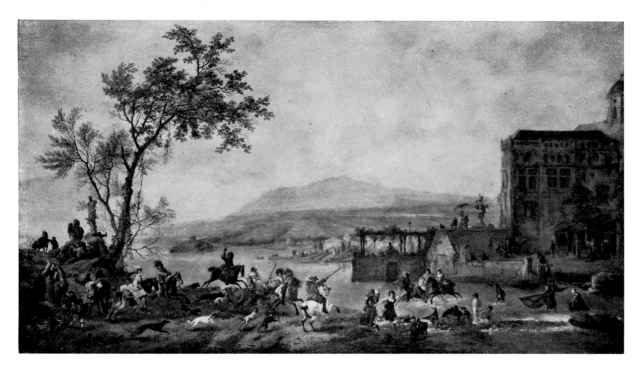

Philips Wouverman

STAG HUNT BY A RIVER

With monogram
Canvas, 71.5 × 128 cm.
Dresden, Gallery
No. 1449.

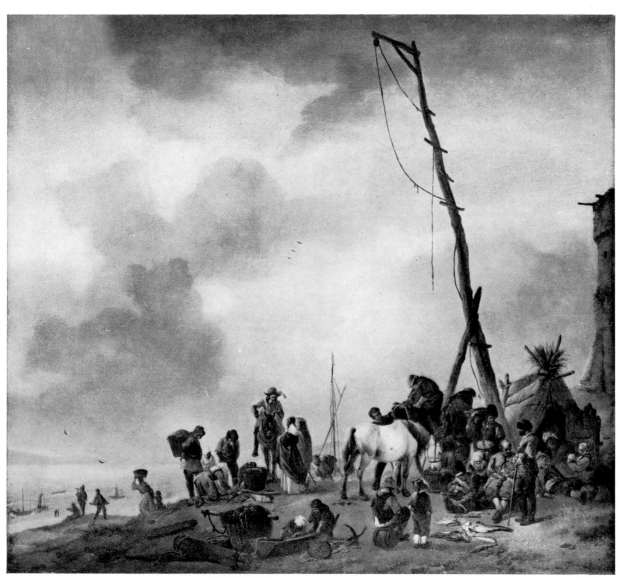

Philips Wouverman

FISHERMEN ON THE BEACH

With monogram
Wood, 55 × 60 cm.
Dresden, Gallery
No. 1434.

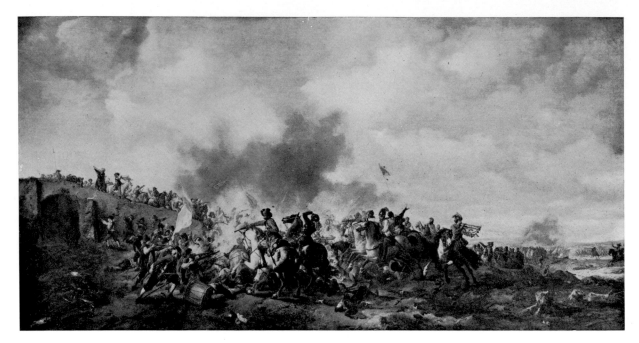

Philips Wouverman

LARGE BATTLE SCENE

With monogram
Canvas, 127×245 cm.
The Hague, Mauritshuis
No. 219.

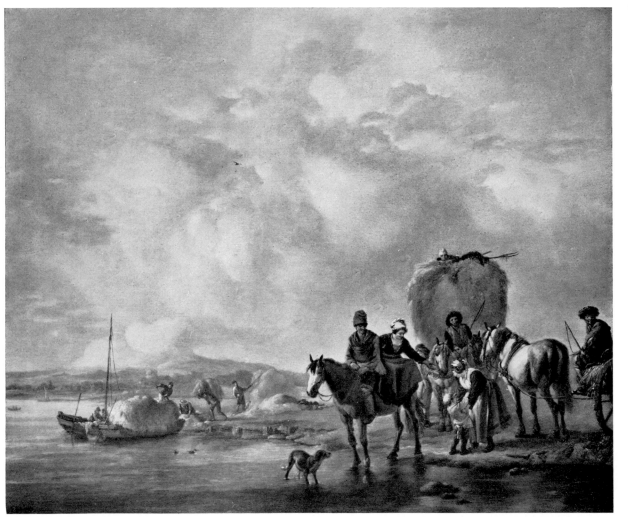

Philips Wouverman

THE HAYWAIN

With monogram
Wood, 40×48 cm.
The Hague, Mauritshuis
No. 218.

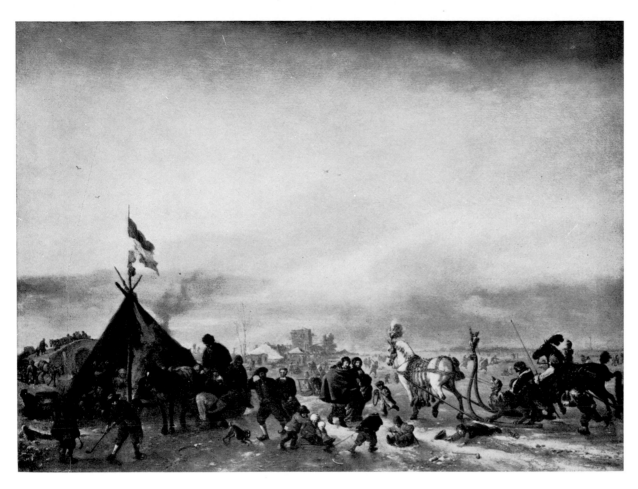

Philips Wouverman

WINTER LANDSCAPE
WITH SKATERS

With monogram
Wood, 47×63 cm.
Munich, Alte Pinakothek
No. 152.

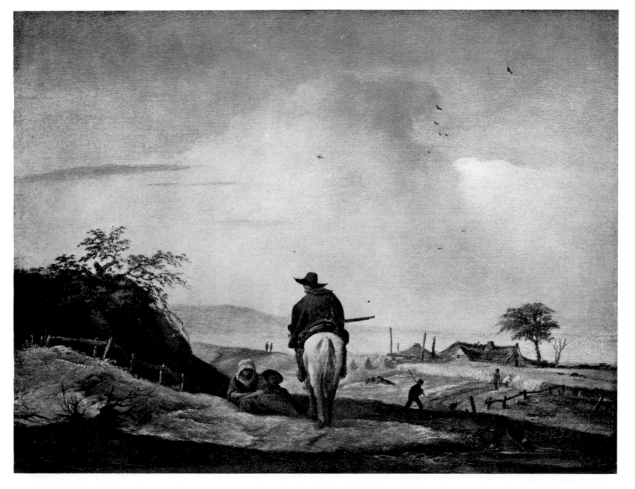

Philips Wouverman

RIDER OUTSIDE A
PEASANT COTTAGE

With monogram
Wood, 23.5×30.5 cm.
Dresden, Gallery
No. 1409.

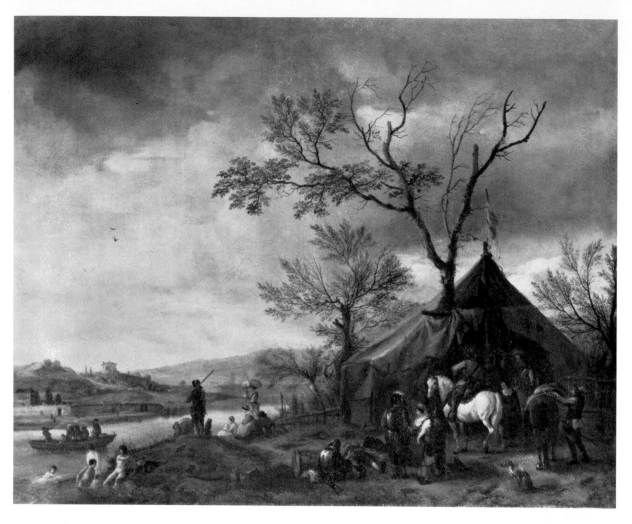

Philips Wouverman

RIVER LANDSCAPE
WITH TENT

With monogram
Canvas, 56.5 × 70 cm.
Aachen, private collection.

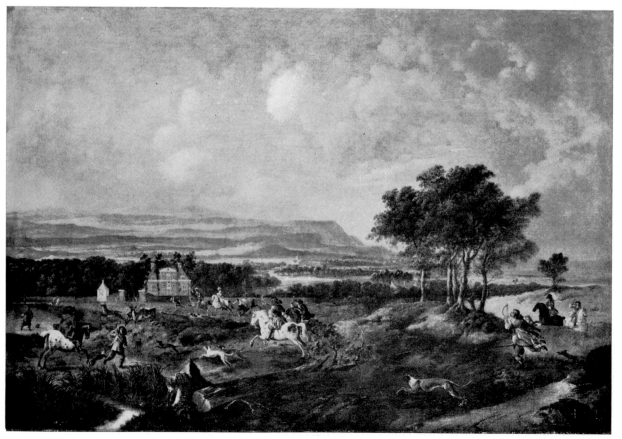

Pieter Wouverman

STAG HUNT

With monogram
Canvas, 87 × 122 cm.
Budapest,
Museum of Fine Arts
No. 1729.

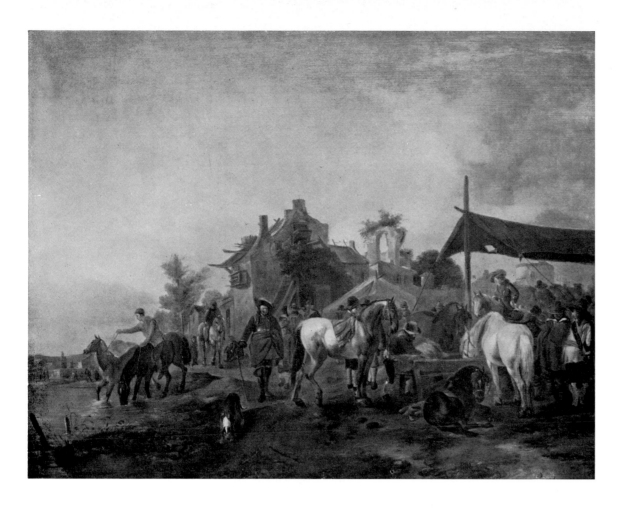

Pieter Wouverman

RIDERS RESTING

With monogram
Wood, 43 × 54 cm.
Stuttgart, private collection.

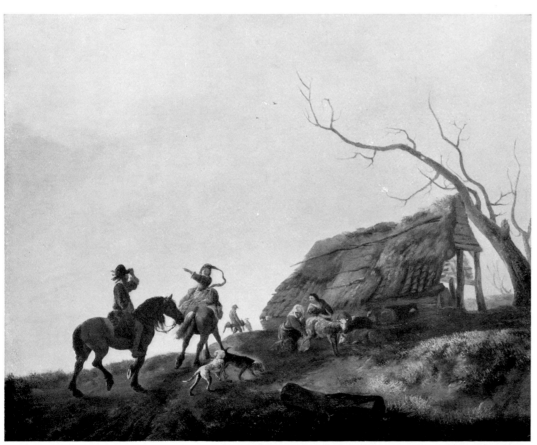

Pieter Wouverman

DUNE LANDSCAPE
WITH RIDERS

With monogram
Wood, 42 × 51.5 cm.
Munich, art trade.

Joachim Antonisz. Wtewael

SELF-PORTRAIT

Signed and dated 1601
Wood, 98×74 cm.
Utrecht, Central Museum
No. 236.

Joachim Antonisz.
Wtewael

Diana and Actaeon

Signed and dated 1607
Wood, 58×79 cm.
Vienna,
Kunsthistorisches Museum
No. 798.

Joachim Antonisz.
Wtewael

Woman Selling Vegetables

Wood, 116.5×160 cm.
Utrecht, Central Museum
No. 238.

Jan Wyck

HILLY LANDSCAPE
WITH HUNTSMEN

Signed
Canvas, 86.5 × 151 cm.
London, Sotheby's sale,
16 November 1966.

Thomas Wyck

THE ALCHEMIST

Signed
Canvas, 39 × 56 cm.
Dresden, Gallery
No. 1403.

Thomas Wyck

ITALIAN STREET SCENE

Signed
Wood, 50×37.5 cm.
Dresden, Gallery
No. 1405.

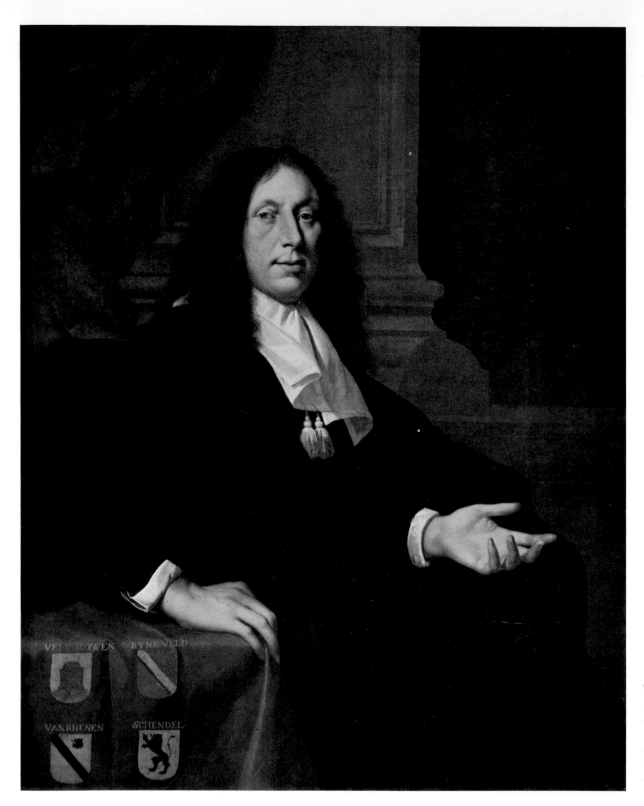

Jan van Wyckersloot

DR. L. VAN VELTHUYSEN

Canvas, 115 × 91,5 cm.
Utrecht, Central Museum
No. 240.

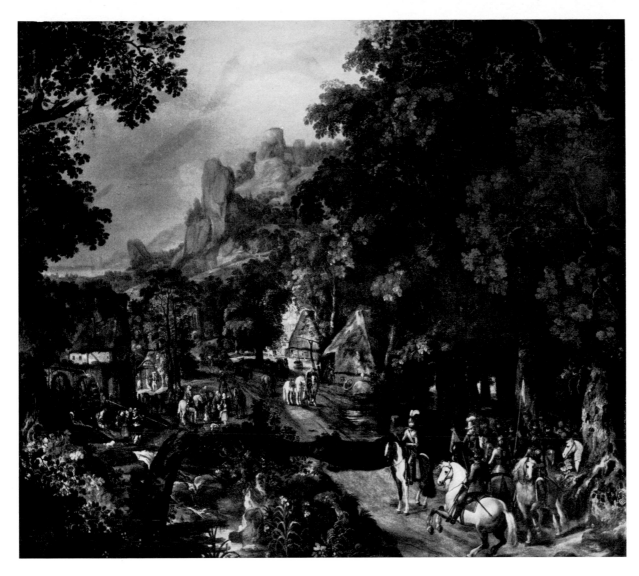

Jacques van der Wyhen

FOREST LANDSCAPE
WITH RIDERS

Signed and dated 1626
Canvas, 177 × 197 cm.
Wiesbaden, art trade.

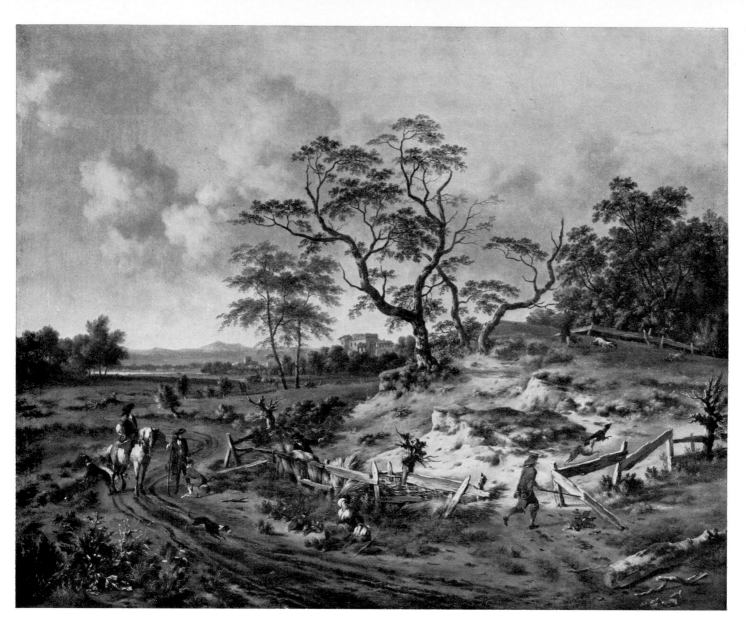

Jan Wynants

LANDSCAPE WITH HARE HUNT
(Figures by J. Lingelbach)

Signed and dated 1666
Canvas, 85.7×103.5 cm.
Formerly Munich,
Alte Pinakothek
No. 576.

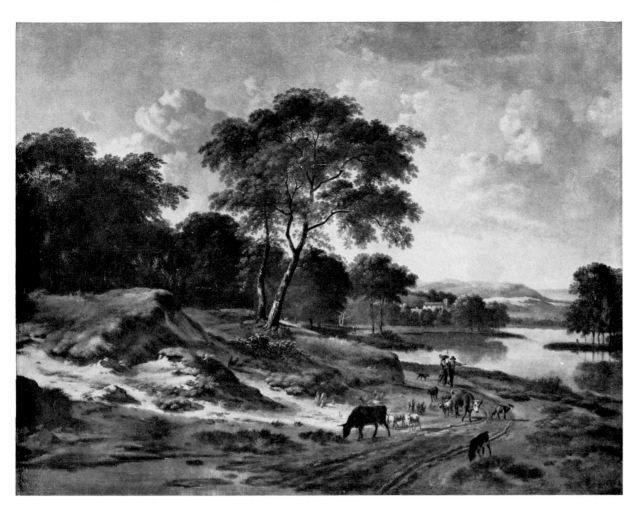

Jan Wynants

MORNING LANDSCAPE
(Figures by A. van de Velde)

With monogram
Canvas, 154 × 197 cm.
Munich, Alte Pinakothek
No. 579.

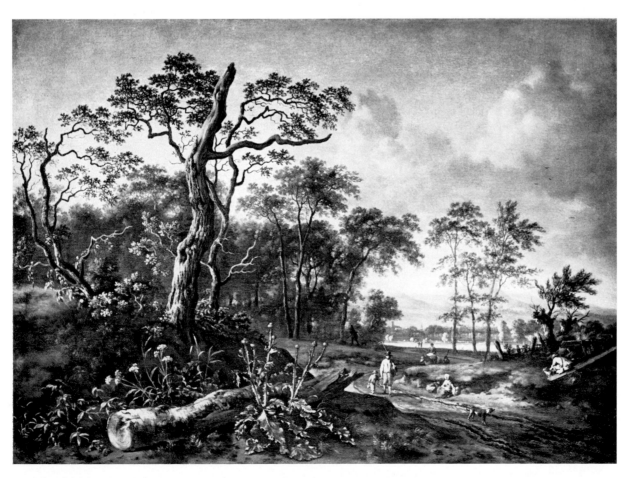

Jan Wynants

PATH ALONG THE FOREST

Signed and dated 1667
Canvas, 65 × 87.5 cm.
Budapest,
Museum of Fine Arts
No. 188.

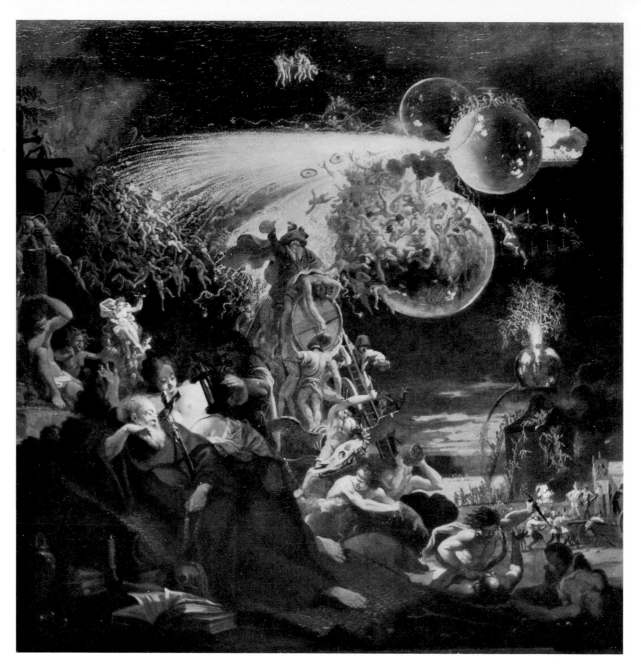

Dominicus van Wynen

THE TEMPTATION
OF ST. ANTHONY

Signed
Canvas, 74 × 74 cm.
Dublin,
National Gallery of Ireland
No. 527.

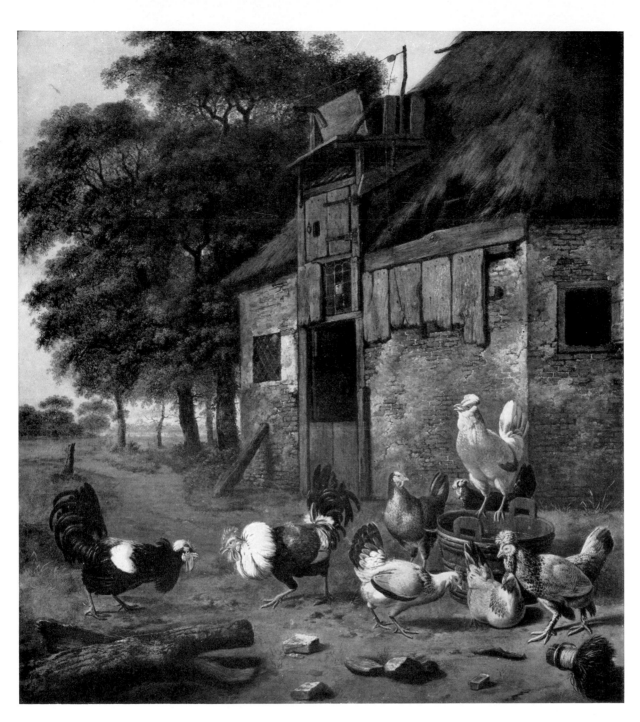

Dirk Wyntrack

THE CHICKEN RUN

Signed
Canvas, 80 × 73 cm.
Munich, art trade.

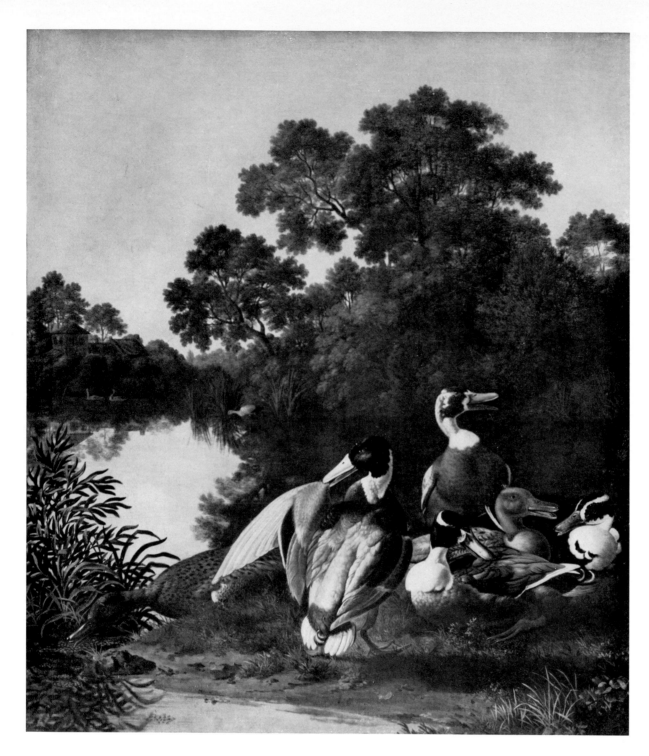

Dirk Wyntrack

DUCKS AT A LAKE

Signed
Canvas, 129×110 cm.
Munich, art trade.

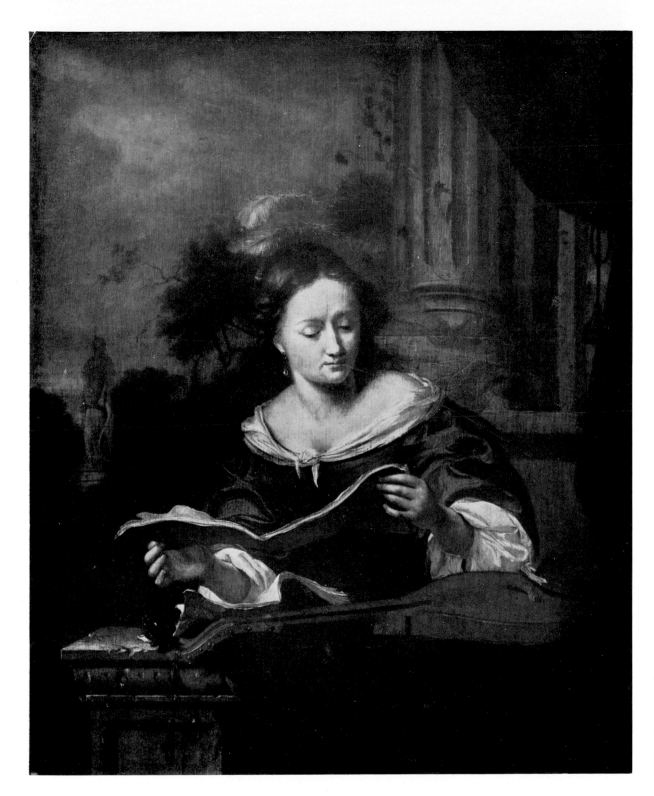

Mattheus Wytmans

WOMAN PLAYING THE LUTE

Signed
Wood, 28.5 × 23 cm.
Dresden, Gallery
No. 1313.

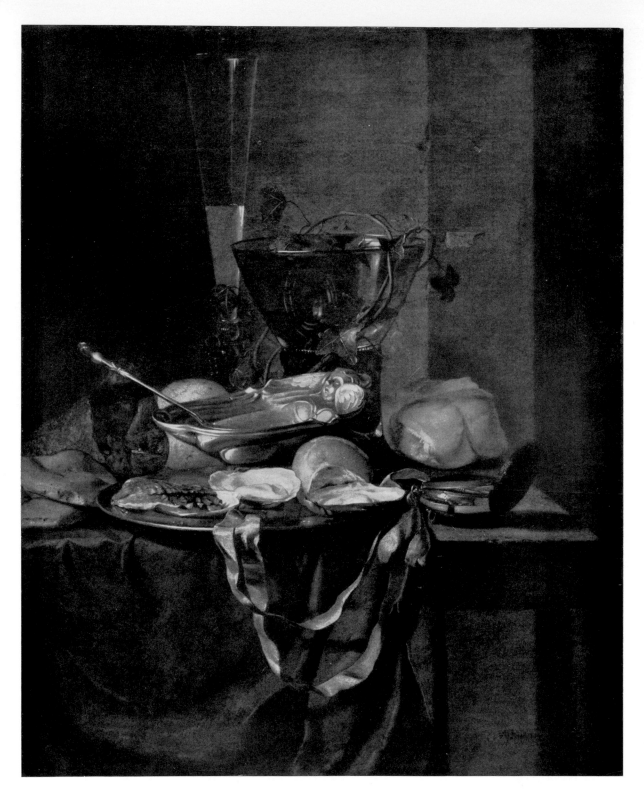

Mattheus Wytmans

Still Life

Signed
Canvas, 54×43.7 cm.
Budapest,
Museum of Fine Arts
No. 391.

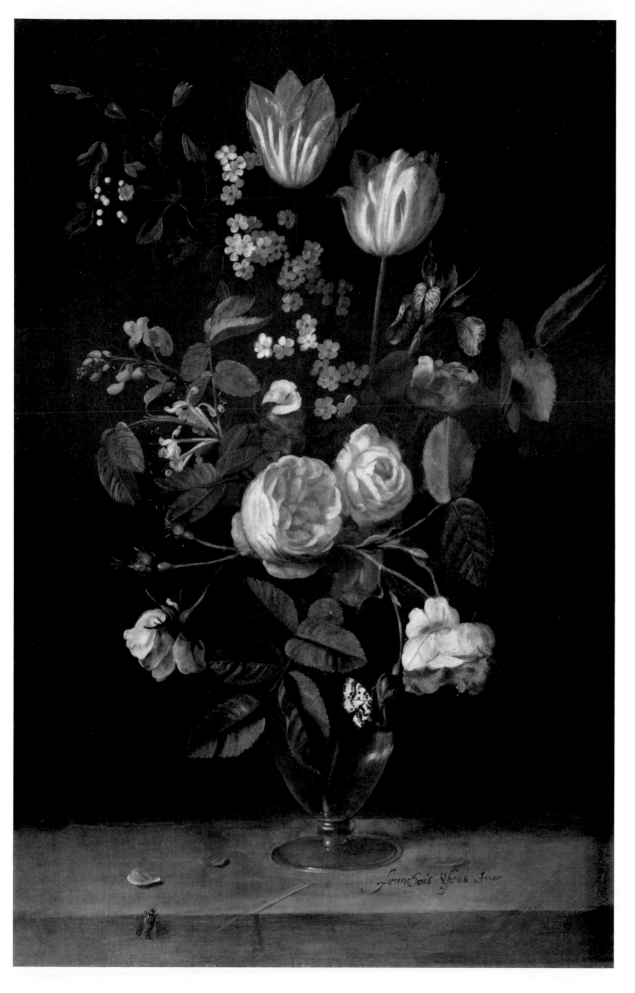

Frans Ykens

FLOWER STILL LIFE

Signed
Wood, 62 × 39.8 cm.
Munich, art trade.

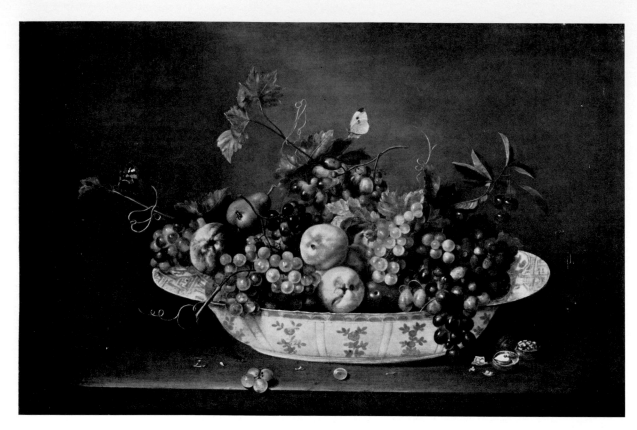

Frans Ykens

STILL LIFE

Signed
Wood, 53 × 81 cm.
Berlin, Staatliche Museen
Gemäldegalerie
No. 910A.

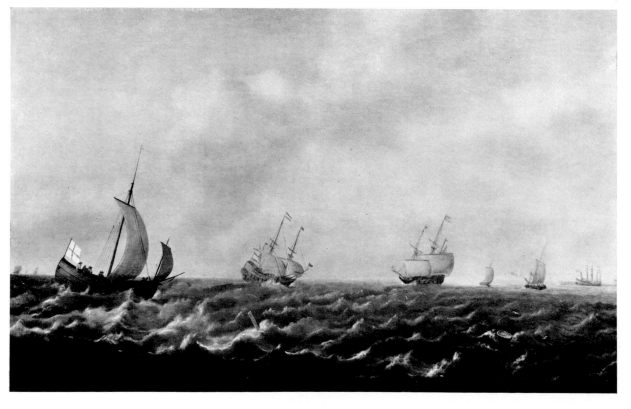

Pieter de Zeelander

SEASCAPE

With monogram,
dated 1644
Wood, 56.6 × 89 cm.
London, art trade.

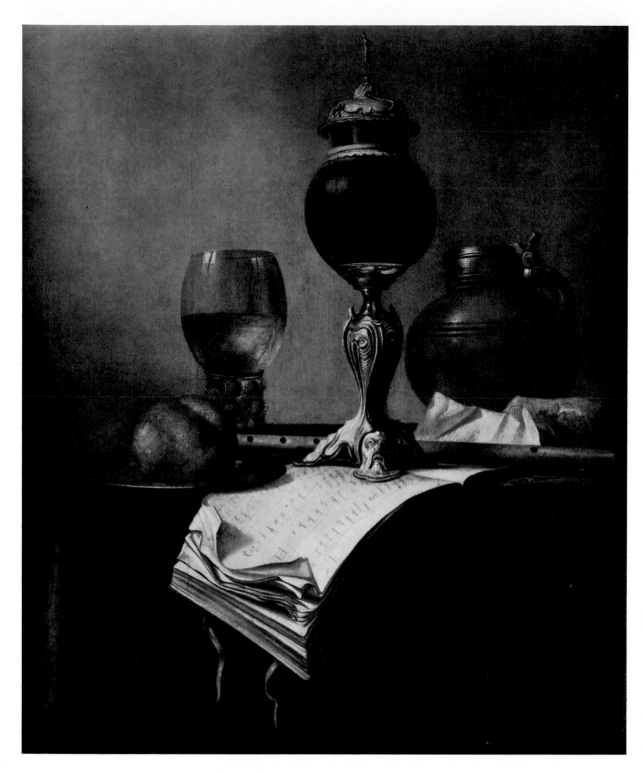

Jan Hendriksz.
van Zuylen

STILL LIFE

Signed
Wood, 75×61.5 cm.
Utrecht, Central Museum
No. 364.

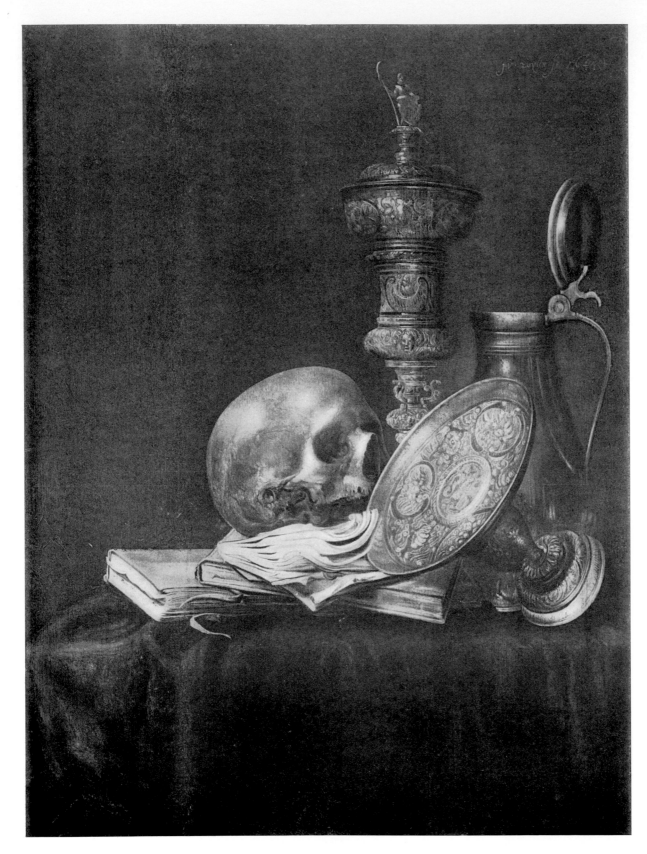

Jan Hendriksz. van Zuylen

Vanitas

Signed and dated 1644
Wood, 62.5 × 51.5 cm.
Ghent, Musée des Beaux-Arts

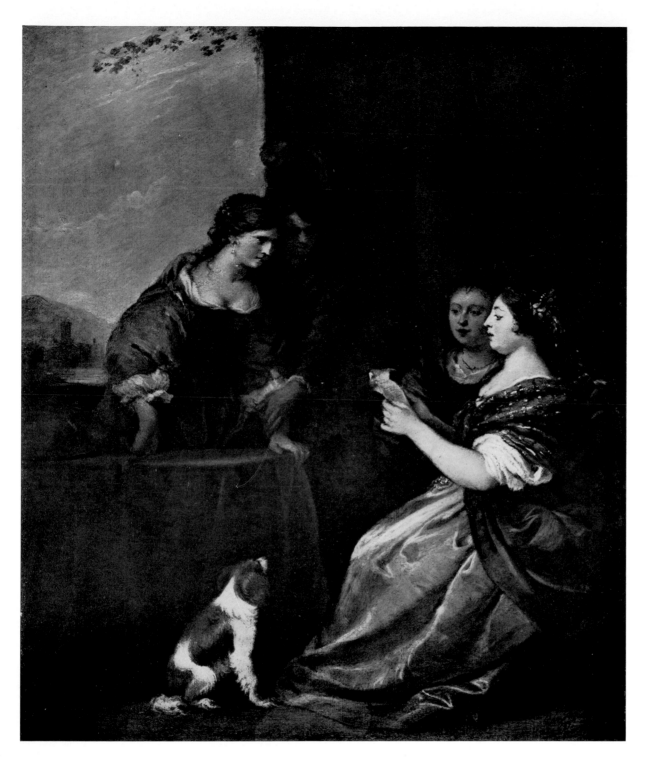

Gerard Pietersz. van Zyl

THE LETTER

With monogram
Wood, 30.4 × 25.7 cm.
St. Gilgen,
F. C. Butôt collection.

INDEX

SOURCES OF PHOTOGRAPHS

LIST OF ARTISTS

Sources of the Photographs

Aachen, Suermondt-Museum
181

Amsterdam, Rijksmuseum
I. 14 19 20 40 62 63 94 112 138 208
 250 307 337 405 410 422 459 479 487
II. 509 524 531 541 579 582 611 629 632 647
 648 649 749 750 772 896 951 958a 962 963
III. 1103 1154 1173 1187 1189 1211 1384

Antwerp, Musée Royal des Beaux-Arts
254

Arnhem, Gemeente Museum
523

Basel, Öffentliche Kunstsammlungen
469 637 1379

Berlin, Staatliche Museen
I. 5 33 121 154 226 408 426
II. 514 555 619 655 696 697 721 738 828 829
 881 928 940 969
III. 1012 1035 1041 1049 1057 1063 1239 1273 1279 1311
 1338 1392 1403

Bonn, Rheinisches Landesmuseum
564

Bremen, Kunsthalle
1366

Brussels, A. C. L.
I. 95 102 111 266 317
II. 571 635 693 735
III. 982 1126 1127 1420

Cassel, Gemäldegalerie
813 912 1015

Cologne, Rheinisches Bildarchiv
108 424

Copenhagen, Statens Museum
110 153 194 245 353 354 407 456 549 578 661
801 1051 1079 1137 1149 1158 1360 1419

Darmstadt, Hessisches Landesmuseum
18 211 929

Dordrecht, Museum
103 255 673

Dresden, Gallery
222 773 831 1450

Dresden, Deutsche Fotothek
6 668 734

Dublin, National Gallery of Ireland
1447

Ghent, Musée des Beaux-Arts
590 1178

Göttingen, Universität
650 1359

Gotha, Ducal Gallery
620 1145 1373

Gouda, Stedelijk Museum
1153

Haarlem, Frans Hals Museum
451 728 729 1034 1257 1386 1389

The Hague, Mauritshuis
30 216 625 932

The Hague, Bredius Museum
13 76 265 267 281 1081

The Hague, Gemeente Museum
1323 1416

Hamburg, Kunsthalle
114 359 513 1059 1401

Karlsruhe, Staatliche Kunsthalle
731 842 858 897 947 1013 1388

Leiden, De Lakenhal
139 746 1077 1227

London, Dulwich College Gallery
663

London, National Gallery
149 1010 1252

London, Victoria and Albert Museum
432

London, Wallace Collection
330

Madrid, Prado
69 1391

Mainz, Gallery
40

Marburg, Foto

I. 7 22 25 29 30 58 79 212 242 291
 346 376 386 427 436 473
II. 497 540 686 691 700 732 744 758 760 784
 796 861 927 931 943 964 966 975
III. 980 1011 1039 1046 1061 1062 1094 1119 1152 1208
 1270 1292 1320 1371 1383 1424

Munich, Bayerische Staatsgemäldesammlungen

I. 54 61 172 252 363 366 389 419 434 438
II. 570 585 652 665 705 859 915 945 950 955
 957
III. 1014 1093 1121 1238 1245 1272 1280 1315 1340 1399
 1411 1422

Munich, Verlag Bruckmann, Bildarchiv

I. 1 26 27 37 39 41 42 43 57 70
 72 73 74 77 78 80 82 90 91 98
 105 106 113 118 120 126 131 134 137 142
 145 147 155 159 162 168 169 170 175 176
 182 185 186 191 193 195 196 197 200 201
 202 206 213 215 221 224 225 235 238 243
 251 256 260 262 273 274 275 283a 284a 288
 289 293 295 300 309 314 318 320 323 328
 329 334 336 341 343 345 348 361 367 370
 371 372 373 377 379 381 382 387 388 390
 395 398 411 413 415 416 429 435 437 439
 442 450 452 453 460 461 465 467 476 477
 488 489
II. 491 492 493 495 499 500 504 507 511 516
 525 526 537 542 544 553 558 568 569 572
 594 597 598 599 600 602 603 607 612 613
 621 622 631 639 641 652 664 666 672 678
 687 689 692 698 706 707 713 720 737 739
 754 755 756 759 761 762 764 765 766 767
 769 771 774 785 787 793 795 802 803 811
 812 814 822 832 834 837 841 844 847 850
 851 852 856 860 864 870 873 876 878 884
 889 901 902 903 905 906 913 919 920 925
 926 933 934 936 937 947 953 959 960 971
 974 978
III. 983 984 994 995 1005 1006 1007 1008 1009 1016
 1019 1021 1022 1023 1025 1032 1033 1037 1038 1043
 1056 1060 1072 1073 1075 1080 1081 1095 1104 1105
 1111 1115 1116 1120 1123 1125 1129 1135 1144 1151
 1155 1162 1164 1172 1177 1180 1181 1182 1184 1186
 1188 1195 1197 1200 1206 1207 1209 1213 1214 1215
 1217 1219 1220 1221 1223 1225 1240 1241 1242 1247
 1248 1249 1253 1254 1255 1256 1258 1268 1278 1281
 1282 1286 1288 1290 1291 1294 1295 1296 1302 1304
 1310 1316 1317 1318 1319 1321 1324 1330 1333 1334
 1344 1345 1349 1352 1361 1369 1370 1372 1375 1377
 1378 1381 1382 1387 1393 1394 1395 1396 1406 1418
 1426 1427 1428 1429 1431 1440 1441 1445 1457

Munich, Verlag Hanfstaengl

I. 2 3 8 46 51 52 53 75 81 83
 84 85 86 87 89 107 116 125 128 130
 135 136 146 152 161 163 166 174 179 187
 190 198 199 203 204 205 218 234 236 239
 257 259 263 276 285 286 287 290 294 298
 302 322 324 339 343 347 355 368 369 374
 380 394 396 397 402 440 441 462 463 464
 478
II. 490 495 505 506 517 518 519 520 521 522
 527 528 529 536 556 559 584 587 595 601
 608 624 642 654 656 690 694 702 716 718
 723 751 752 753 763 768 770 779 781 782
 783 788 805 807 809 817 818 819 836 839
 840 848 849 865 875 879 887 888 890 891
 899 900 921 922 935 938 939 970 977
III. 988 989 990 991 993 999 1004 1018 1020 1026
 1027 1028 1044 1045 1050 1066 1067 1074 1076 1085
 1086 1089 1096 1097 1098 1099 1100 1101 1122 1156
 1161 1163 1166 1167 1168 1176 1183 1185 1190 1191
 1196 1201 1204 1218 1229 1232 1234 1235 1236 1237
 1244 1251 1271 1287 1289 1299 1303 1322 1325 1336
 1337 1363 1376 1430 1433 1451 1453

Munich, author's photographic archive

I. 9 10 11 12 12a 15 32 34 35 44
 45 50 71 92 101 122 151 158 160 167
 173 177 180 192 207 217 220 223 230 231
 232 233 237 244 246 248 249 268 271 279
 283 284 292 296 301 310 315 340 344 349
 350 360 375 384 385 392 399 403 417 423
 480
II. 501 508 510 550 551 554 557 566 567 573
 581 589 604 609 610 614 618 630 638 643
 644 645 646 662 667 669 671 675 683 684
 699 710 712 724 726 741 745 748 757 777
 778 780 786 791 792 794 797 798 804 806
 810 815 816 820 826 827 833 835 838 853
 854 855 869 871 874 877 882 883 892 893
 894 898 904 907 911 914 916 917 918 924
 930 933a 942 946 949 954 956 958 965 967
 973
III. 986 987 992 996 997 1000 1001 1003 1040 1042
 1047 1048 1053 1054 1055 1064 1069 1071 1078 1087
 1088 1092 1102 1113 1118 1124 1128 1134 1141 1143
 1146 1148 1157 1160 1165 1170 1171 1175 1179 1198
 1202 1210 1212 1216 1222 1228 1233 1243 1246 1250
 1262 1264 1269 1285 1293 1297 1298 1301 1305 1306
 1308 1313 1326 1327 1341 1342 1343 1346 1353 1365
 1367 1368 1380 1397 1398 1407 1409 1417 1421 1444
 1446 1452 1456

New York, Metropolitan Museum of Art
331

Nuremberg, Germanisches Museum
1058

Oxford, Ashmolean Museum
150 303 985

Paris, Louvre
321 701

Prague, National Gallery
17 311

Rotterdam, Boymans-van Beuningen Museum
60 409 535 923

Salzburg, Galerie Czernin
466 961

Schwerin, Gemäldegalerie
258 358 576

Stockholm, Hallwyl Museum
264 634

Stockholm, National Museum
183 240 253 799 1090 1276

Strasbourg, Musées Municipaux
165

Utrecht, Centraal Museum
I. 124 140 143 156 188 209 214 327 468 481
 486
II. 534 543 545 547 593 862 863 872 885 909
 910
III. 1029 1030 1070 1106 1132 1169 1226 1230 1300 1312
 1339 1354 1358 1362 1390 1404 1415 1423 1436 1438
 1442 1455

Vienna, Akademie der Bildenden Künste
132 418 1364

Vienna, Kunsthistorisches Museum
12 420 695 715 727 1024 1264 1437

Zwolle, Rathaus
448

Private collectors and art dealers

I.	4	16	21	23	24	28	31	38	47	49
	55	56	59	64	65	66	67	68	88	93
	96	97	99	100	104	108	115	117	119	123
	127	129	133	141	144	148	157	164	171	178
	184	189	210	219	227	228	229	241	247	261
	269	270	272	277	278	280	282	297	299	304
	305	306	308	312	313	316	319	325	326	332
	333	335	338	351	352	356	357	362	364	365
	378	381	391	393	400	401	404	406	412	414
	421	425	428	430	431	433	443	444	445	446
	447	449	454	455	457	458	470	471	472	474
	475	482	483	484	485					
II.	496	498	502	503	512	515	530	532	533	538
	539	546	548	552	560	561	562	563	574	575
	577	580	583	586	588	591	592	596	605	606
	615	616	617	623	626	627	628	633	636	640
	651	657	658	659	660	670	674	676	677	679
	680	681	682	685	688	703	704	709	711	714
	717	719	722	725	730	733	736	740	742	743
	747	775	776	787	790	800	808	821	823	824
	825	830	843	845	846	857	866	867	868	880
	886	897	908	941	948	952	968	972	976	
III.	979	981	998	1002	1017	1036	1065	1068	1082	1083
	1084	1091	1107	1108	1109	1110	1112	1114	1117	1130
	1131	1133	1136	1138	1139	1140	1142	1147	1150	1159
	1174	1192	1193	1194	1199	1203	1205	1224	1231	1259
	1260	1261	1263	1265	1266	1274	1275	1277	1283	1284
	1307	1309	1314	1328	1329	1331	1332	1335	1347	1348
	1350	1351	1374	1385	1400	1402	1405	1408	1410	1412
	1413	1414	1425	1432	1434	1435	1439	1443	1448	1449
	1454									

Corrigenda

Text

J. J. VAN BADEN. *For* Steenwijk *read* Steenwijck

B. VAN BASSEN. *For* Steenwijk *read* Steenwijck

A. VAN BEYEREN. *For* J. de Bondt *read* J. de Bont

A. BROUWER. *For* J. van Craesbeek *read* J. van Craesbeeck

G. COQUES. *For* G. van Tilborch *read* G. van Tilborgh

J. VAN CRAESBEECK. *For* A. van Tilborgh *read* G. van Tilborgh

J. W. DELFF. *For* M. J. Mierevelt *read* M. van Mierevelt

CHR. VAN DIELAERT. *For* W. Kalff *read* W. Kalf

J. VAN DOUW. The signature shown is that of another artist

C. VAN EVERDINGEN. *For* Bronchhorst *read* Bronchorst

F. FRANCKEN THE YOUNGER. *For* Steenwijk *read* Steenwijck

A. GOVAERTS. *For* Chr. van der Lanen *read* J. van der Lanen

B. GRAAT. *For* J. van Noort *read* J. van Noordt

J. D. VAN HEEM. *For* Steenwijk *read* Steenwijck

J. D. VAN HEEM. *For* N. van Verendael *read* N. van Veerendael

W. VAN HERP. *For* D. van Deelen *read* D. van Delen

P. DE HOOCH. *For* I. Koedyk *read* I. Koedyck

A. J. HOUBRAKEN. *For* W. van Drielenburch *read* W. van Drielenburgh

W. KALF. *For* I. Luttichuys *read* S. Luttichuys

C. MAN. *For* Koedijk *read* I. Koedyck

M. VAN MIEREVELT. *For* Hendrik van Vliet *read* Willem van Vliet

M. NAIVEU. *For* P. van Slingelandt *read* P. van Slingeland

A. VAN OSTADE. *For* M. van Muscher *read* M. van Musscher

Plates

No. 13 P. Angel, Breakfast Still Life, The Hague, Bredius Museum. Painted on canvas, not wood.

No. 27 J. Asselyn, Winter Landscape, Amsterdam, Rijksmuseum 2152–E2. Formerly with monogram J. A., now attributed to Willem Schellinks.

No. 69 Osias Beert the Elder, Still Life, Madrid, Prado. Painted on wood, not canvas.

No. 76 C. Bellekin, Kermesse, The Hague, Bredius Museum. Painted on wood, not canvas.

No. 221 Camphuysen, River Scene, Brunswick, Museum. After a different interpretation of the monogram R. C. the picture is now regarded as a work of Reyer Claesz. Suycker.

No. 813 P. Mulier, Noah's Thank-Offering. The size should read 121,5 × 172 cm. The size given in the Museum Catalogue of 1958 and quoted in the caption is wrong.

No. 834 Pieter Neeffs the Younger, not the Elder.

No. 886 Adriaen van Ostade. The caption should read: Peasants in a Barn.

No. 965 *Read* Miss K. McDouall.

No. 1115 Jan Steen, Merry-Making Peasants, The Hague, Mauritshuis. Signed.

No. 1138 Jacobus Storck. *Read:* Harbour Scene.

No. 1306 Jan Victors, The Dentist. Signed, Canvas, 75 × 95 cm.

List of Artists in alphabetical order

The numbers refer to the illustrations. Names in italics refer to an artist's teachers or pupils – as far as such a connection can be inferred from the style – or to artists whose work is similar in subject-matter or execution, irrespective of chronological and art-historical relations. This list will therefore enable the reader to trace connections between the Dutch seventeenth-century painters whose work is represented in these three volumes.

Volume I

ACHTSCHELLINCK, Lucas 1	*J. d'Arthois, I. van der Stock, L. de Vadder*
ADRIAENSSEN, Alexander 2	*P. Angel*
AELST, Willem van 3, 4, 5	*I. Denies, W. G. Ferguson, I. van Kipshaven, N. Lachtropius, H. Loeding, A. de Lust, W. F. van Royen*
ALDEWERELT, Herman van 6	*D. van Baburen, J. van Bronchorst, J. van Bylert, J. A. Rootius*
ALSLOOT, Denis van 7, 8, 9	*J. Leytens*
ANDRIESSEN, Hendrik 10, 11	*J. de Claeuw, E. Collier, N. L. Peschier, P. S. Potter, J. Vermeulen, L. van der Vinne, P. van Willigen*
ANGEL, Philips 12, 12a, 13	*A. Adriaenssen, F. Ryckhals, C. Saftleven*
ANRAADT, Pieter van 14, 15	*G. ter Borch, N. Maes, J. van de Velde*
ANTHONISSEN, Hendrick van 16	*A. van Antum, A. van Eertvelt*
ANTUM, Aert van 17	*H. van Anthonissen, A. van Eertvelt, H. Vroom*
APSHOVEN, Thomas van 18	*D. Teniers*
ARENTSZ., Arent, van der Cabel 19, 20, 21	*H. Avercamp*
ARTHOIS, Jaques d' 22, 23	*L. Achtschellinck, C. Huysmans, Ph. A. Immenraet, I. van der Stock, L. de Vadder*
ASCH, Pieter Jansz. van 24	*J. van Goyen, J. van Looten, A. Verboom, A. Waterloo*
ASSELYN, Jan 25, 26, 27	*J. Both, J. Martsen the Younger, Fr. de Moucheron, A. Pynacker, W. Schellinks*
ASSTEYN, Bartholomeus 28	*B. van der Ast, Joh. Bosschaert*
AST, Balthasar van der 29, 30, 31	*B. Assteyn, J. Baers, G. de Bergh, Ambr. Bosschaert, Joh. Bosschaert, J. Bouman, A. Claesz.*
ATTEVELT, Joost van 32	
AVERCAMP, Barent 33, 34, 35	*A. Arentsz., Hendr. Avercamp, A. van Breen, A. Verstralen*
AVERCAMP, Hendrick 36, 37, 38	*A. Arentsz., Barent Avercamp, A. van Breen, A. Verstralen*
AVONT, Pieter van 39	
BABUREN, Dirck van 40	*H. van Aldewerelt, P. Bor, J. van Bylert, G. van Honthorst, Th. Rombouts, H. Terbrugghen*
BACKER, Jacob Adriaensz. 41, 42	*J. de Baen, F. Bol, G. Flinck, L. Jacobsz., J. van Neck, J. Verspronck, J. Victors*
BACKHUYSEN, Ludolf 43, 44, 45, 46	*P. Coopse, H. Dubbels, G. Pompe, J. Cl. Rietschoof, A. Smit, A. Storck, W. van de Velde, W. Vitringa*
BADEN, Jan Juriaensz. van 47	*B. van Bassen, D. van Delen, N. de Gyselaer, H. van Steenwyck, J. van Vucht*
BAEN, Jan de 48	*J. A. Backer, A. Hanneman, C. Janssens van Ceulen, J. Levecq, P. Nason*
BAERS, Jan 49	*B. van der Ast, Bosschaert, A. Claesz.*
BAILLY, David 50	
BALEN, Hendrik van 51, 52	*J. van Balen, J. Brueghel, H. de Clerck*
BALEN, Jan van 53	*Hendr. van Balen*
BAREN, Jan Antoine van der 54, 55	*D. Seghers, J. van Thielen*
BARTSIUS, Willem 56	
BASSEN, Bartholomeus van 57, 58	*J. J. van Baden, D. van Delen, N. de Gyselaer, G. Houckgeest, H. van Steenwyck*
BATIST, Karel 59	

GALLIS, Pieter 405, 406 *Jak. Rootius, J. van de Velde*
GEEL, Jakob van 407, 408
GEEL, Joost van 409, 410 *G. Metsu, C. Netscher*
GEEST, Wybrand de 411 *P. Moreelse, J. van Ravesteyn, J. A. Rootius*
GELDER, Aert de 412, 413, 414
GELDER, Nicolaes van 415
GELDORP, Gortzius 416 *M. van Mierevelt, P. Moreelse, J. van Ravesteyn*
GERARDI, Jasper 417 *Th. Gaep, J. D. de Heem*
GHERINGH, Anton Günther 418 *W. van Ehrenberg*
GHERWEN, Reynier van 419, 420
GHEYN II, Jacques de 421, 422, 423, 424 *H. Goltzius, R. Savery, J. Vosmaer*
GILLEMANS the Elder, Jan Pauwel 425 *C. de Heem*
GILLIG, Jakob 426, 427 *W. Ormea*
GILLIS, Nicolaes 428 *F. van Dyck*
GLAUBER, Johannes 429 *J. Fr. van Bloemen, A. Meyeringh, I. de Moucheron, Jan van Nickelen, H. van Swanevelt*

GODERIS, Hans 430 *Jan Porcellis*
GODEWYCK, Margaretha van 431 *C. Bisschop, N. Maes*
GOEDAERT, Johannes 432, 433
GOLTZIUS, Hendrick 434 *C. Cornelisz. van Haarlem, J. de Gheyn*
GOUBAU, Antoni 435 *P. de Laer, J. Lingelbach*
GOVAERTS, Abraham 436, 437 *J. Brueghel, J. van der Lanen*
GOVAERTS, Hendrik 438 *G. Thomas*
GOYEN, Jan van 439, 440, 441, 442, 443, 444, 445 *P. van Asch, J. Coelenbier, A. J. van Croos, F. de Hulst, A. van der Kabel, F. van Knibbergen, W. Knijff, W. Kool, J. van Moscher, P. de Neyn, P. Nolpe, S. van Ruysdael, C. van der Schalcke, E. van de Velde, J. de Volder*

GRAAT, Barent 446 *G. ter Borch*
GRAS, Willem 447 *S. Rombouts, R. van Vries, Jan Wouwerman*
GRASDORP, Jan 448
GRASDORP, Willem 449 *A. Mignon, M. van Oosterwijck, R. Ruysch*
GREBBER, Pieter de 450, 451 *D. Bleker*
GRIFFIER the Elder, Jan 452, 453 *H. Saftleven*
GROENEWEGEN, Pieter van 454 *B. Breenbergh*
GRYEFF, Adriaen de 455
GYSBRECHTS, Corn. Norb. 456, 457 *Fr. Gysbrechts, J. D. de Heem, J. Leemans*
GYSBRECHTS, Franciscus 458 *C. N. Gysbrechts*
GYSELAER, Nicolas de 459 *B. van Bassen, D. van Delen*
GYSELS, Pieter 460 *J. Brueghel*

HAAGEN, Joris van der 461, 462 *J. Lagoor, J. van Ruisdael, J. G. van Stockman*
HACKAERT, Jan 463, 464, 465
HAEN, Gerrit de 466, 467
HAENSBERGEN, Jan van 468 *A. van Cuylenborch, D. van der Lisse, C. van Poelenburgh*
HAFTEN, Nicolas van 469 *R. Brakenburgh*
HALS, Claes 470, 471 *J. van Kessel, J. van Ruisdael, J. Vermeer van Haarlem the Elder*

HALS, Dirck 472, 473 *W. Buytewech, J. Leyster, A. Palamedesz., Es. van de Velde*

HALS, Harmen 474
HALS, Johannes 475 *J. M. Molenaer*
HANNEMAN, Adriaen 476, 477 *J. de Baen, C. Janssens van Ceulen, J. Mytens*
HANNOT, Johannes 478 *J. D. de Heem*
HARINGH, Daniel 479 *C. Netscher*
HATTICH, Petrus van 480 *A. van Cuylenborch, W. G. Ferguson, C. de Hooch*
HAYE, Reynier de La 481, 482 *C. Netscher, J. Verkolje*

Volume II

MATTHIEU, Cornelis 743
MEERHOUD, Jan 744, 745
MERCK, Jacob van der 746, 747, 748 *R. G. Camphuysen*
MESDACH, Salomon 749, 750 *C. van der Voort*
METSU, Gabriel 751, 752, 753 *Joost van Geel, M. Musscher*
MEULEN, Adam Frans van der 754, 755 *P. Snayers*
MEULENER, Pieter 756 *A. F. van der Meulen, P. Snayers, P. Palamedesz.*
MEYER, Hendrik de 757, 758 *A. Cuyp, C. W. Schut*
MEYERINGH, Aelbert 759 *J. Glauber*
MICHAU, Theobald 760, 761 *J. Brueghel*
MIEL, Jan 762, 763 *P. van Laer, J. Lingelbach*
MIEREVELT, Michiel van 764, 765 *J. W. Delff, G. Geldorp, J. Houckgeest, J. A. van Ravesteyn, W. van Vliet*

MIERIS the Elder, Frans van 766, 767, 768 *B. Douven, B. Maton, Will. van Mieris, J. Tilius, A. de Vois*

MIERIS, Willem van 769 *Frans van Mieris, J. Tilius*
MIGNON, Abraham 770, 771, 772 *W. Grasdorp, J. D. de Heem, O. Marseus, M. van Oosterwyck, R. Ruysch, H. Schoock*

MINDERHOUT, Hendrik van 773
MIROU, Anton 774 *M. Molanus, P. Schoubroeck*
MOLANUS, Mattheus 775 *A. Mirou*
MOLENAER, Bartholomeus 776 *A. van Ostade*
MOLENAER, Claes 777, 778 *C. Decker, Th. Heeremans, S. Rombouts, R. van Vries*
MOLENAER, Jan Miense 779, 780, 781, 782 *F. Carree, J. Hals, Egb. van Heemskerck, J. Leyster*
MOLIJN, Pieter de 783, 784, 785, 786, 787 *P. D. Santvort*
MOMMERS, Hendrick 788, 789 *N. Berchem*
MOMPER, Frans de 790, 791
MOMPER, Joost de 792, 793, 794, 795, 796 *T. Verhaecht*
MONOGRAMMIST I. S. 797, 798, 799
MOOR, Karel de 800, 801 *C. Netscher*
MOREELSE, Paulus 802, 803 *W. de Geest, G. Geldorp, C. van der Voort*
MORTEL, Jan 804 *J. D. de Heem*
MOSCHER, Jakob van 805, 806 *J. van Goyen, Sal. van Ruysdael*
MOUCHERON, Frederick de 807 *J. Asselyn, J. Both, I. de Moucheron, W. Schellinks, H. van Swanevelt*

MOUCHERON, Isaac de 808 *J. Glauber, Fr. de Moucheron*
MOYART, Nicolaes 809, 810, 811 *L. Jacobsz., S. Koninck, P. **Lastman**, J. Pynas, M. van Uyttenbroeck*

MULIER, Pieter 812 *J. Th. Blankerhoff, W. van Diest, J. Porcellis, S. de Vlieger*

MULIER, Pieter, known as Tempesta 813, 814
MURANT, Emanuel 815, 816 *J. van der Heyden*
MUSSCHER, Michiel van 817, 818 *A. van den Hecken II., N. Maes, G. Metsu, F. Sant-Acker*

MYN, Herman van der 819, 820
MYTENS the Elder, Daniel 821
MYTENS, Jan 822, 823 *A. Hanneman*
MYTENS the Elder, Martin 824 *N. Maes*

NAIVEU, Matthys 825
NAIWINCX, Herman 826, 827 *A. van Everdingen*
NASON, Pieter 828, 829 *J. de Baen, W. C. Heda, I. Luttichuys*
NATUS, Johannes 830
NECK, Jan van 831 *J. A. Backer*
NEEFFS the Elder, Pieter 832, 833 *P. Neeffs the Younger, H. van Steenwyck*
NEEFFS the Younger, Pieter 834 *P. Neeffs the Elder, H. van Steenwyck*

NEER, Aert van der 835, 836, 837, 838, 839, 840	*A. van Borssom, R. G. Camphuysen, J. Meerhoud*
NEER, Eglon Hendr. van der 841, 842, 843	*J. Verkolje, Th. van der Wilt*
NELLIUS, Martinus 844	
NETER, Laurentius de 845, 846	*P. Codde, J. Olis, A. Palamedesz.*
NETSCHER, Caspar 847, 848, 849, 850, 851	*A. Boonen, G. ter Borch, Joost van Geel, D. Haringh, R. de La Haye, A. van den Hecken II., N. Maes, K. de Moor, Const. Netscher, A. de Vois*
NETSCHER, Constantin 852	*Casp. Netscher*
NEYN, Pieter de 853	*J. van Goyen, P. Nolpe, S. van Ruysdael, E. van de Velde*
NEYTS, Gillis 854, 855	
NICKELE, Isaac van 856, 857	
NICKELEN, Jan van 858, 859	*J. Glauber, J. van Huysum*
NIEULANDT, Adriaen van 860	*P. C. van Ryck*
NIEULANDT, Willem van 861	*P. Bril*
NIWAEL, Jan R. van 862, 863	*W. van Honthorst*
NOLPE, Pieter 864, 865	*J. van Goyen, P. de Neyn, S. van Ruysdael*
NOOMS, Reinier, known as Zeeman 866, 867	
NOORDT, Jan van 868, 869	*A. van den Tempel*
NOORT, Pieter van 870, 871	*J. Cuvenes, I. van Duynen, P. de Putter*
NOUTS, Michiel 872	
OCHTERVELT, Jacob 873, 874, 875	*P. de Hooch*
OEVER, Hendrick ten 876	
OLIS, Jan 877, 878, 879	*P. Codde, J. Duck, L. de Neter*
OOLEN, Adriaen van 880	*M. de Hondecoeter, D. Wyntrack*
OOST, Jakob van 881	
OOSTEN, Isaak van 882, 883	*J. Bouttats, J. Brueghel the Elder*
OOSTERWYCK, Maria van 884	*W. Grasdorp, J. D. de Heem, A. Mignon, R. Ruysch*
ORMEA, Willem 885	*J. de Bont, J. Gillig*
OSTADE, Adriaen van 886, 887, 888, 889, 890	*C. Dusart, B. Molenaer, I. van Ostade, A. Victoryns*
OSTADE, Isaac van 891, 892, 893, 894	*A. van Ostade*
OUDENDYCK, Adriaen 895	*A. van de Velde*
OUDENROGGE, Joh. Dircksz. 896, 897	*C. Beelt, C. Decker, Sal. Rombouts*
OVERSCHEE, Pieter van 898	*A. van Beyeren, J. D. de Heem*
PALAMEDESZ., Anthonie 899, 900, 901	*P. Codde, J. Duck, D. Hals, Chr. J. van der Lamen, L. de Neter, H. G. Pot, J. van Velsen*
PALAMEDESZ., Palamedes 902	*J. Martsen de Jonge, P. Meulener, P. Post, J. van der Stoffe*
PAPE, Abraham de 903	*Qu. van Brekelenkam, G. Dou, A. van Gaesbeeck*
PAULYN, Horatius 904	*J. van der Heyden, Fr. van Mieris*
PEETERS, Bonaventura 905, 906	*C. Mahu, Jan Peeters, Jan and Jul. Porcellis*
PEETERS, Clara 907, 908, 909	*P. Claesz., F. van Dyck*
PEETERS, Gillis 910, 911	*J. Tilens*
PEETERS, Jan 912, 913	*B. Peeters, Jan and Jul. Porcellis*
PESCHIER, N. L. 914	*H. Andriessen, J. de Claeuw, J. Vermeulen, V. L. van der Vinne, P. van Willigen*
Pickenoy siehe ELIAS	
PLATTENBERG, Matthieu van 915	
PLUYM, Carel van der 916	
POEL, Egbert van der 917, 918, 919	*A. Colonia, H. Potuyl, C. Saftleven, H. M. Sorgh, D. Vosmaer*
POELENBURGH, Cornelis van 920, 921, 922	*B. Breenbergh, A. van Cuylenborch, J. van Haensbergen, D. van der Lisse, W. van Rysen, D. Vertangen, F. Verwilt*

POMPE, Gerrit 923, 924	*L. Backhuysen*
POORTER, Willem de 925, 926	*L. Bramer*
PORCELLIS, Jan 927, 928	*W. van Diest, H. Goderis, P. Mulier, B. and J. Peeters,* *Jul. Porcellis, C. Stooter*
PORCELLIS, Julius 929	*B. and Jan Peeters, Jan Porcellis*
POST, Frans 930, 931	
POST, Pieter 932	*J. Martsen de J., P. Palamedesz., J. van der Stoffe*
POT, Hendrick Gerritsz. 933, 933a, 934	*P. Codde, A. Palamedesz., J. Duck*
POTHEUCK, Johann 935	*B. Vermeer*
POTTER, Paulus 936, 937, 938, 939	*G. D. Camphuysen, K. Dujardin, A. Klomp,* *A. van de Velde*
POTTER, Pieter Sym. 940, 941, 942	*H. Andriessen, P. Codde, E. Collier, J. Duck*
POTUYL, Hendrik 943	*E. van der Poel, F. Ryckhals, D. Ryckaert,* *C. Saftleven, H. M. Sorgh*
PUTTER, Pieter de 944	*A. van Beyeren, I. van Duynen, P. van Noort*
PUYTLINCK, Christoffel 945, 946	
PYNACKER, Adam 947, 948	*J. Asselyn, A. Begeyn, J. Both, N. Ficke, J. Sonje,* *Th. Wyck*
PYNAS, Jacob 949, 950, 951	*L. Jacobsz, P. Lastman, N. Moyart, Jan Pynas,* *J. Tengnagel*
PYNAS, Jan 952, 953	*L. Jacobsz., P. Lastman, N. Moyart, Jacob Pynas,* *J. Tengnagel*
QUAST, Pieter 954, 955, 956	*J. J. Buesem*
QUELLINUS, Erasmus 957	*P. van Lint*
RAVESTEYN, Hubert van 958, 958a	*C. Saftleven, H. M. Sorgh, J. van de Velde, D. Wyntrack*
RAVESTEYN, Jan Anth. van 959, 960	*N. Elias, W. de Geest, G. Geldorp, J. Houckgeest,* *M. van Mierevelt, W. van Vliet, C. van der Voort*
RENESSE, Constantyn van 961	
RIETSCHOOF, Jan Claesz. 962, 963	*L. Backhuysen, A. Storck*
RING, Pieter de 964	*J. D. de Heem*
ROEPEL, Conraet 965, 966	*R. Ruysch, K. B. Voet*
ROESTRATEN, Pieter G. van 967, 968, 969	*E. Boursse, R. van Campen*
ROGHMAN, Roeland 970	*J. Looten, H. Saftleven*
ROMBOUTS, Gillis 971, 972, 973	*C. Beelt, J. Esselens, W. Kool, S. Rombouts, R. van Vries*
ROMBOUTS, Salomon 974, 975, 976	*C. Decker, W. Gras, Cl. Molenaer, J. D. Oudenrogge,* *G. Rombouts, J. van Ruisdael, R. van Vries, J. B. Wolfert*
ROMBOUTS, Theodor 977, 978	*D. van Baburen, G. van Honthorst, A. Janssens*

Volume III

ROMEYN, Willem 979, 980	*N. Berchem, K. Dujardin, A. Klomp, J. F. Soolmaker*
ROOTIUS, Jakob 981	*P. Gallis, J. D. de Heem*
ROOTIUS, Jan Albertsz. 982, 983	*W. de Geest, W. C. Heda*
ROYEN, Willem Frans van 984, 985	*W. van Aelst, J. Weenix*
RUELLES, Pieter des 986	
RUISDAEL, Jakob van 987, 988, 989, 990, 991, 992, 993	*A. van Borssom, G. Dubois, A. van Everdingen,* *G. van Hees, M. Hobbema, J. van Kessel, J. Lagoor,* *S. Rombouts, C. Vroom*
RUYSCH, Rachel 994, 995	*E. van den Broeck, W. Grasdorp, J. van Huysum,* *A. de Lust, O. Marseus, A. Mignon, M. van Oosterwyck,* *C. Roepel*
RUYSDAEL, Jakob Salom. van 996, 997	*S. van Ruysdael*
RUYSDAEL, Salomon van 998, 999, 1000, 1001, 1002	*J. Coelenbier, J. van Goyen, W. Kool, J. van Moscher,* *P. de Neyn, P. Nolpe, J. S. van Ruysdael, J. Schoeff,* *J. de Volder*

Ruytenbach, E. 1003	B. Gael, Th. Heeremans
Ryck, Cornelia de 1004	M. de Hondecoeter, Jac. Victors
Ryck, Pieter Corn. van 1005	C. Jac. Delff, A. van Nieulandt, F. van Schooten
Ryckaert the Younger, David 1006, 1007, 1008, 1009	H. Potuyl, F. Ryckhals, G. van Tilborgh
Ryckaert, Marten 1010, 1011	P. Bril
Ryckhals, François 1012, 1013	P. van den Bosch, H. Potuyl, D. Ryckaert, H. M. Sorgh
Rysbraeck, Pieter 1014	P. A. Immenraet, L. de Vadder
Rysen, Warnard van 1015	C. van Poelenburgh, Fr. Verwilt

Saenredam, Pieter 1016, 1017, 1018, 1019	
Saftleven, Cornelis 1020, 1021, 1022, 1023	Ph. Angel, P. de Bloot, E. van der Poel, H. Potuyl, H. van Ravesteyn, H. Saftleven, H. M. Sorgh
Saftleven, Herman 1024, 1025, 1026, 1027	J. Griffier, R. Roghman, C. Saftleven
Sallaert, Antoine 1028	
Sanders, Hercules 1029	B. van der Helst
Sant-Acker, F. 1030, 1031	M. van Musscher, J. van Streeck
Santvoort, Dirck 1032, 1033	J. G. Cuyp, N. Elias, C. van der Voort
Santvort, Pieter D. 1034, 1035	P. de Molyn
Sauts, Dirck 1036	J. van Son
Savery, Roelant 1037, 1038, 1039, 1040	J. and F. Bouttats, A. Bosschaert, J. de Gheyn, G. de Hondecoeter
Schalcke, Cornelis S. van der 1041, 1042	J. Vermeer van Haarlem the Elder, J. de Vos
Schalcken, Godfried 1043, 1044, 1045	A. Boonen, G. Dou
Schellinks, Willem 1046	J. Asselyn, J. and W. de Heusch, J. Lapp, F. de Moucheron
Schoeff, Johannes 1047, 1048	Sal. van Ruysdael
Schoevaerdts, Mathys 1049, 1050	A. F. Boudewyns, P. Bout
Schoock, Hendrick 1051	A. Mignon
Schooten, Floris van 1052, 1053, 1054	C. J. Delff, Fl. van Dyck, J. van Es, R. Koets, P. C. van Ryck
Schotanus, Petrus 1055	
Schoubroeck, Pieter 1056, 1057	A. Mirou
Schut, Cornelis 1058	
Schut, C. W. 1059	H. de Meyer
Seghers, Daniel 1060, 1061	J. A. van der Baren, F. van Everbroeck, H. Galle, J. van den Hecke, C. Luycks, J. van Thielen, N. van Veerendael, F. Yckens
Seghers, Gerard 1062, 1063	J. Janssens, Th. Willeboirts
Seghers, Hercules 1064, 1065	
Siberechts, Jan 1066, 1067, 1068	
Simons, Michiel 1069, 1070	J. D. de Heem
Sion, Peeter 1071	
Slabbaert, Karel 1072, 1073	
Slingeland, Pieter van 1074, 1075, 1076	P. van den Bosch, G. Dou, A. van Gaesbeeck, H. M. Sorgh
Sluys, Jacob van der 1077, 1078	
Smit, Aernout 1079	L. Backhuysen, J. Th. Blankerhoff
Snayers, Pieter 1080, 1081	L. de Hondt, P. Meulener, S. Vrancx
Snellinck, Andries 1082	
Snellinck, Cornelis 1083	
Snyders, Frans 1084, 1085, 1086, 1087, 1088	P. Boel, J. Fyt, A. van Utrecht, P. de Vos
Snyers, Pieter 1089, 1090	
Son, Joris van 1091, 1092	F. van Everbroeck, J. D. de Heem, D. Sauts
Sonje, Jan 1093	N. Berchem, A. Pynacker
Soolmaker, Jan Frans 1094, 1095	J. van der Bent, M. Carree, W. Romeyn

SORGH, Hendrick Martensz. 1096, 1097, 1098, 1099, 1100, 1101 *P. de Bloot, E. van der Poel, H. Potuyl, H. van Ravesteyn, F. Ryckhals, C. Saftleven, P. van Slingeland, E. de Witte*

SPREEUWEN, Jacob van 1102, 1103 *G. Dou, J. van Staveren*

STALBEMT, Adriaen van 1104, 1105 *P. Stevens*

STALPAERT, Pieter 1106

Stap siehe WOUTERSZ.

STAVEREN, Jan van 1107, 1108 *Qu. van Brekelenkam, G. Dou, P. Leermans, B. Maton, J. van Spreeuwen*

STAVERENUS, Petrus 1109, 1110

STEEN, Jan 1111, 1112, 1113, 1114, 1115, 1116, 1117 *R. Brakenburgh*

STEENWYCK, Harmen van 1118, 1119 *J. D. de Heem*

STEENWYCK the Elder, Hendrick van 1120, 1121 *B. van Bassen, D. van Delen, H. van Steenwyck the Younger*

STEENWYCK the Younger, Hendrick van 1122, 1123 *B. van Bassen, P. Neeffs, H. van Steenwyck the Elder*

STEENWYCK, Pieter van 1124 *H. Andriessen, J. de Claeuw, N. L. Peschier, J. Vermeulen*

STEVENS, Pieter 1125 *A. van Stalbemt, Fr. van Valckenborch*

STOCK, Ignatius van der 1126, 1127 *L. Achtschellinck, J. d'Arthois, C. Huysmans, L. de Vadder*

STOCKMAN, Jan G. 1128 *J. van der Haagen*

STOFFE, Jan van der 1129 *J. Martsen de Jonge, P. Palamedesz., P. Post*

STOOP, Dirck 1130, 1131 *H. van Lin, P. C. Verbeeck, H. Verschuring, Ph. Wouwerman*

STOOP, Maerten 1132, 1133

STOOTER, Cornelis 1134 *J. Porcellis*

STORCK, Abraham 1135, 1136 *L. Backhuysen, J. Lingelbach, J. Cl. Rietschoof*

STORCK, Jacobus 1137, 1138 *A. Storck*

STRAATEN, Lambert van der 1139

STREECK, Hendrik van 1140, 1141 *J. van Streeck, E. de Witte*

STREECK, Juriaen van 1142, 1143 *W. Kalf, S. Luttichuys, F. Sant-Acker, C. Striep, B. Vermeer, H. van Westhoven*

STRIEP, Christian 1144 *G. W. Horst, W. Kalf, O. Marseus, J. van Streeck*

SUSENIER, Abraham 1145 *A. van Beyeren*

SUSIO, Ludovico de 1146

SUYCKER, Reyer Claesz. 1147 *E. van de Velde*

SWANENBURGH, Jacob Is. 1148, 1149, 1150

SWANEVELT, Herman van 1151 *J. Glauber, F. de Moucheron*

SWEERTS, Michiel 1152, 1153, 1154 *P. van Laer, W. Vaillant*

TEMPEL, Abraham van den 1155, 1156 *B. van der Helst, N. de Helt-Stocade, P. Hennekyn, J. van Noordt*

Tempesta siehe MULIER

TENGNAGEL, Jan 1157, 1158, 1159 *P. Lastman, Jac. and Jan Pynas*

TENIERS, David 1160, 1161, 1162, 1163, 1164, 1165, 1166, 1167 *Th. van Apshoven*

Terborch siehe BORCH

TERBRUGGHEN, Hendrick 1168, 1169, 1170, 1171 *D. van Baburen, P. Bor, J. van Bylert, G. van Honthorst*

TERWESTEN, Augustin 1172

THIELEN, Jan van 1173 *J. A. van der Baren, Chr. Luycks, F. van Everbroeck, D. Seghers, N. van Veerendal, F. Ykens*

THOMAS, Gerard 1174 *H. Govaerts*

THULDEN, Theodor van 1175, 1176

THYS, Pieter 1177, 1178

TIELING, Lodewyck 1179 *A. van de Velde*

TILBORGH, Gillis van 1180, 1181	G. Coques, J. van Craesbeeck, M. van Helmont, D. Ryckaert
TILENS, Jan 1182	G. Peeters
TILIUS, Jan 1183	Fr. and Will. van Mieris
TOL, Dominicus van 1184, 1185	G. Dou
TOORENVLIET, Jacob 1186, 1187, 1188	
TORRENTIUS, Johannes 1189	
TRECK, Jan Jansz. 1190, 1191	W. Kalf, J. J. den Uyl, J. van de Velde
TROYEN, Rombout van 1192, 1193	A. van Cuylenborch
TYSSENS, Jan Baptist 1194	
UDEN, Lucas van 1195, 1196, 1197	
ULFT, Jakob van der 1198	
URSELINCX, Johannes 1199	G. de Hondecoeter
UTRECHT, Adriaen van 1200, 1201, 1202	J. Fyt, Fr. Snyders
UYL, Jan Jansz. den 1203	W. C. Heda, J. J. Treck
UYTTENBROECK, Moses van 1204, 1205, 1206	D. Dalens, N. Moyart, J. Pynas
VADDER, Lodewyk de 1207	L. Achtschellinck, J. d'Arthois, C. Huysmans, P. Rysbraeck, I. van der Stock
VAILLANT, Wallerant 1208, 1209	M. Sweerts
VALCKENBORCH, Frederick van 1210, 1211, 1212	P. Stevens
VALCKENBORCH, Gillis van 1213	M. van Valckenborch
VALCKENBORCH, Lucas van 1214, 1215, 1216, 1217, 1218	
VALCKENBORCH, Martin van 1219, 1220, 1221	G. van Valckenborch
VALCKERT, Werner van den 1222, 1223	
VALK, Hendrik de 1224	R. Brakenburgh
VALKENBURG, Dirk 1225	J. Weenix
VEEN, Balthasar van der 1226, 1227	
VEEN, Otto van 1228, 1229	
VEER, Johannes de 1230	
VEERENDAEL, Nicolaes van 1231, 1232	D. Seghers, J. van Thielen
VELDE, Adriaen van de 1233, 1234, 1235, 1236, 1237	J. van der Bent, D. van Bergen, J. and S. van der Does, K. Dujardin, A. Oudendyck, P. Potter, L. Tieling
VELDE II, Anthonie 1238	
VELDE, Esaias van de 1239, 1240, 1241, 1242	J. C. Droochsloot, J. van Goyen, P. de Neyn, R. Cl. Suycker
VELDE, Jan van de 1243, 1244	P. Anraadt, J. Fris, P. Gallis, P. Janssens, H. van Ravesteyn, J. J. Treck
VELDE, Pieter van den 1245, 1246	
VELDE the Younger, Willem van de 1247, 1248, 1249, 1250, 1251	L. Backhuysen, J. van de Cappelle, H. Dubbels, S. de Vlieger
VELSEN, Jacob van 1252	P. Codde, A. Palamedesz.
VENNE, Adriaen P. van de 1253, 1254, 1255	
VENNE, Pseudo van de 1256	
VERBEECK, Cornelis 1257	H. C. Vroom, C. C. van Wieringen
VERBEECK, Pieter Cornelisz. 1258, 1259	D. Stoop, Ph. Wouwerman
VERBOOM, Adriaen 1260, 1261	P. J. van Asch, J. Lagoor, J. Vermeer van Haarlem, A. Waterloo
VERBRUGGEN, Gaspar Peeter 1262, 1263	
VERBURGH, Dionijs 1264	C. J. van der Willigen
VERDOEL, Adriaen 1265, 1266	E. Collier, A. Gael, P. P. Vromans, J. de Wet
VERELST, Pieter 1267, 1268, 1269	Ph. and S. Koninck
VERELST, Simon 1270, 1271	E. van den Broeck, C. Kick
VERHAECHT, Tobias 1272, 1273	J. de Momper

VERHAERT, Dirck 1274, 1275
VERHOUT, Constantyn 1276, 1277
VERKOLJE, Jan 1278 — *R. de La Haye, E. van der Neer, N. Verkolje,*
Th. van der Wilt, G. P. van Zyl

VERKOLJE, Nicolaes 1279 — *J. Verkolje*
VERMEER, Barent 1280 — *J. van Kipshaven, J. Potheuck, J. van Streeck,*
H. van Westhoven

VERMEER VAN HAARLEM the Elder, Jan — *Cl. Hals, J. van Kessel, J. and Ph. Koninck,*
 1281, 1282, 1283, 1284 — *A. Verboom, C. S. van der Schalcke*
VERMEER VAN HAARLEM the Younger, Jan 1285 — *D. van Bergen, J. and S. van der Does*
VERMEULEN, Jan 1286 — *H. Andriessen, J. de Claeuw, E. Collier, N. L. Peschier,*
P. van Steenwyck, V. L. van der Vinne, P. van der Willigen

VERSCHUIER, Lieve 1287, 1288
VERSCHURING, Hendrik 1289, 1290 — *H. van Lin, D. Stoop, Ph. Wouwerman*
VERSPRONCK, Jan 1291, 1292 — *J. A. Backer*
VERSTRALEN, Antonie 1293, 1294 — *H. Avercamp*
VERTANGEN, Daniel 1295, 1296 — *A. van Cuylenborch, C. van Poelenburgh*
VERWER, Abraham de 1297 — *J. de Verwer*
VERWER, Justus de 1298 — *A. de Verwer*
VERWILT, François 1299 — *C. van Poelenburgh, W. van Rysen*
VIANEN II., Paulus van 1300
VICTORS, Jacobus 1301, 1302 — *M. de Hondecoeter, C. de Ryck*
VICTORS, Jan 1303, 1304, 1305, 1306 — *J. A. Backer, F. Bol, G. Flinck*
VICTORYNS, Anthonie 1307 — *A. van Ostade*
VILLEERS, Jacob de 1308
VINCKBOONS, David 1309, 1310, 1311, 1312
VINNE, Vincent Laur. van der 1313 — *H. Andriessen, J. de Claeuw, E. Collier, N. L. Peschier,*
J. Vermeulen, P. van der Willigen

VITRINGA, Wigerus 1314, 1315 — *L. Backhuysen*
VLIEGER, Simon de 1316, 1317, 1318, 1319 — *J. A. Bellevois, W. van Diest, H. Dubbels, P. Mulier,*
W. van de Velde

VLIET, Hendrik van 1320, 1321 — *D. Blieck, G. Houckgeest, E. de Witte*
VLIET, Willem van 1322 — *M. van Mierevelt, J. A. van Ravesteyn*
VOET, Karel Borch. 1323 — *C. Roepel*
VOIS, Arie de 1324, 1325, 1326 — *Fr. van Mieris, C. Netscher*
VOLDER, Joost de 1327 — *J. van Goyen, S. van Ruysdael*
VONCK, Elias 1328 — *J. Vonck*
VONCK, Jan 1329 — *E. Vonck*
VOORHOUT, Jan 1330
VOORT, Cornelis van der 1331, 1332 — *N. Elias, Th. de Keyser, S. Mesdach, M. van Mierevelt,*
P. Moreelse, J. A. van Ravesteyn, D. Santvoort

VOS, Cornelis de 1333, 1334 — *J. Cossiers, C. de Crayer*
VOS, Jan de 1335 — *C. van der Schalcke*
VOS, Paul de 1336, 1337 — *F. Snyders*
VOS, Simon de 1338
VOSKUYL, Huyg. Pietersz. 1339, 1340 — *Th. de Keyser*
VOSMAER, Daniel 1341, 1342 — *E. van der Poel*
VOSMAER, Jacob 1343 — *J. de Gheyn*
VRANCX, Sebastian 1344, 1345, 1346, 1347 — *P. Snayers, J. van der Wyhen*
VREE, Nicolaes de 1348 — *J. Wynants*
VREL, Jacobus 1349, 1350, 1351 — *E. Boursse, I. Koedyck*
VRIES, Abraham de 1352
VRIES, Michiel van 1353, 1354 — *R. van Vries*
VRIES, Roelof van 1355, 1356, 1357 — *C. Decker, W. Gras, Cl. Molenaer, G. and S. Rombouts,*
M. van Vries, J. B. Wolfert

VROMANS, Isaac 1358 — *N. Lachtropius, O. Marseus, M. Withoos*
VROMANS the Younger, Pieter P. 1359 — *Adr. Gael, A. Verdoel, J. de Wet*
VROOM, Cornelis 1360, 1361 — *G. Dubois, J. van Ruisdael*

Vroom, Hendrik 1362, 1363 *A. van Antum, C. Verbeeck, C. C. Wou*
Vucht, Gerrit van 1364, 1365
Vucht, Jan van 1366 *J. van Baden, D. van Delen*

Wabbe, Jakob 1367, 1368
Wael, Cornelis de 1369
Walscapelle, Jacob van 1370, 1371 *J. D. de Heem*
Waterloo, Anthonie 1372, 1373 *P. J. van Asch, J. Looten, A. Verboom*
Wautier, Michaelina 1374
Weenix, Jan 1375, 1376, 1377 *C. Lelienbergh, W. F. van Royen, D. Valkenburg,*
 J. B. Weenix

Weenix, Jan Baptist 1378, 1379, 1380 *J. Weenix*
Werff, Adriaen van der 1381, 1382 *B. Douven, H. van Limborch P. van der Werff,*
Werff, Pieter van der 1383 *A. van der Werff*
Westerbaen the Younger, Jan 1384
Westhoven, Huybert van 1385 *J. van Streeck, B. Vermeer*
Wet, Jacob Will. de 1386, 1387 *A. Gael, A. Verdoel, P. P. Vromans*
Weyerman, Jacob Campo 1388
Wieringen, Cornelis Cl. van 1389, 1390, 1391 *C. Verbeeck, H. C. Vroom, C. C. Wou*
Wildens, Jan 1392, 1393
Willaerts, Abraham 1394, 1395 *Ad. Willaerts*
Willaerts, Adam 1396 *Abr. Willaerts*
Willeboirts, Thomas 1397 *G. Seghers*
Willigen, Claes Jansz. van der 1398 *D. Verburgh*
Willigen, Pieter van der 1399 *H. Andriessen, J. de Claeuw, N. L. Peschier, J. Vermeulen,*
 V. L. van der Vinne

Wils, Jan 1400, 1401, 1402
Wilt, Thomas van der 1403 *E. van der Neer, J. Verkolje, G. P. van Zyl*
Withoos, Matthias 1404, 1405 *N. Lachtropius, O. Marseus, I. Vromans, G. A. van Wittel*
Witte, Emanuel de 1406, 1407, 1408, 1409, *G. Houckgeest, R. van Langevelt, H. M. Sorgh,*
 1410 *H. van Streeck, H. van Vliet*
Witte, Gaspard de 1411
Wittel, Gaspar Adr. van 1412, 1413 *M. Withoos*
Wolfert, Jan Baptist 1414, 1415 *S. Rombouts, R. van Vries*
Wolffsen, Aleida 1416 *C. Netscher*
Wou, Claes Claesz. 1417 *H. C. Vroom, C. C. van Wieringen*
Wouters, Frans 1418, 1419, 1420
Woutersz., Jan, known as Stap 1421, 1422, 1423
Wouwerman, Jan 1424, 1425 *W. Gras, P. Wouwerman, J. Wynants*
Wouwerman, Philips 1426, 1427, 1428, 1429, *J. van Huchtenburgh, D. Stoop, P. C. Verbeeck,*
 1430, 1431, 1432 *H. Verschuring, P. Wouwerman*
Wouwerman, Pieter 1433, 1434, 1435 *J. and Ph. Wouwerman*
Wtewael, Joach. Antonisz. 1436, 1437, 1438 *A. Bloemaert*
Wyck, Jan 1439 *D. Maas*
Wyck, Thomas 1440, 1441 *J. Lingelbach, A. Pynacker*
Wyckersloot, Jan van 1442
Wyhen, Jacques van der 1443 *S. Vrancx*
Wynants, Jan 1444, 1445, 1446 *N. de Vree, J. Wouwerman*
Wynen, Dominicus van 1447
Wyntrack, Dirk 1448, 1449 *A. van Oolen, H. van Ravesteyn*
Wytmans, Mattheus 1450, 1451

Ykens, Frans 1452, 1453 *J. van Hulsdonck, D. Seghers, J. van Thielen*

Zeelander, Pieter de 1454
Zeeman siehe Nooms
Zuylen, Jan Hendriksz. van 1455, 1456
Zyl, Gerard P. van 1457 *J. Verkolje, Th. van der Wilt*